images

cts

d

To my wife Diane
and my children Laini and Adam
who so completely embody the wonder
and beauty of the world

images
objects
and ideas

VIEWING THE VISUAL ARTS

Barry Nemett

The Maryland Institute, College of Fine Art

HARCOURT BRACE JOVANOVICH COLLEGE PUBLISHERS

Fort Worth Philadelphia San Diego New York Orlando Austin San Antonio

Toronto Montreal London Sydney Tokyo

Publisher	*Ted Buchholz*
Acquisitions Editor	*Janet Wilhite*
Senior Project Editor	*Dawn Youngblood*
Production Manager	*Kenneth A. Dunaway*
Art & Design Supervisor	*John Ritland*
Photo/Permissions Editor	*Kevin E. White*
Text Design	*DUO Design Group*
Cover Designer	*Pat Sloan*

LIBRARY OF CONGRESS CATALOGING-IN-PUBLICATION DATA

Nemett, Barry.
 Images, objects, and ideas : viewing the visual arts / Barry Nemett.
 p. cm.
 Includes bibliographical references and index.
 ISBN: 0-03-021782-2
 1. Art–Psychology. 2. Art–Philosophy. 3. Art appreciation.
I. Title.
N71.N46 1991
701' .1–dc20 90–25238

2 3 4 5 0 4 8 9 8 7 6 5 4 3 2 1

Photo credits appear on page 324.

The genuine wonder and excitement that a stimulating teacher may inspire cannot be bound up inside the covers of a textbook. These qualities lead students of art back to museums and galleries when they are not required to be there. In this book I have attempted to participate in the teacher's task of igniting the student's interest in the provocative, marvelous world of visual expression by demonstrating that viewing art, like making art, can be a highly creative activity which promises a lifetime of growth and pleasure.

Like most art appreciation books, *Images, Objects, and Ideas: Viewing the Visual Arts* addresses general principles that underlie patterns of visual expression. But general principles are just that — general. While in the midst of designing a building, architects do not ask themselves: "How do I design buildings?" The more appropriate question is, "What must I do to resolve the design of this building?" Likewise, the most vital question an individual looking at a work of art can ask is not, "How should I look at works of art?" but "How should I look at this work of art?" An understanding of the basic visual elements and principles enables a viewer to approach an image or object with some guidelines for interpretation; the quality of the encounter between the viewer and the work of art, however, depends on the viewer's ability to interpret the special qualities and ideas generated by an individual image or object. This book provides example after example of just this kind of particularized viewing experience, a viewing experience wherein individual works of art are addressed directly — not with an abstract theory in mind but with the work of art in sight.

Images, Objects, and Ideas: Viewing the Visual Arts focuses on the two key participants of any viewing experience — the work of art itself and the viewer. Works of art are inexhaustible — they do not lend themselves to one "right" interpretation. Throughout the text, students are reminded that numerous judgements can be made concerning the form, which, in turn, produce differing interpretations affecting the content. Students learn that their personal backgrounds and ways of seeing the world, as well as their familiarity with pertinent historical, religious, or literary references, contribute substantially to their interpretation of a work of art.

This book is distinguished by numerous organizational and educational details. Featured, for example, in each chapter are two "In Depth" discussions of individual works of art. These discussions bring together, and examine more comprehensively, key chapter points. Moreover, they represent sustained viewing experiences which, by example, demonstrate that works of art deserve more than the passing glances they too often receive. As a means of developing a student's ability to look intensely at, and come to personal terms with, an individual work of art, the "In Depth" discussions also provide examples of the kind of writing assignments students could carry out themselves. In addition to the twenty "In Depth" analyses provided, many of the commentaries accompanying the other reproductions in this book are more detailed than even the most sustained discussions of individual works found in comparable texts.

Questions that precede the "In Depth" discussions challenge the students' interpretive powers while guiding them towards notable aspects of the works under consideration. Although I provide responses to these questions, students are encouraged to form their own interpretations based on the visual information they find in the work as it relates to their own frames of reference.

Placed in the margins alongside discussions in which a specific art historical movement is mentioned is information regarding the major characteristics of that movement and some of the movement's most important proponents. This use of marginalia serves several purposes: 1) contextual art historical information is provided with a minimum of interruption to the flow of the essentially non-art historical text, and 2) by separating the art historical information from the text, that encapsulated information is highlighted, enabling the student to locate historical data more easily. Hopefully, the simplicity and directness of these notes will not blur the fact that art is governed as much by exceptions as by rules. Artists living at particular time periods may have demonstrated important shared characteristics, enabling us for the sake of convenience to legitimately identify their creations as Mannerist, or Baroque, or Romantic art. We should remind our students, however, that, although it is a useful and accepted practice, the formulation of these characteristics into this or that art movement is an invented, artificial construct, and that many of the artists included within a given category do not conform to all the tenets that characterize that movement. Further, we should point out to our students that an artist's preoccupations are subject to change. Frank Stella, for example, a leading force in the creation of Minimal Art, is presently creating art that has virtually nothing in common with the tenets of Minimalism. Ultimately, art will always defy even the best intentioned comforts of categorization.

Closing each chapter are Critical Questions that are unaccompanied by commentary. These questions, which relate to the principles and ideas introduced earlier in the chapter, are designed to stimulate students to rely more fully on their own interpretive powers. The Critical Questions sections allow students to experience consciously this fundamental means of analysis while placing themselves in the role of active participants in the learning process. Additionally, these sections provide examples of the kinds of questions students may want to ask themselves when they view other works of art.

Essentially, every significant topic and general principle addressed in this book is illustrated by visual examples that embody diverse media or materials, and that stem from diverse time periods and cultural backgrounds. Works from Western and non-Western countries are consistently considered alongside one another. This procedure underscores my belief that although art from diverse cultural backgrounds will inevitably be influenced by an exclusive set of conventions or motivations, and

despite the fact that every medium and material displays unique characteristics, all art stems from one creative source and speaks a common language. As teachers we can impress upon students the importance of context—that viewing an African mask, for example, while it is worn by a dancer during the ritual for which it was originally created is a very different experience from seeing that same mask hanging perfectly still on a museum wall. We can explain to students that the more they know about the world within which a work of art was created, the richer their enjoyment and more insightful their interpretation of that work is likely to be. But before a student is likely to be motivated to independently explore background information such as the myth, ritual, or historical influences that underlie a given work of art which may, at first, look particularly "foreign," some form of connection between the student and the work must be established. By developing an appreciation for the visual elements and principles that underlie works of visual art, such a connection is provided.

Images, Objects, and Ideas: Viewing the Visual Arts is divided into five parts. Part 1 emphasizes the importance not only of the creative process of the artist, but of the viewer as well. Parts 2 and 3 include intensive examinations of each of the visual elements and principles. A notable feature of Part 3, Principles of Visual Art, is the analysis of one painting, Francisco Goya's The Executions of the Third of May, which is considered within the context of a different visual principle in each of the three chapters that comprise this part. Relatedly, in order to demonstrate the interdependence of the individual components that comprise visual expression, in one section of Part 3 (Chapter 8), each of the visual elements is considered within the context of the visual principle, Rhythm.

Part 4 addresses many of the principal materials and techniques artists have employed throughout history. In addition to providing technical information, I have tried to relate the way in which particular materials and techniques contribute to particular visual effects and expressive results. Part 4 allows you flexibility of positioning: depending on your approach, the two chapters that comprise this part may be effectively introduced at any time during the semester.

A chronology in the Appendix lists important art historical movements. Artists included in *Images, Objects, and Ideas: Viewing the Visual Arts* are listed alongside the art historical period with which they are generally asssociated so that students can see at a glance where these artists fit into art history. A detailed Glossary is also included in the Appendix.

Looking directly at a work of art can be a profoundly satisfying and stimulating experience, limited only by our ability to appreciate its unique mode of expression. It is my hope that this book will enable students to understand and enjoy the silent, yet eloquent, language of ideas portrayed through visual images and objects.

ACKNOWLEDGMENTS

Many people contributed directly and indirectly to the writing of this book. My first note of thanks goes to my wife Diane and my children Laini and Adam, who shared my excitements and frustrations throughout this project. One cannot go far wrong being surrounded by three such vital, giving individuals. I wish to thank, as well, my parents Bobbie and Milton Nemett, whose devotion to their children and toward each other has never failed to amaze and inspire me. Other family members to whom I am indebted include Danny Rosen, whose kindness and generosity serve as a model for me, and Rose Rosen, who did not live to see this book's completion. Rose's curiosity, wisdom, and sensitivity enriched my life — and so many other lives — immeasurably. I am indebted, as well, to Marsha and David Freidman, Abby and Marc Rosen, and Gemma Torsiello, whose guidance and support are always there.

Teaching at The Maryland Institute, College of Art for the past twenty years has afforded me the priviledge of viewing and discussing works of art in particular, and ideas in general, alongside some of the most perceptive and sensitive individuals with whom anyone could ever hope to work. Over and over again, I have been enriched by my conversations with Richard Kalter, Howie Weiss, Stuart Abarbanel, Albert Sangiamo, Patricia Alexander, Kevin Labadie, Jan Pierce-Stinchcomb, Dan Dudrow, Jo Smail, and Joe Shannon. But my thanks are extended to the entire faculty at The Maryland Institute whose dedication to their art and to the art of teaching has inspired much that is written in this book.

Teachers learn more from their students than the other way around, and I am no exception. I have had the rare, good fortune to work with countless gifted individuals whose committment to their art is matched only by their enthusiasm for life in general. My students' influence on my thinking is reflected on every page of this text.

And what would I have done without the extensive collection of writings contained in the Maryland Institute library and the expert staff of librarians for whom no reference was too obscure to locate? To John Stoneham, Irma Sangiamo, Mary Anne Rosinsky, and the rest of the library staff, thankyou for making this book so much richer, and my life so much easier.

I am grateful to the staff at Harcourt Brace Jovanovich for their professionalism. I will always be thankful to: Karen Dubno, who was willing to take an unconventional approach to an Introductory Arts text; Anne Boynton-Trigg, Developmental Editor, for her attention to detail (although there were times I wished her red pen would run out of ink), her corrections, advice, and easy-going personality; Buddy Barkalow, for his helpful administrative assistance; Kevin White, who fulfilled the monumental task of acquiring the rights and reproductions of the approximately 400 illustrations; Dawn Youngblood, Senior Project Editor, for her creative and conscientious problem solving talents; Ken Dunaway, for his meticulous handling of the complex production of the art and text;

John Ritland, for his expertise in management of the tasteful design of the text and cover; to Mary Pat Donlon, for her marketing expertise; and to my current Acquisitions Editor, Janet Wilhite, who presided over all of the stages in the publishing process. And finally, I'm most grateful to Harcourt Brace Jovanovich for taking a chance on a painter who likes to write.

Finally, I want to extend my sincere thanks to the following artists, college, and university teachers who reviewed the manuscript when it was still in draft form and offered invaluable ideas and critical comments: Tom Turpin, University of Arkansas; Richard Iskowitz, Lebanon Valley College (PA); Helen Muth, Southwest Missouri State University; Pamela Lawson, Radford University; Rita DeWitt, University of Southern Mississippi; Pamela Simpson, Washington & Lee University; Pat Covington, Southern Illinois University; Stan Wisniewski, Lock Haven University; Jim Knipe, Radford University; Kathy Dambach, Henry Ford Community College (MI); Bob Fisher, Yakima Valley Community College (WA); Karen White Boyd, Murray State University; Mary Griesell, Lewis & Clark Community College (IL); David Sharpe, Eastern Michigan University; William Richardson, University of Maryland; Pat Craig, California State University - Fullerton; Jack Breckenridge, Arizona State University; George Heimdal, The Ohio State University; Berk Chappell, Oregon State University; Candace Stout, University of Missouri.

Barry Nemett

contents

PART one

Artist
and
Audience

1

The Creative Process

An artist creates a work of art; then it is up to the viewer. If the viewer responds, communication takes place. If not, the work must wait for someone else. Of course, communication always remains on a superficial level until a common language is found. The premise of this book is that works of art speak a common language that can be learned and enjoyed by anyone who wants to do so.

Once you have become familiar with the elements and principles that comprise a work of art and, through practice, have learned to see how those elements and principles operate in specific examples, you will be well on your way to understanding the language of visual communication. The visual artist arranges the elements of line, shape, volumetric form, color, value, texture, and pattern, which

determine or characterize principles such as structure, space, and rhythm. These principles, in turn, characterize the figure, still life, place, abstraction, or narrative presented. This book addresses, in individual chapters, each of these elements and principles.

Works of art share common characteristics; this is the grammar of visual expression. But every work sustains its own particular set of circumstances. By addressing art in general, we run the risk of losing sight of the individual image or object. The seventeenth-century French classical author La Rochefoucauld wrote that "it is easier to know man in general than to understand one man in particular."[1] This statement applies equally well to the world of art. *Images, Objects, and Ideas: Viewing the Visual Arts* attempts to demonstrate that it is not only possible, it is highly stimulating, enriching, and enjoyable to come to a personal understanding of a particular work of art.

A FORMIDABLE BALANCING ACT

Did you ever try riding a horse while balancing a bowl almost as big as a canoe on your head? *Mounted Horseman* **[1]**, a figurative wooden sculpture from Yoruba, depicts just such a situation, but the sculpted horseman supporting the bowl appears to have the situation fully under control. The creative process, like the Yoruba horse, man, and bowl, involves the balancing of diverse elements.

Like the vessel borne upon the Yoruba horseman's head, creative expression requires a base to support it. Even the briefest artistic impulse ultimately depends on the artist's understanding, and appreciation of, his or her chosen means of visual expression. The photographer, for example, must understand how to use a camera and how to develop a print before issues of aesthetics and personal vision can be

entertained. An architect must understand basic principles of geometry, as well as various construction systems and the nature of diverse building materials; only then will the architect's more expressive concerns be capable of being effectively communicated to others. An artist's

1

Mounted Horseman (bowl). Yoruba, Nigeria. Wood stained brown, height 11⅞" (30.3 cm). Collection of the Newark Museum, Purchased 1924. Walter Dormitzer Collection.

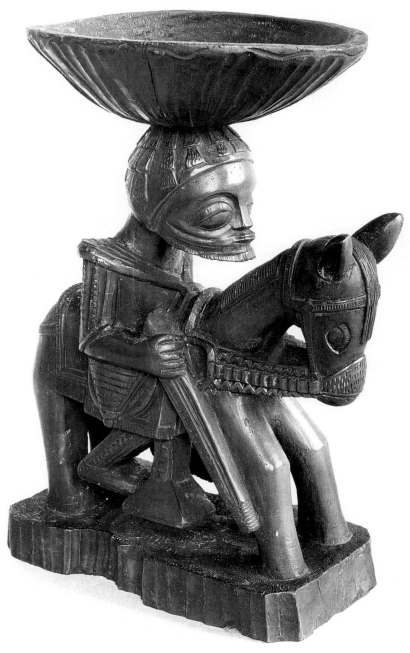

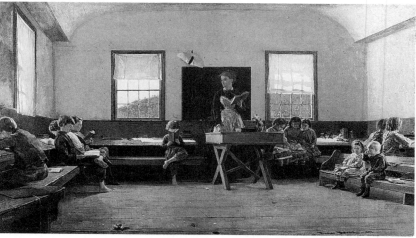

2

Winslow Homer. *The Country School.* 1871. Oil on canvas, 29⅜ x 38⅜" (54.3 x 97.5 cm). The Saint Louis Art Museum, Museum Purchase.

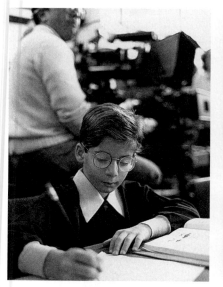

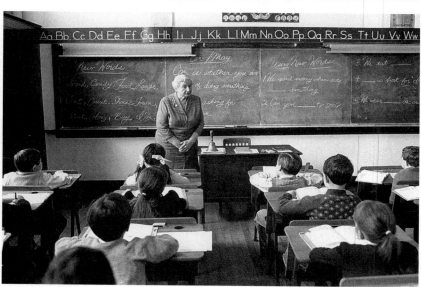

3, 4

Two stills from the film *Avalon,* directed by Barry Levinson, 1990. Courtesy of Tri-Star Pictures, Inc.

fundamental knowledge of the materials and techniques of his or her craft supports exploration and expression.

Consider our example of the *Mounted Horseman.* The sculptor's technical proficiency allows us to read the forms of horse, rider, and bowl. Many separate yet related factors must be balanced. *Mounted Horseman* is a functional, spiritual, aesthetic object. It was used by a *babalawo* (diviner-priest) in divination rituals to hold the sixteen sacred palm nuts which are said to represent the means by which Orunmila (the god linking humanity to the creative process) communicates his wisdom to mankind. This myth of

the Yoruba, a people that inhabit southwestern Nigeria, maintains that through communication with Orunmila, worldwide disorder and anxiety are replaced by harmony.

Mounted Horseman is a harmonious work of art. The body of the bearded man is visually fused with the horse he rides; the reins from the horse's mouth lead directly into the hand and forearm of the horseman whose curving hairline parallels the animal's neck. The bottom of the man's jacket can be read as part of the horse's saddle, just as the saddle's stirrups can be read as the man's feet. There are many other connections between the horse and rider (and the bowl as well)

and each of these formal determinations fortifies one of the work's major aesthetic themes: **balance,** the sense of equilibrium resulting from a harmonious arrangement of the visual elements.

Some of us may feel that the carver of this work harmonizes more than just the formal elements. For example, we may see in *Mounted Horseman* a fusion of the language of reality—the figure of the bearded man—with the language of fantasy—the horse. You may view the rider as an individual who will eventually dismount, set his vessel on the ground, and walk away, leaving his make-believe horse to rock back and forth like a child's toy. For

one viewer, the carved horse of *Mounted Horseman* is fanciful, for another viewer it may not be, at least no more so than the rider. Each of us brings a unique set of circumstances to the interpretation of a work of art, and so, participates to a certain degree in its perpetual re-creation.

CONSTRUCTING A WORLD

Creation, in a theological sense, refers to the act of bringing the world into existence. A work of art is a creation that, although confined to a limited physical expanse, inevitably attempts to construct a world. If what the artist produces is convincing, the viewer's unbounded imagination is invited or challenged to enter this world and explore it.

The nineteenth-century American **Realist** painter Winslow Homer's *The Country School* **[2]** is literally nothing more than a flat stretch of canvas covered with oil paint. But few among us see it like that. The illusion Homer created presents us with a believable slice of nineteenth-century life, a classroom scene into which the artist invites us to enter.

Working with many different materials and techniques, artists fabricate worlds for us. The film *Avalon*, directed by Barry Levinson, chronicles one family's experience of the first half of the twentieth century. Because the screen illusion he created is so convincing, we may not be conscious of the countless details that went into the creation of each scene. For a classroom scene that was filmed during the early fall of 1989, the facilities of a private Baltimore school were rented. Artificial snow was sprayed onto surrounding trees and buildings to create the look of winter, the desks and other props were changed in one of the classrooms in order to evoke the time period of the late 1940s **[3]**, and the actors were given haircuts and outfitted in period clothing **[4]**. Such care was taken because the director knew that any inappropriate details would have broken the illusion of the time and place he wanted to create.

The creative process, as it is considered within the context of this book, is the responsibility of two parties. The first, of course, is the artist, the originator of the image or object. Then the work of art undergoes a kind of rebirth when the viewer appears. In this chapter we will consider both parts of the process—the doing as well as the viewing. Let us start with the doing.

THE ARTIST

CONCEPTION

Conception, which is part of the creative process, refers to the intentions, ideas, and underlying emotions that generate a work of art. A sculptor's motivating conception may be formed before the chisel ever touches the stone—in this case creation is born from conception. Or, weeks of carving may ensue before an organizing conception forms—here conception is born from creation. Sometimes a single sentence, or even a phrase, is enough to get a writer's creative juices flowing; other times several chapters must be fleshed out before the organizing concept is realized. A model or theory will often function as the underlying conception

Realism refers to a mid-nineteenth-century style of art in which the appearance of everyday subject matter was portrayed in a straightforward, true-to-life manner. In Realist art, stylization and idealization are kept to a minimum. Important nineteenth-century Realists include Gustave Courbet and Winslow Homer.

5
Nicolas Poussin. *Landscape with the Burial of Phocion.* 1648. Oil on canvas, 47 x 70½" (1.2 x 1.8 m). Earl of Plymouth Collection, Oakley Park, England.

for original scientific research; for Sir Isaac Newton, the father of the laws of gravity, a falling apple triggered a revolution in physics. An apple sitting on a table in the studio of the French Post-Impressionist painter Paul Cézanne started a comparable revolution in the world of painting. For writer, scientist, and artist alike, the formation of a creative project is dependent upon the formulation (conscious or otherwise) of an underlying conception.

Look at the seventeenth-century French painter Nicolas Poussin's *Landscape with the Burial of Phocion* [5]. Perhaps Poussin executed this work in order to create on a two-dimensional surface the illusion of deep, receding space. Maybe his initial conception involved evoking the fading complexion of late afternoon sunlight, or a sense of the sovereignty of nature. Perhaps he wanted to construct an ordered landscape structure that would strike a grand and solemn note to accompany the noble Athenian general Phocion, who we see being carried along a path in the foreground. Poussin's was a calculating artistic temperament. "My nature," he once wrote, "constrains me to seek and to love well-ordered things, and to flee confusion, which is as much my antithesis and my enemy as light is to dark."[2] Given his penchant for organization and control, it is likely that through his preparatory studies Poussin determined the underlying conception(s) for *Landscape with the Burial of Phocion* before his brush ever touched the canvas. But who knows? We can never be certain of the

particular sequence of thoughts and emotions that comprise the complex and often baffling nature of the creation of a work of art.

The twentieth-century Spanish artist Pablo Picasso wrote, "I don't know in advance what I am going to put on the canvas. . . . Everytime I begin a picture, I feel as though I were throwing myself into the void."[3] "A picture," he stated elsewhere, "is not thought out and settled beforehand. While it is being done it changes as one's thoughts change. And when it is finished it still goes on changing according to the state of mind of whoever is looking at it."[4] Like the author who writes a novel in order to see how the story will turn out, many artists are as surprised by their creations as are their audiences. Creativity is a mysterious process; its path takes many unexpected turns. The most we can do is try to determine for ourselves whether or not a completed work of art reveals an organizing conception which, earlier, may have guided the creating artist

and, later, may guide us as creative viewers.

Unlike Nicolas Poussin's paintings which look well-rehearsed, twentieth-century American abstract painter Helen Frankenthaler appears to be guided by a more spontaneous approach. Her technique of pouring thinned-out acrylic washes onto raw canvas brought her international recognition. Recently she has experimented with a new technique: pouring and painting a mixture of chemicals, pigments, and dyes onto a series of three-panelled bronze screens, as we see, for example, in *Gateway* [6]. Her methods may change, but her penchant for exploring the role of accident in the creative process by exploiting the liquidity of her media remains consistent. Frankenthaler does not work from a rigidly formulated preconception of what a painting is going to look like when it is completed. Nonetheless, there is an underlying conception or emotion (of which the artist may or may not be consciously aware) at any given point

6
Helen Frankenthaler. *Gateway*.
1988. Patinated cast bronze screen
(7/12), 5'9" x 7' x 4½" (176 x 214
x 11.5 cm). Courtesy the artist and Tyler Graphics Ltd.

in the creative process that informs, supports, and directs the image or object being created.

INTUITION/INTELLECT

In order to understand the world, we tend to divide reality into manageable parcels. We define terms and thereafter disconnect those definitions from seemingly contrary portions of our vocabulary. For example, intuition can be defined as knowledge, understanding, or direction that is obtained by "internal apprehension without the aid of perception or the reasoning powers."[5] The word itself comes from the Latin *intueri*—"to look or see within." Intellect can be described as "the faculty of understanding, whether of the objects immediately presented in sense perception, or of those known by processes of reasoning."[6] These dictionary definitions are accurate as far as they go, but they do not go far enough. Moreover, they are misleading because they suggest that the two terms they define are mutually exclusive.

Where the creative process is concerned, intuition and intellect are inextricably connected. An artist's intuition is developed by painting many pictures, by carving or assembling many sculptures, by designing many buildings. It is necessary to do a subject over and over again, the French Impressionist painter and sculptor Edgar Degas believed. "Nothing in art must seem accidental, not even a moment."[7] "I assure you," Degas stated elsewhere, "that no art was ever less spontaneous than mine. What I do is the result of reflection and study of the great masters; of inspiration, spontaneity, temperament . . . I know nothing."[8] But despite such beliefs, Degas also stated: "Only when he no longer knows what he is doing does the painter do good things."[9] Intuition may ultimately exist as nonverbal thought, but it is formed by innumerable decision-making episodes from the artist's past. Intuition is always informed by experience and intelligence, which is what distinguishes it from pure, unbridled emotion, and it operates unnoticed, which is what distinguishes it from thought processes controlled by the conscious mind. Speaking about the conscious mind, the twentieth-century American sculptor Louise Nevelson insisted that great artists permit consciousness and unconsciousness to work together. "You don't have to analyze every minute. When you breathe, you don't think every minute, 'I'm breathing.' "[10] The artist, she maintained, taps everything at once.

The Far Eastern tradition of Zen painting offers a particularly vivid and productive illustration of how intuition and intellect overlap in the visual arts. The Zen artist believes deeply in the underlying harmony of heaven (spirit) and earth (matter). To separate intuitive release (spirit) from intellectual or physical control (matter) is to set heaven and earth apart. Zen painting is based on a long, disciplined period of study and training in painting techniques. Only after one becomes totally familiar with the way of the brush can one not think about the brush. For the Zen painter, methodical training and preparation liberates. It is in this sense that the Zen artist speaks of "controlled spontaneity," and it is in this context that we should understand the Zen maxim: "Develop an infallible technique, and then place yourself at the mercy of inspiration."[11]

Let us imagine the Chinese painter Li Shan sitting down with his brush, ink, grinding stone, and paper—what the Chinese call the "Four Precious Things of a Writing Desk." Imagine the many preceding years of running an ink-laden brush across paper so absorbent (like blotting paper) that the brush stroke must be absolutely unhesitating since the stroke is not subject to correction. Consider the years spent learning the basic laws of preparing inks, of practicing to hold the brush and press it to the paper according to prescribed conventions, of portraying the same few subjects time and time again (the range of subject matter in Chinese art is decidedly limited). With this background in mind, look at Li Shan's painting entitled *Orchids* [7].

Orchid stems stretch and bend generously across the page. The rhythmical intermingling of the lines clearly appears to lie closer to the artist's heart than does the attempt to depict the plant **naturalistically,** that is, in a manner in which the artist's visual description of the subject closely resembles the subject's actual appearance. The inscription Li Shan included next to the flower image refers to the act of looking within (*intueri*): "As I painted the orchid I apprehended its essence in broad outline." Intuition stems from Li Shan losing himself in his activity and in his subject. Mastery of the art of brush painting prepared the artist to communicate his penetrating response in broad outline.

CONCEPTUAL/PERCEPTUAL

Li Shan's statement that he "apprehended" the essence of the orchid should be understood in the broadest sense. Imagine the artist seizing his subject completely, with his mind and body. One senses that Li Shan perceived the fragrance and the feel and the pulse of the flower—which does not mean that he painted from direct observation. Zen painting is not an art of faithful depiction; traditionally, the general concept or universal characteristics of a subject are all-important. For the Zen artist a picture is painted first in the mind, then it is set down on paper. There is no need to look outwardly at a particular subject because everything required is already pictured (conceptualized) within the artist's imagination.

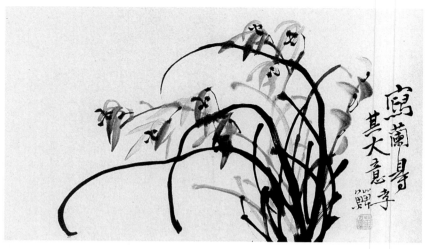

7
**Li Shan. *Orchids*. c. 1710–1740.
Ink on paper, 9⁷⁄₁₆ x 13³⁄₈"
(24 x 35 cm).** Collection of Peter C.
Swann, Kitchener, Ontario.

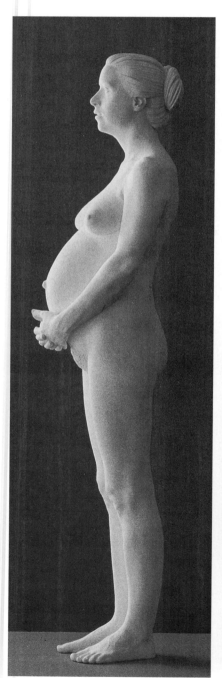

8
**Isabel McIlvain. *Venus*. 1981.
Bronze, height 26" (66.3 cm).**
Robert Schoelkopf Gallery, New York.

9
**Nicoya Red Ware Effigy representing a pregnant woman. From El
Panamá (Culebra Bay), Guanacaste,
Costa Rica. Height 11½" (29.3 cm).**
Private Collection, San José, Costa
Rica.

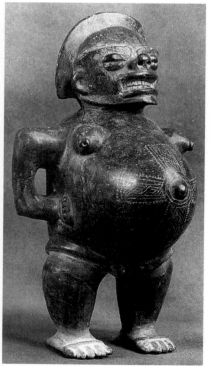

Earlier we described conception as the originating intentions, ideas, and underlying emotions that generate a work of art. Let us now broaden our use of the term. When we refer to an artist's conceptual approach, we are referring to an approach that emphasizes the artist's mental or emotional interpretation of a subject, as opposed to a primarily perceptual orientation which is based on direct observation. All art is conceptual to some degree inasmuch as all artists inevitably make interpretive choices such as what to include or what to eliminate. But some forms of art emphasize objective recording based on the perception of a situation from a single, fixed vantage point, while other forms do not.

When Pablo Picasso stated, "I do not paint what I see, I paint what I know,"[12] he emphasized the importance, where his vision was concerned, of looking inward, of tapping his emotional and intellectual experience as a means of responding to a given situation. The exact duplication of naturalistic appearances mattered little to him.

In *Venus* [8], the contemporary American sculptor Isabel McIlvain recorded the forms and features of the human body as accurately as she could. She is a perceptual artist, and her sculpture is a portrayal of a specific human being. Compare *Venus* with *Nicoya Red Ware Effigy* [9], an eleven-

inch-high figurine from the Nicoya peninsula in northwestern Costa Rica. This is not an attempt to reproduce as accurately as possible the features of a particular person. The pottery handle-like arms extending from the exaggerated sphere of the torso are not the result of the artist's inability to portray a female figure in an anatomically correct manner. The artist who created *Nicoya Red Ware Effigy* worked from a decidedly conceptual or interpretive approach. The pose and the subject of a pregnant figure relates the American and Costa Rican sculptures; otherwise, there are many differences. One artist is not better or worse than the other because of the representational approach taken. To make value judgments based on degrees of lifelikeness is to disregard the complexity and uniqueness of works of creative expression. "How believable is the world an artist portrays?" is surely a more productive and provocative question than "How realistically did the artist depict the visible world?" Ananda K. Coomaraswamy, one of the world's most respected scholars on East Indian art, once wrote: "It is no criticism of a fairy tale to say that in our world we meet no fairies: we should rather, and do actually, condemn on the score of insincerity, a fairy tale which should be so made as to suggest that in the writer's world there were no fairies."[13] By appreciating an artist's general orientation (conceptual versus perceptual, for example), one is more readily in a position to formally consider the work from the point of view from which it was created.

While labels such as perceptual and conceptual serve as useful educational aids, they are, of course, artificial constructs. The lines we try to draw between separate categories are often easily blurred, so it is important not to allow labels to limit how we view art.

Consider *Dead Tree, Sunset Crater National Monument, Arizona* [10], a

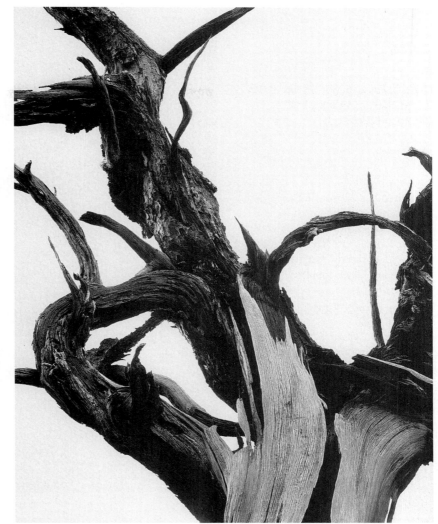

10
Ansel Adams. *Dead Tree, Sunset Crater National Monument, Arizona.*
1947. Courtesy of the Trustees of the Ansel Adams Publishing Rights Trust.
All Rights Reserved.

photograph by the twentieth-century American photographer Ansel Adams, compared with Li Shan's *Orchids*. Clearly, Adams's photograph leans decidedly toward a perceptual approach regarding visual depiction. Actual details of texture and form are precisely captured by the camera, a machine designed to impersonally and painstakingly record visual information. But like any work of art, a good photograph entails making many deliberate, as well as intuitive, decisions during its creation. In his writings, Adams repeatedly referred to a photograph as a concept. This makes sense when we realize that Adams did

not just set up his camera and objectively record what was in front of the lens. He composed. He determined where he wanted definition and where he wanted unnamed shape. He framed his subject and made choices regarding the equipment he used to create the most expressive distribution of forms, textures, and tones—that is, the abstract qualities of the image—and he anticipated how he was going to print the image. Then he clicked the shutter.

Li Shan used a brush, Ansel Adams used a machine; both were engaged in the creative process. One artist

11
Henri Matisse. *Self Portrait*. 1918.
Oil on canvas, 23⅝ x 21¼"
(60.2 x 54.2 cm).

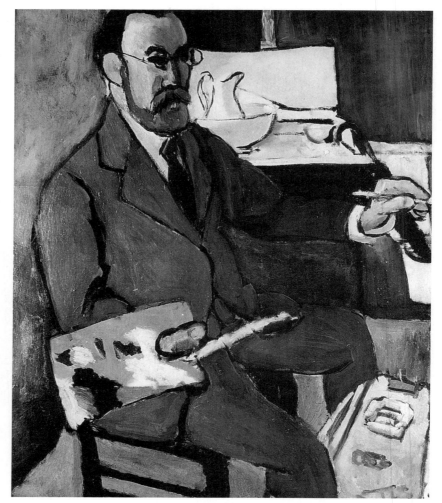

"apprehended" his subject; the other "took" a picture. Supported by a thorough grounding in his craft, each captured, or at least "remade," a part of the world within the heightened awareness of his personality.

THE ARTISTIC TEMPERAMENT

Paul Gauguin, the nineteenth-century French Post-Impressionist painter, left his wife and children so he could lead a more primitive life in exotic Tahiti. Vincent van Gogh (Gauguin's short-term roommate) suffered from bouts of rage and profound depression, and ultimately committed suicide. Lives such as these offer high drama, and so receive a great deal of attention. Indeed, irascibility, instability, and tragedy have become, at least in the twentieth century, intimately associated with an artistic temperament—the psychological make-up of the creative personality. We enthusiastically misinterpret the meaning behind a statement such as that delivered by the sixteenth-century Venetian Renaissance painter Paolo Veronese: "We artists take the same liberties as poets and madmen."[14] By focusing too readily on the artists/madmen connection, we overlook the fact that there is a profound difference between the calculated liberties taken by artists as they design paintings, sculptures, or any other structured form of visual communication, and the out-of-control, often destructive liberties taken by madmen. In the case of the former, the work of art represents a controlled context within which an individual makes choices. In the latter, the individual is often incapable of productively ordering, or choosing between, life's endless options.

The one-sided, romantic myth of the discontented artist is not confined to Western cultures. In Nigeria there is an Igbo expression that reinforces the stereotype of the temperamental artist: *Onye nakwa nka na-eme ka ona-adu iru*, which can be translated as "An artist at work is apt to wear an unfriendly face." Extending this thought, Nigerian author Chinua Achebe states in his study of Igbo art that the Igbo people view artists as individuals "excused from the normal demands of sociability."[15] In another African country, Liberia, the "normal" members of the Gola community regard artists as aberrant, the kinds of individuals "whose behavior is strange—irresponsible yet marvelous, dangerous yet attractive, and childish though wise."[16]

So pervasive is this popular conception of the antisocial and eccentric artist that college art teachers report that highly motivated, gifted, and intelligent art students will occasionally question their artistic potential because these students do not consider themselves to be aberrant or, as they put it, neurotic enough to be "real artists"—a clear case of the romanticism of myth interfering with the uniqueness of reality. Of course, many of these same college art teachers report that their most creative and gifted students are often the very students who least fit the stereotypical image of the outrageous, discontented artist. Individuals may readily adopt the appearance and behavior of rebellious artists: an act that often has little or nothing to do with those individuals' ability to exhibit genuine signs of artistic unpredictability, inventiveness, or insight where it matters most—in the works they produce.

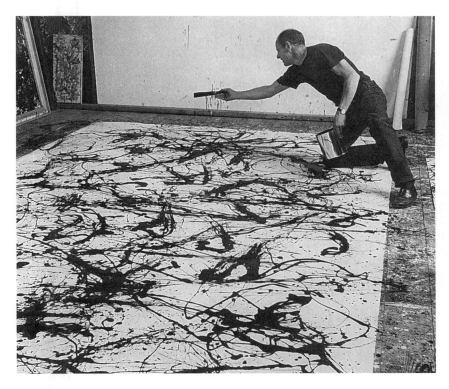

modesty, passion or dispassion, sensitivity or even heartlessness. What matters most regarding artistic expression is not the definition or quality of an artistic temperament but an artist's ability to address and express genuine feelings, ideas, and insights.

SUBJECT MATTER

Today, it is generally accepted that one subject is inherently no better or worse than another—how a given subject is handled or interpreted is what counts. But this belief was not always held. Consider, for example, the following statement by one of the giants of art history, the Italian Renaissance sculptor, painter, draftsman, and architect Michelangelo Buonarroti: ". . . but that work of painting will be most noble and excellent which copies the noblest object. . . . who is so barbarous as not to understand that the foot of a man is nobler than his shoe, and his skin nobler than that of the sheep with which he is clothed, and not to be able to estimate the worth and degree of each thing accordingly?"[20] Nicolas Poussin reinforces the idea that a rating system be applied to artistic subjects when he states: "The first requirement, fundamental to all others, is that the subject and the narrative (of a painting) be grandiose, such as battles, heroic actions, and religious themes."[21] For many centuries, a definite hierarchy of subject matter prevailed. The human figure serving as artistic subject matter, portrayed particularly in the context of heroic or divine activity, was considered most grand. Landscape and still life painting did not come into their own as separate divisions of painting until the seventeenth century.

Like Ansel Adams, who once wrote: "My world has been a world too few people are lucky enough to live in—one of peace and beauty,"[17] the twentieth-century French artist Henri Matisse was evidently a contented individual. Matisse once implored an interviewer to "tell the American people that I am a normal man; that I am a devoted husband and father, that I have three fine children, that I go to the theatre, ride horseback, have a comfortable home, a fine garden, that I love flowers, just like any man." *Self Portrait* [11] shows Matisse painting—in a suit and tie! Matisse's relatively conventional lifestyle belied a body of avant-garde work that profoundly challenged conventional standards and paved the way for much of the most pictorially experimental research still being produced today.

Matisse's temperate social persona belied his creative radicalness. The art produced by Jackson Pollock [12], whose highly developed, radical sense of pictorial order was anything but orderly (at least in the conventional sense of the word), seemed to spring naturally from the social persona displayed by the man. Pollock created paintings that were often explosive in nature. Accordingly, many accounts of Pollock describe him as a passionate, explosive individual. Relatedly, lamenting the coldness that he felt pervaded his paintings, the pioneer Cubist painter Juan Gris finally resigned himself to the fact that he was who he was. "One must after all paint as one is oneself," Gris wrote. "My mind is too precise to go dirtying a blue or twisting a straight line."[18] However, one with a refined social manner may be capable of giving shape to demonic fears and fantasies. An artist possessing a nasty disposition may produce delicate, uplifting works of art. As the contemporary American writer Joyce Carol Oates maintains, "Not all artists are worthy of their art."[19] Just as there are untold manifestations of creativity, the artistic temperament manifests itself in limitless, complex ways.

A fundamental challenge for twentieth-century Western artists involves exploring the emotional and experiential charges that comprise or determine an individual's artistic temperament. That temperament might be characterized by flamboyance or

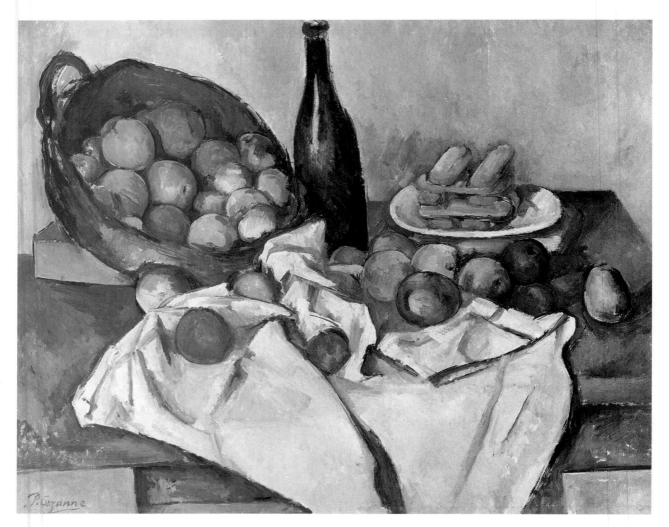

13
Paul Cézanne (French, 1839–1906). *The Basket of Apples*. c. 1895. Oil on canvas, 25¹¹⁄₁₆ x 31⅞" (65.5 x 81.3 cm).
Helen Birch Bartlett Memorial Collection (1926.252). ©1990 The Art Institute of Chicago. All Rights Reserved.

Today, most of us recognize that there are no unworthy subjects, only uncultivated outlooks. Subject matter should not be rated; its standard is belief—the artist's belief in the subject (challenge) he or she wishes to pursue. Everything else follows. Certain subjects set in motion an artist's strengths and obsessions, causing that individual to return over and over to the same theme. Return visits generally produce in the artist a deeper sense of intimacy and insight toward the subject. After exploring the obvious problems and the reasonable or conventional solutions of a given subject or theme, artists often arrive at territories they simply never thought

to investigate earlier; they begin to see things that neither they nor anyone else ever saw before. Repetition and familiarity are often the precursors of insight and invention. The Nabi painter Édouard Vuillard addressed this idea when in 1893 he wrote in his journal: "Why is it in familiar places that one's spirit and sensibility find the most that is really novel?"[22] The list of artists who spent their lives repeatedly returning to creative obsessions is endless: the lifelong series of Rembrandt, van Gogh, and Käthe Kollwitz self-portraits; the apples of Cézanne; the mother and child images by Mary Cassatt; Charlie Chaplin's tramp; the reclining female abstrac-

tions carved by Henry Moore; the rigid lines of Mondrian or the streaming ones of Jackson Pollock; the battle scenes filmed by Akira Kurosawa. . . .

But to look at a work by any of the artists listed above and see only the literal subject matter or the isolated artistic obsession is to look from an obstructed vantage point. Consider the case of Cézanne, for example. Yes, apples inspired this French master whose canvases such as *The Basket of Apples* **[13]** revolutionized the art of painting. Not since the indiscretion in the Garden of Eden has an apple caused such a sensation. Cézanne painted apples for many reasons,

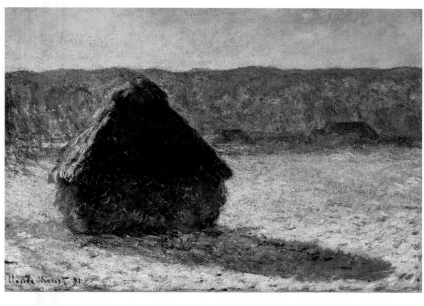

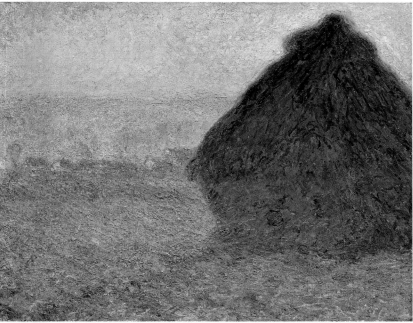

perhaps the most basic of which was that they sat still and could therefore be calmly observed. Cézanne methodically arranged and rearranged them at will, using their colors and shapes to establish the kinds of patterns and spatial organizations that he was simultaneously exploring in his landscape and figure paintings. Presumably, this grandeur and rigorous order that Cézanne imposed across his shelves and tabletops is what prompted the French painter and writer Maurice Denis to call Cézanne "that Poussin of the still life."[23] But while apples may have served as the literal subject of Cézanne's still life paintings, the subject of the artist's most vital energies was his radical concept of form.

FORM AND CONTENT

Form refers to the elements—line, shape, volumetric form, texture, color, value—and principles—structure, space, and rhythm—that comprise the language of visual art. When form is the primary focus of an artist's attention, form becomes **content,** that is, what the work of art is primarily about. Fundamentally, the form and content of a work of art are interdependent.

Both *Grainstack (Snow Effect)* [14] and *Grainstack (Sunset)* [15] illustrate an artist's depiction of a haystack, the literal subject matter of his attention.

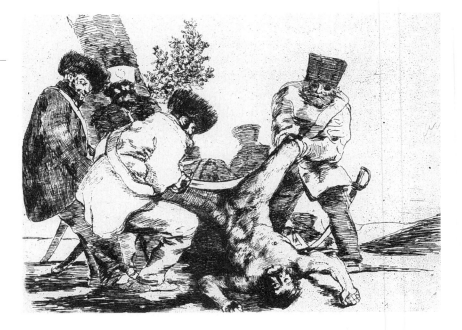

16
Francisco de Goya. *Qué hai que hacer más?* from *The Disasters of War*. 1863. Aquatint, 6 x 8" (15.3 x 20.4 cm). Biblioteca Nacional, Madrid.

The challenge of capturing the vibrancy and transience of nature's light-filled moments played a major role in the art movement called **Impressionism**. Using small, flickering strokes of color, the Impressionists portrayed the intangible phenomenon of light in a more substantial manner than the way they portrayed three-dimensional form. The French Impressionists, including Claude Monet, Auguste Renoir, Camille Pissaro, Alfred Sisley, and Berthe Morisot, were based in Paris during the latter decades of the nineteenth century.

But the primary pictorial or formal subjects that preoccupied the French **Impressionist** Claude Monet in each of these canvases are color and light—visual elements which he saw as inseparable. "When you go out to paint," Monet once told a young follower, "try to forget what objects you have before you—a tree, a house, a field, or whatever. Merely think, here is a little square of blue, here an oblong of pink, here a streak of yellow. . . ."[24] Monet believed that if the strokes of color were right, identification of the literal subject matter would take care of itself. The viewer who sees only pretty scenes in Monet's paintings overlooks an important part of the artist's motivation and the experience he provided.

On the other hand, sometimes a viewer can get so involved with the form that the content is inappropriately disregarded. Consider the following account which begins the second half of our consideration of the creative process.

THE VIEWER

FORM AND CONTENT

While I was still a student in art school I once talked to a nonartist friend about a particularly gruesome etching captioned *Qué hai que hacer más?* ("What more can one do?") **[16]** from a series of etchings known as *The Disasters of War* by the nineteenth-century Spanish painter and printmaker Francisco José de Goya y Lucientes. The etching depicts a Spanish peasant being disemboweled. The man is upside down and the blade of a French soldier is about to split him in half from the crotch to the skull. I talked about the range of light and dark tones in the print, about the contrasting attire of the fully clothed soldiers surrounding the naked Spaniard, about the variety of marks Goya employed to distinguish a hat from a coat from a leafy branch from bare, tortured skin. I even commented upon the graceful rhythm of curves winding through the soldiers' belt straps and sabers. I ignored the utter hideousness of the scene. Perhaps it seemed obvious and therefore unnecessary to discuss it. Maybe the grotesqueness of the image overwhelmed my ability to address it. Maybe. But I suspect that it was my art school training that caused me to approach the work as I did. I was taught to appreciate the formal elements of a work of art; little attention was ever brought to subject matter—form, not content, was what counted. My friend went along with

me and exhibited interest in my observations on the etching. Perhaps he was just being polite.

Less polite was a group of junior high school students that I was invited to lecture early in my teaching career, who—upon glimpsing a slide of the same etching flashed on a screen—immediately screamed at me to go on to the next picture. This one was "disgusting, gross." These students instinctively related to the physical suffering of the victim; their anger at being assaulted by the flash of lights, darks, and halftones projected into their otherwise blackened auditorium was the outcome of the pain they experienced in their imaginations. Theirs was a wholly emotional response, an important, gut response—a wonderful response really—but a limited one, as limited as the analysis I had offered my friend years before. Goya, who the French novelist and critic André Malraux described as unquestionably the greatest exponent of agony that Western Europe has ever known,[25] probably would have welcomed the reaction of these junior high school students. Goya wanted to disturb and provoke his audience as he himself was disturbed by the plight of his countrymen. The literal subject he portrayed was profoundly important to him. But Goya was also a master craftsman, and we overlook a crucial part of his art if we ignore the sober artistic decisions he made while he depicted even the most emotion-packed situation. Few artists have ever infused the subject of horror with such grace of form.

Allowing the literal subject to be the sole factor determining our likes and dislikes regarding works of art severely limits the potential pleasures the world of art holds in store for us. Likewise, focusing exclusively on form and disregarding the content of a work can be equally shortsighted. When one of the most influential critics and art theorists of the first half of the

twentieth century, Clive Bell, wrote that "The representative element in a work of art may or may not be harmful; it is always irrelevant,"[26] he was reacting to the prevailing conservativism of the time (1914). Bell wanted to sensitize his audience to the radical contributions of an artist such as Cézanne whose most original ideas involved the interpretation of form, not the realistic depiction of content (if, in fact, form and content can ever legitimately be said to be separate). Bell's point of view is interesting because it is so extreme. It is also preposterous. Regardless of the formal sophistication Goya demonstrates, how can we not consider relevant the powerful, inhuman act he portrays in *Qué hai que hacer más*. Clearly, some works of art lend themselves to an especially formal reading; other works generously open themselves up to an historical, mythological, or religious appreciation; still others are primarily about the expression of a particular emotion. Unique works of art deserve unique viewing responses which combine an appreciation for both form and content.

THE SUBJECTIVITY OF SUBJECT MATTER

Personal preference makes subject matter appealing or unappealing. One person likes horror films, another likes romantic dramas, still another prefers comedy. What determines personal preference? Genetic preconditioning, environmental influences, educational background, what happened to us yesterday, what happened to us ten years ago—many factors contribute to who we are and what we like, and all of these things affect the way we perceive the world. By sensitizing ourselves to the universal language of visual expression, we can learn to see beyond the confines of our cultural and environmental conditioning where works of art are concerned. Nonetheless, our conditioning will

inevitably affect our perceptions. Showing an African an equestrian carving could potentially lead to a discussion about mystical union and incarnation between the horse and rider. Rodeos and riding herd on cattle are not likely to come up as they might if an equestrian carving were shown to someone from Wyoming.

EMPATHY AND THE SUBJECTIVITY OF INTERPRETATION

Every creative act is an expression of empathy. For the purposes of our study, we will define **empathy** as the capacity to project one's feelings and imagination onto an outside stimulus. Such projection and identification are essential for artist and viewer alike. The painter and illustrator N. C. Wyeth addressed the problem of empathy when he told his son, the contemporary American painter Andrew Wyeth: "If you paint a man leaning over, your *own* back must ache."[27]

Throughout this book, works of art will be discussed in terms of the way their parts cooperate to express a unified visual statement. Occasionally alternative interpretations will receive attention; after all, they are always waiting for the appropriate viewer to give them life. Artists hope for fair treatment: they hope the viewer will consider the work as a whole, that the particular language of form employed will be acknowledged, and that the world they present will be entered. But the artist must expect that the biases and personality of the viewer will inevitably take over (where the artist's biases and personality leave off). What one imagination fashions will likely be transformed when it enters another imagination. Too often we check our imagination at the coatroom when we enter a museum. We solemnly look at the solemnity of the masterpieces of art history. Such a solemn process. We hope we will appreciate what we think is supposed to be appreciated, and we

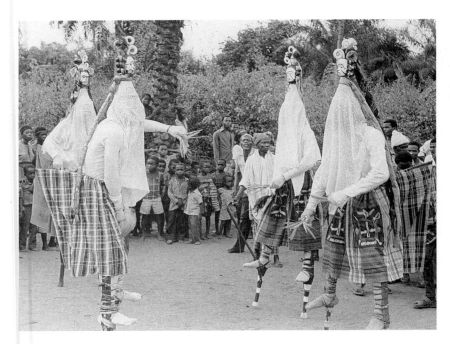

17
Four Ekeleke dancers in a unison performance. Agwa, 1983. Photo courtesy Dr. Herbert Cole, University of California, Santa Barbara.

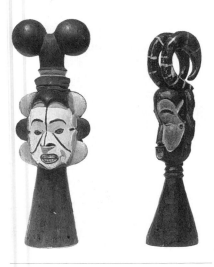

limit our seeing accordingly. And then we wonder why the experience is flat.

If you want a museum experience of depth, it is up to you to delve beneath the surface of what you learn in books or lectures. The potential for a significant viewing experience will appear most readily when you allow yourself to engage in a genuine dialogue between the world of the artist and your own world. The point of this book is not to explain the images and objects reproduced. This book presents principles that will enable you to look at art with an

informed eye, to ask the questions that matter most to you, and to listen with care to the answers that you yourself will provide.

THE SITUATION OF VIEWING

The above comments notwithstanding, it should be stated that the more we know about the world within which a work of art was created, the closer our interpretation of that work of art is likely to be to the artist's intent. Viewing African masks or headdresses during the ritual for which the headdresses were created **[17]** is a very different experience from seeing those same headdresses hanging perfectly still on a museum wall **[18]**. Nowhere do El Greco's seventeenth-century canvases look more at home than in the churches and hospitals of Toledo, Spain, for which many of them were commissioned **[19]**. Artists absorb (and affect) the political, philosophical, religious, and social realities of their place and time. The works of art they create often reflect these influences. While it may be financially prohibitive for most of us to view works of art in their faraway settings, information is readily accessible about the society in which the artist was working. By learning as much as you can about the context of the art that interests you, you will be able more fully to project your imagination into the artist's world.

18
Headdresses, Ekeleke. Wood and pigment. Fowler Museum of Cultural History, UCLA.

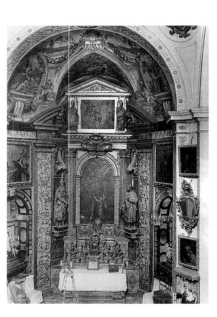

19
Altar of the Church of San José, Toledo.

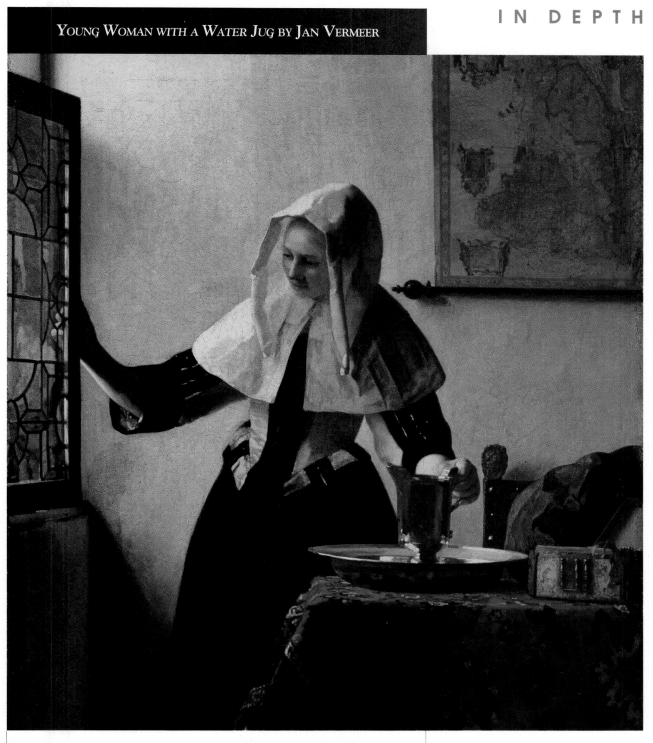

YOUNG WOMAN WITH A WATER JUG BY JAN VERMEER

Before reading the text that accompanies Jan Vermeer's painting *Young Woman with a Water Jug* **[20]**, think about the image by answering the following questions.

1. The objects in Vermeer's paintings of interiors are always handled with great attention and respect, not just as subordinate props or accessories accompanying the main figure, but as presences that enjoy lives of their own. Cite some of the items in *Young Woman with a Water Jug* that display this kind of visual integrity. Regarding these items, how many different textures can you identify?

20
Jan Vermeer. *Young Woman with a Water Jug.* c. 1663. Oil on canvas, 18 x 16" (45.7 x 40.6 cm). The Metropolitan Museum of Art, Gift of Henry G. Marquand, 1889. Marquand Collection.

2. The substances portrayed in this painting range from the cool surface of the plaster wall behind the figure, to the rough, highly detailed Turkish rug that covers the table in front of the woman. What effect does Vermeer's extraordinary ability to capture the sense of surfaces such as these have on your capacity to be engaged by this painting? Do you think artists are only interested in engaging your sense of sight, or do you think that an artist like Vermeer might have hoped you would enter the world he portrayed through your other senses as well? Consider, for example, how the sense of touch can be brought into play in this painting.

3. What mood does Vermeer establish in *Young Woman with a Water Jug*? Cite some of the artist's pictorial decisions that contribute to your impression. Do you associate this image with a sense of balance? If so, does this have any effect on your impression of the mood Vermeer created in this painting?

4. Empathize with the woman in this painting. Describe her mood. Does she present herself to us freely, or does she maintain a sense of reserve and aloofness? If you observe a sense of reserve, do you think that her turned-away glance contributes to your response? She is separated from us by the table. Do you think that the placement of the table between us and the woman reinforces her psychological distance? Explain.

5. At one time, only heroic or *important* subject matter (such as myth-ological or religious scenes or powerful political figures) was considered worthy of an artist's attention. Do you think that individuals who evaluated works of art according to a prescribed hierarchy of *importance* in this respect would have given Vermeer high marks for his choice of subject? How do you think Vermeer might have explained the *importance* he associated with the subject of *Young Woman with a Water Jug*?

The following remarks reflect my response to Vermeer's painting. They are not the "right" responses—there are no right or wrong responses to a work of art, only more or less verifiable, insightful, provocative responses given the visual clues available in the image or object. If your interpretation differs significantly from mine, re-examine the painting. Take into account how each part of the picture contributes to your impression. If your original reaction still holds, that's terrific. You have heard a voice in the image that I either missed or chose not to discuss. Works of art do not lend themselves to last words, and they seldom, if ever, mean only one thing.

The Dutch seventeenth-century painter Jan Vermeer's repertoire of subject matter was remarkably limited. He was at his best when he focused on the problem of balance and dignified calm as embodied by interior spaces, inanimate articles, and twenty-year-old women. Over and over again Vermeer returned to the theme of a solitary woman in a corner of a room. Of the approximately thirty-five paintings that are generally accepted as definitely the product of his hand, more than half of them depict this theme. Indeed, the very same women, maps, windows, rugs, tiled floors, and still life items often reappear from painting to painting. But if the fundamental focus of Vermeer's vision remained relatively constant, we should appreciate that he did not repeat himself as far as his portrayal of that vision was concerned.

It is instructive to compare two paintings by Vermeer: *Young Woman with a Water Jug* and *The Kitchenmaid* [21]. Although they are similar in many respects, notice how the artist's detailing particularizes each work. Consider, for example, the way Vermeer characterized the dissimilar social standing of the two women. The fabrics that cover the woman in *Young Woman with a Water Jug* are not fancy, but clearly they are more refined than those worn by the kitchenmaid. Likewise, the environmental details and still life items displayed throughout *Young Woman with a Water Jug* look more elaborate and costly than those in *The Kitchenmaid*. Especially noteworthy in this regard are the windows, tablecloths, and pitchers included in both paintings. The subject of a female alone in a shallow-spaced room, the general deportment of the women, and the direction of the natural lighting that illuminates each scene represent common ground on which both works stand. But despite these similarities, each painting exists as a genuine and singular painting challenge. So focused, yet so subtly varied, for example, is Vermeer's approach to color, that I had looked at these works for years before ever realizing that coloristically both paintings are based mainly on the interaction (and variations) of just two colors: yellow and blue.

In Vermeer's *Young Woman with a Water Jug,* sunlight asserts itself along a vertical strip of casement, enters the partly open window, travels through the room, encounters a far wall hidden from view, and echoes silently back. Every texture in the room reflects its contact with the afternoon light. Look at the texture of the woven red, yellow, and blue Turkish carpet that covers the table—colors that are carefully modulated and tactually distributed throughout the interior. Sunshine beats against flesh as a cool jug handle warms beneath the woman's grip. Like an open circuit, her body conducts the heat of the sun from one hand to the other, from outdoors to indoors.

Just as afternoon sunlight can affect our perception of indoor objects, the use of maps can bring the outside indoors. In 1663, a contemporary of Vermeer, the Dutch cartographer Johan Blaeu, wrote, "Maps enable us to contemplate at home and right before our eyes, things that are farthest away."[28] Accordingly, Vermeer convinces us that nothing in his painting is so remote that it cannot be pressed against the palm of the hand. Inconspicuously he introduces thousands of miles of information into the close quarters of a domestic setting as he describes the vellum frontiers of a map that fill the top right-hand corner of his canvas. The blue pole weighing down the square of geography points from the measured expanse of the room to the measureless world beyond the window. But we cannot see outside. Our angle of vision, the complicated linear geometry of the leaded window framing, and clouded glass obscure the view.

We can, along with Vermeer's quiet, refined woman, but touch the edge of the window that opens onto the outdoors. But we *can* touch the window, and that is the point. Vermeer's *Young Woman with a Water Jug* has the potential to present the empathetic museum-goer with the gift of holding the world suspended. Vermeer's painting illustrates that we have within our reach the ability to contact even that which we may assume is inaccessible—be it a physical object, a state of mind, or the subjects of our imagination.

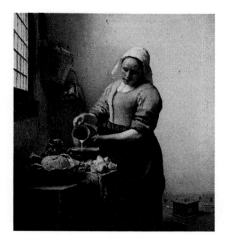

22
Susan Rothenberg. *Pontiac*. 1979.
Acrylic and flashe on canvas,
7'4" x 5'1" (2.24 x 1.56 m).
Private collection.

23
Four Horses of Saint Mark's
Cathedral, Venice. 1st century A. D.
Bronze.

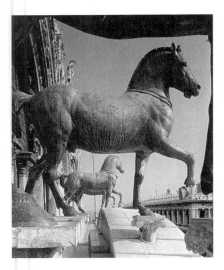

Judgment and Interpretation

There are examples of artists from almost every period of art history who are considered masters today, but who were either ignored during their lifetimes or were forgotten almost immediately after their deaths. Jan Vermeer remained unknown to the general public for over 150 years after his death. Yet his paintings such as *Young Woman with a Water Jug* [20] and *The Kitchenmaid* [21] are regarded today as unsurpassed masterpieces. The public's taste changed with time and a once neglected artist became an undisputed master. The reverse scenario occurs even more frequently: artists are considered masters during their lifetimes, only to be ignored by future generations. As historical changes of opinion indicate, there are no absolutes where value judgments regarding art and artists are concerned.

While we should all certainly try to remain as fair-minded as possible when viewing a work of art, the fact remains that personality, education, cultural conventions, and other forms of preconditioning are bound to affect our judgments. Viewing art, like making art, is a subjective experience. Works of art exist through you. The following suggestions, which summarize some of the key points presented in this chapter, are intended to enhance your pleasure and degree of participation in the dialogue of visual expression.

1. Become as familiar as possible with the elements and principles of visual expression. With this background in hand, you can begin to judge a work of art on its own terms.
2. Be careful to distinguish between projecting yourself into a work of art based on genuine responsiveness to the visual signals available, and simply indulging your imagination despite what the image or object shows. This cannot be overemphasized. It is reasonable to infer from the visual evidence provided that the female in Vermeer's *Young Woman with a Water Jug* is about to water flowers growing in a window box just beyond our view. It is unreasonable to infer that the female in Vermeer's painting is wondering whether or not she ought to sign up for a course entitled The Art of Zen Brush Painting at a nearby university. Nowhere in the painting does the artist suggest this. Accusations of "Don't you think that's a little far-fetched?" frequently accompany eccentric interpretations that cannot be supported by visual verification. But if a particular interpretation of a work of art honestly makes sense to you based on what is visible in the image or object, then your interpretation is as legitimate as anyone else's.
3. Base your response to a work of art on the kinds of concerns that you believe challenged the artist. "What was the artist trying to do?" is a question that almost always serves to position us close to the performance at hand. The counterparts to this question, "What was the artist not interested in doing?" or even "What was the artist reacting against?" are also important questions to consider. It would be inappropriate to judge the contemporary American artist Susan Rothenberg's see-through portrayal of a horse in motion, such as *Pontiac* [22], against the standards of the Greek sculptors who fashioned the four muscular horses marching proudly atop the central portal of the Basilica of Saint Mark in Venice [23]. Rothenberg's painting addresses, in twentieth-century terms, the haunting elusiveness of speed; the Saint Mark horses speak, in a classical voice, to issues of permanence and stability. Likewise, it would be inappropriate to judge the twentieth-century Romanian sculptor Constantin Brancusi's interpretation of the general concept bird (or flight) such as we see in *Bird in Space* [24] with the same set of criteria and expectations that we apply to the woven Native North American *Chilkat Tunic* [25]. Focusing on a single, abstract three-dimensional form, Brancusi evokes the idea of the simple, graceful line of the general concept

24
Constantin Brancusi. *Bird in Space*. 1928. Bronze (unique cast),
54 x 8½ x 6½" (138 x 22 x 17 cm). Collection, The Museum of Modern Art,
New York. Given Anonymously.

25
Chilkat Tunic. c. 1900. Yellow cedar bark and goat wool, 50 x 24"
(128 x 61 cm). Collection of The Portland Art Museum, Oregon Art Institute,
Gift of Elizabeth Cole Butler.

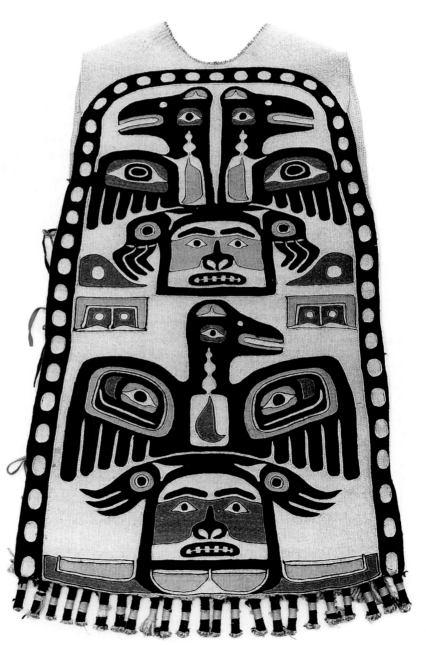

26
Albrecht Dürer. *Wing of a Roller.*
1512. Watercolor and gouache on
vellum, 7¾ x 7⅞" (19.7 x 20 cm).
Graphische Sammlung Albertina,
Vienna.

27
Anselm Kiefer. *Wayland's Song
(with Wing).* 1982. Oil, emulsion,
and straw on photograph, mounted
on canvas, with lead, 110¼ x 149⅝"
(280 x 380 cm). Saatchi Collection,
London.

Neo-Expressionism refers to a wide-ranging style of painting developed at the end of the 1970s and in the early 1980s, that is characterized by spirited paint handling, figurative (often narrative) imagery, a concern for myth, investigations into the workings of the subconscious mind, and an emphasis on the passionate (as opposed to the intellectual). Neo-Expressionism became popular in Germany (through artists such as Anselm Keifer, Georg Baselitz, and A. R. Penck) and Italy (through artists such as Sandro Chia, Mimmo Paladino, and Francesco Clemente) before reaching the United States.

"bird"; the artist who created the *Chilkat Tunic* manipulated a series of interlocking, flat, hard-edged shapes to interpret the subject of a raven, a powerful symbol which in Native North American mythology functions as, among other things, a mediator between life and death.

4. Appreciate that the degree of realism, or lifelikeness to a subject that an artist is able to achieve does not necessarily indicate how accomplished an artist is or is not. Every work of art presents a unique set of circumstances, and deserves to be judged accordingly. The fact that the sixteenth-century German artist Albrecht Dürer's *Wing of a Roller* **[26]** looks very much like the subject from which it was drawn does not make it better (or for that matter, worse)

than the twentieth-century German **Neo-Expressionist** artist Anselm Kiefer's *Wayland's Song (with Wing)* **[27]**, which is not concerned with the problem of accurate, lifelike depiction. Relatedly, the fact that Kiefer's reference to a bird is handled in a bold, expressionistic manner does not make it better or worse than Dürer's meticulous handling of the same subject. Each artist handled the subject of a bird's wing in his own way, for his own reasons.

5. Become familiar with as many examples as possible of an individual artist's work. The special ways an artist manipulates the visual elements and principles, and the particular, relatively consistent preoccupations peculiar to that artist can best be understood by

29
Piet Mondrian. *Composition in
White, Black and Red*. 1936. Oil on
canvas, 40¼ x 41" (1.03 x 1.05 m).
Collection, The Museum of Modern
Art, New York.

repeated exposure to numerous works created by that individual. For this reason, many of the artists included in this book are represented by more than one work.

6. In order to get a true and complete picture of an artist's interests and visual preoccupations, try to familiarize yourself not only with the visual consistencies that characterize an artist's work, but with a wide range of often significantly differing ideas that may have influenced the work as well. Like all people, artists change. It is not unusual to find that an individual may completely reject the motivations that once fueled his or her most passionate and penetrating artistic investigations. Such change in an artist's thinking and feeling often results in the creation of

distinct periods of expression. Moreover, even without rejecting one's past performances, an artist may simply want to explore new territory, thereby creating work that is subtly—and sometimes extremely—different from the work that artist produced before. *Woods near Oele* **[28]**, created early in the career of the twentieth-century Dutch painter Piet Mondrian, displays definite characteristics of **Fauvism**, an art movement that was decidedly fiery and impetuous in nature. However, *Composition in White, Black and Red* **[29]**, a representative example of the kind of far more cerebral, geometrically precise work for which Mondrian is best known, is a clear example of **Neo-Plasticism**, an art movement in which highly

Fauvism refers to a style of painting developed between approximately 1904 and 1907 by a group of Paris-based painters. The name of the movement was adopted by the group of artists after a critic derisively equated their paintings with *Fauves* (wild beasts). Fauvist paintings are characterized by brilliant, clearly delineated shapes of color. Important Fauvist painters include Henri Matisse, André Derain, and Maurice de Vlaminck.

Neo-Plasticism (also called De Stijl) refers to a movement developed in approximately 1917 that is characterized by simplified, abstract shapes, rigidly ordered geometry, and bright colors. Important artists associated with this movement include the Dutch painters Piet Mondrian, Theo van Doesburg, and Bart van der Leck, and the Dutch architects Jacobus Johannes, Pieter Oud, and Gerrit Rietveld.

30
I. M. Pei and Partners with Cossutta and Ponte, Fountain view of the Christian Science Church Center, Boston, 1973.

premeditated, often austere visual qualities prevail. Mondrian explored many styles of painting before he developed the pictorial language of Neo-Plasticism. To know only his Fauve paintings, or to know only his Neo-Plasticist paintings, is to have an extremely limited knowledge of Mondrian's art.

7. Visit the museums, galleries, and noteworthy architectural structures located near you in order to view works of art directly. A good reproduction of a work of art gives an idea of what may be embodied by the original, but until you actually confront the original your impressions will necessarily be incomplete. Significant details such as the actual surface, size, or color of a work of art are almost always devitalized by mechanical reproduction. Although this, of course, holds true for every art form, reproductions of three-dimensional works of art such as sculpture and architecture offer particularly inadequate substitutes for a first-hand viewing experience. No reproduction can capture the expansive sense of space embodied by the group of buildings surrounding the 700-foot-long pool that stretches like a liquid spine within the middle of the *Christian Science Church Center* [**30**] in downtown Boston. One needs to stand, sit, and walk in the carefully designed interior and exterior spaces of this complex in order to fully appreciate the architectural experience offered.

8. Consider factors such as the cultural, historical, political, religious, and biographical context within which the work was created. Context can figure into your response in several ways: a) knowing something about an individual's artistic development and biographical background can increase your understanding of that individual's work, b) comparing the work of two artists who addressed a similar subject or set of formal concerns will often demonstrate the degree of inventiveness, insight, and originality a given artist brings to the creative process, c) taking into account how a work of art both conforms to the prevailing artistic conventions of the time period in which it was created and how it challenges those conventions can also enrich your experience of a work. The art critic Hilton Kramer called the "collisions of convention and imagination, of tradition and the individual talent" the most vital artistic events that occur within the creative process. "In the life of art," Kramer contends, "there are no virgin births."[29]

9. When you lack knowledge about a work's context, rely on the strengths and interests that you already possess in order not to miss out on many potentially rewarding experiences. The art of cultures significantly different from our own, for example, will forever remain a mystery until we accept with confidence that there is a universal language of visual expression which invites us to extend ourselves into even altogether unfamiliar realms. How unnecessarily limited our experience of the world would be if we lived our lives according to the short-sighted embrace of sameness and isolation suggested by the otherwise probing and insightful nineteenth-century American writer Henry David Thoreau when he wrote: "The telephone company is trying to connect Maine and Tennessee by telephone. Even if it were to succeed, though, what would the people say to each other? What could they possibly find to talk about?"[30] The answer to that question is, "at best, plenty." Granted, the more we know about the rituals and beliefs peculiar to a foreign culture, the more complete our enjoyment and understanding of that culture's art is likely to be. But how rewarding it is to be able to enter into a dialogue with the unfamiliar in the first place! The language of visual communication makes that dialogue possible.

10. Be patient and keep an open mind. It took me years before I could see anything in the work of one of the twentieth century's most important artists, Henri Matisse. Now this French master is one of my favorite artists. What you do not care about or understand today may fascinate you tomorrow.

Ultimately, coming to terms with an artist's motivations matters less than coming to terms with your own need for creative expression. We cannot all be creative artists, but each one of us has the capacity to be a creative viewer. It just takes a little study, a lot of looking, and a willingness to imagine.

MOTHER AND SISTER OF THE ARTIST BY ÉDOUARD VUILLARD

31
Édouard Vuillard. *Mother and Sister of the Artist*. c. 1893. Oil on canvas, 18¼ x 22¼" (46.5 x 57 cm). Collection, The Museum of Modern Art, New York. Gift of Mrs. Saidie A. May.

Before reading the text that accompanies Vuillard's painting *Mother and Sister of the Artist* [31], think about the image by answering the following questions.

1. Which of the two women seems to be more dominant? Why? Does Vuillard's handling of the relationship between form and content in this painting affect your response?

2. What are some of the qualities you would attribute to the mother in this painting? How does her placement, posture, and clothing affect your feelings about her?

3. How would you describe Vuillard's sister? How does her placement and posture affect your interpretation? Vuillard's mother ran a corsetmaking workshop at her home, where, in all likelihood, dresses were made as well. Perhaps the bolts of patterned cloth with which she and her seamstresses worked exerted some influence on the artist's decision to paint his sister in a patterned dress, standing before patterned wallpaper. Why else do you think Vuillard may have chosen to clothe and position his sister this way?

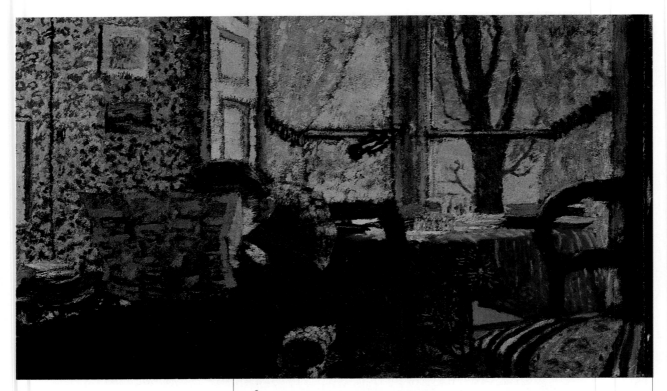

32
Édouard Vuillard. *The Newspaper.*
1898. Oil on canvas, 13½ x 21½"
(34 x 54 cm). The Phillips Collec-
tion, Washington, D.C.

4. Cite several contrasts between the two women. Can you point to any details that suggest compatibility?

Édouard Vuillard lived with his mother until she died in 1928, when he was sixty years old. The artist created many paintings in which he portrayed his mother (who he called his muse) as the main character. Often she blends softly into her environment, as we see, for example, in the *The Newspaper* **[32]**; sometimes she stands out sharply. In *Mother and Sister of the Artist,* Vuillard placed Madame Vuillard directly in our path of entry. We see her first. If by any chance we should overlook her, the bureau right behind prevents us from exploring the compressed space of the room further without first paying our respects to this fascinating, complex, even contradictory individual. The startling simplicity of the simplified black shape of her dress is calmed by the stabilizing triangle formed by her hands and face. She is seated, but there is no indication of a chair. She is a small woman, yet she dominates the rather claustrophobic environment. Her pose and placement suggest firmness and authority, while her face is soft and smiling.

Contrasted to her mother's frontal pose, the daughter is positioned at an angle to the picture plane and painted in such a way as to almost apologize for the inconvenience of her presence. Her placement on the side of the canvas and her posture suggest timidity and submissiveness. Entwined in the mesh of the pattern, she is spun back into the space of the room. The exaggerated perspective of the black floor moulding below and the white windowsill above largely determine this recession. The sound she makes is the cautious crumpling cloth of her dress, barely audible against the slam of the black material defining her mother's body.

The brushstrokes further characterize the two women. The seated woman, the floor plane, and the bureau are presented broadly and solidly, providing a sense of wholeness to the mother, while the figure and wall on the left are fractured and disturbed, contributing to the daughter's sense of

indeterminancy. Yet even in these areas of contrast Vuillard finds connections. He harmonizes the bend of his mother's right arm with his sister's torso and waist; the right foot of the mother leads straight to her daughter; the black floor moulding running uninterruptedly between them establishes a direct line of communication between the pair.

Carefully chosen pictorial details cause us to read this image in a specific way, much as punctuation determines the manner in which we read a sentence. In *Mother and Sister of the Artist*, Vuillard employed shape, pattern, posture, and placement to tell us something about two members of his immediate family. You may come to a different conclusion about what this painting is saying, but your conclusion will inevitably be determined by your interpretation of the artist's masterful merging of form and content.

CRITICAL QUESTIONS

1a. How very different is the fifteenth-century Florentine sculptor, goldsmith, and painter Andrea del Verrocchio's equestrian statue of the Venetian military commander Bartolommeo Colleoni **[33 and 34]** from the equestrian wood carving entitled *Mounted Horseman* **[1]** with which we began this chapter. Can you point out any of these differences?

b. *Mounted Horseman* measures less than twelve inches high, while the *Monument to Bartolommeo Colleoni* stands twelve feet tall. What effect do you think the colossal physical dimensions of the Colleoni Monument (which includes a twelve-foot-high base) have on the impression it makes? Or stated another way, imagine yourself standing below the Colleoni Monument. What effect do you think your vantage point would have on your emotional response to this work? Do you think there is any difference between physically *looking down at*

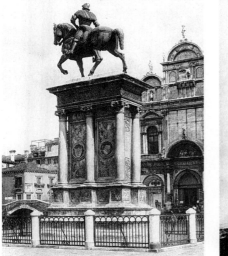 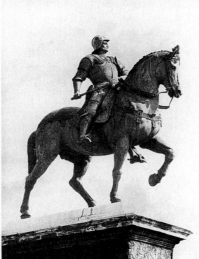

33, 34
Andrea del Verrocchio. *Monument to Bartolommeo Colleoni*. 1483–1496 (finished by Leopardi). Bronze. Approx. 13' high. Venice.

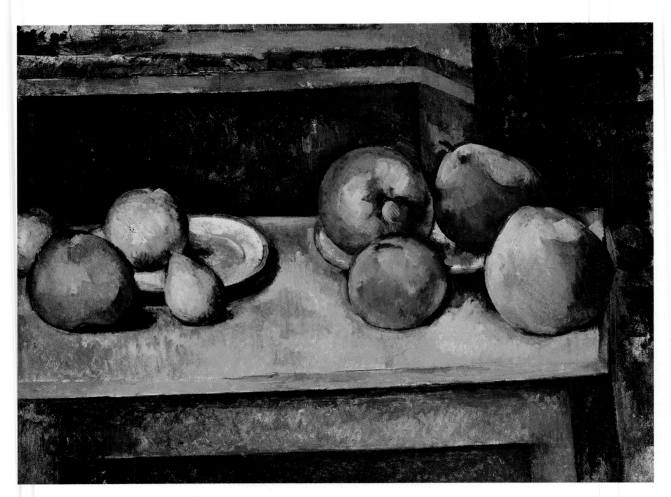

35
Paul Cézanne (c. 1885–1887).
Still Life: Apples and Pears. Oil on
canvas, 17⅝ x 23⅛"
(44.8 x 58.7 cm). The Metropolitan
Museum of Art, Bequest of Stephen
C. Clark, 1960.

something as opposed to *looking up to* that same thing? These two expressions suggest very different connotations from a semantic point of view. Do you think there is any connection between the semantic connotation and the visual?

c. Look at the relative size of the man and horse of *Mounted Horseman* as compared to the size of Bartolommeo Colleoni in relation to his horse. How does size relationship affect the sense of power and authority of the two men?

d. Colleoni's horse is muscular and altogether larger than life. Through association with the high-stepping, majestic animal, do you think the Venetian commander gains in power and authoritative stature? Explain.

e. Why do you think Verrocchio portrayed Colleoni with his left shoulder thrust forward? What effect does it have on the appearance of the military leader? Do you think it contributes in any way toward a sense of authority? What other physical characteristics can you cite that contribute to the rider's authoritative manner?

f. Colleoni's armored torso can be compared to the massive chest of the horse. Can you cite another visual analogy between the man and the horse?

g. Form and content in the Colleoni Monument are integrally connected. Explain.

2a. Like artist and viewer, the two dishes of fruit in Paul Cézanne's *Still*

Life: Apples and Pears [**35**] are mutually dependent. Explain. Cézanne also believed that vision and mind were mutually dependent for a painter and should work in unison. "As a painter," he said, "one must try to develop them harmoniously: vision, by looking at nature; mind, by ruling one's senses logically, thus providing the means of expression. This is now my aim."[32] How does this comment relate to our discussion included in this chapter under the heading Conceptual/ Perceptual?

b. This simple, frontal, rather evenly spaced pattern of fruit could have easily resulted in a common-place and uneventful picture. It does not. Why not?

c. In our discussion of *Mounted Horseman*, the term *balance* was applied. What would you say about the role balance plays in this painting? Why do you think the table below and the strip on the wall above do not continue all the way across the painting? Why do you think Cézanne lifted the right-hand side of the tabletop?

d. We look down at the left-hand plate from a higher vantage point than the position from which we view the right-hand plate. Do you think this inconsistency of vantage points was an oversight, a mistake on Cézanne's part? Can you think of any reasons he might have purposely shifted his (and our) spatial position in relation to the subject? Does it make the painting more dynamic?

e. What happens in the larger grouping on the right recurs in the smaller collection on the left. Nonetheless, the two groupings are different. Cite some of the differences.

f. Would you characterize Cézanne's approach in *Still Life: Apples and Pears* as fundamentally intuitive or intentional?

PART two

Elements
of
Visual
Expression

2

Line

A line is a mark or extended point in space that is noticeably longer than it is wide. Line is the simplest form of visual communication. Fifteen thousand years ago, animal images were delineated on cave walls and ceilings **[36]**. The portraits and figures that young children label mother and father are often drawn entirely in line **[37]**. Lines form the letters of the alphabet, numbers, musical notation, and countless doodles that decorate reams of scrap paper. In the visual arts, line fulfills many functions and the configurations it can assume are infinite.

36
Paleolithic cave painting.
Lascaux, Dordogne, France.
c. 15,000–10,000 B.C.

37
Laini Nemett, age 3. *Ma.* 1988.
Crayon on paper, 8½ x 11"
(21.6 x 28 cm). Collection of
the Author.

DIRECTIONAL LINES

One of the basic qualities of line is
direction, which we tend to associate
with different physical and emotional
states. We associate the horizontal line
with rest, the diagonal with motion,
the angular line with agitation, and
the simple curve with calmness and
grace. The way our bodies typically
function in the world supports these
associations. We lie down horizontally
to rest, whereas we are usually in a
state of motion when our bodies are
diagonal to the ground. We generally
read a curved line more slowly than a
straight one, because the shortest (and
therefore quickest) path between two
points is a straight line.

39
Court of the Lions, The Alhambra, Granada, Spain. 1354–1391.

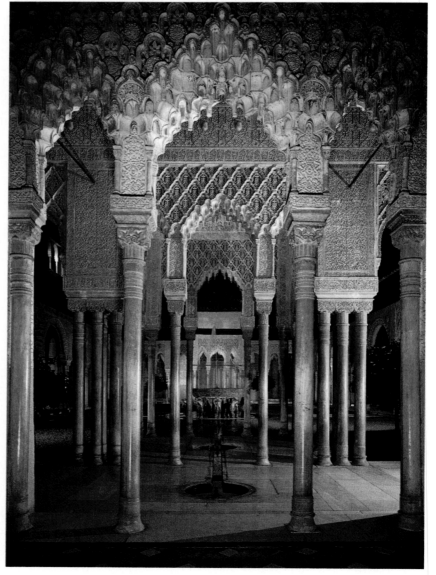

VERTICAL LINES

The straight vertical line suggests stability and dignity. When we refer to an individual as upright or as having achieved high standing in the community we are associating verticality with solid, noble attributes. In *Redwoods, Bull Creek Flat, Northern California* [38], a photograph by Ansel Adams, the variously shaded vertical lines seen against a dark background suggest stateliness and stability. An image such as this makes tangible the nineteenth-century American poet William Cullen Bryant's observation that "The groves were God's first temples."[1]

The dignity and order that pervades the spacious *Court of the Lions* in The Alhambra Palace in Granada, Spain [39], largely results from the straight vertical lines of the columns that support the intricately decorated arches and lacelike walls. The slender proportions of these columns display none of the massive power of the cigar-like columns that comprise more solid and compact looking temples such as the *Basilica* erected in the sixth century B.C. in southern Italy [40]. But despite their delicate grace, the columns of *The Alhambra* create an atmosphere of timeless stability.

40
Basilica, Paestum, Italy. c. 550 B.C.

The seated *Ancestor Figures* of the
Dogon tribe **[41]** also embody
qualities of dignity and stability
typically associated with the vertical
line. The Dogon artist emphasized
verticals (note the long necks, upper
arms, fingers, and toes **[42]**) and
greatly understated every other
direction (look at the almost nonexist-
ent forearms). The lines to which we
refer here represent the **axis** or
predominant visual direction that runs
through the center of the forms. Lines
such as these are implied lines, not
actual ones—we use our imagination
to complete a visual suggestion.

The exaggerated straight lines of the
ancestral figures' poses suggest what an
African might term a sacred calm. By
their example of perfect composure,
the carved couple establish standards
of grace and respectability for the
people of their village to honor.
Regarding longevity, primordial
ancestor figures such as those por-
trayed in this sculpture can be
understood as Adam and Eve equiva-
lents. "They were the first human
couple which later gave birth to all
ancestors."[2] Regarding presence, a
sculpture such as this is meant to
embody more than mere beauty; it is
meant to convey everlastingness and
character, what the Yoruba describe as

41
Ancestor Figures. Dogon, Mali.
Reitberg Museum, Zurich.

42
Vertical emphasis in the Dogon
ancestor figures.

43
Michelangelo Buonarroti. *David.*
1501–1504. Marble, height 18'
(5.49 m). Galleria dell' Accademia,
Florence.

44
Contrapposto in
Michelangelo's *David.*

45
Ando Hiroshige. *Boats Sailing Home to Yabase,* from the series *Omi Hakkei (Eight Views of Lake Biwa).* c. 1835.
Color woodblock print. Victoria and Albert Museum.

iwa. This is how an elder of a Yoruba community explained the difference between beauty and character: ". . . beauty does not have the force that character has. Beauty comes to an end. Character is forever."[3] The straight vertical lines pervading *Ancestor Figures* of the Dogon Tribe **[41, 42]** contribute greatly to the quality of *iwa* embodied by this work.

It is, of course, unnatural to stand, sit, or lie perfectly straight—which is one of the reasons why these figures capture the attention of many Western viewers. The straight, vertical line of a human being is more an idea than a gestural reality. Skyscrapers— contemporary monuments to pressure,

power, and progress—stand perfectly straight, but the standing posture of a relaxed human being is less rigid. In Michelangelo's sculpture of *David* **[43]** the right leg supports the weight of the body while the left leg is relaxed, employed mainly for balance. This shifting of the weight places the hips at an angle, causing the shoulders to slope in the opposite direction. We refer to such a pose as **contrapposto**, which is an Italian word meaning "counterpoise." For most people the contrapposto position is a natural, comfortable way to stand. If we compare the softly curving line that flows from David's head down to his weight-bearing foot **[44]** with the strict vertical axis of the Dogon sculpture **[42]**, the rigid poses of the one and the relaxed pose of the other are immediately apparent.

HORIZONTAL LINES

Horizontal lines suggest rest and tranquility. The calm that pervades the block print entitled *Boats Sailing Home to Yabase* **[45]**, created by the nineteenth-century Japanese artist Ando Hiroshige, is largely a result of the many horizontal bands that set the tone for this image. The parallel orientation of the repeated horizontal motions are amicably coordinated with the top and bottom edges of the paper and work together in perfect harmony. If rhythm can be defined as repetition with variation, then *Boats Sailing Home to Yabase* can surely be said to represent a smooth, rhythmical exercise in horizontality.

46
Frank Lloyd Wright. Robie House, Oak Park, Illinois. 1908–1909.

Before reading the text that accompanies Frank Lloyd Wright's *Robie House* [**46**], think about the image by answering the following questions.

1. What kind of directional line governs the organization of *Robie House*?

2. Why do you think the architect chose to keep the height of the chimney low?

3. The rooflines of *Robie House* extend significantly beyond the reach of the supporting walls below. How does this feature affect the appearance of the house? Cite several details that emphasize the horizontality of this building.

Early in his career, the twentieth-century American architect Frank Lloyd Wright designed dwellings known as "prairie houses." These houses are distinguished by the masterful way in which they harmonize with their essentially flat environment. *Robie House*, the last and most celebrated of these commissions, owes its graceful, streamlined presence to a series of long horizontal lines. The house not only ingeniously conforms to, but gloriously celebrates, the strict confines of a Chicago city lot whose narrow proportions are three times longer than they are wide. This site, which for a lesser architect might have represented an insurmountable obstacle, was for Wright an occasion for invention of the highest order.

Wright's ideas overturned many of the commonly accepted architectural practices of his day. For example, Wright rejected the convention of designing tall buildings with even taller chimneys. In *Robie House*, a centralized broad chimney, the largest single mass that interrupts the otherwise essentially continuous run of interior space, projects minimally above the house. Wright eliminated the attic, thereby allowing him to bring the long, horizontal rooflines closer to the ground. By freely extending the thrust of these rooflines without relying on any visible means of weight-bearing support, he radically opened up the concept of the building-as-box with its four enclosing corners, which was the standard architectural model up to this time.

Horizontality prevails. Vertical doorways and diagonal movements, such as the outside steps leading up from the garden, are hidden from view. The sweeping lines of roofs and walls appear to function independently, largely because of the long, dividing spaces of repeating windows and the space created by the exaggerated cantilevers (horizontal structures that extend significantly beyond supporting walls or columns). Even details like the vertically compressed flower urns built into the corners of the low-lying garden wall contribute to the architectural theme of horizontal expansion. The stone slab which caps each urn mimics the cantilevering rooftops and the long horizontal stone slabs that trim the exterior walls, as well as the slender, elegantly proportioned shape of the bricks used throughout the building, further reinforce the theme of horizontality.

47
Ando Hiroshige. *Rain Shower on Ohashi Bridge*. **19th century. Color woodblock print, 13⅞ x 9⅛" (35.2 x 23.2 cm).** The Cleveland Museum of Art, Gift from J. H. Wade, 21.318.

DIAGONAL LINES

Unlike vertical and horizontal lines, diagonals suggest action. Indeed, diagonal lines derive much of their dynamic character from the fact that they challenge notions of stability that we generally associate with the vertical and horizontal. Diagonal lines are neither prone nor upright. They are in between—in the process of moving from one extreme to the other.

In *Rain Shower on Ohashi Bridge* **[47]** by Ando Hiroshige, everything is on a slant, from the hectic lines of rain streaked across the surface of the print, to the bridge in the foreground and the row of trees in the background. Even to describe the pedestrians crossing the bridge, Hiroshige relied on the diagonal, which is an appropriate directional line to use for portraying the hurried movement of people caught in a rainstorm. In contrast, note how effectively the horizontally ordered *Boats Sailing Home to Yabase* **[45]**, by the same artist, establishes a sense of clear sailing and well-being.

48
Figure of Siva Dancing. Southern India. 16th or 17th century. Bronze, height 3' 1½" (95.3 cm). Philadelphia Museum of Art. Given by Charles H. Luddington.

49
Film still from *The Cabinet of Dr. Caligari*. 1920. Museum of Modern Art Film Stills Archive.

Expressionistic art takes many forms. It is characterized by distortion of form, color, and space, and a willingness on the artist's part to replace naturalistic description with emotional expression. Two of the earliest groups of twentieth-century artists to be termed Expressionist were the German-based Blaue Reiter (Blue Rider) and Die Brücke (The Bridge). The Blaue Reiter group includes Franz Marc, Wassily Kandinsky, August Macke, and Paul Klee. Die Brücke artists include Ernst Ludwig Kirchner, Karl Schmidt-Rottluff, and Erich Heckel. Important Expressionist architects include Erich Mendelsohn and Rudolf Steiner.

Although sensuous curves are the mainstay of most Indian sculpture, diagonal lines most profoundly motivate *Figure of Siva Dancing* **[48]**. Or perhaps we should say that the series of diagonals that comprise this sculpture seem to function as steps leading to the underlying spirit that invigorates this sensuously modelled god. Through his diagonally positioned limbs and torso Siva's divinity reaches outward, pointing in many directions at once.

A particularly powerful and disturbing use of the diagonal appears in the 1920 German silent film classic, *The Cabinet of Dr. Caligari* **[49]**, directed by Robert Wiene. Although the action of the film takes place mostly outdoors in the fictitious town of Holstemwall, the movie was filmed entirely indoors. And although architecture plays a primary role in the film, very few vertical lines are evident. Wiene employed **Expressionistic** artists to paint background canvases and to design three-dimensional streets and buildings. The distortions and exaggerated angles of these sets create an overwhelming atmosphere of psychological unrest. The plot of *The Cabinet of Dr. Caligari* involves mentally unbalanced individuals, murder, and the madness inherent in amoral, out-of-control authority.

50
Mother and Children. **Punjab Hills, Chamba. c. 1720. Black line on tan paper, 8⅛ x 6½" (20.6 x 16.5 cm).** Jagdish and Kamla Mittal Museum of Indian Art, Hyderabad, India.

51
Mary Cassatt. *Mother's Kiss.* 1891. Drypoint and soft ground etching in color, 13⅝ x 8⁵⁄₁₆" (34.6 x 21 cm). The National Gallery of Art, Washington, D.C., Chester Dale Collection.

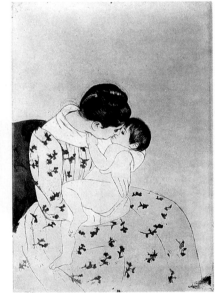

Everything, from the dramatically slanting architecture to the painted shadows, which are sometimes painted even across the faces of the actors, serves to invigorate the crazed, demonic nature of the movie's main themes.

THE CURVED LINE

Curved lines generally appear to move more slowly than diagonals. A curved line is inherently graceful and fluid, lending itself naturally to the portrayal of easy-going, tender subject matter. In *Mother and Children,* an eighteenth-century Indian drawing **[50]**, a mother plays affectionately with her two children. Despite the fact that the child closest to her is upside-down, there is little sense of roughhousing; calmness and control prevail. The mother will not accidentally drop the child, so completely intertwined in a curvilinear embrace are they. One form leads smoothly and securely into another. Appropriately, the flowering plants decorating the background continue the flowing lines of the threesome below.

Decorative flowers adorn the billowing dress of the woman in Mary Cassatt's tender print, *Mother's Kiss* **[51]**. Unlike the Indian drawing, the background of the Philadelphia-born Cassatt's print is empty. Otherwise, these two images have much in common in terms of subject matter and their dependence on the soothing nature of interweaving curvilinear lines.

Artists sometimes choose to contradict the natural tendencies of a general visual principle. As a creative viewer, it is important not only to become familiar with general principles regarding the art of visual expression, but to come to terms as well with extenuating circumstances that may temper the way a particular visual principle functions in a particular work of art. For example, in the

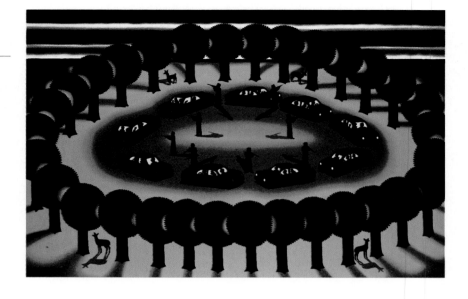

52
Roger Brown. *Surrounded by Nature*. 1986. Oil on canvas, 48 x 72" (1.22 x 1.83 m). Phyllis Kind Gallery, New York and Chicago.

contemporary American painter Roger Brown's *Surrounded by Nature* [52], the artist uses curved line in a less agreeable manner than do the two preceding mother and child images. Ordinarily, curved lines suggest peace and tranquility. Here, a series of circles sets the stage for fear. The armed and armored people contained within the innermost circles are protecting themselves against something, but we do not know what that something is. Perhaps they themselves do not know. The title of the painting and the visible evidence suggest that nature has not run amok. The mere fact that nature is near appears to pose the only threat.

It is dark. The car lights and the unexplained light beams apparent between the otherwise silhouetted crowns of the thirty-one encircling lollipop trees cast an eerie glow. Equally disturbing is the stylized sameness of many of the painting's parts, which creates simple geometric patterns with complex overtones. Like the protective ring of a wagon train, Roger Brown's circles suggest neither peace nor tranquility. *Surrounded by Nature* is a cross between a cartoon, a cowboy-and-Indian movie, and an apocalyptic comment on the nightmare of anxiety. The anxiety seems

endless, due largely perhaps to the sense of endlessness that is an inherent part of the ultimate curved line, the circle: a continuum without a beginning or an end. Brown portrays an endless nightmare that remains a quiet, pent-up dread, not an outright panic-stricken expression of horror. Attribute the difference largely to the series of curves which slightly soothe the unnerving mood of the image without denying the painting its tense, quirky edge.

COORDINATION AND COMPARISON OF STRAIGHT AND CURVED LINES

Often, artists coordinate the inherent characteristics of several visual principles in order to emphasize a particular idea. For example, coupling two types of directional lines such as the curve and the horizontal is apt to reinforce the curve's inherent grace and gentle, easy-going motion by aligning it with the restful character of a horizontal line. We see this

53
Imperial Ancestral Temple, Forbidden City, Beijing, China. 15th century.

principle at work in the rooftops of many of the buildings of the Forbidden City in Beijing, China. Look at the double-eaved *Imperial Ancestral Temple* [53]. Proportionately, the two roofs for this long, low building with significant eave projections are massive, yet the temple does not look top-heavy. Gentle slopes visually lighten the load of the roofs, instilling the building with a sense of elegance and tranquility.

Rheims Cathedral [54] is clearly dominated by a multitude of monumental vertical thrusts that take the form of intricately detailed portals and windows with pointed arches, pinnacles, and towers that look like they are prepared to climb straight up to heaven. Where else does so much stone appear so weightless? The art of geometry and the geometry of art have joined forces. The program of curves punctuating the cathedral introduces a welcome and graceful tension to the solemn authority of the strict, vertical rhythms.

The aggressive contrast of curves and straight lines in the eighteenth-century Japanese artist Suzuki Harunobu's *Girl on Kiyomizu Terrace* [55] provides a surprisingly charged atmosphere to a subject involving rest and contemplation. It has been suggested that this seemingly serene girl dressed in a flower-patterned kimono that is folded into fluidly flowing lines is, perhaps, considering whether or not to leap over the edge of the verandah as a test of love.[4] The author of this suggestion offers nothing to reinforce his imaginative speculation. However, the extreme pictorial conflict (which for some viewers may suggest emotional conflict) created by the artist's bold juxtaposition of distinct directional lines does lend a degree of credibility to this romantic response to the image. Consider, at any rate, how much more serene this scene would appear if Harunobu had chosen to surround the curvilinear

54
Facade of Rheims Cathedral, France. 1225-1299.

55
Suzuki Harunobu. *Girl on Kiyomizu Terrace*. 1767–1768. Woodblock print (7 colors), 11⅛ x 8¹/₁₆" (28.2 x 20.5 cm). Courtesy, Museum of Fine Arts, Boston.

56
**Keith Haring. *'Growing' Suite, #1*. 1988. Silkscreen print, 40 x 30"
(102 x 76 cm).** Courtesy The Keith Haring Foundation and Martin Lawrence Limited Editions.

lines of the girl with more softly curving lines, or with a more simplified, uninterrupted expanse of space.

TYPES OF LINE

There are many types of line. The kind of line artists adopt in their work informs the idea or emotion they wish to convey. **Outlines** indicate in a diagrammatic way the general shape and size of things or where one thing ends and another begins. **Contour lines** describe three-dimensional form. Unlike outlines, contour lines tend to be spatially descriptive. **Implied lines** are, in effect, invisible; they depend on our imaginations to fill in the blanks. **Gestural lines** respond to a situation's overall movement or spirit. **Organiza-tional lines** order or organize the individual parts of a work of art into a cohesive unit which, in turn, forms a significant part of the work's overall structure. In this section we will see how artists employ these types of line to express their ideas.

OUTLINE

Outlines indicate, in a flat, simplified manner, where one thing ends and another begins. From the earliest times, line has been used to describe, and outline is, perhaps, the most basic form of linear description. Outline broadcasts the unapologetically silly statements of the twentieth-century American artist Keith Haring. Unlike most of the works reproduced in this

57
Howie Lee Weiss. *Events Leading to the First Born.* 1984. Vine charcoal on paper, 37 x 36¼" (94 x 93 cm). Collection of the Artist.

58
Jean-Auguste-Dominique Ingres. *Study for the Grande Odalisque.* c. 1814. Pencil, 9¾ x 10½" (25 x 27 cm). Louvre, Paris.

book, sustained, patient viewing of an image such as *'Growing' Suite, #1* **[56]** is not going to reveal a whole lot more than will a split-second glance. What you see (right away) is what you get. "Basically," Haring has stated, "I work as fast as I can, maybe doing five paintings in a day. . . . My position is: get the information out fast . . ."[5] Like graffiti, from which Haring's work derives great influence, *'Growing' Suite, #1* is immediate, loose, and flashy.

Far more probing are the charcoal drawings of Howie Lee Weiss. In *Events Leading to the First Born* **[57]**, the artist packs the image with anecdotal references to a wedding ceremony, a couple's embrace, pregnancy, and in the very foreground, a nuclear family. But the literal subject matter tells only part of the story— and not the most fascinating part. More captivating is the artist's linear performance as a complex system of bold black outlines construct a richly patterned, mechanical, bizarre hide-and-seek world.

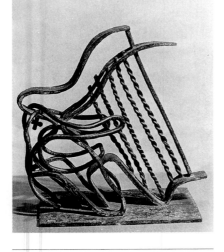

59
Jacques Lipchitz. *The Harp Player.*
1928. Bronze, height 10½" (27 cm).
Private collection, courtesy
Marlborough Gallery, New York.

In its broadest sense, the **Neo-Classical** style of painting refers to images that derive their greatest influence from the formal clarity of the art of ancient Rome or Greece. More particularly, it refers to a style of painting that was popular from approximately 1750 to the early 1800s. Two of the most important Neo-Classical artists are Jacques Louis David and Jean-Auguste-Dominique Ingres.

CONTOUR LINE

Contour lines describe not only the outside edge of a substance; they reflect, as well, the mass or three-dimensional form that determines the edge. Outlines, on the other hand, define in a mechanical, two-dimensional manner only the outside boundaries of a substance. In the French **Neo-Classical** artist Jean-Auguste-Dominique Ingres's *Study for the Grande Odalisque* [58], intensely felt contour lines shape the woman's body. There is nothing mechanical or flat about Ingres's approach.

Like the *Imperial Ancestral Temple*, Ingres's drawing effectively coordinates two different directional lines. The horizontal format of the paper on which the image is drawn emphasizes the model's languid, sensual pose. Delicate contours extend across the length of the page, describing the sensually rounded forms of this faceless woman.

GESTURAL LINE

Gesture is the dynamic spirit, feeling, or attitude demonstrated by a particular pose or motion. A **pose** refers to the manner in which someone or something is placed or arranged; generally, it implies at least temporary stability. Motion has to do with an active changing of positions. Gesture refers to an action, not an object; stated in grammatical terms, gesture is a verb, not a noun. A dynamic gesture is peculiar in some respects, and that is what makes it matter. The figure is distinctly shaped or extremely stiff (*Ancestor Figures* of the Dogon tribe), the pose is extremely graceful (Michelangelo's *David*), the motion is so fluid or so agitated that we must react to it. Such reactions promote deeper viewer empathy.

Gestural lines describe a general sense of action or expression. Artists frequently employ gestural lines to work out problems such as the sense of movement of an individual figure (not the individual details of the figure) or the overall flow of a proposed work of art.

Lines sweep across actual space in *The Harp Player* [59], created by the twentieth-century sculptor Jacques Lipchitz. This sculpture is a virtual three-dimensional gesture drawing in welded steel. With seemingly effortless abandon, in such an unlikely medium, the sculptor allows gesture to orchestrate his idea. Lipchitz does not detail the facial features or any other parts of the figure's body. Rather, the sculptor attempts to capture the general flow or motion of the seated musician whose curvilinear grace merges with the lines of the harp. Steel is strong and rigid; it is, by nature, conducive to supporting heavy weights. But here, Lipchitz makes steel function like a rambling pencil line as the artist's expert control of his medium enables him to create the impression of freedom and spontaneity.

ORGANIZATIONAL LINE

An **organizational line** orders or organizes the individual parts of a work of art into a cohesive unit, which, in turn, forms a significant part of the work's structure. Generally, if we wish to appreciate its structure we must step back (if not physically, at least reflectively) and view a work of art from a distance. Too close attention to individual details causes us to lose sight of the artist's larger organizational decisions. For example, in the epic poem *The Odyssey,* written by the ancient Greek poet Homer, the mythical hero Odysseus was challenged by, among other things, hardship, loss, discovery, impiety, and redemption. What unifies the many disparate incidents that Odysseus encountered during his return home from the Trojan War is the author's underlying organizing technique. Our fascination with the details of

60, 61
Two stills from the film *The Godfather, Part II,* directed by Francis Ford Coppola. 1974.
Courtesy of Paramount Pictures.

crowd as if it were his personal audience **[60]**. His white suit and hat stand out sharply against the intense colors, tones, and patterns surrounding him.

And then there is the other line. Up above, Vito Corleone maneuvers like a jungle cat from rooftop to rooftop **[61]**. In dramatic contrast to Don Fanucci, Corleone is all alone, surrounded only by smokestacks, chimneys, and the long horizontal lines of tenement rooftops and cornices. Corleone's coat and hat are the same drab colors as the muted buildings behind him. There are moments when he is almost invisible.

Parallel lines do not converge, except in art. Here they converge with a vengeance. Corleone descends the dark stairway leading from the roof as Fanucci climbs up the steps of his apartment building. When their paths meet, the young godfather-to-be ambushes and kills his unsuspecting prey. Only one line remains as Corleone takes Fanucci's place on the street. The camera follows the young killer's path through the riotous festivities now taking place. The contrast of his composure amidst the dancing and fireworks provides a focus for our attention as Corleone, having completed his brief but brutal odyssey, returns home.

Just as they serve to unify complexly staged cinematic scenes, organizational lines allow painters to unify their compositions by providing pathways that, in effect, lead a viewer

Odysseus's adventures may obscure the fact that Homer provides his reader with a continuously unfolding idea involving an individual's growth through self-discovery. Without these unifying factors (which form invisible organizational lines), the story would amount to little more than a series of unrelated episodes.

Francis Ford Coppola's film *The Godfather Part II* includes a remarkable stalking scene in which the young Vito Corleone ultimately murders Don Fanucci, the reigning tyrant of the neighborhood. The scene unfolds along two essentially parallel organizational lines that serve to unify the proceedings. Let us consider first the stop-and-start promenade of the sinister Don as he struts arrogantly alongside the religious procession in the crowded street. Coppola textures this sequence with ornate religious statuary, colorful flags and banners, and throngs of city dwellers and church officials. Decorative balls of light hang everywhere like daytime stars in a festive golden atmosphere. As Fanucci walks, he motions with operatic gestures to bystanders and well-wishers all around, playing the

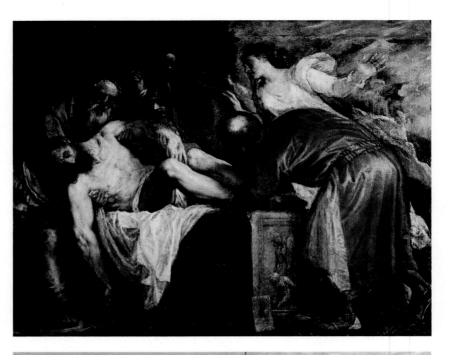

62
Titian. *The Entombment.* 1559. Oil on canvas, 4'6" x 5'9" (137 x 175 cm). Museo del Prado, Madrid.

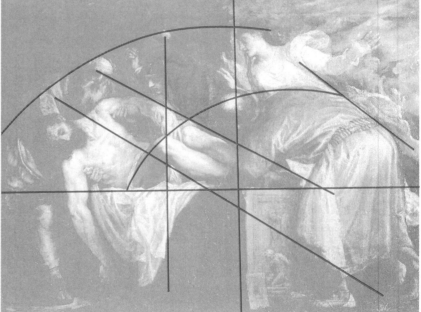

63
Organizational lines in Titian's *The Entombment.*

through the image. *The Entombment* **[62]** by the Venetian **Renaissance** master Titian (Tiziano Vecellio) provides a clear example. As we see in the diagram of this painting **[63]**, horizontal and vertical organizational lines divide the canvas into four parts. Overriding this breakup of the space is a tightly controlled series of organizational lines that lead us through the scene. The bald spot of the foreground figure with his back to us is perfectly aligned with the relatively centralized vertical division of the composition, establishing a moment of pictorial stability (and a momentary pause from the solemn proceedings). But we do not stay for long on this spot. As the bald man helps lower Christ into the coffin, the diagonal of his back, reinforced by the strong diagonal of the theatrically posed, cloudlike Mary Magdalene just behind, leads us up and over toward Christ. The cluster of figures occupying the top left quadrant of the composition receive, in a kind of slow motion, the emotional velocity of the figures on the right. A single arm and leg punctuate the bottom left area. These two limbs, along with the triangular form of the drapery, lifelessly complete the arc of mourners. Many other areas in this painting vie for our attention as well. Organizational lines lead us to each area in its turn.

64

Leonardo da Vinci. *Study for the Adoration of the Magi.* Pen and ink with metalpoint over traces of black chalk, 11³⁄₁₆ x 8⁷⁄₁₆" (28.4 x 21.4 cm). Louvre, Paris.

Renaissance—A period ranging from the early 1400s (Early Renaissance) to the late 1600s (Late Renaissance) in which artists demonstrated a renewed interest in ancient Greek and Roman styles of art and literature. Ideas involving proportion, balance, stability, symmetry, and harmony were especially celebrated. Important Italian Renaissance artists include Filippo Brunelleschi, Lorenzo Ghiberti, Leonardo da Vinci, Raphael, Michelangelo, and Titian.

PURPOSES OF LINE

Lines can establish size, shape, and location; they can describe three-dimensional volumes, capture a sense of movement, and organize a work of art into a structured whole. Another important function they serve is to allow artists to investigate an idea or to work out a visual problem. Lines such as these may be a direct visualization of the artist's thinking process.

Study for the Adoration of the Magi [64], a pen drawing by Renaissance artist Leonardo da Vinci, is one of many preparatory studies for a large painting. Its lines represent possibilities; they are questions, not answers. Here we see the artist working out narrative details and pictorial problems of size, space, and staging. Da Vinci seems to be less interested in the drawing itself as a

finished product than as a relatively quick step toward the solving of a sequence of problems. Today, works such as this are proudly displayed in galleries and museums and even evaluated in terms of the masterful quality of the lines they display. But we should keep in mind the more practical and less public purposes for which they were originally intended.

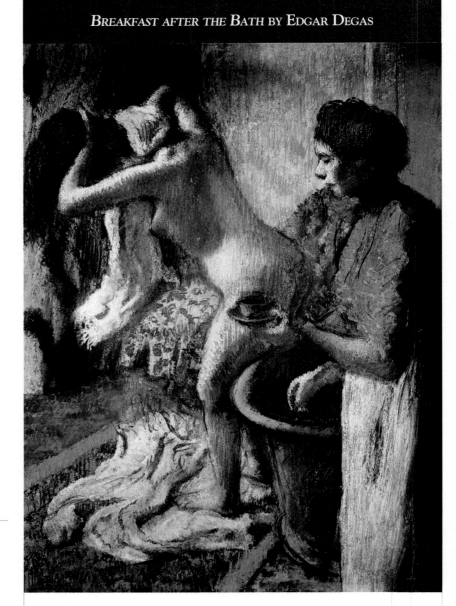

BREAKFAST AFTER THE BATH BY EDGAR DEGAS

65
Edgar Degas. *Breakfast after the Bath.* c. 1895. Pastel, 47⅝ x 36¼" (121 x 92 cm). Private collection.

Before reading the text that accompanies Degas's pastel drawing *Breakfast after the Bath* [65], think about the image by answering the following questions.

1. What are the two principal activities taking place? How does the pictorial activity of the immediate environment surrounding the bather relate to what the bather is doing? How do the details surrounding the attendant reinforce her activity?

2. Does Degas rely on outlines to describe the forms in this image? Explain.

3. The color and tones of the two towels associated with the bather are almost exactly like the colors and tones of the towel (apron) worn by the attendant. But the lines of the towels are significantly different. Explain. What effect does this difference have on the way we read the gestures of the two women?

4. How do the women differ? Why do you think Degas positioned the torso of the bather along such a diagonal axis? Why do you think he positioned the attendant along a vertical axis? Visually, do the two women have anything in common? Which organizational lines unify the two major parts of this composition?

Every painting and drawing is "about" something. Literally, this pastel drawing is about a nude woman drying herself after a bath while being brought a cup of tea or coffee by her servant. How the artist achieves a sense of both these activities, setting up an unspoken dialogue between the stiffness of the servant and the the motion of the bather, is one of the things this image is about on a pictorial level.

Degas claimed he was "a colorist in line."[6] Nowhere is this more apparent than in this drawing. In keeping with our earlier discussion of vertical versus diagonal lines, notice how the bather is leaning—a dynamic pose— while the vertical posture of the servant is rigid and stable. The vertical line behind the clearly profiled face of the woman on the right, and continued below by the dark fold in her apron, helps steady the cup and saucer she balances, while the linear and textural disarray surrounding her employer scramble the path provided the viewer's eye. The hair of the bather pours loosely downward; that of her servant is pulled up tightly into a bun. Even the white drapery speaks to important linear or gestural differences between the women: the towel above seems to turn to acknowledge the quick, offhand comment made by the nude's falling hair, while the folding lines of the footcloth below scurry impulsively at her feet. The white apron worn by the maid is still. What is Degas trying to convey through such an insistent series of contrasts? Could it be that Degas believes we will experience the impact of composure more fully by presenting it next to its opposite—exertion? Clearly, each figure becomes more expressively what she is because of the existence of the other.

Yet the interaction between the women is not based solely on contrast. The Chinese proverb which asserts that serving and being served are folds in the same garment is especially appropriate here. Like observing a solid wall of glass, Degas invites us to see through the separation. Both women have brown hair; both face toward the left; the heads of both adhere to a common horizontal axis; both are associated with the curved, similarly colored vessels of the cup and tub.

Major organizational lines also help tie things together. The forearm of the maid **[66]** (A–B) leads directly into the contour of the bather's leaning torso (C–D). This diagonal is crisscrossed by a line which extends from the bottom edge of the bather's hanging white towel to the mouth of the servant (E–F) and by a nearly parallel diagonal just below this one (G–H). The implied line of the maid's eye glance (I–J) connects up with the line that runs from the cup (J) to the bather's head (K) which, as we observed earlier, lies along the same horizontal axis as the head of the servant (I). Notice how points I, J, and K join to form a nearly equilateral triangle. Geometric organization such as this provides visual stability for the portrayal of a fleeting moment.

Degas structured his picture to make sure the maid's preoccupation with not spilling her employer's refreshment is carried out. Even if she let go of it, the teacup would not fall, so carefully supported by the surrounding shapes, colors, and organizational lines does the teacup appear to be. Degas

66
Organizational lines in Degas's *Breakfast after the Bath*.

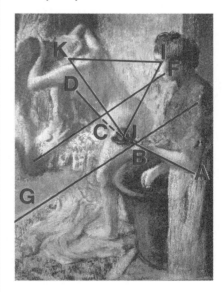

adds another dimension to the notion of compositional balance. **Composition** refers to the work's structure or organization, that is, how the visual details interact (are balanced) to form a whole. Usually balance works behind the scene; here it is a crucial part of the subject itself. But not only does he balance the cup, Degas also balances various contradictory conditions: restlessness and stability, curved and straight, clothed and naked.

An even more basic balancing act, however, concerns the profound thoughtfulness and control exerted by the artist to portray an unposed, unselfconscious moment: a private, yet shared one. But can we, in fact, call this situation unposed or everyday? Why do we have a maid bringing a beverage to her employer while the employer is just exiting from her bath, still in the bathroom, and not yet even dressed? Degas may be forcing things, slipping artifice into a seemingly natural circumstance in order to introduce the kinds of pictorial relationships he wished to investigate. Degas's convincing performance looks right, so he persuades us that the experience depicted is a typical part of this particular bather's morning ritual—that is, to awaken, wash, and enjoy her morning beverage as she dries.

An artist often contrives and deludes in order to convince an audience of the honesty and naturalness of what is being conveyed. What matters in the work of art is the reality created, not that real life is faithfully imitated. Degas put it well when he said that "a picture is something which requires as much knavery, trickery, and deceit as the perpetration of a crime."[7] "He will be truly a painter," wrote the French poet Baudelaire, "who will know how to draw out of our daily life its epic aspects and will make us see and understand in color and design, how we are great and poetic in our neckties and polished boots."[8] Whether his subjects wear neckties and polished boots, aprons and drying towels, or nothing at all, Degas convincingly captures the poetry of people and their passing moments.

CRITICAL QUESTIONS

1a. The seated figure in the foreground of Henri de Toulouse-Lautrec's *At the New Circus* **[67]** embodies an almost uncontrollable sense of energy. What a marvelous visual invention she is! Why do you think the artist chose to describe her with such long, fluid, sometimes reckless, sometimes graceful lines? Does this loosely drawn, extravagantly attired connoisseur of dance overwhelm the painting and destroy the picture's sense of balance? Explain your answer.

b. The expressive handling of the seated woman contrasts sharply with the more rigid characterization of the row of suited spectators seated across from her. Even the orange line of the woman's chair back takes a delightful but unexpected turn. Compare this line to its counterpart, the orange band of the wall behind which the row of men are sitting. What other contrasts do you see? (Consider the gestures, sizes, and paint handling of the shapes). What impact do these contrasts have on the nature of the painting?

c. Visual echoes unify a composition by revealing commonality between seemingly disparate details. The sinuous orange band of the woman's chair back joins company with the dark lines contouring her dress, and a wave of motion invigorates the foreground. How does the low, slow curving wall behind the dancer affect our reading of the dancer's performance? Why do you think the artist chose to overlap and parallel the gesture of the dancer with the shape of the opera glasses held by the seated woman? Why do you think the artist aligned the dancer's body along a horizontal axis?

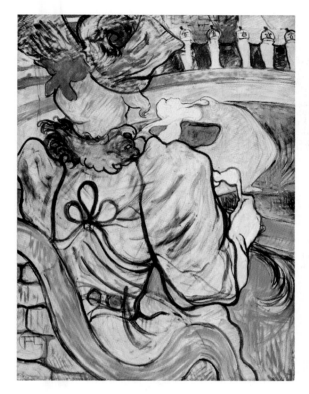

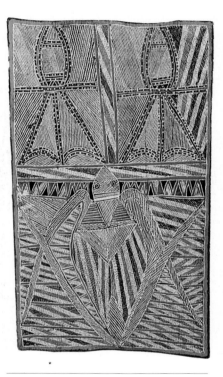

67
Henri de Toulouse-Lautrec. *At the New Circus* (also called *Five Stuffed Shirts*). 1891. Watercolor, 45¾ x 33½" (116 x 85 cm). Philadelphia Museum of Art. Purchased: John D. McIlhenney Fund.

68
Liwukang Bukurlatjpi. *Squid and Turtle Dreamings*. 1972. North East Arnhem Land. Ochre on bark, 36¼ x 20½" (92 x 52 cm). South Australian Museum Collection.

d. This painting portrays a dancer and some of her audience. The exquisite gesture of the performer, sharply delineated by the simplified space that surrounds her, lends a certain drama and importance to her action. What does Toulouse-Lautrec seem to be saying about the activity of viewing? Do you think he sees it as a passive activity? Explain.

2a. Many different kinds of line comprise *Squid and Turtle Dreamings*, a bark painting by the contemporary Aboriginal Australian artist Liwukang Bukurlatjpi [68]. Find examples of vertical horizontal, and diagonal lines in this painting. There are lines that divide the painting into major sections, lines that delineate large shapes, and lines that fill up those shapes. Find examples of each of these types of lines.

b. What effect is created by the diagonal lines in this painting? Are they soothing or stimulating?

c. Would you describe the lines surrounding the female turtle (the large figure that fills the bottom half of the composition) as outlines or contour lines? Explain.

d. The Aborigines' religious beliefs are based on a concept known in English as the Dreaming or Dreamtime. The Dreaming is sometimes described as a time when ancestral beings first created the features of the people, landscape, plants, and animals of the world. The Dreaming represents, among other things, the itinerary of the ancestral beings' travels across the landscape.[9] Without a working knowledge of Aboriginal religious beliefs, it is virtually impossible to understand the meaning of the figures and other details included in paintings such as *Squid and Turtle Dreamings*. Does this 1) cause you to want to read more about Aboriginal traditions and beliefs so that your appreciation of Aboriginal Australian art will be that much greater? 2) Allow you nonetheless, even without a working knowledge of Aboriginal beliefs, to enjoy the image on a visual level? 3) Discourage you from attempting to come to terms on any level with art such as this that stems from a tradition of thought different from your own? Explain your answer.

e. "Shimmering brilliance," indicative of ancestral power, states the anthropologist Dr. Peter Sutton in *Dreamings: The Art of Aboriginal Australia*, is a primary visual aspect of this kind of art.[10] Cite several ways Liwukang Bukurlatjpi created this sense of brilliance.

3

Shape and Volumetric Form

A **shape** is a two-dimensional area that displays both width and length and has relatively clear boundaries. When an area or surface displays clear three-dimensional qualities—that is, when its sense of spatial depth is significant—the element of volumetric form comes into play. The visual authority of each of the images and objects that we will discuss in this chapter is largely a result of the emphasis the artist placed on the elements of shape and volumetric form.

SHAPE

Flat shapes tend to present themselves crisply and immediately. The flatter and more sharply bordered the outside edge of the shape, the more quickly we read it. The power-packed shape bursting open the center of Polish graphic designer Wiktor Gorka's movie poster **[69]** immediately captures the viewer's attention—a requirement for any successful poster. It succeeds because the size and gesture of the sharply delineated configuration seen against the solid background is visually striking, and because the psychological impact of the image assaults the imagination. The be-headed figure is made out of four high-heeled, black-stockinged legs racing in circles around the face of a sleazy, singing (maybe screaming) master of ceremonies. This humanized swastika refers to the Nazi politics of terror that provides the background for the film Gorka is advertising. It is a war cry, a symbol of decadent humor overrun by sadism. Against the spinning of this central image, Gorka marches a bold **typeface** (style of lettering) straight across the top of the poster. It is no coincidence that this typeface is similar to the style of lettering often employed by the military. The blocky shape of the movie title couples message and meaning, which rein-forces the warlike menace of the illustration below.

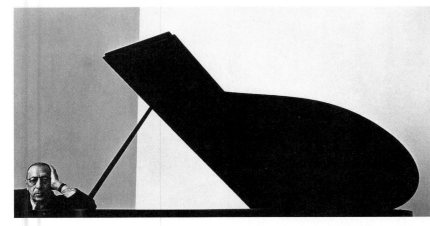

71
**Negative shape in Arnold Newman's
photograph of Igor Stravinsky.**

The American photographer Arnold Newman's portrait of the twentieth-century composer Igor Stravinsky [70] is more calm, yet no less dynamic, than Gorka's poster. Stravinsky inconspicuously occupies a small corner of the page. The dark strip of the piano running along the base of the picture, coupled with the black shape of the piano lid, looks like an ominously open mouth. The composer completely ignores the threat. Instead, he stares into the camera and relaxes on an arm that calls to mind, through its parallel diagonal direction, the slant of the weighty yet elegant shape looming above. But the piano lid is more than a pictorially whimsical threat. It represents the very heart of the photograph. For Newman, it echoed the composer's music. "All I could think of," Newman has explained,"was this big, beautiful piano shape that I had always admired—strong, harsh, linear, like Stravinsky's work in a sense."[1]

NEGATIVE SHAPES AND FIGURE/GROUND RELATIONSHIPS

Although it may not be immediately noticeable, one of the most important shapes in Arnold Newman's photograph of Stravinsky is the nearly perfect equilateral triangle formed by the diagonal line holding open the flat shape of the piano lid on the left, the diagonal edge of the piano on the right, and the black strip of the piano on the bottom [71]. Enclosed areas such as this are called **negative shapes** because they are theoretically empty areas. Despite the inauspicious label, negative shapes play an active, and often crucial, role in the organization and spirit of a work of art. The base of the triangular negative shape in Newman's photograph, for example, parallels the bottom edge of the picture, creating a sense of stability which contrasts with the heavy, tilted piano lid, which is supported only by the thin line of the lid prop. Visual

conflict like this contributes to the multi-dimensional character of the portrait.

Other terms that refer to the interaction of positive/negative shapes in a two-dimensional image are **figure** and **ground.** In this context, figure refers not only to the human figure but to any **positive shape,** a tangible or solid shape that appears in front of, and encloses, an area of the background (ground). Sometimes artists intentionally play with the optical flip-flop effect that occurs when figure/ground shapes seem to reverse their spatial positions. *Venus* [72], for example, is a paper cut-out in which the cut scissors line replaces the drawn line, and pasted sheets of painted paper replace the more traditional method of applying paint directly to canvas. Henri Matisse was 83 years old when he created *Venus*. Here, the large, centralized white (negative) shape of the paper, which serves as the

72
Henri Matisse. *Venus.* **1952. Paper on canvas (collage), 39⅞ x 30⅛"** **(1.012 x 0.765 m).** National Gallery of Art, Washington, D.C., Ailsa Mellon Bruce Fund.

actual ground or physical support for this image, constitutes the subject of the work. The title helps us to see this white shape as a female figure, in which case we see it as a positive shape and the surrounding blue shapes as negative. But the vivid blue shapes display a pictorial aggressiveness of their own. When we allow ourselves to see the image more as an arrangement of shapes and less as a visual abbreviation of a human being, the blue shapes pop forward and the white ones recede, reversing the figure/ ground effect. Follow the lack of repeated shape, or asymmetry, from one side of the nude's body to the other. On the left, for example, a long, straight line describes the figure's neck, then curves abruptly into a

shoulder or breast. On the right, no neck is evident, but the line of the shoulder is well defined. *Venus* consists of just four shapes, but, when seen together, these richly individuated shapes provide more than enough pictorial invention to create an engaging figure statement and to take command of the composition.

It is difficult to say what accounts most for the overwhelming sense of vitality we feel throughout the American **Abstract Expressionist** painter Franz Kline's *Untitled* [73]. Is it the positive black shapes or the negative white ones? Indeed, can we definitively label one set of shapes as positive and the other as negative in this painting? Many of the white areas

Abstract Expressionism, which was developed by a group of New York–based artists that included Franz Kline, Willem de Kooning, Jackson Pollock, and Lee Krasner, became the dominant international force in the world of painting in the 1950s. An important characteristic of this style of painting involves an aggressive, gestural handling of the brushstroke in particular and the paint medium in general. Abstract Expressionists were particularly concerned with capturing a sense of the emotional energy underlying their personal responses to the world.

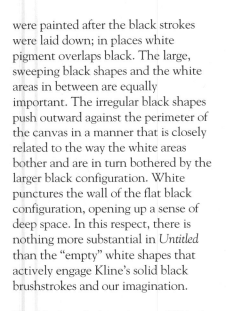

73
Franz Kline. *Untitled.* **1952.
Oil on canvas, 53⅜ x 67½"
(135.6 x 171.5 cm).**
The Metropolitan Museum of Art.
Promised gift of Muriel Kallis
Newman, The Muriel Kallis
Steinberg Newman Collection.

74
Elizabeth Murray. *Keyhole.* **1982.
Oil on two canvases, 99½ x 110½"
(2.53 x 2.81 m).** Collection Agnes
Gund. Photo courtesy Paula Cooper
Gallery, New York.

were painted after the black strokes were laid down; in places white pigment overlaps black. The large, sweeping black shapes and the white areas in between are equally important. The irregular black shapes push outward against the perimeter of the canvas in a manner that is closely related to the way the white areas bother and are in turn bothered by the larger black configuration. White punctures the wall of the flat black configuration, opening up a sense of deep space. In this respect, there is nothing more substantial in *Untitled* than the "empty" white shapes that actively engage Kline's solid black brushstrokes and our imagination.

The black and white shapes of Kline's painting impact on one another with such a sense of urgency that the work not only looks like it was executed in one passionate heave, but like it is still in the process of coming into being. Interestingly enough, many of the broadest, most sweeping brushstrokes were actually painted with small brushes. This painting may look like it is the product of one big impulsive outburst, but its development is actually the result of the artist's steady back-and-forth manipulation of figure/ground spatial dynamics, as well as the

interaction between his physical markmaking and more cerebral decision-making.

Keyhole [74], a large painting by the contemporary American artist Elizabeth Murray, consists of two overlapping, irregularly shaped canvases. Here, the wall on which the painting hangs plays as great a part in the work's dynamic presence as do the shapes or colors that the artist created within the painting's borders. Despite all the painterly activity of the artist's brush, the centralized void (backed by the wall) can be characterized, both pictorially and conceptually speaking, as the main point of the painting. The title of the work provides a context for this area. If we wish to view the painting from a less literal point of view, the artist herself provides us with a clue: "*Keyhole;*" Murray has stated, "is about finding an image that's a sexual one."[2]

Some works of art suffer more when translated into reproduction form than do others. The sensation of near vertigo that an individual may feel, for example, when standing before *Keyhole*, a massive, three-dimensional construction, cannot be compared to the much more subdued experience of seeing this painting within the narrow confines of a textbook. The off-center merging of the two parts of this painting, which accounts largely for the strikingly dynamic nature of the centralized negative shape, is disorienting. In this regard, consider the inclusion of the upside down bottle with its outlined and darkly toned mouth and neck painted upon the pink, curved shape split in half at the bottom middle of this painting. The artist herself has commented upon her associations with the yellow area arching around the keyhole shape as a splash and as fingers of a hand.[3] Both of these associations fortify an interpretation of pouring and even intoxication. Does this painting have something to do with fumbling in the

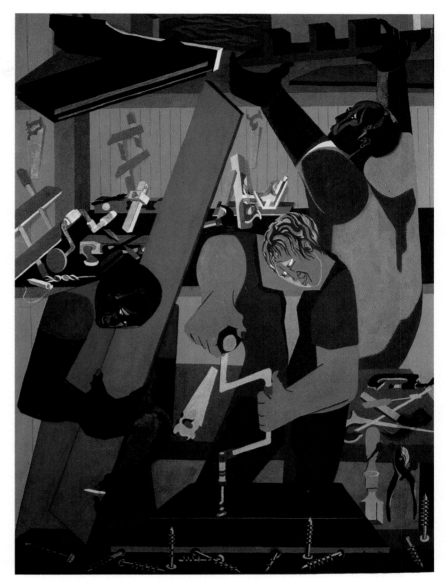

75
Jacob Lawrence. *Builders*. 1974. Gouache on paper, 30 x 22" (76 x 56 cm). Collection of the Vatican Museum, Rome.

dark, with attempting to insert a key into its hole at the very time that our sense of equilibrium is lost? The artist lays out divergent paths for us to follow. Like the negative shape around which everything in this painting revolves, in *Keyhole* the meaning is physically and conceptually left open.

ORGANIC AND GEOMETRIC SHAPES

Another factor contributing to the sense of disorientation created by Elizabeth Murray in *Keyhole* is the

conflict she establishes between the geometry of the interlocking canvases and the organic nature of the painting that goes on inside the borders. **Geometric shapes** are usually bordered by straight lines, precise angles, or uniform curves, as is the case in such simplified, geometric shapes as squares, circles, and triangles. **Organic shapes,** which are usually curvilinear in nature, display irregular outlines or contours.

Builders [75], painted by the contemporary American artist Jacob

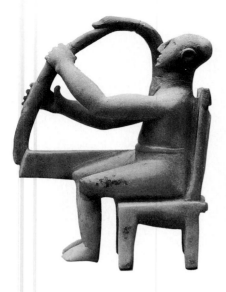

76
 Cycladic Harpist. Marble, height
11½" (29.2 cm). Third millenium
B.C. The Metropolitan Museum of
Art, Rogers Fund, 1947.

Lawrence, derives much of its pictorial
animation from the interaction of
organic and geometric shapes. The
diagonal red board on which the
carpenter clad in blue is making a
chalk mark, and the plane of wood
into which the carpenter dressed in
red is drilling, occupy the foreground
with geometric, mechanical precision.
Other pieces of wood and large
architectural divisions continue the
theme of geometry that we see
employed throughout the workshop.
Apparent as well, however, are
numerous organic shapes such as those
representing shadows on the bodies
and hair of the men. This integrated
play of organic and geometric shapes is
part of a larger pattern of pictorially
compatible opposites that includes
brightly colored shapes versus diluted
tonal contrasts, large shapes against
small, and fast, oblique planes that
puncture an otherwise calming,
frontally oriented interior space.

VOLUMETRIC FORM

Volumetric form is the three-
dimensional equivalent of two-
dimensional shape. Depth differenti-
ates three-dimensional volume from
flat shape. Volume can take the form
of an actual, physical substance as in a
piece of jewelry, a bowl, a sculpture, or
a work of architecture. Or it can be
illusionistic, as in a photograph,
painting, or drawing, where an
impression of three-dimensional space
is created by shading or some other
means.

In order to simplify the creative
process of making and viewing art, the
visual elements and principles are
being addressed separately in this
book. As your ability to view works of
art becomes more sophisticated, you
will become increasingly more
receptive to the integral relationship
of the individual components of visual
expression. The supreme importance
of this interdependence cannot be
overemphasized. The study of volu-
metric form offers a particularly apt
means of addressing this issue because
the element of volumetric form always
involves other aspects of the vocabu-
lary of visual expression, such as the
principle of space. This is true whether
a given form exists as pure illusion
(incorporating a sense of three-
dimensional depth) on a flat canvas or
sheet of paper, or is physically real, as
is the case in a carved marble sculp-
ture.

In Chapter 2, we discussed Jacques
Lipchitz's *The Harp Player* **[59]** in
terms of gestural line. By comparing
Lipchitz's attention to line with the
concentration on volumetric form
apparent in *Cycladic Harpist* **[76]**, a
representation of the same subject, we
can begin to appreciate the bulky,
three-dimensional nature of **mass** or
volume as opposed to the more two-
dimensional nature of even a sculp-
tural line.

Cycladic Harpist was carved from a
marble block sometime between
2600—1500 B.C. in an area known as
the Cyclades, a group of islands near
Greece. In this work, all of the forms
are rounded in space. Even the long
curve of the harp, perhaps the single
most linear area of the sculpture, is
clearly more than an extended two-
dimensional mark in space. It is a form
that displays a significant proportion
of breadth and width, essential
features characterizing volumetric
form.

BASIC VOLUMETRIC FORMS

Many works of art derive their
visual vitality from the repeated
development of a single category of
geometric form such as the cube,
sphere, cone, or pyramid. The
charming, rotund ivory carving of
Ganesha, the Indian god of good luck
[77], for example, concentrates
especially on the swelling form of the
sphere. Tiny strings of rounded beads
comprise the anklets, bracelets,
necklace, and parts of the head
ornament, which, in each case,
wrap around the major forms of the
elephant, emphasizing the corpulence
of the figure even while decorating it.
The fullness of *Ganesha's* form
symbolizes the fruitfulness that his
worshippers believe they will enjoy.

A painted woodcarving from Papua
New Guinea **[78]**, on the other hand,
is based on repeated, thin volumes of
cylindrical forms, while a sculpture
such as the twentieth-century Cubist
sculptor Henri Gaudier-Brzeska's
Portrait of Ezra Pound **[79]** relies
primarily on the sharp angles derived
from cubic forms to unify his figure
statement. In each case a distinct
visual order is achieved as a result of
the sculptor's decision to continuously
address a single type of geometric
volume.

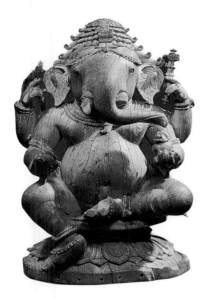

77
Ganesha. 14th–15th century.
Ivory, 7¼ x 4¾ x 3½"
(18 x 12 x 9 cm). The Metropolitan
Museum of Art, Gift of Mr. and
Mrs. J. J. Kleman, 1964.

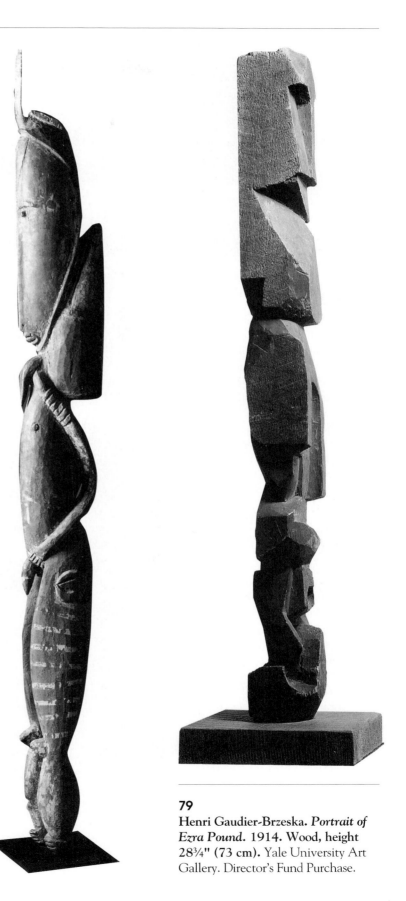

78
Painted wooden figure from
Papua New Guinea. Height 53⅞"
(1.37 m). Musée Barbier-Mueller,
Geneva.

79
Henri Gaudier-Brzeska. *Portrait of
Ezra Pound.* 1914. Wood, height
28¾" (73 cm). Yale University Art
Gallery. Director's Fund Purchase.

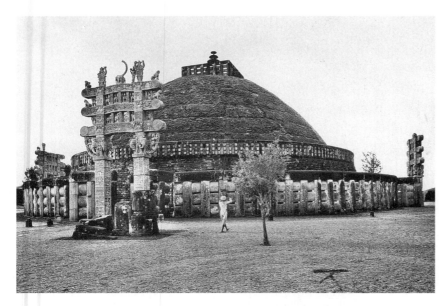

Throughout history, architects have employed standard geometric volumes not only for design purposes but to express ideas regarding content as well. This is particularly true of religious architecture. The 120-foot in diameter and 54-foot-high dome of the *Great Stupa* (or *Stupa No. 1*) at Sanchi, India **[80]**, one of the most important examples of Buddhist architecture and sculptural decoration in the world, provides a telling example of this practice. The intimate *Tempietto* **[81]** in Rome and the majestic *Hagia Sophia* in Istanbul **[82]** offer two other examples. In each of these architectural/religious monuments, the spherical form—the perfect earthly symbol to represent the vault of heaven and the unity of a divine spirit—is meant to embody ideas of grand serenity and devotion. Here is how a poetically minded church official described Hagia Sophia's magnificent dome shortly after it was constructed in the first half of the sixth century A.D.: "There, overhead, looming vast in the shadowing air/ Arches the rounded helm of the heavenly house/ Like unto the burnished roof of heaven."[4] As this description demonstrates, volumetric form is often connected in the human imagination with the loftiest conceptualizations.

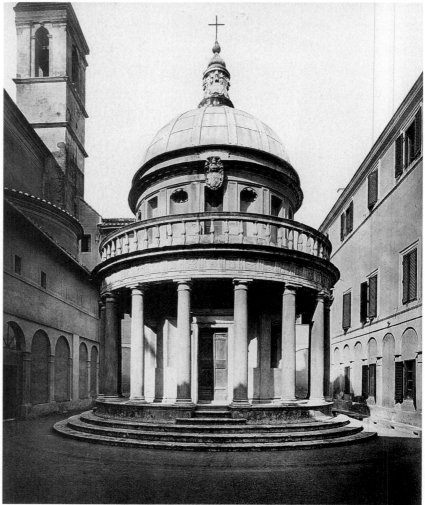

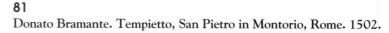

81
Donato Bramante. Tempietto, San Pietro in Montorio, Rome. 1502.

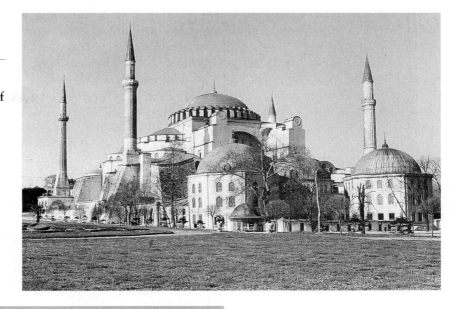

82
Anthemius of Tralles and Isidorus of
Miletus. Hagia Sophia, Istanbul.
532–537 A.D.

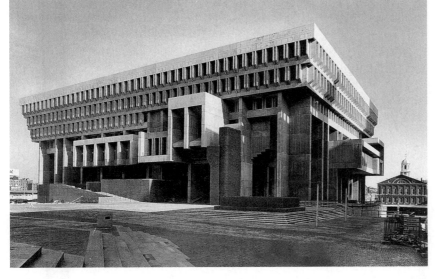

83
Kallman, McKinnell & Knowles.
West façade and south side, Boston
City Hall. 1968.

Of course, the human imagination is often motivated by pragmatic concerns as well. The *Boston City Hall* [83] was designed to house conference rooms, council chambers, reference libraries, exhibition halls, public service counters, offices for the mayor and other city officials, as well as additional public offices that would service the needs of Boston's population. Sharp right angles and the severity of cubic forms govern the design. Seen especially within the context of the unusually large, empty plaza on which it is located, the building creates a sense of authority and permanence. The long walk from the street to the building may be for some city residents off-putting and impractical, but the building itself is a vital and imaginative structure. There is a playful sense of syncopation in the pattern and pacing of the many interlocking cubic forms and in the boldly outlined windows—areas that we expect to be accented or outlined are not, and areas that we do not expect to be singled out for special attention are. The top two rows of windows establish a constant, regimented beat. From there down visual unpredictability prevails. The interrupted and conflicting rhythms were inspired by Igor Stravinsky's musical compositions, among other influences.[5] Walking up and around the outside of the building amidst concrete columns and planes of ever-changing dimensions can be reminiscent, surprisingly enough, of childhood play with building blocks. Nonetheless, the *Boston City Hall* reflects a highly controlled sense of order and formality.

YOUNG ACROBAT ON A BALL BY PABLO PICASSO

84
Pablo Picasso. *Young Acrobat on a Ball.* 1905. Oil on canvas, 57⅞ x 37½" (1.47 x .95 m). Pushkin Museum, Moscow.

Before reading the text that accompanies Picasso's *Young Acrobat on a Ball* [84], think about the painting by answering the following questions.

1. The two main figures in this painting are associated with two basic geometric forms. What are these forms and why do you think Picasso chose to relate the figures to them? Regarding stability and instability, what is the nature of the two forms?

2. Cite several ways the strongman and the acrobat differ visually. Cite several ways they are pictorially related.

3. Picasso's *Young Acrobat on a Ball* is an early, yet highly accomplished, even profound, painting by one of the most innovative and radical artists of the twentieth century. Nonetheless, it is based on elementary principles. What are some of these principles?

4. With which of the main characters do you more closely identify? Explain.

Picasso portrays a massively muscled man seated on a box that is planted squarely in the foreground. The man is immutable, immovable. By carving out the volume of the man with a pattern of light and dark boulderlike shapes, endowing him with heroic proportions, and setting his foot so squarely on the ground, Picasso confirms the grand and infinite moment embodied by the Herculean figure. The strongman exists in a space that is timeless and a time that is neither distant nor near. No Egyptian pharoah sat more confidently upon his throne.

Whereas the arms of the girl are spread well apart, Picasso includes only half of one arm for the strongman and fuses it onto his torso, transforming the rectangle of the strongman's upper body into a square. For the moment, at least, he needs neither his arms nor his hands nor even both his legs. That is part of the point he makes. The seated figure is portrayed as a secure, fixed being. He does not reflect a liquid state as does the girl. We see him; we watch her.

By depicting the box from a side angle, the artist emphasized its solid, three-dimensional structure. The man's leg is modelled like the cube; that part of the form facing the sun is bright. After a ninety-degree turn, the tone darkens. The cubic handling of the leg contributes to the man's blocklike presence. The blue cloth on which the strongman sits further connects the idea of the man to the idea of the box by dressing the box in the kind of shape and color worn by the man.

Above the strongman's shorts, a dramatic outburst of chiselled form dominates the overlapped landscape like a mountain eclipsing a mound of sand. The deep recessions and pronounced swelling of muscle coursing through the man's broad back contrast sharply with the smooth, simplified forms of the surrounding landscape and the scant modelling in the basically cylindrical limbs and torso of the delicate acrobat.

Just as the strongman is associated with the box on which he sits, the acrobat is associated with the ball on which she stands. The acrobat differs from the man in many ways. Her gesture, unlike that of the strongman, is animated; any minute she will hop off the ball or fall. The slight amount of modelling inside her basically cylindrical forms is fluid; her pointed toes never touch the ground. Almost everything about her reinforces the idea of motion and the curve, just as stability and cubic solidity give meaning to the man.

But there are connections between the man and the girl as well. The left arm of the acrobat forms a right angle, which relates to the cube, or an outgrowth of the cube: the leg of the man. The ball that supports the acrobat is modelled and even colored like the back of the man. Even the

distant horse represents a link—a kind of silent communication—that moves in the space between the man and the girl.

Picasso depicted the "space between"—the time of exercise and waiting after the crowds have departed and the tents of these anonymous travelling performers have been dismantled. He depicted the silent relationship between male and female, young and old, active and passive, grand and ephemeral, the cube and the sphere.

The conflicting yet fundamental system of exchanges evident within Picasso's circus performers is not so very different from the kind of oppositions that beleaguer and sustain the painter. In the studio there is enactment as pigment goes from palette to brush to canvas, and there is observation as the painter steps back to view the painted image from a distance. Like balancing on a ball, painting is an act of equilibrium, for the painter must balance form with content, personal insight with public exchange, the known with what might be, intuition with intention, figure with ground, shape with form. Like the man on the box, the painter reflects and sometimes rests, firmly, confidently, while tracing with the deep pressure of his or her body, the solid outline of a thought or emotion. But first of all, and invariably, the painter must deal with the spheres and the cubes.

ORGANIC FORMS

Organic forms, like organic shapes, display irregular contours and are usually curvilinear and nonmechanical looking. When we compare the *Boston City Hall* designed by Gerhard Kallman with the Spanish architect Antonio Gaudí's *Casa Milá* in Barcelona **[85]**, we are struck by the rigid geometry of the governmental building as opposed to the sinuous forms that comprise the apartment house designed by Gaudí. Or compare the irregular, sharply angled geometric forms that comprise Henri Gaudier-Brzeska's Cubist portrait of his friend, the twentieth-century American poet Ezra Pound, with the African *Mftume Figure* **[86]** from the northwestern region of Cameroon. Such a comparison displays in sharp relief the difference between the warped, organic, curvilinear forms of the

African sculpture and the more rigid nature of the Cubist work. (Despite the differences between these two sculptures, Gaudier-Brzeska, like many other Cubist artists including Picasso, Lipchitz, and Leger, was greatly influenced by tribal art such as that produced in Africa, New Guinea, and Easter Island.)

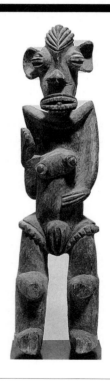

86
Mftume Figure, Cameroon.
Wood, height 25½" (65 cm).
Private Collection.

85
Antoni Gaudí. Casa Milá,
Barcelona. 1905–1907.

87

Hans Memling. *The Madonna with Child on the Throne, Two Angels, St. John the Baptist, and St. John the Evangelist, St. Catherine and St. Barbara.* 1479. **Central panel of triptych, oil on panel.** Hans Memling Museum, Bruges, Belgium.

THE INTERACTION OF ORGANIC AND GEOMETRIC SHAPES AND FORMS

As might be expected, the interaction of organic and geometric shapes and volumes often leads to rich and complex works of art. The composition of the fifteenth-century Flemish painter Hans Memling's *The Madonna with Child on the Throne* [87] is based largely on the interaction of these contrasting visual characteristics. The painting is a virtual tapestry of color, pattern, shape, and form. The top half of the image is ruled by the geometry of the patterned marble and solid stone columns which flank the decorative wallhanging adorning the throne of the Madonna. Screening the figures from the landscape, these repeated verticals create a feeling of enduring stability and calm. Memling signals the importance of the Christ child and the Virgin Mary by placing them in the center of the composition. Directly above them is the energetic design of the wallhanging, the primary instance of intricate, curvilinear activity within an area that is other-

wise so rigorously contained by long, straight lines. The organic, three-dimensional, peekaboo forms of the background landscape provide another foil against which the geometry of the columns asserts itself. Below, notice how the simple, organic volumes that describe mother and child contrast sharply with the flat, complicated patterns of the Oriental carpet and the wallhanging immediately surrounding them. Although many of the straight vertical lines patterning the top half of the composition are picked up by the folds of the drapery of the Virgin Mary and her attendants, the bottom half of the image, in contrast to the top half, consists primarily of organic and lavishly decorated shapes and forms.

Generally speaking, for every new kind of form an artist introduces into a work of art, another potential visual conflict materializes to challenge the skills of the artist and the taste and interpretive powers of the viewer.

Interweaving a wide range of organic and geometric forms and combining three-dimensional volumes with flat shapes such as Memling does in *The Madonna with Child on the Throne* presents a formidable set of pictorial problems. Does the boldly patterned shape of the wallhanging destroy the spatial integrity of the area it is intended to define? Do the bright, organic curves surrounding the shoulders and right arm of St. John the Baptist's red robe represent too abrupt a contrast to the dark tones and strict geometry of the columns directly behind? Far from undermining the painting's sense of unity, potential problems such as these invigorate and help order the image by providing a series of pictorial contrasts that set a tempo of their own.

88
Margaret Bourke-White. *Mahatma Gandhi Spinning (India)*. 1946. Gelatin silver print, 14⅝ x 19½" (37.1 x 49.4 cm). Gift of the Photography Purchase Fund, 1957.134. ©1990 The Art Institute of Chicago. All Rights Reserved.

Before reading the text that accompanies Margaret Bourke-White's *Mahatma Gandhi Spinning* [**88**], think about the photograph by answering the following questions.

1. Flat shape and volumetric form combine in Margaret Bourke-White's *Mahatma Gandhi Spinning* to create a provocative and penetrating portrait of a great spiritual and political leader. Which shape and which volumetric form in this photograph do you consider to be of paramount importance?

2. Visual tension underlies this image of a spinner quietly spinning. Explain.

3. The stark triangular negative shapes of the spinning wheel break up the left-hand side of this photograph. What effect does this have on your emotional response to this part of the image? The figure of Gandhi is bathed by a softer light and is smaller than the spinning wheel that overlaps him. What effect do these visual details have on the pictorial relationship that exists between the man and the wheel?

4. A camera is a machine that records visual information. Do you think that this fact limits its potential as a tool for artistic expression because it places a photographer completely at the mercy of pre-existing visual circumstances?

In *Mahatma Gandhi Spinning*, natural light models into three-dimensional relief the soft, bare flesh of the great Indian leader's body. On the other

hand, the light flattens the form and emphasizes the hard, pointy spokes of the spinning wheel that overlap the man. The wheel looms large in the foreground. An irregular circle of thread caps the negative shapes between the blades, which, starkly shadowed and sharply edged, infuse the object with a threatening, weaponlike presence.

The pictorial abstraction of the wheel's shape and gesture conflicts with its peaceful function. The spinning wheel extends beyond the perimeter of the photograph, threatening by its extreme foreground positioning to encroach on our space outside the image. We can speak of the wheel's motion, or of qualities such as aggravation or even aggression that its hard-edged, pointed shapes suggest. Seen against the restful, more distanced pose of the Mahatma, the world's best-known proponent of the political strategy of nonviolent resistance, the spinning wheel assumes grand implications. Although it is generally thought of as simply a domestic object, an emblem of honest and humble toil, it can be read here as a gesture of discord pitted against Gandhi's tranquil pose. It can also be interpreted as another aspect of Gandhi, as a visualization of the political, confrontational qualities that were an important part of the make-up of this powerful Indian leader whose actions often represented more than met the eye. *Mahatma Gandhi Spinning* embraces multiple meanings, aided by the sharply delineated interaction of shape and volume.

A photograph of Gandhi sitting next to a spinning wheel means something different than a portrait of anybody else coupled with this household object. Homespun cloth became, through Gandhi's efforts, the uniform of India's National Movement, and a forceful philosophical and economic weapon in the cause of India's unity and independence. Encouraging the manufacture and purchase of only homespun cloth was the means toward the achievement of Home Rule which Gandhi and his countrymen so desperately desired.

In her collection of essays entitled *On Photography*, Susan Sontag wrote, "all photographs are *memento mori*. To take a photograph is to participate in another person's (or thing's) mortality, vulnerability, mutability. Precisely by slicing out this moment and freezing it, all photographs testify to time's relentless melt."[6] Bourke-White's photograph depicts yesterday. It depicts Gandhi when he was still alive, when India had not yet achieved independence, when the spinning wheel and Mahatma Gandhi were living symbols in the unstable state of world affairs.

We trust the camera's objectivity as we trust the importance of a verified quotation. Although it can reinterpret or distort experience as well as the paint brush or the chisel, many people regard it primarily as a machine that objectively documents situations. But as Henry Peach Robinson, a nineteenth-century pioneer of the art of photography, claimed, photography is an art precisely because it can lie. Of course the "lie" that Robinson refers to is, in fact, the most direct way that a pictorial "truth" is achieved. Consider how different the effect of the spinning wheel would have been if Bourke-White had chosen to display its shape more softly— under more delicate light or as a small circular shape located far in the background behind the spinner. Any work of art, executed in any medium, may offer a viewer an experience that opens itself to diverse interpretations. As *Mahatma Gandhi Spinning* demonstrates, it all depends on how the visual elements come together.

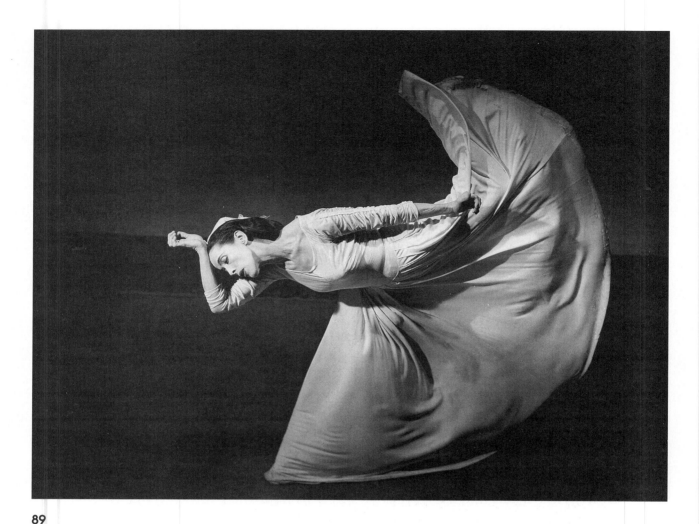

89

Barbara Morgan. *Martha Graham in "Letter to the World" (Kick)*. 1944. **Gelatin silver print.** Courtesy the artist.

CRITICAL QUESTIONS

1a. How would you describe the figure/ground relationship in Barbara Morgan's photograph entitled *Martha Graham in "Letter to the World" (Kick)* **[89]**?

b. In Morgan's photograph the camera records many details within dancer Martha Graham's exquisite gesture. Do you think the lack of detail behind the shape of the figure weakens or enhances the photograph? The power of the figure's gesture? Explain.

c. Characterize the shape, volume, and direction of Graham's head and upper body. Characterize her skirt and lower body. How are her upper and lower body pictorially different? How are they related?

d. What effect do the folds of the skirt, which spiral out from the torso or waist of the dancer, have upon the quality of the motion that Morgan captured in this photograph?

2a. Although the subjects are very different, there are numerous similarities between Ernst Barlach's sculpture entitled *The Avenger* **[90]** and Barbara Morgan's photograph of Martha Graham. Explain. What are some of the differences between these two works of art?

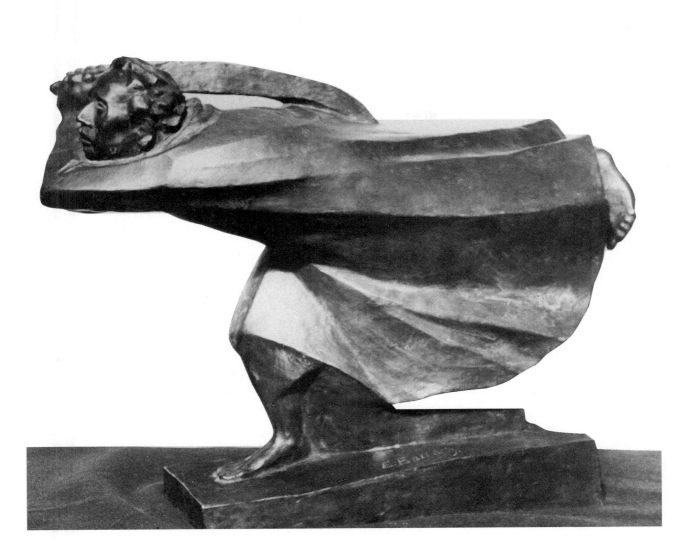

b. What is the effect of the long shapes of the cloak that stretch from the Avenger's left elbow to his left foot? Does it slow down or speed up the action suggested by his gesture? Why do you think the artist positioned the sword and the base in line with the dominant axis of the Avenger's body? Notice that the foot supporting the weight of the Avenger's body is not positioned in the middle of the sculpture's base. How does this affect the sense of movement that informs the sculpture?

c. If Barlach had employed soft, sensuous curves instead of more cubic forms to describe the man's clothing, do you think the impression made by the sculpture would have been significantly different? Explain.

d. What do you think was Barlach's primary concern, a detailed depiction of natural appearances or an interpretation of his subject's emotional and physical energy?

e. The silent film actor and director Charlie Chaplin believed that "a film was like a tree: You shook it and all that was loose and unnecessary fell away, leaving only the essential form."[7] Regarding *The Avenger*, does Barlach appear to have "shaken the tree"? Explain.

90
Ernst Barlach. *The Avenger.* **1914.**
Bronze, height 17¼" (43.8 cm).
Courtesy Galerie St. Étienne,
New York.

CHAPTER

Texture and Pattern

If you placed a leaf in your hand and closed your eyes, you would feel the texture of the leaf. If you opened your eyes, patterns such as those formed by the leaf's vein system would become more readily apparent. **Texture** refers to the surface quality of an actual or represented substance. **Pattern** is the product of a relatively constant repetition of a visual detail or motif. Visual *patterns* appeal primarily to our

sense of sight; visual *textures* appeal primarily to our sense of touch. Multiplicity and distance also play important parts in distinguishing the elements of texture and pattern. Stand close to the leafy branch of a tree and you are apt to appreciate the texture of individual leaves; step back and you are more likely to see the patterns created by the cluster of the tree's foliage.

Clearly, there are significant differences between the elements of texture and pattern. But despite their differences, texture and pattern are closely related in the visual arts. Often, patterns create illusions of texture. In *La Grande Odalisque* [see **95**], Jean-Auguste-Dominique Ingres created the texture of soft peacock feathers in a hand-held fan [**91**] by indicating the pattern of curving lines that comprise each feather. The linear pattern of the curves does not provoke our sense of touch, but the illusion of the feathery texture does.

Of course, the interplay of texture and pattern in the visual arts is not limited to the realm of two-dimensional illusion. Ceramics, fiberworks, jewelry, sculpture, and architecture all employ actual, or physical, textures within the context of funtional and even purely decorative patterns. The *Colosseum* in Rome [**92**], which was was designed to accommodate approximately 50,000 spectators, exists today as a monumental skeleton of its original state. Time, weather, and vandalism have transformed its splendidly decorated surfaces into a beautiful but ruined vestige of ancient Rome. The smooth marble that once covered the outer walls is gone. What remains is an eroding, pockmarked surface that creates a textured pattern of its own. The broken, distinctly textured brick, stone, and concrete that comprise this building form unceasing structural patterns that function as piers, columns, arches, vaults, steps, and corridors. Form and function are thoroughly intertwined. Exactly where the textures cease and the patterns begin is hard to say.

Texture and pattern also interact on a purely decorative level. For example, texture and pattern often work interdependently to activate raised surfaces and three-dimensional spaces. *The Mirror Room* [**93**] of the Amalienberg pavilion in Munich was designed by the Flemish-born eigh-

91
Jean-Auguste-Dominique Ingres. *La Grande Odalisque* (detail). 1814. Oil on canvas. Louvre, Paris.

92
The Colosseum, Rome. 72–80 A.D.

teenth-century **Rococco** architect François Cuvilliés. In this circular salon, the walls are virtually dissolved by the ornately raised patterns of variously textured surfaces.

The actual materials, such as stone, clay, or metal, out of which a three-dimensional work of art is fashioned, contribute fundamentally to the work's form and content. So do the patterns that may develop as a direct result of the physical textures of these materials. For many of us there is, in fact, a direct link between the actual feel (tactility) of the physical charac-

An extension of the seventeenth-century Baroque movement, the **Rococco** style is characterized by profuse and intricate (often curvilinear) ornamentation, soft colors, gracious movements, and above all, by a lighthearted, decidedly delicate and charming atmosphere. Although most often associated with eighteenth-century France, the Rococco style ultimately spread throughout Europe.

93
93
François de Cuvilliés. The Mirror
Room of the Amalienberg Pavilion,
Munich, with stucco work by
Johann Baptist Zimmerman.
1734–1739.

teristics of a substance and the
emotional feelings we associate with
those characteristics. In this respect,
we can speak of the softness of a flower
petal (delicate, tender), the hardness
of stone (strength, durability), the
warmth of wood (earthy), the coldness
of steel (mechanical, rigid). We do not
have to actually touch a substance for
associations to be triggered; the mere
sight of mud is likely to suggest filth,
while the sight of polished marble may
suggest majesty. Likewise, visual
patterns are capable of triggering
associations: the pattern of soft lines
that comprises a stretch of lawn is
inviting; a bed of nails, with its pattern
of straight, pointed lines, is not.

94
Still from the film *City Lights,* directed by Charlie Chaplin. 1931. Museum of
Modern Art Film Stills Archive.

TEXTURE

Charlie Chaplin's silent screen classic,
City Lights, focuses on the tender
relationship between a blind woman,
who sells flowers on a streetcorner,
and a tramp (Chaplin). The blind
woman believes that her devoted
admirer is a wealthy man, although he
is, in fact, penniless. Through a
hilarious series of misadventures

resulting in his imprisonment, the
tramp finances an operation that
restores the sight of the flowerseller.

In the film's final scene, the tramp,
looking more impoverished than ever,
has just been released from prison. As
he stoops to pick up a discarded flower
lying in the gutter in front of a
flowershop, he looks into the shop and

his eyes meet those of the
flowerseller's, who is no longer blind.
He is transfixed. Although initially
taken aback by the tramp's obvious
and instant infatuation, the woman,
with a combination of compassion (or
perhaps mere pity) and a trace of
condescension, gives him a coin and a
flower from her shop. As her fingers
touch his [94] we see a flash of dismay,

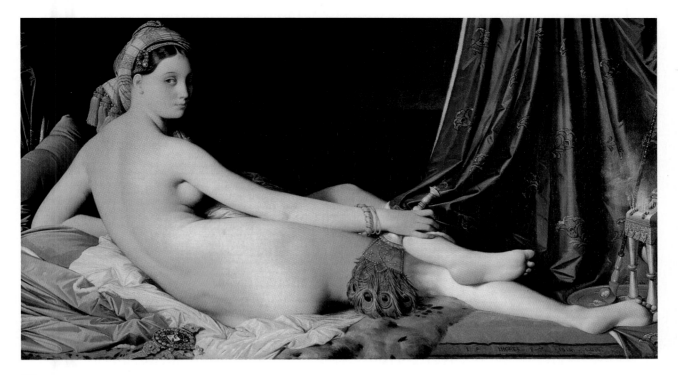

95
Jean-Auguste-Dominique Ingres. *La Grande Odalisque*. 1814. Oil on canvas, 35¼ x 63¾" (89.5 x 162 cm).
Louvre, Paris.

even repulsion, cross her face. Slowly, she explores the tramp's hand with hers. Her fingers trace the familiar feel of his coat and then his face. "Is it you?" the caption reads. The tramp does not speak, but his eyes confirm her realization. Her romantic fantasy about her cherished benefactor has been shattered. "You can see now?" the tramp asks quietly. "Yes, I can see," she answers.

The exchange that takes place between the woman and the tramp places little importance on speech. Seeing plays a part, but more fundamental yet is the touching experience, or rather, the act of seeing through touch. Initially, the woman does not see her unprincely hero; she feels him. Her fingertips ultimately disclose the true identity of the tramp; in fact, through her fingertips she sees beneath the surface.

Because her sight was impaired, the flowerseller developed a keen sense of touch. Many of us do not take advantage of this precious faculty—at least not on a conscious level. And

yet, consider how dismal our environment would be if the surfaces surrounding us were unvaried and offered no opportunity for tactile stimulation.

Throughout history, artists have enriched the meaning and appearance of the images and objects they created by sensitively controlling the textural qualities in their work. Two-dimensional artforms such as drawing, painting, and photography illusionistically represent diverse textures. We refer to such textures as **implied textures.** Three-dimensional artforms such as ceramics, jewelry, fiber arts, sculpture, and architecture incorporate physical or **actual textures.** Whether the texture is implied or actual, the effect it can have on a work of art is of great consequence.

IMPLIED TEXTURES

We do not have to actually touch a substance to comprehend its texture. The visual pattern that activates a surface or the way a surface reflects light is often all that is necessary to convincingly evoke a particular

texture. Look at the wealth of tactile experiences that Jean-Auguste-Dominique Ingres provides in his exacting, highly sensual portrayal of a harem slave, or *odalisque* **[95]**. We can almost feel the woman's skin and the silks and satins surrounding her. Yet these textures are implied, not actual.

The setting of *La Grande Odalisque* is inviting, luxurious. Everything that Ingres depicts receives the light of the room in a different way. The reflective surface of metal, for example, produces sharp light/dark changes, while human flesh absorbs the light rays, creating far more subtle tonal gradations. "Draw with your eyes," Ingres advised young would-be painters, "when you cannot draw with a pencil."[1] His patient observation and scrupulous depiction of the nude's luxurious surroundings, including silk draperies, pillows, jewels, a feathered fan, and a long-stemmed pipe, encourage us to touch with our eyes what we cannot touch with our fingers.

Like Ingres's *Odalisque*, the forms and textures of Jean-Baptiste-Siméon

96
Jean-Baptist-Siméon Chardin.
Kitchen Table. Oil on canvas,
15⅝ x 18¾" (39.8 x 47.5 cm). Gift
of Mrs. Peter Chardon Brooks.
Courtesy, Museum of Fine Arts,
Boston.

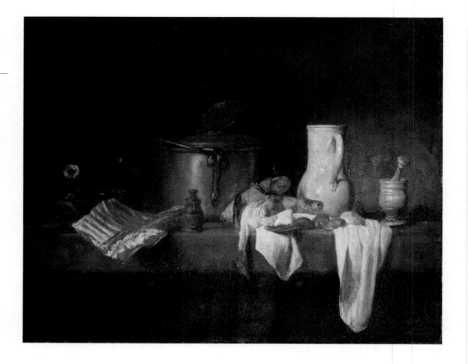

In the 1920s, the avant-garde art movement of **Surrealism** greatly affected the fields of drama, literature, and the visual arts. The subjects of many Surrealist works of art were inspired by the kinds of incongruities and extraordinary relationships that we often associate with unconscious thought processes such as dream states. The Surrealists especially delighted in overturning our conventional understanding of time and space.

Chardin's *Kitchen Table* **[96]** stretch out along the strong horizontal axis of the canvas. Unlike Ingres, Chardin, a French eighteenth-century painter best known for his humble still lifes and interiors, concerns himself with the commonplace.

Chardin uses texture to move us across the composition of his painting. The simple horizontal line of a wooden shelf serves as the stage above and below which the rich textures of an everyday drama unfolds. Light allows us to see these textures, but we get the impression that even if there were no light, we would be able to identify the objects by feel alone. Beginning on the left with the smooth, hard surface of the ceramic bowl, we move down to the moist ribs of beef, up to the cold metal of the copper soup tureen, down to the feathery dead fowl hanging next to a piece of cloth, up to the tall porcelain pitcher, farther down to the other end of the cloth we just passed, and, finally, back up again to the wooden mortar and pestle. These beautifully realized details punctuate the "crossing" as incidents or separate scenes build the narrative line of a story.

The author Eudora Welty writes that ". . . the real dramatic force of a story depends on the strength of the emotion that has set it going,"[2] a comment that helps explain the power of a work such as *Kitchen Table*. This painting was created by an artist who loved and respected his subject. Its power is conveyed through contrasts, straightforward observation, and, perhaps most fundamentally, through its passionate celebration of the everyday textures and forms with which we surround ourselves.

ACTUAL TEXTURES

If you run your finger across Chardin's *Kitchen Table*, you will immediately appreciate that the tactile sensation you had earlier experienced from looking at the painting is not the result of actual textures but, rather, illusionistic ones. Unlike implied textures, actual textures can be detected through the fingertips as well as the eyes.

Not just our fingertips, but our lips as well, can inform us of the Swiss **Surrealist** Meret Oppenheim's focus of attention in her presentation of a

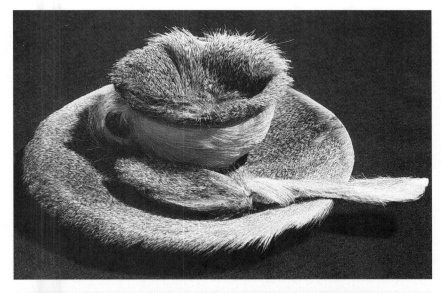

97
Meret Oppenheim. *Object*. 1936.
Fur-covered cup, saucer, and spoon;
cup, diameter 4⅜" (11.1 cm);
saucer, diameter 9⅜" (23.8 cm);
spoon, length 8" (20.3 cm); overall
height 2⅞" (23.8 cm). Collection,
The Museum of Modern Art, New
York. Purchase.

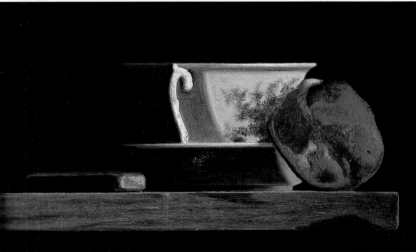

98
John Frederick Peto. *Cup, Biscuit,
and Fruit*. c. 1890s. Oil on board,
5⅞ x 9¼" (15 x 23.5 cm). Mr. and
Mrs. Meredith Long, Houston, Texas.

not-so-commonplace *Object* **[97]**. By
covering a cup, saucer, and spoon with
rabbit fur, Oppenheim mocks our
conventional habits of association,
and demonstrates why she has been
described as the "queen of the realm
in-between." To appreciate the extent
to which actual surface texture can
affect a work of art, we have but to
compare the unpredictable, richly
tactile surface of Oppenheim's
interpretation of a cup and saucer with
the illusionistic (and more straight
forward) cup and saucer included in
the American still life painter John
Frederick Peto's *Cup, Biscuit, and Fruit*
[98].

The twentieth-century **Cubist**
painter Georges Braque's *Musical
Forms* **[99]**, a **papier collé** (a form of
collage in which cut papers are pasted
onto a flat support), represents
another example of actual texture.
Braque believed that objects should be
brought within the viewer's reach,
creating what he termed "tactile
space." Even the literal subject matter
of *Musical Forms* (subjects that
frequently find their way into his
imagery) involves touch: guitars
require the touch of the fingers;
clarinets require the touch of the
fingers and lips. Of course, texture
results not only from pictured illusion

Working closely together during the
early years of the twentieth century,
Pablo Picasso and Georges Braque
invented a radically new conception
of geometricized form and space
known as **Cubism**. Because the Cubists
were not concerned with naturalisti-
cally reproducing the subjects that
appeared before them, they took
many liberties, including rejecting the
notion that artists must portray their
subjects from a single, fixed vantage
point.

99
Georges Braque. *Musical Forms.*
1918. Collage on paper,
30⅜ x 37⅜" (77.2 x 95 cm).
Philadephia Museum of Art: The
Louise and Walter Arensberg
Collection.

or the associations we draw from the subject of musical instruments. Here, the actual textured surfaces of materials such as pasted paper and corrugated cardboard exert a definite impact on our response to the work.

The element of actual texture is a primary feature of Navaho sandpaintings. **Sandpaintings** (sometimes called drypaintings) of the Navaho Indians differ in several significant respects from the tradition of painting within which most of the images in this book fall. 1) Sandpaintings are made on and for the ground, not for a wall. 2) Paintbrushes are not used. Colored designs are created by trickling dry pigments from between the thumb and flexed forefinger onto clean, tan-colored sand that has been smoothed with a weaving batten. Sometimes materials of vegetable origin (such as colored cornmeals or pulverized flower petals) are spread onto a ground of buckskin or some other cloth. 3) Sandpaintings are meant not only to be touched, but to be sat on. 4) They are intended to last for little more than a week at most. (When the ceremony is completed, the sandpainting is destroyed.)

Sandpaintings are carefully prescribed, colored designs created as a means of, among other things, controlling dangerous elements, exorcising ghosts, reestablishing harmony, curing sickness, immunizing an individual to further distress, aiding childbirth, and blessing a new home. When the sandpainting *People of the Myth with Mountains* **[100]**, which represents one major feature within a complex ceremony, is completed, the afflicted individual for whom the painting is executed is directed to sit on one of the painted Holy People represented within the image. The leader (called a singer because singing plays a principal role in the ceremony) then rubs the patient's body with sand taken from various parts of the painted figures' bodies as a means of identifying the patient with the Holy People portrayed in the painting. From the applied sands, the patient absorbs the powers of the Holy People, thereby becoming immune to further harm.

TEXTURES OF RITUAL

As is the case with Navaho sandpaintings, in many societies art and ritual are inseparably united. Ritualistic objects serve as a kind of

People of the Myth with Mountains. **Collected by Franc J. Newcomb at Newcomb, New Mexico, 1933 (painted by Mrs. Newcomb).** Photograph by Herb Lotz, Courtesy of the Wheelwright Museum of the American Indian, No. P10#9.

**Oath-taking Figure, Congo. Wood, nails, cloth, tacks, glass, paint, height 26"
(66 cm).** Collection Musée de l'Homme, Paris.

shorthand language of meaning, custom, and veneration for those who are versed in their unique, communal form of expression. Ritualistic objects ordinarily speak most profoundly to the members of the community that employ those objects in their ceremonies. Even without knowing its practical function, however, we can often sense the general intent of a ritualistic object if we allow ourselves to respond emotionally to its appearance. Largely because of the arrangement of a sequence of shapes, colors, or textures, the object may seem to us frightening or calm, festive or sad, authoritative or conciliatory.

In the Congolese *Oath-taking Figure* **[101]**, the striking textural contrasts apparent among the chiseled wood of the figure, cloth, glass, and embedded metal nails angling every which way, create a powerful, frightening impression. Most of us think of the skin of the human body as relatively smooth and sensitive. Confronting an outer covering of a human form such as we see here disrupts our expectations and, if we project ourselves into the circumstance, may suggest for some viewers severe physical pain.

From the time we are first introduced to works of art we are told: "Do not touch." This is not the case in all cultures. Traditional African artists do not distinguish between fine art and functional art. As Henry John Drewal, an historian of African art, points out: "In Africa, it is not only the artist and patron who determine how an object will look, but also the caretakers and inheritors of art. The object is not untouchable, although it may be sacred. Rather, generations of people wash, rub, dress, decorate, paint, and oil it, in a sense personalizing art and in the process affecting its meanings, enhancing its evocative powers and its efficacy."[3] The pronounced texture of *Oath-taking Figure*, which is the direct result of community members ritualistically imbedding nails, tacks,

glass, and cloth into the painted wooden figure, was not created with the idea of formal design in mind; function, not form, was the guiding force. Nails were hammered into the sculpture every time the magic powers of the object were required. Power figures that proved to be ineffective in bringing about desired results were discarded. Judging from the density of the nails covering the surface of the sculpture, *Oath-taking Figure* must have satisfied the needs of many clients.

The ritualistic objects of non-Western cultures have greatly influenced twentieth-century Western European and American artists. Consider the textural relationship between *Oath-taking Figure* and the contemporary Greek-American artist Lucas Samaras's *Untitled Box No. 3* [102]. Samaras exploits the disturbing, disjunctive quality that is naturally associated with significant textural changes within a single image or object. The relatively small physical dimensions of this shrinelike sculpture do not prepare us for its potential emotional jolt. The pins create a sinister texture; if we come too close we might get pricked. At the same time, the pathetic predicament of the stuffed sparrow, partially visible within the box, elicits our pity. The power of this work is expressed through its decidedly tactile nature. Pinpoints say to us: "Danger, stay away!" Nevertheless, the inclination to touch this spiny area is strong, like the urge to touch your aching tooth with your tongue, knowing full well that by doing so you will cause yourself discomfort. Conversely, the delicate bird is there to be stroked—gently. The chaotic lines of the rope pouring out the bottom of the box contrast with the dangerous but small-scale lines of the pins that are arranged above in sometimes orderly, sometimes haywire patterns.

102
Lucas Samaras. *Untitled Box No. 3*. 1963. Wood, pine, rope, and stuffed bird, 24½ x 111'2" x 101'4" (62.23 x 29.21 x 26.04 cm). Collection of Whitney Museum of American Art. Gift of the Howard and Jean Lipman Foundation, Inc. 66.36.

Both the ritualistic *Oath-taking Figure* and *Untitled Box No. 3* display an exaggerated degree of attention to texture. There are, however, fundamental differences between these two sculptures. African ritualistic artifacts are communal by nature, and the members of the community for whom their powers are employed are generally aware of the objects' functions and meanings. What *Untitled Box No. 3* means is fascinating to speculate about. It may mean many things or its meaning may be unexplainable, even by the artist. It suggests a ritual having something to do with entrapment, vulnerability, or death. *Untitled Box No. 3* is private and allusive, like a personal fantasy or nightmare. Certainly, the museum or gallery context for which Lucas Samaras's object was created represents a very different world from the one in which *Oath-taking Figure* was conceived.

The Western ritual and pomp of the parade, as well as the urge to commemorate camaraderie through the convention of the group portrait, serve

103
Rembrandt van Rijn. *The Sortie of Captain Frans Banning Cocq's Company of the Civic Guard (The Night Watch)*.
1642. Oil on canvas, 11'9½" x 14'2½" (3.59 x 4.33 m). Rijksmuseum, Amsterdam.

as the basis of one of the most famous paintings in the history of Western art, *The Sortie of Captain Frans Banning Cocq's Company of the Civic Guard* **[103]**, popularly known as *The Night Watch*. The seventeenth-century Dutch master Rembrandt van Rijn's unorthodox handling of this group portrait commission overturned the convention of stiffly lining up costumed people who all stare blankly (or, at best, self-consciously) at a common spot in front of the canvas, such as we see in Frans Badens's *The Company of Captain Arent ten Grootenhuys and Lieutenant Nanning Florisz* **[104]**. The seventeenth-century painter of this group portrait,

like countless other portrait painters of the day, unquestioningly accepted a tired formula. Rembrandt did not. In *The Night Watch*, Rembrandt focused more on the action and detailing of the hectic proceedings he staged than on presenting straightforward like-nesses of the civic guardsmen who had commissioned him to paint their portraits. The artist lavished particular attention on the textures of the event. He described the wooden lances, wooden-handled and metal-barreled rifles, and other weapons fabricated out of a wide range of materials; he described the metal helmets, cloth flags, uniforms, plumed hats, and musical instruments that play an

integral part in creating the necessary atmosphere in which to carry out the ritual of the parade. The dynamic character of the painting can be atttributed as much to the wide range of textures richly pictured as to the fact that not one of the participants is sitting still.

Just as individual tribal objects influence contemporary artists, so do the organizational patterns of tribal rituals (including collective expres-sions such as dance) affect the contemporary artist's view.[4] As Kirk Varnedoe points out in *"Primitivism" in 20th Century Art*, "Lost religious systems, new concepts of the Primitive

104
Frans Badens. *The Company of Captain Arent ten Grootenhuys and Lieutenant Nanning Florisz.* 1613. Oil on canvas, 6'1¼" x 11'10½" (186 x 362 cm). Amsterdams Historisch Museum, Amsterdam.

105
Joseph Beuys. *Coyote: I Like America and America Likes Me.* 1974.
Performance, Courtesy Ronald Feldman Fine Arts, New York.

Conceptual Art developed in the 1960s out of the belief that the process of making art, and the ideas or concepts underlying the work of art, were more important than actual images or objects. Accordingly, Conceptual artists believe that a work of art does not have to assume visible form, or if the idea is translated into visible, that it need not remain permanently visible. Earthworks and Performance Art are often categorized as forms of Conceptual Art. Important Conceptual artists include Sol Lewitt, Walter de Maria, and Joseph Kosuth.

mind, and enigmatic monuments . . . have largely displaced discrete objects as the dominant source of inspiration for primitivizing artists today."[5] Many of the ritualistic works staged by one of the most important twentieth-century **Conceptual** and **Performance artists,** the German-born Joseph Beuys, allude to the kinds of activities enacted by shamans (individuals in tribal societies who are often regarded as a combined sorcerer, healer, priest, psychiatrist, magician, and artist[6]). Beuys's work, which incorporates a wide range of materials, includes live and dead animals, felt, fat, honey, rope, and tape recorders. One of his best-known performances, *Coyote: I Like America and America Likes Me* [105], involved the artist's week-long confinement with a coyote in a New York art gallery. Referring to the materials he uses and the shamanistic nature of his work, Beuys has stated:

I take this form of ancient behavior as the idea of transformation through concrete processes of life, nature and history. My intention is . . . to stress the idea of transformation and of substance. . . . When I appear as a kind of shamanistic figure, or allude to it, I do it to stress my belief in other priorities and the need to come up with a completely different plan for working with substances.[7]

Performance Art involves an act or series of actions which the artist or other participant(s) perform, usually in front of an audience. Happenings, which are often essentially unrehearsed by the performers and the participating viewers on hand, and body art, in which the artist's (or a designated stand-in's) body functions as the primary art object, constitute other related forms of Performance Art. Important Performance artists include Joseph Beuys, Laurie Anderson, and Vito Aconci.

106

Interior of the Katsura *Shokintei* (teahouse), with hearth and tree trunk used to support a partition. 17th century.

Before reading the following discussion of the ceremonial tearoom [106, 107] of the *Shokintei* (teahouse), think about the work by answering the following questions:

1. What is your first impression of the ceremonial tearoom of the Shokin-tei? Does the room look fancy or simple? Serene or busy? Full or empty? The traditional tea ceremony encourages silent meditation as a means of promoting spiritual tranquility. Do you think qualities such as simplicity and serenity would be conducive to the achievement of a state such as spiritual tranquility?

2. Notice that the central post which supports a half wall inside the teahouse differs from the typical interior column we would expect to see inside a building. How does this detail affect your response to the room? The interior of the teahouse and the spirit and textures of the surrounding landscape were intended to be appreciated as a single, harmonious experience. Does the central column of the ceremonial tearoom play any special part in this respect? Explain.

3. Cite some of the natural textures that integrate the interior with the outdoors in this setting.

Contrasting textures are intermingled throughout the approximately sixteen acres that comprise the setting of the *Katsura* Imperial Villa, an assembly of buildings and interrelated gardens located in southwestern Kyoto. Katsura, one of the hallmarks of Japanese architecture during the Edo period (1603–1868), was initially designed as the private retreat of the imperial prince Hachijo Toshihito and his family. Here, the integration of landscape and architecture creates a sanctuary of calm that reflects the aesthetic of the tea ceremony, an ancient ritual practiced as a means of cleansing the mind and spirit.

Despite the austerity of the space, every inch of the room's perimeter has been softly and sensitively defined by another texture and material. The floor is covered with rice-straw mats; the ceiling of reeds and bamboo splits is overlapped with an open, wooden grid, and there are rough, mud-covered walls as well as plaster walls. The central post, with its bark still attached, maintains most of its treelike qualities, which blends the tearoom with the natural beauty of the landscape. The deft placement of the translucent rice paper and wooden moldings that surface the room's eight windows offer dramatic decorative detailing to this intimate space which is suffused by natural and somber colors. Since the participants of the tea ceremony sit on the floor, the low guest entrance, sometimes referred to as a "wriggling-in entrance," and the low windows allow for a better view of the gardens. This guest entrance serves another purpose as well: by being forced to bow or kneel in order to enter, a sense of humility and restraint is promoted on the part of the individual entering the room. This humbling gesture shows respect to the other guests already seated. The low entrance may also cause those who pass through it to feel they are entering another world[8]—the achievement of so many great works of art.

Like the ceremonial tearoom, each of the other rooms within the *Shokintei* is sparely and delicately designed. Each room expresses an individual character boasting diverse materials such as fine crepe paper, clay walls, plaster walls, translucent rice-paper screens, black-lacquered framing, transoms made of hemp stalks, rough wooden doors, wicker doors, bark-covered pillars, and velvet wallcoverings. The teahouse itself is situated among a wide variety of trees, spacious landscaped gardens, ponds, and hills [108] which saturate the eye with an endless range of textures. Despite all these potentially disruptive textural contrasts, architecture and landscape work together toward the creation of a serene and well-integrated whole. Clearly, it is not the abundance or scarcity of textures comprising a visual experience that determines the aesthetic or emotional charge of that experience. Rather, the particular nature of the contrasts and how an artist interweaves them is what matters.

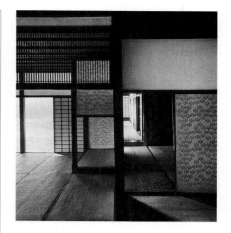

107
Middle Shoin seen from the first room of the Old Shoin.

108
Katsura Gardens and *Shokintei.*

PATTERN

Pattern is the product of a relatively constant repetition of a visual detail or motif. By nature, patterns introduce a sense of uniformity and order to any given design. In order for a visual configuration to be considered a pattern, three characteristics must be present: the parts must be seen primarily as members of a larger arrangement, not as isolated details; the intervals, or spaces between the parts, must be relatively constant; and the configuration must be extensive enough and include enough repetition that, based on the available visual information, you can predict generally how the configuration would be continued.

INTEGRATION

Individual parts must be absorbed into a larger unit before a pattern can be perceived. Integration, not individuation, is the cornerstone of every pattern. An example of the principle of visual integration is apparent in the *Emperor Carpet* **[109]**, where we see vines, animals, and Chinese cloud patterns pictorially interwoven throughout the carpet. Although each shape can be seen individually **[110]**, through multiplication and uniform spacing, the details of this Persian carpet function primarily as integral parts of an overall pattern.

REPETITION, THE INTERVAL, AND THE GRID

Repetition, which is the result of sameness between separate parts, serves to override, to some degree, whatever differences exist elsewhere in an image or object. Repetition is one of the primary means by which an artist can establish unity in a work of art, and it is the prime factor in the establishment of any pattern. Contrary to popular opinion, however, the intervals, or spaces between the parts—not the duplication of the parts

109
Emperor Carpet from Khorasan. c. 1550. Wool pile on silk, Persian knot, 24'8" x 10'10" (7.52 x 3.30 m). Metropolitan Museum of Art, New York. Rogers Fund.

110
Detail of the *Emperor Carpet*.

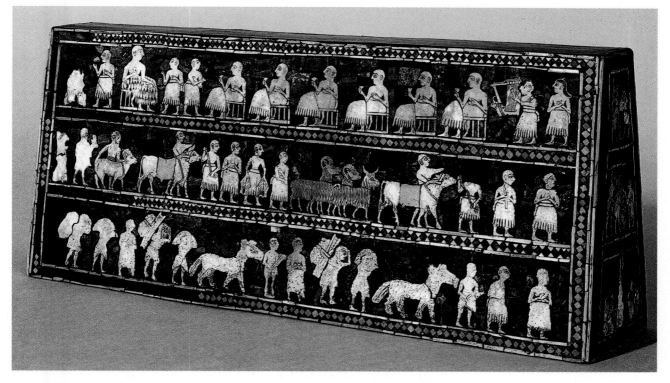

themselves—play the most important role in the establishment of a pattern. "If you preserve the spacing between sequences of (typewritten) letters" writes the art critic Amy Goldin, "it doesn't matter what letters or marks you use, a pattern will appear. On the other hand, a single motif, like a rubber stamp, irregularly applied to a sheet of paper does not yield any sort of pattern at all."[9] And the closer in size the letters are to one another, the more obvious the pattern will be.

In *Scenes of Peace*, a panel from an oblong Sumerian box dated approximately 2700 B.C. called the *Standard of Ur* [111], generally uniform intervals separate the variously shaped men, goats, sheep, and cattle that comprise each of the horizontal strips. It is this uniformity of interval, not the exact repetition of the individual parts, that most significantly accounts for the clarity of the pattern.

A **grid**—an orderly system of implied or actual geometric lines within which a visual composition is organized—divides the panel into three horizontal rows of figures and animals. Because the intervals between the shapes within each row are relatively constant and the light-colored shapes of the figures and animals are uniformly set off against the darker, more intense blue background, the three rows are similarly paced. By dividing this panel into three parallel strips, the artist 1) accentuated the object's horizontality, 2) took full advantage of the resulting linearity by choosing to portray the subject of a procession that, like a comic strip, unfolds in time and space, and 3) created a grid which, by nature, lends itself to narrative description.

Grids are especially conducive to storytelling, or allowing an idea to unfold in time. Like chapters in a book or movements of a symphony, the divisions of a grid permit an artist to combine numerous separately stated thoughts or topics of decidedly contrasting character within a single overall structure. When the Italian Renaissance artist Michelangelo wanted to narrate the creation, fall, and redemption of man across the approximately 5,800 square feet of the Sistine Chapel in Rome [112], he chose the structure of the grid [113] as his formal means of organization. The sizes and shapes of the individual compartments that comprise this

111
Scenes of Peace, panel from the *Standard of Ur*. c. 2700 B.C. Panel inlaid with shell, lapis lazuli, and red limestone, 8 x 19" (20.3 x 48.3 cm). British Museum, London.

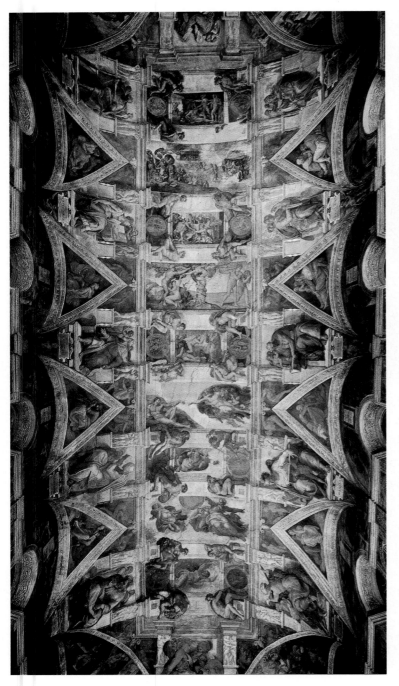

112
Michelangelo Buonarroti. Ceiling of the Sistine Chapel.
1508–1512. Fresco, 44 x 128' (13.4 x 39 m). The Vatican, Rome.

113
Iconographic plan of the Sistine Chapel ceiling.

masterpiece, as well as the compositions and themes within each section, differ significantly, as we see, for example, if we consider one portion of the ceiling [see **224**]. The monumental portrait of *The Prophet Jonah*, who is portrayed within a square compartment located over the main altar, is

bordered on one side by a triangular image of the *Crucifixion of Amman* and on the other side by *The Brazen Serpent*, another triangular cloister vault that is the same size, but a completely different composition. The grid containing these and the many other individual compositions that

comprise the vault of the *Sistine Chapel* pulls the parts together into an integrated whole. The result is one of the most powerful individual human achievements ever created—a supreme example of pattern, monumentality, and religious expression inextricably fused.

114
Grand Escalier, Château Blois, France. 1515–1530.

alludes to just this principle when she states: "If something is meaningful, maybe it's more meaningful said ten times. It's not just an aesthetic choice. If something is absurd, it's much more absurd if it's repeated . . . repetition does enlarge or increase or exaggerate an idea or purpose in a statement."[10] While artists usually temper the elements they introduce into their work with some form of variation in order to maintain visual interest, some works of art are based, essentially, on repetition without variation.

Such is the case with certain important architectural features of the *Palace of Versailles* [115], built by Louis XIV outside Paris. The 1,935-foot-long façade that faces the formal gardens displays a row of windows that maintains a steady, repetitive beat. The slight changes that do occur along the enormous span of the façade are themselves consistently repeated; consequently, these shifts can be understood not as true variations but as repeated details of the larger repetitive pattern. The simplicity of the exterior is particularly striking when we compare it to the extravagant decorations that define most of the interior spaces of Versailles [116]. The exterior simplicity and repetition translate as unswerving directness, confidence, and authority. The profusion of ornamentation and variation that pervades the interior replaces power with wealth and restraint with excess. The long,

REPETITION WITHOUT VARIATION

Within set visual patterns that are dominated by constant repetition we generally welcome moments of inconsistency or variation. Consider how irresistibly, for example, our eyes are drawn to the slant of the open staircase on the court façade of the Castle or Royal Palace at Blois, France [114]. We are drawn to this area largely because it offers an abrupt interruption (relief) to the repeated horizontal rows of windows on either side of the stairs. Relatedly, within open-ended visual patterns dominated by variation, such as we see in the ceiling paintings of the *Sistine Chapel*,

we welcome elements that promote consistency and unification, as are provided, for example, by the geometric regularity resulting from Michelangelo's use of the grid. Patterns unrelieved by any kind of variation can become not only tedious but can drain a theme of its meaning. Select any word and repeat it twenty times in a row; the word quickly becomes a mere sound within a chanted pattern. Because they are not usually intended to capture your attention, wallpaper patterns typically employ this same kind of redundancy. On the other hand, repetition can have the opposite effect; it can emphasize a thought. The twentieth-century American artist Eva Hesse

straight, exceptionally constant line of
the building complex separates city life
from nature, and houses within its
walls the setting within which an
absolute monarch could comfortably
satisfy his personal, ceremonial, and
governmental needs and responsibili-
ties.

Of course, repetition unrelieved by
variation does not always produce
refinement or grandeur. Often it
produces monotony. By incessantly
reproducing a newspaper photograph
of a mourning Jacqueline Kennedy
[117], the twentieth-century Ameri-
can **Pop artist** Andy Warhol called
attention to what he believed was the
media's trivialization of the assassina-
tion of a president of the United
States. "It didn't bother me that he
(Kennedy) was dead," Warhol has
stated. "What bothered me was the
way the television and radio were
programming everybody to be so
sad."[11] Warhol's use of the grid and
unrelieved repetition effectively
communicates his critical response to
the media coverage of a national,
family, and individual tragedy. To
make his point, Warhol transformed
into a decorative pattern subject
matter as powerful as a woman's grief
over the murder of her husband.

The *Emperor Carpet* [109] does not
tend to challenge our preconceptions
regarding decoration and sameness in
the visual arts; Persian carpets are
typically associated with the decora-
tive arts. Besides, the repeated motifs
that comprise this work are enlivened
by other patterns that surround the
central field of the carpet. In the case
of *Twenty Jackies*, however, the
decorative effect is offensive, unnerv-

116
Jules Hardouin-Mansart and Charles Lebrun. Hall of Mirrors, Palace of
Versailles. Begun 1676.

117
Andy Warhol. *Twenty Jackies*. 1964. Acrylic and silkscreen on linen, 20 panels, each 19½ x 16" (49.5 x 40.6 cm). Collection Marx, Berlin.

ing, and untempered. Although the idea of the piece involves the issue of monotony, the image is not altogether monotonous because the repeating frames do not continue long enough; monotony is only threatened. Anyway, monotony is side-stepped because the image is engaging on a conceptual level, no matter how boring it looks. (If, in fact, concept can ever be separated from image, Warhol's work in general can surely be said to be more interesting on a conceptual than a visual level.) The sense of mass production that we may associate with *Twenty Jackies* was probably intended by the artist, as was the tension that surfaces as we attempt to reconcile a poignant subject presented as if it were wallpaper.

THE INTERACTION OF PATTERNS

Any visual system, no matter how well designed, is apt to become boring if it is unrelieved by some form of conceptual or visual conflict. This is where pacing comes in. "How long can I afford to repeat this pattern before I introduce a shift?" "How can I activate this area so it does not become

monotonous?" These are questions artists must inevitably entertain while working with a continuing visual sequence.

Juxtaposition, the placing of one thing directly against another, represents a means of exciting any pattern. When one pattern is placed directly next to another, each is enlivened and made greater than it could ever be by itself. A detail **[118]** of the bottom central portion of Hans Memling's *The Madonna with Child on the Throne* **[87]**

In the late 1950s and early 1960s, **Pop artists**, including Englishman Richard Hamilton and Americans Andy Warhol, Roy Lichtenstein, and Claes Oldenburg, began focusing on subject matter and styles of representation that addressed issues involving popular mass culture. Some characteristics commonly associated with Pop Art are: banal subject matter, or noteworthy subject matter made to look banal; references to mass production; an exploitation of commercial art techniques; and large scale.

118
Hans Memling. *The Madonna with Child on the Throne* (detail). 1479. Oil on panel. Hans Memling Museum, Bruges, Belgium.

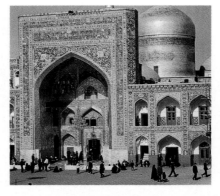

offers a vivid example of the kind of visual intensity achieved by juxtaposing designs of flat, geometric shapes with patterns of organic, volumetric forms. It is remarkable that such lavish and vibrant detail as this should nonetheless result in a work of art that is fundamentally about spiritual tranquility.

In both the *Shrine of Imam Reza* in Mashhad, Iran **[119]** and the *Temple of Surya* in Konaraka, India **[120]**, a profuse interaction of patterns decorates the surfaces of the buildings. In the Persian example, the colorful surface decoration overwhelms the building to such an extent that the division between architecture and painting blurs. The building can be seen as a three-dimensional painting or as a pictorially dazzling work of architecture. Notice how fluidly the pattern of sweeping three-dimensional arches merges with the intricate tile patterns. Likewise, the Indian temple bridges the categories of architecture, sculpture, and drawing. Here, patterns take the form of incised linear ornamentation as well as figurative

stone sculptures carved into the walls and the roof of the temple. The visual splendor that overwhelms the exterior of the buildings represents a marked contrast to the flat, unadorned exteriors of most twentieth-century American architecture.

The contemporary American ceramicist, painter, and muralist Patricia Alexander employed an international range of patterns in order to visually excite both sides of a series of eight horizontal beams that span a recently constructed subway station in Baltimore, Maryland **[121]**. The ceramic-tiled design of each transom in *Geometro* is based on geometric motifs traditionally associated with the major ethnic groups that have settled in Maryland. As the artist states in her original proposal for this commission: "When seen together in the mural, these patterns signify different cultural heritages working together to form a whole." Patterns associated with Native Americans, Europeans, Africans, and Asians are represented. The artist solved the problem of how to activate the huge expanse of the forty-four-foot-long crossbeams by dividing each beam into a chain of interacting patterns. When you descend the escalator leading to the station platform and see all the crossbeams lined up one behind the other, the effect created by the wealth of interacting shapes, colors, and patterns is dazzling.

121
Patricia Alexander. *Geometro* (detail). **1983. Ceramic tile on both sides of eight beams.** Lexington Market Station of the Baltimore Metro System.

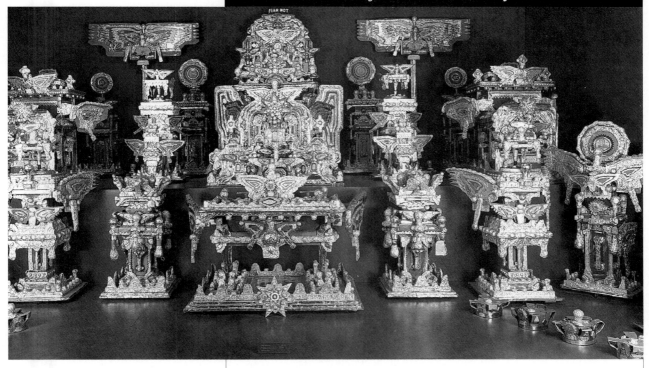

122
James Hampton. *The Throne of the Third Heaven of the Nations' Millenium, The General Assembly.* **1950–1964. Gold and silver tinfoil over furniture, 177 pieces of various sizes.** National Museum of American Art, Smithsonian Institution, Washington, D.C., gift of anonymous donor.

Before reading the following discussion of *The Throne of the Third Heaven of the Nations' Millenium The General Assembly* **[122]**, think about the work by answering these questions:

1. There is an obsessive quality underlying James Hampton's *The Throne of the Third Heaven.* How would you describe the term *obsession*? Do you think it contributes positively to or detracts from this work? Explain.

2. If you isolated one of the objects that comprise this work, do you think it would embody the same degree of fascination as it does when viewed within the context of the entire assemblage? If your answer is no, what does this tell you about the interaction of the separate parts of a work of art? What does it tell you about the potential power of insistence—even excess—within a work of art?

3. The textures and surface patterns of *The Throne of the Third Heaven* are a result of the artist having used materials such as light bulbs, aluminum foil, and jelly glasses in his work. Do you think materials such as these are appropriate items to be included in a work of art?

4. Why do you think Hampton constructed his *Throne of the Third Heaven* out of such commonplace materials? Do you think there might have been any practical considerations that motivated his decision to use these materials instead of a more traditional material such as marble?

5. Hampton employed commonplace materials. Does his creation strike you as commonplace also? If not, why not?

Obsession can be defined as an idea or emotion that exerts an inordinate degree of influence on an individual's behavior. We ordinarily think of an

obsession as abnormal and destructive since there is an element involving lack of control, that is, of causing an individual to feel driven by the power of the obsession. But if the surrounding circumstances are harmless, and the particular nature of the drive is creditable, there is no reason to attach negative associations to an obsessive attraction. In this sense, we can, for example, speak of the grandeur of nature as an apparently healthy obsession that preoccupied photographer Ansel Adams throughout his career.

Works of art are the outward expressions of internal charges. When one of these internal charges assumes significant enough proportions within the mind or feelings of an artist, that charge may become an obsession. Generally, the obsessions that drive artists are most easily observed by stepping back and viewing a given series of works in which the artist's most deeply felt preoccupations are incessantly re-examined. Occasionally an individual work is created that contains within itself the hammering insistence of an artist's vision. James Hampton's *The Throne of the Third Heaven of the Nations' Millennium, The General Assembly* is such a work.

Besides *The Throne of the Third Heaven,* which includes 177 objects, no other works of art are known to have been created by Hampton. Nonetheless, the artist's visual and spiritual preoccupations are vividly embodied in this single, ongoing project that he worked on from about 1950 to 1964. The sense of Hampton's compulsively putting things together is overwhelming. Among other distinctly textured materials collected from his immediate environment, Hampton combined old furniture, cardboard, insulation board, light bulbs, electrical cable, newspaper, desk blotters, aluminum and gold foil, sheets of transparent plastic, glass vases, and jelly glasses to create what Lynda Roscoe Hartigan, Associate Curator of Painting and Sculpture at the National Museum of American Art, describes as a "vehicle for religious renewal and teaching." Driven by an inner vision (the artist claimed God visited and spoke to him), Hampton returned nightly from his job as a janitor to work on this mammoth project in an unheated and dimly lit garage. He once explained to his landlord that it was his "life." The project, he insisted, would be completed before he died.

Whether or not *The Throne of the Third Heaven* was completed when Hampton died of cancer in 1964 is open to debate. Certainly there is an exhaustive sense of textural and patterned activity, to say nothing of the ceremonial character achieved by this extraordinary assemblage. As it is exhibited at The National Museum of American Art in Washington, D.C., where it is permanently installed, *The Throne of the Third Heaven* seems, however, to be incomplete in one significant respect: the background for the objects is undeveloped. It is apparent from the photographs taken before *The Throne of the Third Heaven* was removed from the garage in which it was created that the artist's strengths and enthusiasm involved making and establishing relationships between tactile objects, not in creating a dialogue between figure and ground. Nonetheless, judging from the photographs, the brick walls of the garage provided the insistently patterned and distinctly textured objects with a patterned and textured environment. The designers who installed this assemblage in the museum provided bright, even lighting and constructed

surrounding walls that they painted a flat, gray tone, presumably to blend with the objects. The result is only partly successful. The eccentric, captivating textures of the objects have nothing in common with the flat, anonymous surface of the walls which, in effect, create holes where dynamic negative spaces ought to be.

Nonetheless, the glimmering items that fill the room invigorate the space. Each object is repeated twice, mirrored on either side of a centrally positioned throne located along the back wall. A sense of permanence and formality results from this primarily frontal, symmetrical positioning of the objects which fill the space like a three-dimensionalized Persian carpet. Despite the ordered format of the assemblage, there is an undeniable quality of complexity and entanglement. Contributing significantly to this quality is the artist's activity of gluing, nailing (mostly with upholstery tacks, small nails, and sewing pins), and wrapping a wide range of common materials into an ambitious and eccentric ensemble. The surface encrustation is so intense that one does not immediately realize how unremarkable the underlying objects are that comprise *The Throne*. The artist's belief in the importance of his vision, the peculiar range of materials he used, and the sheer excess of the undertaking transform the commonplace into the extraordinary.

CRITICAL QUESTIONS

1a. While every worthwhile work of art requires an extended period of time and reflection from a viewer, some works, by nature of how they are put together, demand more viewing time from us than do other works of art. Do you think the Persian miniature *Majnun Eavesdrops on Layla's Camp* by Shaykh Muhammad [123], one of twenty-eight pages from a Royal Safavid manuscript of the sixteenth century entitled *Haft Awrang of Jami*, is the kind of visually layered work that must be taken in slowly, or that with one quick glance it will reveal all it has to offer you?

b. It is difficult to say what is in front and what is behind in this painting partly because the positive and negative shapes are so closely intertwined. Accordingly, many pictorial incidents, such as the horse or donkey drinking from the stream that trickles along the very bottom of

this painting, are camouflaged into the overall weave of the image. Point out several other such hide-and-seek areas or incidents. What mood is established as a result of the particular kind of figure/ground flip-flopping? Mischievousness? Forthrightness? Deception? Serenity? Disorder? Does the painting's title support your impression of the painting's mood?

c. The artist has carefully detailed the texture of the men's beards. To what other areas of textural distinction can you point? Do you think these areas contribute to the painting's sense of vitality?

d. The artist keeps us alert as our eyes thread their way through this densely packed tapestry of textures, patterns, organic and geometric shapes and forms. Nonetheless, Shaykh Muhammad also provides moments of rest. Point out some of these areas.

What differentiates these areas from the more spatially ambiguous passages?

e. The subject of this painting is a boy named Lays who became known as Majnun (The Madman) after he fell madly in love with a girl named Layla. Because the families of the young Iranian lovers were enemies, Majnun and Layla (like Romeo and Juliet) could only meet clandestinely. Majnun, partially hidden by the relatively calming rectangle of the awning at the top of the image, can be seen eavesdropping on Layla's conversation. Below, many other conversations take place simultaneously. Do you think the artist has in any way captured the sense of madness that underlies the couple's tragic love affair in general or Majnun's reputed insanity in particular? Explain.

123
Majnun Eavesdrops on Layla's Camp from *The Haft Awrang.* **1555–1556.** Courtesy of the Freer Gallery of Art, Smithsonian Institution, Washington, D.C.

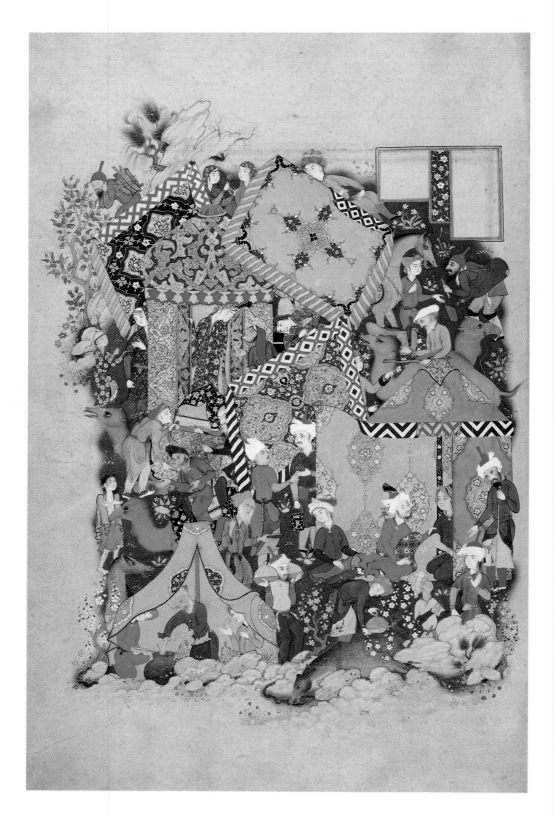

124

Faith Ringgold. *The Wedding: Lover's Quilt No. 1*. 1986. Acrylic on cotton canvas, tie-dyed, printed and pieced fabrics, 77½ x 58" (1.97 x 1.47 m). Private Collection, Photo Courtesy Bernice Steinbaum Gallery, New York.

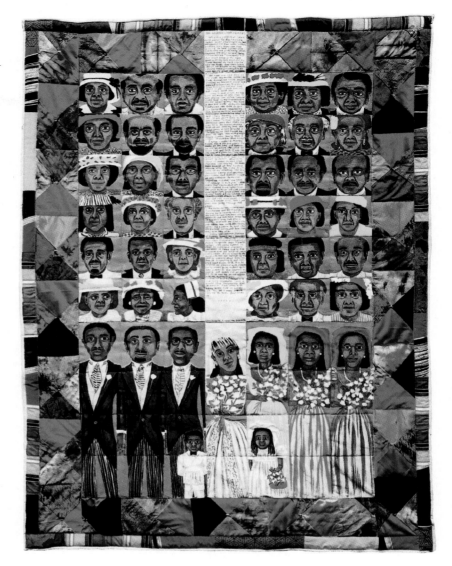

2a. The contemporary American artist Faith Ringgold's *The Wedding: Lover's Quilt No. 1* [124] displays a wide and lively range of interacting patterns. The varied but repeating forms of the heads, and the shapes of the hats represent two of these patterns. How many other patterns can you pick out within this richly orchestrated work?

b. What effect do the straight vertical and horizontal lines of the underlying grid have on these patterns? Compare the topsy-turvy arrangement of patterns evident in *Majnun Eavesdrops on Layla's Camp* with the ordered arrangement of Ringgold's quilt. Can you point to any connection between the form and content of Shaykh Muhammad's painting? Of Faith Ringgold's quilt? Bear in mind that the themes of madness and scheming underlie the Persian miniature while the ordered ritual of a marriage ceremony provides the subject of the quilt.

c. The stiff, frontal, awkwardly drawn figures are part of what the critic Lucy R. Lippard was referring to when she wrote about Ringgold's "unselfconscious continuation of 'old traditions.'"[12] Ringgold, a sophisticated black feminist artist from New York, is enthusiastically pumping contemporary life into the female tradition of quilting, which is not typically associated with cosmopolitan modernity. Perhaps there is another reason the artist posed the figures so rigidly. By doing so, she created a degree of tension that she considered appropriate for expressing the story described in the vertical strip of text that runs through the center of this quilt. Text that completes this three-part narrative is continued in two companion quilts that are not illustrated here. The story that unfolds is told by the bride of *The Wedding*, who describes the details of her longstanding affair with her brother-in-law, her husband's discovery of the affair, and finally, her death. Do you think the conflict between the rigid poses and the flamboyant colors and patterns of *The Wedding* sets the stage for the conflict that is revealed to us through the handwritten text?

Color
and Light

Color and light are inextricably connected. **Color** is composed of wavelengths of light, and without light we cannot see color (or, for that matter, any of the other visual elements that we discuss in this book). Broken down into its most basic components, light *is* color. Because certain properties are more readily apparent in one of these visual elements than the other, let us look at color and light separately, always knowing that when we are discussing one of them, the other is never far away.

COLOR

"What a blue landscape," I said to myself upon stopping to gaze at *Mont Sainte-Victoire* **[125]**, one of Paul Cézanne's many paintings of a particular mountain view located near his studio in southern France. The single color saturated the painting and saturated me. Then I thought, "No, it's not blue at all; it is more like violet," and I became fascinated by the violet that saturated the canvas. But when I looked again, the violet became green, and I was overwhelmed by the green

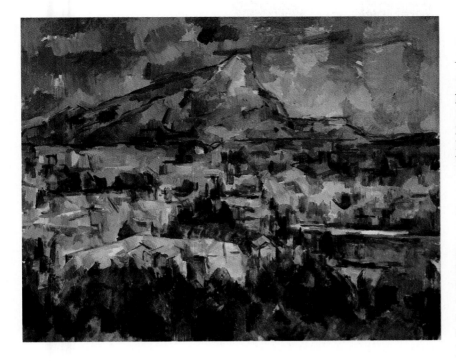

125
Paul Cézanne. *Mont Sainte-Victoire.*
1902–1904. Oil on canvas,
27½ x 35¼" (70 x 90 cm).
Philadelphia Museum of Art, George
W. Elkins Collection.

that filled the leaves, and carried over into the sky, the ochre middle ground, and the mountain in the distance. "What an incredibly green painting," I thought. And then the green turned to. . . . Cézanne's color cannot be stated by a word. His color is an experience, a sensation, a temperament.

The colors of this painting, which Cézanne completed shortly before he died, were so subtly and sensitively adjusted to one another that when the color of one area—say a blue area— preoccupied me, it cast its influence over the rest of the painting, pulling out the blue in other mixtures. Green (which is a mixture of blue and yellow) suddenly became predominantly blue, and violet (which is a mixture of blue and red) appeared more blue as well. When my eye noticed several predominantly green areas, other green areas in the painting immediately became more noticeable. All of this I thought about later. While I was gazing at the painting, I was not really conscious of anything other than an extraordinary performance of color unfolding before me.

Like no other visual element, color has the capacity to elude definition. Blue

is a finite word with exactly four letters. It helps us specify, to some degree, what we mean by a particular, or at least a limited, aspect of the spectrum of colors. But in a single Cézanne painting, the color blue is apt to be light, dark, intense, dull, reddish, *and* greenish—which indicates that the color blue (or any other color, for that matter) is tough to pin down. Relatedly, consider the playful, yet sensitive way in which the British writer Rudyard Kipling (whose father was the director of an art school in India) uses color in his "Just-So Stories" for children. Kipling describes a leopard, for example, as the ". . . sandiest-yellowist-brownist of them all—a greyish-yellowish catty-shaped kind of beast. . . ."[1] Words lend themselves naturally to creating definitions; the elements of visual communication do not. Ultimately, the art of color eludes explanation— which does not mean that we should forsake attempting to come to terms with its mysterious ways, but only that we do well to maintain a healthy respect for its elusive nature.

As we turn our attention to the specifics of color theory, keep in mind that one cannot hope for a more lasting or moving experience involv-

ing the visual arts than the experience that does not depend on words or theories. The most moving viewing experiences are not so much thought about while they are occurring as they are *felt*. By making us more aware of the sensual world that surrounds us, knowledge guides us toward the realm of wonder.

Hue

Artists use color in diverse ways. Its artistic functions include: 1) identifying an object or subject, 2) organizing a composition, 3) creating the illusion of space, 4) symbolizing learned, cultural conventions and associations, 5) creating mood, and 6) reflecting an emotion. A color's hue contributes to the achievement of each of these functions.

Hues are the common names by which we identify colors; yellow, blue, green, and blue-green are hues. Hues or colors play an important role in enabling us to identify the substances that comprise our world. We visually distinguish limes from lemons solely on the basis of color. The seventeenth-century sculptor Gianlorenzo Bernini alluded to the importance of color as an identifying agent when he described the portraitist's challenge of achieving a human likeness in the medium of marble. "If a man whitened his hair, beard, eyebrows, and—were it possible—his eyeballs and lips," Bernini reportedly stated, "and presented himself in this state to those very persons that see him everyday, he would hardly be recognized by

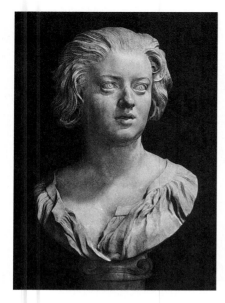

126
Gianlorenzo Bernini. *Costanza Buonarelli.* 1636–1639. **Marble, life-size.** Muzeo Nazionale, Florence.

them. . . .Hence you can understand how difficult it is to make a portrait, which is all of one color, resemble the sitter."[2] An important aspect of most successful works of art is their capacity to persuade an audience to temporarily suspend its disbelief, to read an unlimited range of hues, for example, into the whiteness of marble. Works such as Bernini's *Costanza Buonarelli* **[126]** have conditioned us to suspend our disbelief where art is concerned, to temporarily embrace, for example, the notion that white marble is not necessarily white and certainly not marble but, rather, colored clothing, flesh, or hair. Consider Bernini's proposition, however, as it pertains to everyday life, not to art. How unnerving it would be to see your best friend if he or she was somehow transformed into all white—or any other single color for that matter. The importance of hue regarding visual identification cannot be overemphasized.

Every color or hue has a different wavelength of light. Our experience of color is a result of the way light waves of differing wavelengths, vibrating at different speeds, affect our vision. This principle was discovered by Sir Isaac Newton when he projected a beam of sunlight through a glass prism **[127]**. The shortest wavelengths of light are refracted, or bent, the most, and the longest wavelengths are refracted the least. The subsequent dispersal of the light conforms to the systematic arrangement of colors we see in a rainbow. Red contains the longest wavelengths and violet contains the shortest. Newton also discovered that by reversing his initial experiment, that is, by projecting the dispersed colors through another prism, the colors were transformed back into sunlight, therefore establishing the fact that color is basically white light, and that when all the colored lights are mixed together they create white.

Unlike colored light, when all the pigmented colors (the substances from which artists' colors are derived) are mixed together they do not create white; they create dark gray or black. With pigments, the color we see is determined by the partial absorption of white light. In the case of a yellow banana, all the light rays except those from the wavelength that create yellow are absorbed by the surface. Therefore only the yellow rays are reflected, which causes us to see the banana as yellow.

In *pigment,* the three **primary colors** are red, yellow, and blue. Primary colors cannot be created by mixing other colors together. All other pigment colors are derived from mixtures of these colors. On the other hand, in terms of *light,* the three primary colors are red, blue, and green. Compare a chart displaying the

127
Beam of sunlight projected through a glass prism.

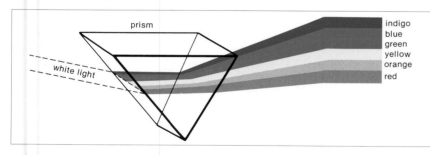

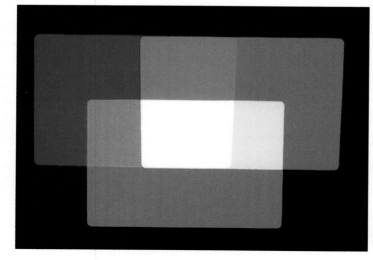

128
The additive principle in light.

primary colors mixed in light [128] with a color wheel displaying the primary colors mixed in pigment [129]. (The color wheel is formed by curving the spectrum of colors derived from white light in the order that they emerge from a glass prism, joining the uppermost color, violet, to the lowest color of the spectrum, red.) When the primary colors of *light*, green and red, are mixed together, they create yellow; red and green *pigments* mixed together make a gray color. Those who work with stage lights in the theatre must understand the principles of colored light. Most artists need concern themselves primarily with pigmented light. When we refer to color in this book, we are referring to colors derived from mixtures of pigment rather than mixtures of light.

129
Traditional color wheel.

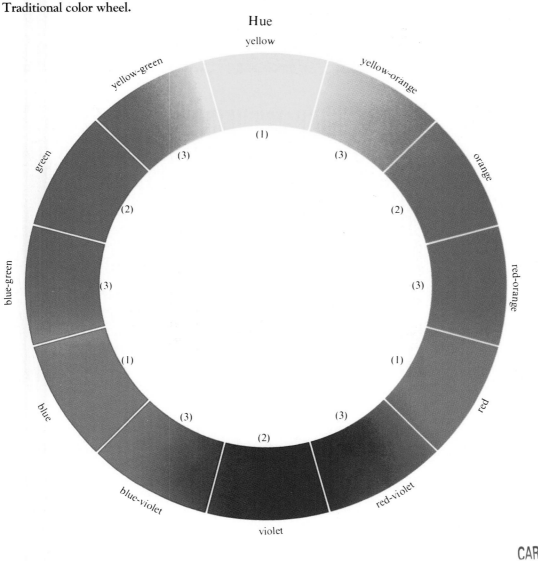

130

Navajo Woman's Chief Blanket, First Phase. 1800–1860. Handspun native wool, warp 43" (1.09 m), weft 58" (1.47 m). Transparency Number K12998, Courtesy Department of Library Services, American Museum of Natural History.

131

Navajo "Eyedazzler" Blanket. 1885–1895. Handspun native wool, warp 51" (1.30 m), weft 74" (1.88 m). Collection of Anthony Berlant, Santa Monica, California.

The **secondary colors** of the color wheel are produced by combining any two primary colors: red and yellow make orange, blue and yellow make green, and blue and red make violet. **Tertiary colors** are produced by combining a secondary color with an adjacent primary color. Yellow and green make yellow-green, blue and green make blue-green, blue and violet make blue-violet, and so on.

Hues that are located near each other on the color wheel (such as yellow, yellow-orange, and orange), and that share a common color (in this case,

yellow) are called **analogous colors,** while hues that are located directly across from one another (such as yellow and violet, red and green, and blue and orange) are called **complementary colors.** Analogous colors usually create a peaceful effect, such as we see in the predominantly yellow, yellow-orange, orange-red palette that prevails in Monet's *Grainstack (Sunset)* [15] or in the more subdued colors of *Navajo Woman's Chief Blanket* [130]. Complementary colors are usually more disruptive or antagonistic by nature; the contrast of red and green is responsible for the explosive presence

of another style of Navajo blanket, commonly referred to as the "eyedazzler" style. The unopposed horizontal lines of *Woman's Chief Blanket* certainly contribute to the soothing character of the blanket, just as the row of radiating diamond shapes overlapping, and set in opposition to, the series of verticals in the *Eyedazzler* blanket [131] contributes to the visual liveliness of this weaving. In each case, however, it is the choice of colors and how they interact that most significantly determines whether we experience tranquility or agitation when we view these works.

132
Vincent van Gogh. *Crows over a Wheatfield*. 1890. Oil on canvas, 20 x 39½" (.51 x 1m). Vincent van Gogh Foundation, National Museum Vincent van Gogh, Amsterdam.

WARM AND COOL COLORS

Colors are often classified in terms of temperature: reds, oranges, and yellows are generally described as **warm colors,** while greens, blues, and violets are described as **cool colors.** Of course, if we simultaneously touch a blue shape and a red shape within a given painting we will not physically feel a thermal difference between the two areas. Nonetheless, we are likely to respond differently to warm and cool colors—especially when one is set in opposition to another as often occurs in visual works of art.

Complementary colors always involve one cool and one warm color. Pronounced color contrasts often signal an artist's desire to convey a mood of emotional disturbance. Such is the case in the Dutch **Post-Impressionist** painter Vincent van Gogh's *Crows over a Wheatfield* [132], which was painted a few days before the artist fatally shot himself. By juxtaposing warm and cool colors, van Gogh exploited the visual jolt that naturally accompanies the direct convergence of two unmixed hues from opposite sides of the color wheel. About 100 years before van Gogh completed this painting the English connoisseur Sir George Beaumont

pronounced, "A good picture, like a good fiddle, should be brown."[3] The intervening 100 years may not have appreciably colored the art of fiddle making, but as *Crows over a Wheatfield* demonstrates, color played a crucial role in transforming the art of picture making.

In *Crows over a Wheatfield* the unrelenting urgency and passion of the thickly built-up, or **impastoed**, paint application, and the intensity of the colors in the areas above and below the horizon line is consistent and serves to unify the image. Otherwise, a sense of visual conflict prevails. The black zigzag lines that read as crows (and have been described by some critics as birds of death) seem to have been unleashed from the frenzied weave of marks scattered across the painting. But perhaps of more immediate import, because it dominates the image, is the almost violent slap of warm color against cool. The long, uninterrupted expanse of the cool blue of the sky contrasts dramatically with the warm golden color of the wheatfield that sweeps across the bottom half of the painting like a turbulent sea. Cool, grassy borders surround warm, reddish pathways which streak inconclusively into and across this field of yellow, further

Post-Impressionism refers more to a time period (roughly between the 1880s and 1906) than to a specific movement of art. Post-Impressionists such as Vincent van Gogh, Paul Gauguin, Paul Cézanne, and Georges Seurat were active just after the heyday of Impressionism and just before the development of the movements of Fauvism and Cubism.

133
Georges Seurat. *Sunday Afternoon on the Island of La Grande Jatte.* 1884–1886. Oil on canvas, 6'9¾"x10'1¼"4"
(207.6 x 308 cm). Helen Birch Bartlett Memorial Collection, 1926.224. ©1990 The Art Institute of Chicago. All Rights
Reserved.

upsetting the sense of tranquility and order of this landscape.

Warm and cool color contrasts do not always create feelings of emotional disturbance. As is displayed in the Post-Impressionist painter Georges Seurat's *Sunday Afternoon on the Island of La Grande Jatte* **[133]**, warm and cool color contrasts are fully capable of creating works of art characterized by serenity and balance. By applying dots of warm colors directly against dots of cool colors, Seurat effectively tempered the intensity and antagonism of his colors, while he successfully created the impression of shimmering sunlight pervading an outdoor setting. If you stand within a foot or two of this painting, the complementary and warm/cool color contrasts are likely to strike you as particularly vibrant and unsettling. In some areas, for example, intense blue dots of colored pigment

pulsate sharply against dots of intense red pigment. When you step back, however, these same blue and red colored dots appear to merge (a process known as optical coloration), producing softer, more subtle shades of violet. Seurat's technique of applying small dots of color directly to the canvas to create differing (optical) color mixtures, as opposed to mixing colors on a palette and then transferring those mixtures onto the canvas, came to be known as Pointillism.

HUE AND CULTURAL CONVENTIONS

Works of art communicate learned, as well as experiential associations. Every culture develops its own system of color associations. Most people in the United States, for example, associate mourning with the color black; in Japan, the color of mourning is white.

A myth told by Native American Anishinable people describes how the first human being started life on earth by taking four breaths of air. These four breaths were the four winds that created the four directions. "The north wind," the myth specifies, "is the color of white and gives men wisdom. The south wind is the color of green and brings life energy and a strong heart. The west wind is the color of black and brings the power of the thundergods. The east wind is the color of gold and gives a man the vision of morning eagles soaring over the woodland and prairie."[4]

Relatedly, in many cultures an artist's choice of hue is determined by convention, not by an idiosyncratic, spontaneous emotion. In some societies, the choice and placement of colors incorporated into an image or object often conform to time-honored

conventions in which a given color may designate such diverse characteristics as direction, season, or spiritual power. In *The Mythic Image*, Joseph Campbell, a scholar of comparative mythology and religion, states that in the Chinese cosmological view, each of the five elements—wood, fire, metal, water, and earth—is represented by a different hue, which also relates to a particular compass direction and season. Green, he explains, stands for the element of wood, the compass direction East, and the season spring; red relates to fire, the South, and summer; white relates to metal, the West, and autumn; black relates to water, the North, and winter; earth, the center, is yellow.[5] In Nigeria, many Yoruba associate red with spiritual radiance or *ashe*, which translates as spiritual command or what the African art historian Robert Farris Thompson describes as "the power-to-make-things-happen."[6]

VALUE

Value refers to the lightness or darkness of a color. Light colors are located high on the value scale [134] and are often called tints; darker colors, which correspond to the lower range of the value scale, are called shades. In order to demonstrate that any color, including white, black, and gray, is inevitably affected by its surrounding color(s), our value scale includes a gray circle located within the center of each gray square. In this scale, the lighter tones contain more white in the mixture, while the darker ones contain a greater percentage of black. Notice that although each of these circles is exactly the same middle tone of gray, each circle appears lighter or darker depending on the value of the square surrounding it.

Before the introduction in the 1850s of synthetic aniline dyes (a colorless, oily liquid derived from benzene) that enabled Navaho women to create the kinds of blankets discussed earlier, weavers relied heavily on the natural wool colors white and brown such as we see in a Ute-style First Phase *Chief Blanket* [135]. This blanket is divided into different values of brown ranging from light, cream-colored tints to dark,

134
Gray scale.

white

high light

light

low light

middle

high dark

dark

low dark

black

135
Navajo Chief Blanket, First Phase, Ute style. 1800–1860. Handspun native wool, warp 59½" (1.51 m), weft 77" (1.96 m). Collection of Anthony Berlant, Santa Monica, California.

136
Artemisia Gentileschi. *Judith Beheading Holofernes.* c.1630. Oil on canvas, 78¼ x 64" **(1.99 x 1.62 m).** Uffizi, Florence.

137
Film still from *The Wizard of Oz,* directed by Victor Fleming. ©1939 Loew's Inc. Renewed 1966 Metro-Goldwyn-Mayer Inc.

umber shades. While the weaver of this blanket did employ stripes of dark blue (indigo), which introduce a subtle breadth of hue, the design of this blanket derives its strength largely from the striking contrast of values.

Similarly, in *Judith Beheading Holofernes* [136], created by Artemesia Gentileschi, the seventeenth century Italian painter, the colors employed are kept to a minimum. Compensating for the limited range of hues is the painting's wide tonal or value range. Consistent with the shocking violence and drama of her subject (an Old Testament story), Gentileschi assaults us with values that leap wildly from screeching lights to deep, thunderous darks.

INTENSITY

"Toto, I've got a feeling we're not in Kansas anymore!" These are the first words Dorothy, the main character of the film classic *The Wizard of Oz,* utters after the violence of a tornado sets her house down in the strange and exotic land of Oz. What makes Oz appear so strange—even before the appearance of witches and Munchkins, and other peculiar creatures—is color, or more precisely, the abundance of color intensities that fill the landscape. The everyday reality of Kansas is filmed in black and white; the fairy-tale land of Oz is portrayed in colors that are notable particularly by virtue of their intensity [137].

Intensity, sometimes called chroma or saturation, refers to the relative brightness or dullness of a color. A color is said to be at its purest and most vivid when it is undiluted through mixture with black, white, or any other color. The division of red that is marked #1 on the color wheel [129] enjoys a higher degree of intensity, or saturation, than do any of the other divisions of reddish color (red-violet, violet, red-orange, or orange). When blue, for example, is

138
Stuart Davis. *Report from Rockport.*
1940. Oil on canvas,
24 x 30" (61 x 76 cm). Edith A. &
Milton Lowenthal Collection, New
York.

Edward Hopper, whose scenes of
American life painted during approxi-
mately the same time period reflect a
palette governed by less intense colors,
communicated in a far more contem-
plative visual dialect.

The literal subject of *Report from
Rockport* by Stuart Davis **[138]** and
Gas by Edward Hopper **[139]** is
similar inasmuch as each image
incorporates a gas station within a
landscape. Significant differences
between the images are, however,
immediately apparent. In Davis's
painting, mostly undiluted colors
(colors of high intensity) fill a hectic
system of irregular, hard-edged shapes.
One can almost hear the color screech
across the surface of the canvas.
Compared to *Report from Rockport,*
Hopper's painting is calm and quiet.
Only the red and white gas pumps and
the sign are painted with high
intensity colors; the major portion of
Hopper's painting is dominated by low
intensity (toned down) colors. The
yellowish gray or tan color of the
cement surrounding the gas pumps is
very light in color—high in *value,* but
it has been greatly diluted with white,
which makes it low in *intensity.* Even
the yellow beams of artificial light
escaping from the windows and door
of the gashouse display clear signs of
having been diluted with white, as
compared to the the purer cadmium-
yellow ground plane of Davis's
painting, which exhibits the raw
intensity of a bright primary hue as it
comes straight from the tube.

139
Edward Hopper. *Gas.* 1940. Oil on canvas, 26¼ x 40¼" (.67 x 1.02 m).
Collection, The Museum of Modern Art, New York. Mrs. Simon Guggenheim
Fund.

mixed into red to create the color red-
violet or violet, the blue serves to
reduce the intensity of the pure color
red. The intensity of any color is most
effectively compromised, or dulled,
when it is mixed with its color
complement. Although we have seen
that placing complementary colors
directly next to each other creates a
vibrant combination, one of the most
common and effective methods of

toning down or graying a color is to
mix its complement into it.

Great artists inevitably develop the
palette, or range of colors, that most
appropriately meets their expressive
needs. Saturated colors represent an
integral part of the upbeat, electric
images created by the twentieth-
century American painter Stuart
Davis. The more naturalistic painter

GREEN AND MAROON BY MARK ROTHKO

140
Mark Rothko. *Green and Maroon.*
1953. Oil on canvas, 91¼ x 54¾"
(2.32 x 1.39 m). The Phillips
Collection, Washington, D.C.

Before reading the following discussion of *Green and Maroon* **[140]** by
Mark Rothko, think about the work by answering these questions:

1. Would you describe Mark Rothko's *Green and Maroon* as an elusive
image? Explain. Do you personally welcome a quality of elusiveness in a
work of art or does this quality reduce your enjoyment?

2. Describe the difference between the terms "depict" and "evoke."
Would you describe Rothko as a depictive, or as an evocative painter?

3. The means by which Rothko communicates as a visual artist are decidedly spare. Cite some of the features that you might expect to find in a traditional painting that you do not see in *Green and Maroon*. What visual element does Rothko most rigorously depend on to express his ideas? Explain.

At the age of ten, the Russian-born Mark Rothko, emigrated with his family to the United States. He grew up in Oregon, but he lived most of his life in New York City, where he became associated with the Abstract Expressionists.

Rothko's paintings are difficult to write about because they are elusive—they resist definition. Although he often referred to the rectangular color fields in his paintings as "things," "figures," "characters," and "performers," Rothko did not literally depict or even describe anything—but he evoked a great deal. Viewed especially in calm, quiet surroundings, and, ideally, alongside other Rothko paintings, his images are capable of evoking, or calling forth, emotional states of the most exalted nature. To quote Dr. Richard Kalter, Philosopher-in-residence at The Maryland Institute, College of Art: "Rothko's paintings lead us into a deeper awareness of the transcendent—what the ancients called divine presence."[7] But, of course, nowhere in Rothko's paintings will we find images of winged angels, or the figure of God. Strictly speaking, depiction involves specification and isolation. When we depict something we say, in effect, "It is this and not that." If a painter *depicts* a landscape, you will see details such as trees, or mountains, or clouds. If a painter *evokes* a landscape, none of these details will be apparent, but something about the image will suggest trees, mountains, clouds, or maybe simply a sense of outdoor space or place. Sometimes depiction will suggest more than what it specifically describes, which is when depiction approaches evocation. Evocation opens experience up to ever greater and more resonant possibilities of meaning. Rothko's spare, abstract canvases *evoke* particular feelings and conditions without *depicting* anything at all.

Every great artist must take a position regarding his or her particular vision of the world, a position and vision that necessarily exist within a particular historical moment. Reduction represents an essential and radical aspect of the position Rothko took as a painter. In Rothko's most mature work, such as *Green and Maroon*, there are no figurative references, essentially no drawing, volumetric modeling, or indication of significant gesture, almost no overlapping of one form by another, and no development of naturalistic textures. It is as if he took a massive paint rag and wiped out the visual details that constituted the outward appearance of art history.

But he left the color. In a seemingly endless number of variations involving two or three closely tuned colors stacked like tiers within a vertically oriented canvas, Rothko focused his sights on the element of color. Through color, Rothko created light, movement, atmosphere, and space.

The insistent frontality of the few shapes that form this spare composition might be expected to produce a wall-like flatness. Instead, the painting offers a remarkably captivating sense of depth. Green and maroon shapes

bleed into the blue ground. The overall color of the painting, as well as that of the individual shapes, hovers, like mist, somewhere in front, and then in back, of the surface of the canvas. Several key factors contribute to the evocation of space: the artist's procedure of soaking, scrubbing, and staining the paint into the canvas; the merging of one diluted film of paint into another; the interaction of semi-separate fields of green, maroon, and blue; Rothko's sensitivity to the blurred edges of the color fields as they parallel, fuse, and separate; and his sensitive manipulation of the edge of one of his islands of color as it delicately approaches the outer edge of the perimeter of the canvas itself. The spatial movement is soft, brooding, and seductive—like the color. Everything about the execution of this image reinforces these qualities, and serves to make visible the underlying subject of this image—the poignant connection between contemplation and emotion.

LIGHT

Before Sir Isaac Newton, it was not known that all paintings, flowers, and spider webs are black. No one understood that color was not an intrinsic part of any object, that all objects are either black or no-color, that color does not exist as a physical phenomenon separate from light.[8] Indeed, light makes it possible for us to see each of the visual elements that we discuss in this book. Without light we can feel texture and form, but we cannot *see* them. Light, an ever-changing part of our surroundings, determines what we see, think, and feel as it continuously recreates our world. My formal training in art school addressed this idea repeatedly. The following experience made it real:

A common spider web caught my attention one morning while I was walking through a field in Maine. The web was about the size of the out-stretched fingers of my two hands placed side by side. Its glimmering network of lines sent a pattern of shadows creeping through the grass below. With every movement of my head, dewdrops hanging from the web like so many glass prisms seemed to pluck a rainbow of colors out of the air. As rays of refracted sunlight transported me to a childlike state of appreciation for one of nature's many

wonders, a spider climbed onto the web. Captivated, I sat down beside it.

Later in the day, I described my find to a friend and convinced him to go back with me. But the sun's altered position and an overcast sky had turned a glistening architectural jewel back into a cobweb. Yet everything was just as I had left it—everything, that is, except the morning light.

VALUE INTO FORM: CHIAROSCURO

From the time of Giotto to the era of Renaissance giants such as Leonardo da Vinci and Michelangelo, pictorial expression involved a continual search for a more convincing means of achieving the illusion of three-dimensionality on a two-dimensional surface. The art historian H. W. Janson describes Giotto, the fourteenth-century Florentine master, as the individual who marks ". . . the start of what might be called the era of painting' in Western art."[9] Giotto broke radically with the flatness of **Byzantine** forms. Many conventions of Byzantine art can be detected in the work of one of the great masters of early Italian art, the thirteenth-century Sienese painter Duccio di Buoninsegna's *"Rucellai" Madonna* **[141]**. Areas in this painting, such as

Byzantine art took Christianity as its subject. The pictorial conventions of Byzantine art include the display of flat or shallow space, resplendent, decorative patterns, and simple, opaque (often gold) backgrounds.

141
Duccio de Buoninsegna. *"Rucellai" Madonna.* 1285.
Tempera on wood, 14'9" x 9'6" (4.5 x 2.9 m).
Uffizi, Florence.

142
Giotto di Bondone. *Madonna Enthroned.* c. 1310.
Tempera on wood, 10'8" x 6'8" (3.25 x 2.03 m).
Uffizi, Florence.

the modeling of the kneeling angels' bodies, clearly indicate Duccio's concern with three-dimensional form. However, when we compare the figures and architecture in Duccio's painting to a similar composition, *Madonna Enthroned* [142] by Giotto, we begin to appreciate the awesome distance of Giotto's leap into the third dimension. One of the principal means by which he achieved the illusion of three-dimensionality entailed lightening or darkening a color so that the forms created appeared to turn in space.

"The first requisite of painting," Leonardo da Vinci once stated, "is that the bodies that it represents

should appear in relief. . . ."[10] Building on the innovations of Giotto and Giotto's followers, Leonardo created the illusion of three-dimensionality to a degree of excellence that has never been eclipsed. The pictorial convention, adopted by **Renaissance** artists such as Leonardo da Vinci and Michelangelo, of modeling a form through gradual tonal modulations is known as **chiaroscuro.** This term is formed from the Italian words *chiaro,* meaning light, and *scuro,* meaning dark. Contrasts resulting from significant gradations of light and dark, such as we see in Michelangelo's *Descent from the Cross* [143], often create a dramatic impact.

The word **Renaissance** means rebirth, and refers to the revival of interest in the arts and sciences of classical antiquity during the fourteenth, fifteenth, and sixteenth centuries. The Renaissance developed in Italy before spreading throughout the rest of Europe. Renaissance artists attempted to penetrate the mysteries of the world by adopting methods of objective analysis. For example, in order to better understand the structure of the human body, Renaissance artists dissected cadavers. Relatedly, in their representational works of art, these artists attempted to portray the world as naturalistically as possible.

143
Michelangelo Buonarroti. *The Descent from the Cross.* c. 1555. Red chalk on discolored pale buff paper, 15 x 11" (38 x 28 cm). Ashmolean Museum, Oxford.

144
Leonardo da Vinci. *Study of Drapery for a Seated Figure.* Gray wash heightened with white on linen, 10⅞ x 9³⁄₁₆" (26.5 x 23.3 cm.) The Louvre, Paris.

Baroque art (seventeenth and early eighteenth century) is governed by exaggerated emotional expression, dramatic lighting effects, sweeping spatial thrusts, rich ornamentation, and, often, an overall sense of theatricality. Artists associated with Baroque art include Gianlorenzo Bernini, Michelangelo Merisi da Caravaggio, Peter Paul Rubens, and Rembrandt van Rijn.

In Leonardo da Vinci's *Study of Drapery for a Seated Figure* **[144]**, analytical examination becomes dramatic spectacle. The subject and title of this drawing suggest that it was executed as an aid in working out a visual problem presented by a more ambitious painting, but it stands as a powerful work of art in its own right. The organic, flowing folds of the fabric are fully realized. Seldom do we see forms that press down and wrap around with such authority. The cloth is lit by a single, clearly directed light source located outside the picture to the left, which allows Leonardo to model the form using *chiaroscuro*. Under this system of tonal modulation, areas that face the source of light most directly are most brightly lit, while forms that are turned away from the light are obscured by variously toned shades. Although we have to work harder to read the details in the shadows, the information apparent in these passages is a reflection of Leonardo's ability to give voice to darkness as well as light.

Drapery also plays an important role in *The Ecstacy of St. Teresa* **[145]**, the sculptural centerpiece of the *Cornaro Chapel* **[146]** in the church of Sta. Maria della Vittoria in Rome. The creator of this masterpiece of Italian **Baroque** art is the most important sculptor-architect of the seventeenth century, Gianlorenzo Bernini. The drapery of the swooning saint and the smiling angel help tell the story of a vision experienced by one of the great mystical saints of the Counter-

145
Gianlorenzo Bernini. *The Ecstasy of St. Teresa.* 1645–1652. Marble, life-size. Cornaro Chapel, Santa Maria della Vittoria, Rome.

146
Anonymous. *The Cornaro Chapel.* 18th century. Oil on canvas. Staatliches Museum, Schwerin.

Reformation, the sixteenth-century St. Teresa of Avila, Spain. In her autobiography, St. Teresa recounts in vivid detail that an angel appeared to her. In his hands the angel held a golden spear with a point of fire at the tip. "This he plunged into my heart several times," St. Teresa wrote, "so that it penetrated to my entrails. When he pulled it out, I felt he took them with it, and left me consumed by the great love of God."[11]

By sensitively manipulating light, Bernini modeled into solid three-dimensional form the incorporeal ecstasy of a spiritual vision. The stirring folds of St. Teresa's robe are heavy and angular, which serve to weigh her down visually. The cloud on which she swoons, on the other hand, seems to float weightlessly in air. In contrast to the massive folds of the saint's robe, the curvilinear folds of the more calmly posed angel's robe appear buoyant, like the form of the cloud freely suspended within its columned architectural setting. This steady give and take between levitation and weightness creates a pulsating sense of spiritual ecstasy mixed with sensual arousal.

Because of the sculpture's positioning beneath a window that is hidden from view by a canopy located just above

147
Joseph Mallord William Turner.
Slave Ship (Slavers Throwing Overboard the Dead and Dying, Typhoon Coming On). 1840.
**Oil on canvas, 35¾ x 48¼"
(90.8 x 122.6 cm).** Henry Lillie Pierce Fund. Courtesy, Museum of Fine Arts, Boston.

St. Teresa and the angel, light both describes and is itself described. Directed onto the figures as if from heaven above, light convincingly transforms the marble of the sculpture into what appears to be, in turn, cloud forms, fabric, flesh, and even the feathers of the angel's wings. Bernini's virtuosity even leads him to translate into three-dimensional form the ethereal quality of light itself by presenting a series of parallel golden rods which pour down from the canopy. Gold, traditionally regarded as light materialized into the color of divinity, functions here as the physical embodiment of divine light directed downward from an image of Heaven painted on the vault of the chapel. Like many of our modern-day directors of movies and plays, Bernini, a master storyteller, was a master of special

effects. Ambitiously merging marble, metal, paint, the illusion of light, and actual light, Bernini created a work of art that in one spectacular embrace merges the disciplines of sculpture, painting, architecture, and theater.

FORM INTO LIGHT

At the end of the nineteenth century, some artists began experimenting with the idea of reversing the practice of manipulating light to emphasize the three-dimensional impression of volumes in illusionistic or actual space. The innovative explorations concerning light and color interaction that we see in many of the works of the nineteenth-century English **Romantic** landscape painter Joseph Mallord William Turner transform solid, three-

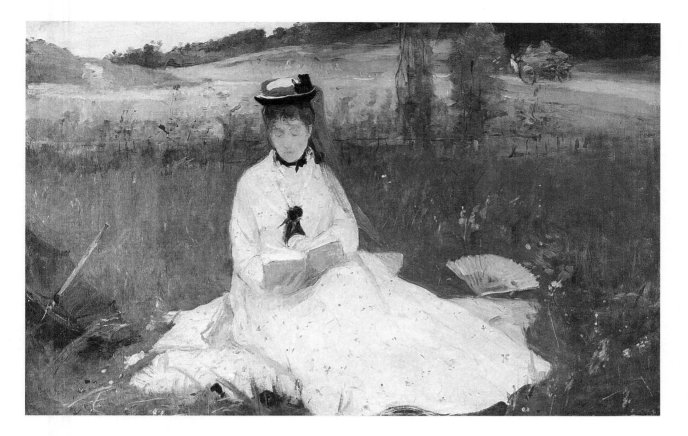

148

Berthe Morisot. *The Artist's Sister Mme. Pontillon, Seated on the Grass.* 1873. Oil on canvas,
17¾ x 28½" (45 x 72.4 cm). The Cleveland Museum of Art, Gift of the Hanna Fund.

dimensional volumes into the more elusive elements of color and light. Turner's *Slavers Throwing Overboard the Dead and Dying; Typhoon Coming On* (more commonly known as *Slave Ship*) **[147]** is an example of this practice. Turner's contemporary, English Romantic landscape painter John Constable, once criticized Turner for his "airy visions painted with tinted steam."[12] Although he meant it as a criticism, today this comment seems more accurate and appreciative than critical. The power of Turner's canvases lay not in their ability to describe solid forms but in their ability to give tangible form to intangible phenomena such as luminosity.

Unlike the many charged subjects and emotions that Turner chose to portray, the landscapes and other subjects of French Impressionist artists such as

Claude Monet, Auguste Renoir, and Berthe Morisot were often (although not always) of a decidedly unexceptional nature. The volumes in their paintings were often described in a cursory or general manner, while the quality of the light was almost always very specific. Compare the handling of the drapery in Leonardo's *Study of Drapery for a Seated Figure* or Bernini's *The Ecstacy of St. Teresa* to the way Morisot handled the woman's dress in *The Artist's Sister, Madame Pontillon, Seated on the Grass* **[148]**. In contrast to the focus of Leonardo's and Bernini's attention, it is not the volumetric quality of the drapery, or the form of the figure beneath the drapery that concerned Morisot. Rather, her attention was directed to the subject of daylight and the way the daylight atmosphere dissolved the forms with which it came in contact.

Romanticism refers to a style of art that is not easily defined because it takes many forms. Lasting roughly from the mid-1700s through the mid-1800s, Romantic painting is characterized by exotic or picturesque subject matter; settings reflecting untamed nature; exaggerated, passionate emotions; and rebellious, often heroic, sometimes violent rejection of authority and oppression. Important Romantic artists include Théodore Gericault and Eugéne Delacroix from France, and George Stubbs, William Blake, John Constable, and William Turner from England. American Hudson River School painters such as Thomas Cole represent a branch of Romantic painting.

LE PROMENADE BY AUGUSTE RENOIR

149
Auguste Renoir. *Le Promenade.*
c. 1870. Oil on canvas, 32 x 25¼"
(81.3 x 65 cm). The J. Paul Getty
Museum.

Before reading the following discussion of *Le Promenade* **[149]** by Auguste
Renoir, think about the work by answering these questions:

1. How would you characterize the mood of this painting? How would
you characterize the individuals Renoir portrays? How would you
characterize the quality of the light of this Impressionist painting?

2. Would you say that this painting is static or active? How does the
artist's handling of the light affect your response to this question?

3. Compare Leonardo da Vinci's handling of drapery in *Study of Drapery
for a Seated Figure* and that of Gianlorenzo Bernini's in *The Ecstacy of St.
Teresa* to that of Renoir's in *Le Promenade* **[150]**. Would you say that
Renoir's handling of light enhances the three-dimensionality of the folds
and overall forms of the drapery he describes, or dissolves them? Do you
think that the answer to this last question has any bearing on how static or
active the painting appears to be? Explain.

4. Do you think the lighting contributes in any way to the quality of the
gestures of the man and woman? What do you think the figures
communicate by the way in which their bodies are positioned?

150
Auguste Renoir.
Detail of *Le Promenade*.

5. The color green pervades this image. How does Renoir prevent the painting from becoming monotonous coloristically? In answering this question, consider the roles of hue, value, and intensity.

A delicate encounter is brought to light. Perched amidst the leaves and branches of the trees, we look at a young couple preparing for a discreet interlude in the French countryside. Leaning dynamically into the space of the painting, the young man's face and torso blend with the deep shadows of the foliage beyond. His left hand points toward the bushes and trees, while the fingers of his right hand tug the delicately poised fingers of his companion.

The young man is ready to go; the young lady is not. Her back is straight and her head is averted shyly from both her escort and the path down which he wants to lead her. Her bright white dress stands out sharply from her surroundings, suggesting resistance to the situation. She needs a little coaxing—but only a little. Already her undecorated dress accepts an arrangement of dark leaves on the skirt—an inventive and gentle way to represent compatibility with the place. Renoir also enlivens her wardrobe with folding lines of light. Sunshine embroiders everything in this painting, lending the scene a sensation of flickering motion. The outside edge of almost every shape is softened by the pieces of sunlight sneaking through the trees, and the interior mass of the volumes are just as fragmented.

One apparent cause of this disturbance is the artist's brushstroke, which functions as a direct translation of the sunlight. The brushstroke directs our eyes through the space and almost dictates how long we remain engaged with any one area. The man's gesturing left hand is nothing but a stab of juicy pigment. Its counterpart, the dangling right hand of the woman, includes lines to indicate fingers and even a little modeling. Together, the two hands describe the spatial stretch of the painting.

Perhaps feeling it would slow down the action, and in keeping with the tenets of Impressionism, Renoir does not especially concern himself with round form. Occasional details, such as the folds in the man's trousers [150], are sufficient to allow the volumes a general sense of three-dimensionality. But basically, sculptural weightiness and bulk are replaced by atmosphere and movement. Look again at the man's trousers. What happens between the waist and knees is designed to break up the form rather than build it. The pattern of lights and darks Renoir introduces here is absorbed into the bushy setting. The energy and excitement generated in the landscape pulses right through the man's groin, contributing strongly to the emotional tone of the scene.

The placement of the figures along a sharp diagonal that extends virtually from the lower left to the top right-hand corner of the canvas, and is reinforced by the paralleling angle formed by the joined hands of the couple, contributes greatly to the fluid sense of movement that permeates this image. Cover the figure of the man with your hand and what remains is a lovely, full-length portrait of a lady, thoughtful and still. The shadowed foliage behind her is relatively unbroken, allowing our eyes a steady, restful moment. Now cover the figure of the female and look at the difference. All is light and motion. The sun pours through the trees, further energizing the already highly charged male. In keeping with the Impressionist tendency to break up form into patches of different colors, Renoir weaves cool violets and warm ochres within the ground plane, creating a luminous sensation that could not have been achieved by merely modulating the tones of a single color. The area beneath the man's feet is active, resembling more a rushing stream than a wooded path. Sun draws the carefree young couple into a glorious green grove. The more deeply the space is penetrated, the more intensely the sun shines.

CRITICAL QUESTIONS

1a. Russian-born Marc Chagall was commissioned by the synagogue of the Hadassah-Hebrew University Medical Center to design twelve windows. Each window represents one of the twelve tribes of Israel (named after the twelve sons of the Jewish prophet Jacob). The windows correspond to themes such as war, power, and happiness. Light and color, which are inseparable in the medium of stained glass, serve as the means through which the stories of the tribes are told. The *Issachar Window* [151], named after Jacob's fifth-eldest son who settled in a fertile valley, has been described as "the very expression of spring and of paradisical joy."[13] Do you

151
Marc Chagall. *Issachar Window.*
1959–1961. Stained glass,
133 x 98¾" (3.38 x 2.51 m).
The Issachar Window, one of the
windows of the twelve tribes of Israel,
was created by Marc Chagall for the
Synagogue at the Hadassah-Hebrew
University Medical Center, Jerusalem,
Israel. These windows are owned by
Hadassah Medical Relief Association,
Inc. ©Hadassah Medical Relief
Association, Inc.

think the colors of the window
contribute to this interpretation?
Explain.

b. What is the dominant hue
employed in this window? Do you
think the artist successfully varied this
dominant hue, or that, by
disproportionately emphasizing one
color over all the other colors, this
image becomes coloristically
monotonous?

c. Throughout the *Issachar
Window* Chagall employed analogous

colors and, to a lesser extent,
complementary colors. What do these
terms mean? What effect does his use
of analogous colors have on your
emotional response to this image?
How does the artist use color to draw
our attention to the Hebrew
inscription apparent within the
triangle of light located near the top of
the window?

d. Point to several examples of
varying degrees of color value and
color intensity in the *Issachar Window*.

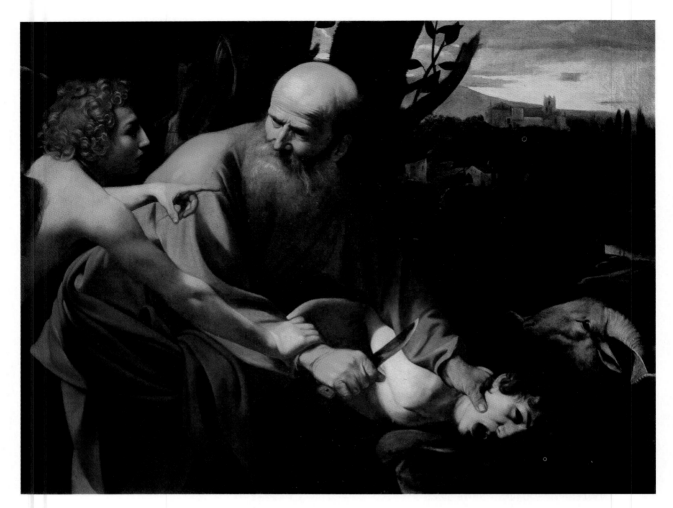

152
Michelangelo Merisi da Caravaggio.
Sacrifice of Isaac. **c. 1600. Oil on
canvas.** Uffizi, Florence.

2a. Do you think the Italian
Baroque painter Michelangelo Merisi
da Caravaggio's the *Sacrifice of Isaac*
[152] is a good example of *chiaroscuro?*
Explain.

b. In this painting, light is used
not only as a means of describing the
three-dimensionality of the forms, but
also as a way of distinguishing one
texture from another. What are some
of the textures that are revealed
through the way light reflects, and is
absorbed by, the various surfaces that
comprise the subject of this painting?

c. In the Old Testament (Genesis
13:10–13) God tests Abraham's faith
and obedience by commanding
Abraham to sacrifice his son.
Caravaggio portrays the moment in
this biblical story when an angel
appears just in time to stop the

sacrifice and to substitute a ram for the
boy. In what ways does Caravaggio
employ light to enhance the drama of
this story?

d. The knife Abraham clutches is
positioned along the same vertical axis
and mimics the short curve of the
silhouetted dead branch up above.
What connection do you think
Caravaggio might have wanted us to
make between the branch and the
knife? Along with placement and
repetition, Caravaggio employed the
drama of light and dark to emphasize
the importance of the knife as a
narrative detail. Explain.

e. Regarding emphasis, note that
Caravaggio intensifies the light that
strikes Isaac's shoulder and upper arm.
Keep in mind that the source of light
originates somewhere outside the

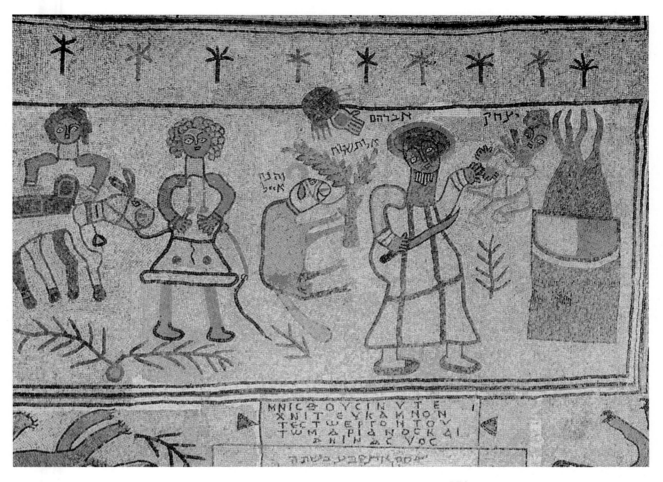

153
Marianos and Hanina. *The Sacrifice of Isaac*. Early 6th century. Detail, floor mosaic. Beth Alpha Synagogue, Israel.

picture behind and above the angel's head (presumably from the direction just traveled by the angel). Since, generally speaking, the closer a form is to the source of light, the brighter that form will appear, we might reasonably expect the angel's shoulder and upper back to be more brightly illuminated than the body of Isaac. This is not the case. Why do you think Caravaggio might have chosen to take this liberty with the logic of light?

f. Follow the diagonal path that stretches from the angel's shoulder to Isaac's grimacing face. Do you feel that the tonal modulations that occur along this organizational line contribute to the drama of this image? With your hands, block out everything in the painting except this diagonal. This powerful diagonal thrust slices through the heart of the

composition, signaling the focus of the action. Caravaggio certainly did not hurry his handling of the forms that build this area. Beginning with the angel's shoulder, and continuing down to Isaac's face, describe the play of light as it moves downward along this path.

g. Many artists throughout history have portrayed this important biblical story. An ancient example is *The Sacrifice of Isaac* [153], one of the three main sections of the sixth-century floor mosaic located in the Beth Alpha Synagogue in Israel. Cite several differences involving the use of light, color, and form between Caravaggio's interpretation of the sacrifice of Isaac and the interpretation presented in the sixth-century floor mosaic.

PART three

Principles
of
Visual
Expression

6

Structure

There is significant overlap between visual elements (such as line, texture, and color) and visual principles (such as structure, space, and rhythm). It is difficult to address, for example, the element of volumetric form without taking into account the principle of space because every volumetric form occupies a certain amount of space. Not surprisingly, there are differing opinions regarding whether a concept such as space ought to be categorized as an element or a principle. Perhaps the simplest and most concise distinction between the elements and principles of visual expression (at least as presented in this book) is that the elements are the components of the principles. We begin this section of the book with an examination of the principle of structure because structure is, in effect, the umbrella under which all the other visual elements and principles exist.

The **structure** of a work of art refers to the way the components of visual expression merge to create an organized whole. It may be orderly and immediately apparent, or it may be difficult to discern, but every work of art has a structure.

A good way to understand the idea of structure in art is to consider for a moment this question: "What makes a work of art different from the world it represents?" Let us take photography as an example.

Many people believe that photography is an accurate recorder of the visible world. But is it? Photography adapts three-dimensional space to a two-dimensional surface; it transforms an infinite range of textures into a limited range of tones; it can emphasize, diminish, or eliminate; it can make perceivable the imperceptible. But

154
Leonardo da Vinci. *Study of Human Proportions According to Vitruvius.* c. 1485–1490. Pen and ink, 13½ x 9¾" (34 x 25 cm). Galleria dell' Accademia, Venice.

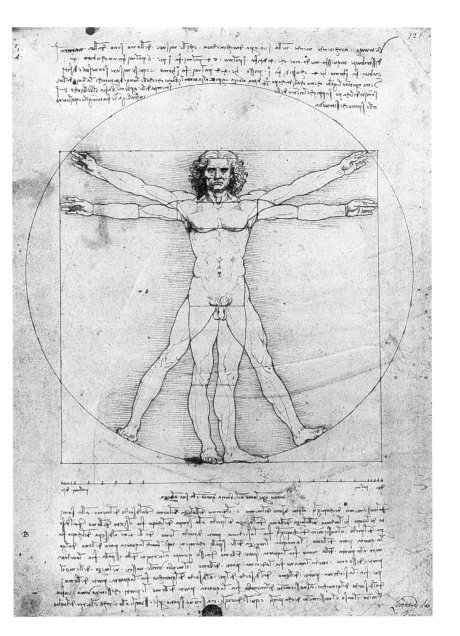

most importantly, a photographic work of art, like any work of art, has a visibly organized structure. This last point serves as the basis for the present chapter.

There is no container for all the things going on in the world; each individual must make sense of a realm of endless possibilities. Van Gogh once referred to the chaotic state of life as "a sketch that didn't come off."[1] But this metaphor ignores the fact that even the most hurried sketch exists within a physical confine, which provides the artist with at least some degree of order or definition. Visual art takes place within a rectangle, a block of marble, a designated period of time, or some other limiting parameter. Photographers use the viewfinders of their cameras to isolate and frame a piece of the world. They include only what contributes to the expression of an idea. Likewise, the figure sculptor does not carve every wrinkle in the body or every strand of hair on the head. An artist makes choices, selecting and arranging. As viewers, we recreate the artwork based on how we see and understand it, that is, based on how the structure of the work and its component parts affect us.

UNITY

The structure an artist provides is intended to guide a viewer through a work of art. When the visual components within the work are well balanced, that is, when one part of the work is related to another part, with each part demonstrating a logic and integrity that informs the whole, we can say that the work is unified. How that **unity** or sense of visual equilibrium is achieved affects the viewer's response. Regardless of the subject matter depicted, the structure of a work can express emotional turmoil or tranquility, unpredictability or boredom, joy or sorrow.

SYMMETRY AND ASYMMETRY

A simple way of balancing or unifying a work of art is through **symmetry,** the mirrorlike repetition of the two halves of an image or object. The twentieth-century English art historian Kenneth Clark contends that symmetry is a distinctly human concept. Despite all our irregularities, he suggests, we are more or less symmetrical, so it is not surprising that a perfectly balanced musical phrase by Mozart, for example, should reflect our satisfaction with our two eyes, two arms, and two legs.[2] Leonardo da Vinci's drawing entitled *Study of Human Proportions According to Vitruvius* **[154]** diagrams basically the same idea in more pictorial terms.

155
Taj Mahal, Agra, India. 1630–1648.

Many architectural works of art display a virtually perfect degree of symmetry as far as their **façades**, or exterior viewpoints, are concerned. The *Taj Mahal* in India **[155]**, perhaps the most famous Islamic structure ever built, displays a clear example of symmetry. A sense of lightness, even bouyancy, seems to inform this magnificent building, a mausoleum which the Mughal emperor Shah Jahan had constructed in honor of his favorite wife. But this bouyancy is tempered by an overwhelming sense of formality and order, which is a direct result of the prevailing symmetrical structure. Notice how all of the architectural details visible on either

156
Carved ivory book cover showing celebration of the Mass. 9th–10th century. Fitzwilliam Museum, Cambridge.

157
Raphael. *The Colonna Altarpiece*. 1505. Tempera, oil and gold on wood, main panel 67⅞ x 67⅞" (1.72 x 1.72 m), lunette 28¾ x 66¼" (.73 x 1.68 m). Metropolitan Museum of Art, New York. The Alfred Stieglitz Collection.

158
Georgia O'Keeffe. *Cow's Skull: Red, White, and Blue.* 1931. Oil on canvas, 39⅞ x 35⅞" (1.01 x .91 m). The Metropolitan Museum of Art, New York. The Alfred Stieglitz Collection, 1949.

side of the huge, centralized white marble dome mirror one another. Even the walkways and rows of trees that border the long, narrow pool of water leading up to the entrance conform to the rule of symmetry that governs the plan of this building.

Many works of art that initially strike us as symmetrical reveal upon closer examination subtle variations that can be discerned on either side of an implied or actual centralized axis. Look closely at the ninth-to-tenth-century ivory book cover that depicts a celebration of the Mass [156]. How many details can you cite that temper the artist's insistence on maintaining a perfectly symmetrical structure for this carving? The Italian Renaissance artist Raphael (Raffaello Sanzio) structured *The Colonna Altarpiece* [157] along basically symmetrical lines. Here again, however, many details can be discerned that offset the perfect symmetry of the work. The twentieth-century American painter Georgia O'Keeffe's *Cow's Skull: Red, White, and Blue* [158] and the contemporary Scottish painter Jack Knox's *Kitchen* [159] represent more recent examples where minor details loosen up otherwise basically symmetrically structured works of art. The balance achieved in each of the four examples cited above is largely a result of the nearly identical repetition of the left- and right-hand sides of each of these compositions.

Dignity, stability, and tranquility often characterize symmetrical structures. But when handled insensitively,

159
Jack Knox. *Kitchen.* 1989. Oil on canvas, 54 x 44" (1.37 x 1.12 m). Courtesy the artist.

160
Seated Buddha from Gandhara, Pakistan. 2nd–3rd century. Dark gray schist, 36 x 22½" (91 x 57 cm). Seattle Art Museum, Eugene Fuller Memorial Collection, 33.180.

symmetry will readily produce boring and static results because of the sameness that governs the structure. On the other hand, an **asymmetrical** structure (the arrangement of dissimilar parts to achieve a balanced whole) is dynamic by nature. These differences keep one's eye (and mind) continuously on the move. A comparison of the third-century *Seated*

Buddha [160] and the twentieth-century American painter George McNeil's *Everyman #2* [161] demonstrates that the less symmetrical a work of art is, the more active it will appear. McNeil's comments on the act of creativity provide a parallel to the dynamic attitude inherent in the asymmetrical composition. "I think anxiety, " McNeil once stated, "has to be present in creativity because you're always going into new areas. If you get too much unity, you're going to be too self-satisfied, whereas when you have one force working to the right and the other working to the left, that keeps you in a state of creative tension. In resolving this antithesis you might come up with something intensely

161
**George McNeil. *Everyman #2*. 1984. Oil on canvas, 78 x 64"
(1.98 x 1.62 m).** Collection of Ruth and Jacob Kainen.

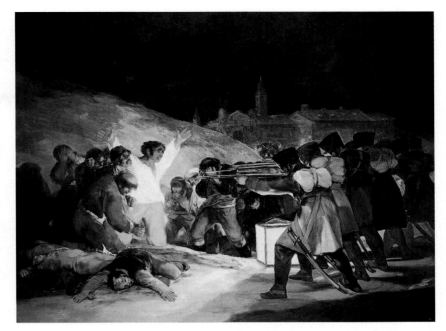

162
Francisco de Goya. *The Executions of the Third of May, 1808.* 1814–1815. Oil on canvas, 8'9" x 13'4" (2.67 x 4.06 m). Museo del Prado, Madrid.

new or immensely greater."[3] The artist needs these "creative tensions," yet must not be overcome by their disruptive potential. There is tension in every work of art, but this tension must be balanced to a certain degree. Perfect symmetry translates as perfect balance. Symmetry diminishes visual tension, asymmetry creates it.

APPROXIMATE SYMMETRY

Except in the case of approximate symmetry, a centralized axis is not generally apparent in asymmetrical structures. **Approximate symmetry** refers to a type of asymmetrical structure in which two clearly differentiated halves of a composition allude to a centralized axis, such as we see, for example, in *The Executions of the Third of May, 1808* **[162]** by Francisco de Goya. For now, we will focus our attention on the asymmetrical structure of the painting, but we will address this work anew in terms of Goya's use of space and rhythm in succeeding chapters. One function of re-examining a single work of art in numerous chapters is to demonstrate that although for educational purposes the organization of a book such as *Images, Objects, and Ideas* may distinguish line from color from space from rhythm, the fact remains that the visual components of a work of art overlap to such a degree that the seams between them often disappear. *The Executions of the Third of May, 1808* is at once a formal, political, and human statement that effortlessly bridges whatever categories the mind invents in order to better understand it.

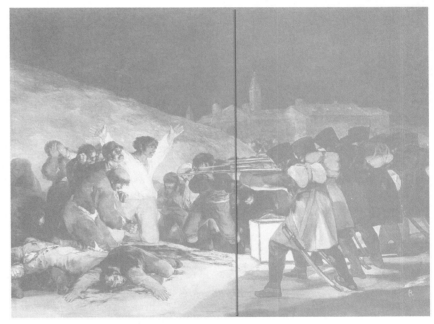

163
Implied vertical axis in Goya's *The Executions of the Third of May, 1808.*

In this painting, Goya neglected none of the pathetic fear, anger, or bloody detail that one might expect to see in such a situation. To depict an event as distasteful as a mass execution, and yet portray it with such intelligence that the viewer's own sense of order and balance is stroked and satisfied in spite of the violent subject matter, is indeed a most disturbing accomplishment. But Goya is a very disturbing artist.

He divided the canvas into two parts: defenseless Spanish peasants are on the left, anonymous French soldiers are on the right. Faceless uniformity aims directly into human flesh. So careful is Goya to restrict human characterization within the band of assailants that only one soldier's hand is visible, despite the number of men comprising the firing squad. Significantly, this outreaching hand does not

164

Louise Nevelson. *Case with Five Balusters.* 1959. Wood painted white, 28 x 63 x 8"
(71 x 160 x 20 cm). No longer extant.

offer the spirit of compassion—it supports the barrel of a gun. Notice that this hand is positioned along an implied vertical axis near the very center of the composition [163], designating, in effect, the point in front of, and behind which, the action dramatically changes.

Form and content merge as the two halves of the composition stand in direct opposition to one another. We anticipate with dread the inevitable burst of destruction when the full effect of the executioners' rifles explodes upon the doomed people of Madrid. The riflemen can hardly miss. It is a straight, uninterrupted path from victor to victim. But while the path (or implied line) of the shots fired is uninterrupted, the way the viewer is led across the scene is not. The executioners' muskets and bayonets point us straight toward the left where we collide into the brightly lit body of the kneeling man with the upraised arms. This figure epitomizes Goya's unconventional conception of light. Traditionally, visual artists have used light as an illuminating metaphor opposing evil, ignorance, or some other form of spiritual or emotional darkness. In *The Executions of the Third*

of May, 1808 the light from the lantern makes visible the darkness of human devastation.

Death and despair are everywhere. Before we meet the brightly lit man with the upraised arms, we pause briefly to notice the distraught man whose head is pictorially severed from his body by the bayoneted rifles that overlap him at the center of the composition. Cowering behind him to the left are two other Spaniards who can do nothing but wait their turn to be killed. On the left side of the canvas we move forward in a rapid descent from the outstretched right hand of the kneeling man, past the heads of the two men in front of him, to the lifeless body of their comrade below. Like the implied line of the rifle shots, this linear downfall ends in death. Close by, sprawled out beyond the edge of the canvas, are the slaughtered remains of still more Spaniards heaped on one another like trash.

But death, savage and unfeeling, is not the only subject. Life is affirmed and defeat is denied by the sheer strength and beauty of the picture's asymmetrical organization. The reader may find

it disturbing to analyze formally the structure of a painting that depicts helpless citizens before a firing squad, but Goya invites such analysis. It is his insistence on construction, even in the face of annihilation, that distinguishes Goya's genius and humanity, and makes his canvases complete experiences which engage the viewer with emotional might and intellectual rigor.

In *Case With Five Balusters* [164], the twentieth-century American sculptor Louise Nevelson also established a significant contrast between two major areas, which allude to a centralized axis. The column of newel posts on the right advances while the fragments of lathed, sawed, broken, and weathered wood on the left appear to recede. The shapes of the balusters swell with life next to the flat, broken pieces of scrap. The long, graceful curve defining the bottom right-hand corner further insulates the pocket of space inhabited by the columns. Against the order of the Victorian newel posts, the cluster to the immediate left appears almost random. The stacked strips function like overlapping brushstrokes, like wooden pigment. When light hits this area it confronts so many cracks

165
Praxiteles. *Hermes and the Infant Dionysus.* c. 340 B.C. Marble, 7'1" (2.16 m).** Archeological Museum, Olympia, Greece.

and planes moving in so many different directions on so many different levels of space, that the uniform white covering of the assemblage creates a kaleidoscopic effect.

But Nevelson did not just saw her composition in half and pack up her tools. She restored unity by echoing on the left side details such as curves and horizontal lines established on the right, and by causing the viewer to span the damaged, tilting chips that shingle the work's top edge. Details such as these soften the impact of the exaggerated contrast established by the approximate symmetry governing this work.

Contrast

Contrast is the relationship established between significantly different elements or forces. Black contrasts to white; big contrasts to small; hard contrasts to soft. The word stems from the early French "contraste," a contest, or more distantly from the Latin "contrastare," to stand against.

There are many contrasts apparent in the **Classical** Greek statue *Hermes and the Infant Dionysus* [165], carved in 340 B.C. by Praxiteles. The tall, mature, muscular body of Hermes is seen against the tiny, plump form of the infant Dionysus. The small, simple mass of Dionysus' figure sits above the long, more complex, cascading forms of folding drapery. The shifting weight of Hermes' body is supported essentially by his straight right leg and his bent left arm. The curly, rough texture of his hair is very different from the smooth surface of his flesh . . . the list goes on.

But it is not enough just to enumerate the contrasts; contrast allows us to measure and compare. We know just

how big Hermes is because we know just how big the infant is. The human forms in Praxiteles' sculpture appear even more simple and supple when seen against the complexity of the drapery.

As we have indicated elsewhere in this book, our interpretation of experience is profoundly influenced by the culture in which we live. In this respect, it is instructive to address conceptual as well as visual aspects of contrast in the case of *Hermes and the Infant Dionysus*. For example, we should note that qualities such as power and tenderness that many individuals of contemporary Western cultures tend to view as contrasting human attributes are fluidly integrated within a single spirit in this sculpture. In Classical Greek art, man enjoyed a more complete portrayal of his humanity than he did in most later periods. Certainly his skills, strength, bravery, and virtue on athletic fields and the fields of battle were enthusiastically depicted. But the ancients' view of the whole, perfect man also included the belief that qualities of strength and virtue did not exist separate from physical beauty, grace, and benevolence. In *Hermes and*

The major periods of Greek art are **Archaic** (seventh and sixth centuries B.C.); Classical (fifth and early fourth centuries B.C.); and **Hellenistic** (late fourth, third, and second centuries B.C.). **Classical** Greek sculpture is characterized by idealized, relatively lifelike representations of freestanding, graceful figures. These figures usually display refined proportions and an overall sense of physical, intellectual, and emotional balance.

the Infant Dionysus two equally important messages are conveyed: the dignity of strength and muscularity; and the belief that gentleness and the expression of tender feelings play an important part of what is considered manly.

One other point deserves our attention: this sculpture is damaged, as is much figurative art that has come down to us from antiquity. It is the only way that much of the sculpture from the past has ever been seen by modern eyes because visual documentation is rarely available to offer any other view. The contrast between how *Hermes and the Infant Dionysus* was conceived and how it exists today deserves our consideration. When we overlook the broken limbs of a statue, we overlook an important, visible fact of its present existence: the pathos of Hermes, whose well-proportioned, muscular presence and easy, confident manner is tempered by the stump of his raised right arm. We overlook the intriguing question, "What is it that once tempted the infant Dionysus?" To see the original bunch of grapes or the shiny, round apple dangled beyond the reach of the child may, in fact, be less interesting than imagining the unknown, missing piece of reality that forever teases Dionysus, as well as the viewer of this tender, manly sculpture.

Contrast is apparent in each of the two sculptures we will consider next. But just as important for the purposes of this discussion are the significant contrasts that exist from one work to the other, despite the fact that in each case the subject is exactly the same.

The subject in both examples is Laocoön. The Greek poet Homer tells us that when a large wooden horse (known today as the Trojan horse) was discovered in the recently evacuated camp of the Greek army, the priest Laocoön implored his fellow Trojans to destroy it. "I fear the Greeks even when they bear gifts," he said. Poseidon, a god who harbored great hatred for the Trojans, thereupon called forth two serpents to attack and kill Laocoön and his two sons. The terrified Trojan onlookers took this as a sign that the wooden horse should be brought inside the walls of the town of Troy. That night, Greek soldiers hiding inside the hollow horse opened the gates of Troy, enabling the rest of the Greek army to enter and ultimately capture the town.

That is the story that inspired our next two examples. Let us consider how different artists, living in different time periods and working with different media and materials, manipulated the same basic elements and principles to create unique works of art.

166
Hagesandros, Polydoros, and Athenodoros. *Laocoön and His Two Sons.* **1st–2nd century B.C. Marble, height 96" (2.44 m).** Vatican Museums, Rome.

In *Laocoön and His Two Sons* **[166]**, a **Hellenistic** sculpture from the second century B.C., the central figure of Laocoön contrasts greatly in size and direction, and in the sheer enormity of the emotion he expresses, to the figures of his sons surrounding him. The sharp diagonal thrust of his strained body, and his pained facial expression, create a powerful statement of anguish that pervades the entire sculpture.

Contrasts abound. The relatively static cloth contrasts with the writhing movement of the serpents. The basically lateral direction of the serpents contrasts with the angle of Laocoön's body. While dynamic negative shapes separate the family members, the trio is tied together by the snakes and other details such as the raised right arms of father and sons. But despite areas of visual harmony, the significant contrasts and the powerfully sculpted gestures create a sense of deadly strife.

A very different portrayal of this Greek myth is a mixed-media construction by the twentieth-century American artist Eva Hesse. There are several significant differences between this artist's interpretation and the previous one. In Hesse's *Laocoön* **[167]**, there are no human characteristics delineated. Hesse portrays the general idea of conflict and entanglement, not the human or reptilian

resemblances of the characters in a particular Greek myth. Hesse takes cord, alters its identity by covering it with cloth, and, if we are to believe the title, asks us to identify this winding line with the writhing of snakes. But Hesse is not illustrating a story. When considered in relation to the title, the contrasts she establishes can, for some viewers, suggest an episode from mythology. Viewed more abstractly, however, it is enough for many of us to be engaged by the freely hanging cord as it overlaps the more ordered, geometric structure of the ladder.

The **Hellenistic** period ranged roughly from the time of Alexander the Great's death (323 B.C.) to the Roman conquest (second century B.C.) of Greece, which had been known as the land of the Hellenes. Hellenistic sculpture is characterized by more dramatic, emotionally expressive figures than those of Classical Greek sculpture.

167
Eva Hesse. *Laocoön.* **1966. Acrylic paint, cloth-covered cord, wire, and papier-mâché over plastic plumber's pipe, 120 x 24 x 24"** **(3.05 x .60 x .60 m).** Allen Memorial Art Museum, Oberlin College, Oberlin, Ohio. Fund for Contemporary Art and Gift of the Artist and the Fischbach Gallery, 1970.

168
Robert Smithson. *Partially Buried Woodshed.* January 1970, Kent State University, Kent, Ohio. One woodshed and twenty truckloads of earth, 18'6" x 10'2" x 45' (5.64 x 3.10 x 13.72 m). Courtesy John Weber Gallery, New York.

The artform of **Earthworks** was developed in the1960s and 1970s. Earthworks involve the substitution of traditional methods and materials, such as paint and paintbrushes or chisels and carved marble blocks, for such methods and materials as those involving bulldozers and dirt. As the name implies, Earthworks are created in close association with the earth. Important artists associated with this movement include Robert Smithson, Nancy Holt, Michael Heizer, and Dennis Oppenheim.

An even more extreme example of the principle of contrast is offered by an **Earthwork** entitled *Partially Buried Woodshed* [168] by the twentieth-century American artist Robert Smithson. The texture and color of the wooden shelter contrasts with the texture and color of the dirt that dump trucks poured over it. The organic flow of earth contrasts with the straighter lines and more definite shape of the woodshed. The dense mass of dirt contrasts with the hollow building, which is punctured by doors and windows.

Who says a work of art must last for centuries? Why must it last at all? And why must we place art in museums, churches, galleries, offices, or houses, to be bought and sold? These are some of the questions raised by artists such as Smithson. Why, these artists asked, should we not rearrange the landscape itself, creating works that are not transportable, and whose only traces will soon be the photographs that document them?

Partially Buried Woodshed provokes these questions and many others. Where, in a work such as this, does art end and nature begin? What is buried beneath this mound of dirt besides a ruined woodshed? The sense of burial apparent in the work suggests suffocation or death such as you might find in stories like *The Pit and the Pendulum* or *The Fall of the House of Usher* by Edgar Allen Poe. What is it about conflict—even destruction—that is so compelling?

Smithson set up a contest between disparate elements. He continuously strengthened only one side of the equation: the dirt. When the weight of the dirt finally overwhelmed the shed, the final (imbalanced) structure was established. Like Goya in *The Executions of the Third of May, 1808,* Smithson crushed one part of his subject with another part. Of course with Goya, the crush is *pictorial* (French soldiers liquidating Spanish citizens), while for Smithson the crush is actual, physical. Despite the sharp contrasts, Goya's work remains visually balanced. Smithson literally and visibly smothered half of his composition. The result is a lopsided, ultimately broken, structure.

Smithson was not working out of a belief in the sanctity of balance, as were, for example, the ancient Greek sculptors for whom artistic excellence was integrally associated with ideal proportions and graceful equilibrium. For the Greeks, contrast was a way of enhancing wholeness. *Hermes* is both strong and gentle, seemingly dissimilar qualities that Praxiteles fashioned into the embodiment of the perfect man. Robert Smithson also addressed the concepts of contrast and balance, but by pushing his contrasts to the point of destruction, he challenged the traditional belief that balance is a necessary component of visual organization.

THE STRONGMAN BY HONORÉ DAUMIER

Before reading the following discussion of Honoré Daumier's *The Strongman* **[169]**, think about the image by answering these questions:

1. What is this painting about? How do the figures of the two main characters differ? What roles do contrast and the overall structure of the image play in contributing to your response?

2. The worlds of film and fiction are filled with devoted companions. One thinks of Don Quixote and Sancho Panza, Beauty and the Beast, Batman and Robin . . . the list is endless. Why do you think artists employ this idea? Do you think Daumier employs this idea? If so, why?

3. Only the strongman (and the legs in the poster) stands erect. Every other figure repeats the parallel established most prominently by the hawker. What do you think was the artist's intention in posing the figures that way?

4. How does the lighting reinforce the respective gestures of, and the emotional impact made by, the two main characters?

5. How do the figures and forms behind the announcer relate to his action? Do you see any connection between the strongman and his immediate surroundings?

169
Honoré Daumier. *The Strongman.*
c. 1865. Oil on wood panel,
10½ x 13¾" (26.6 x 34.9 cm). The
Phillips Collection, Washington, D.C.

6. The hands of the strongman are hidden, while the open palm and outstretched fingers of the announcer's left hand contribute dramatically to the image on both a formal and emotional level. Explain.

7. How would you describe the spirit and atmosphere of this painting? What pictorial details contribute to your response? What are your own experiences and associations with carnivals and circus performances?

The action is simple and direct. A strongman is introduced: "Main attraction! . . . Incredible feats of strength! . . . Pay your nickel and step inside!"

Daumier's carnival barker strives to transform unwitting onlookers into paying customers. His success depends on both the persuasiveness of his harangue and an attention-grabbing gesture that reinforces his impassioned cry. We can only guess at the content of his exhortation, but we can see what he says with his body. His outstretched arms strain along a highlighted diagonal like a lightning flash in an emblazoned sky.

The figure of speech ends with an exclamation point—the hand. It is a brightly lit, open-fingered, tense hand: the only hand given any real attention in the painting. Daumier thrusts it into the middle of the composition and loads it up with pigment. It is the painting's most thickly painted area, connecting the two main characters along a powerful sweep.

The strongman is confident, solid, and serious. He withstands the open, frenzied manner of the announcer by wrapping himself up in a self-contained, fixed pose. Until he moves out of the way of the curtained entrance surely no one will enter, for who would dare walk in front of this intimidating figure?

From the strongman's muscular arms the viewer's eyes can dart to the announcer's sleeve that dangles from the diagonal line of his arm. The shape and gesture of this detail glides, in turn, directly toward the individual drawing the curtain. The barker's sleeve cuff merging with the curtain holder's upper arm forms a slanted variation on the wrapped forearms of our circus Hercules. The strongman's arms are stable, heavy, and compressed. In contrast, the joined shape of the announcer's robe and the limb of the figure behind is dynamic, thin, extended, like the open wings of a bird in flight. In keeping with the two predominant moods operating throughout the scene—active versus passive—two contrasted gestures are established once again.

Contrast can be found as well within the horizontal band implied at the top of the canvas. On the left, in poster form, we see solidly planted legs bullying the screaming figures below. Next to the poster is the tent flap. Notice how the diagonal folds of this form echo the barker's sweeping gesture. Left and right below become right and left above. But it is all there—and more. Something whimsical is going on. The strongman stands so still and authoritatively, but he has no legs under him. Daumier seems to have misplaced them. The poster completes the picture of the brutish showman like a piece out of order in a jigsaw puzzle. But if the artist is poking fun it is a joke that is over the head of the man of brawn; if he is the straight man it is the carnival barker who gets all the good lines.

The strongman and the barker are a team, but the nature of their respective activities sets them apart. To dramatize his point, the artist contrasts details of the composition so as to inflate two distinct gestures. The loose-fitting garment of the hawker, for example, reinforces his spirited presence, while the skin-tight outfit of his partner emphasizes his stationary, muscular frame. The screaming announcer overlaps screaming figures, while the only person the silent he-man overlaps appears to be silent as well.

Artists do not always communicate their ideas in the form we expect. The English author Thomas Hardy, for example, painted vivid landscape images with his words, while Claude Debussy, the French composer, created impressions of the French countryside through sound. In this sense, we can refer to the Daumier of *The Strongman* as a stage designer or as the director of a play. Observe how he posed the figures, arranged the lighting, how he costumed and even seems to have provided dialogue for his cast of characters. Through his convincing theatrics, Daumier transports us from the museum to the carnival, from picture viewer to paying customer at a sideshow.

Daumier captures the thrilling insecurity we may occasionally feel when surrounded by the unfamiliar. We never know what to expect when we step into another's world. The other is calling the shots. Daumier's announcer seems more than just enthusiastic. He looks desperate, and his feverish cry is intensified by the virulent voices of the two heads behind him. The curtain is drawn back. Inside the tent it is dark and a little frightening. But despite the sense of apprehension he creates, Daumier seduces many of us into wanting to buy a ticket, sit down on a bench, and wait impatiently for the man of strength to enter. It will be a sensational act—just look at the performance going on outside.

FOCAL POINT

Some images and objects establish a **focal point,** a particular spot or part of the work around which the rest of the composition is organized. The hand of the announcer in Daumier's *The Strongman* can be described as a focal point, a detail that everything else within the work can be seen in relation to. The Spanish citizen with his arms outstretched and his entire body so sharply illuminated by the lantern functions as the focal point of Goya's *The Executions of the Third of May, 1808*. Many of the figures in Goya's painting receive individual attention, but the expansive gesture and coloring of the brightly lit man with the outstretched arms single him out above all the others.

Look at Cardinal Albergati's ear [170]. It so commandingly establishes a particular point in space that all the other facial features seem to locate and define themselves in relation to it. "You belong here and you belong there," the ear seems to proclaim to the other facial features, "if I am going to be positioned in this spot." The ear in this drawing by fifteenth-century Flemish artist Jan van Eyck received the most detail, the widest range of tones, and the most sharply delineated contours. Diffused by the rich sense of air that pervades the image, poten-

170
Jan van Eyck. *Cardinal Niccolò*
Albergati. **c. 1431. Silverpoint on**
grayish-white paper, 8⅜ x 7⅛"
(21.4 x 18 cm). Staatliche
Kunstsammlungen, Dresden.

tially prominent features such as the
cheekbone, jaw, and hair enjoy added
definition from their association with
the highly defined ear.

A great cultural and geographic
expanse separates many of the
conventions that conditioned Jan van
Eyck from those that conditioned the

African artist who created the Kuba
mask **[171]**. Nonetheless, a basic
organizing principle informing the
African mask involves the reliance on
a focal point that, within the context
of the structure of the human head, is
situated only a few inches away from
the focal point that played such an
important role in *Cardinal Niccolò*

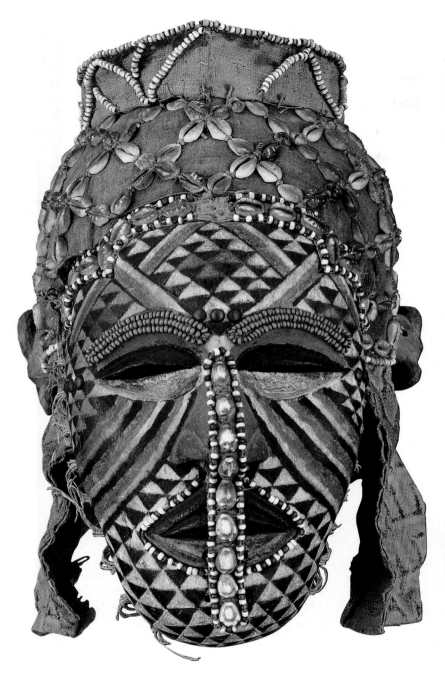

171
Mask, African (Kuba). 19th century.
Wood, cloth, fibers, cowrie shells,
and paint, height 13½" (34.3 cm).
The Baltimore Museum of Art. Gift of
Alan Wurtzburger.

MULTIPLE POINTS OF ATTRACTION

Many works of art rely on more than one point of focus to bring the component parts into an ordered whole. Works such as these can be said to be based on **multiple points of attraction.** Comparing a twentieth-century abstract painting and a sixth-century mosaic that both embody what he calls dynamic space, professor of philosophy and art theorist William Bywater, Jr., states: ". . . dynamic space is achieved by virtue of the fact that no area in these works captures and holds the spectator's vision totally. No matter where one looks in the work, there is to the right or left, above or below, a vibration, a variance, a spot of excitement which calls him away from one focus to another.[4] Each of the vibrations or spots of excitement to which Professor Bywater referred represents one of the multiple points of attraction that informs and structures the works of art under discussion.

Albergati. Just as the ear in the silverpoint drawing takes the lead in directing us through the image, the eyebrows in the Kuba mask establish a definite focus for our attention in this richly patterned and textured object. Patterns such as the curved lines covering the cheeks point us toward the beaded eyebrows. The most compelling feature of the eyebrows, however, is the color. The icy turquoise of this area interrupts the predominantly warm, earth-colored

form of the mask. The unpredictably placed cowrie-shelled and beaded line that leads us vertically toward the eyebrows and the more softly stated, beaded lines delineating other important areas of the head only partially prepare us for the attention-grabbing blue arches. This striking color choice coupled with the calming nature of a pair of closely aligned, curved, symmetrical lines endow the focal point of the Kuba mask with a disquieting power.

172

Lorenzo Ghiberti. The east doors of the Baptistery of the Cathedral of Florence ("Gates of Paradise"). 1425–1452. Gilt bronze, approximate height 17' (5.18 m).

The Italian Renaissance artist Lorenzo Ghiberti structured his bronze *East Door* [172] simply and symmetrically. In this door, designed for the *Baptistery* in Florence, Italy, large, geometrically divided areas are clearly delineated. Several outside borders surround ten square panels. Each panel and decorative border represents a point of attraction, causing the viewer's eye to travel across the entire work, much as it might do with the overall decorative pattern of an Oriental carpet. Because

of their size, centrality, and degree of detail, the ten door panels dominate the pictorial structure of the work, forever offering new, choice moments that engage the viewer's eye.

Seen from a distance, the individual panels of Ghiberti's door remain important primarily as a series of framed bumps and hollows neatly integrated within the design as a whole. But such a view reveals only part of the meaning of this magnificent and complex work. Standing before the *Baptistery Doors* in Florence, you can move in close to appreciate the independent and well-orchestrated statement made by each of the panels. Let us look at an example.

The Sacrifice of Isaac [173] reveals the degree of detail that Ghiberti, a sculptor and architect whose earliest training was in the craft of goldsmithing, brought to this project. In each of the panels of this door, Ghiberti illustrated a story from the Old Testament. This panel shows Abraham obediently demonstrating his complete faith in the word and supreme wisdom of God, who had commanded him to sacrifice his son. Multiple points of attraction fill the panel. There are the figures of Abraham's wife, Sarah; Abraham meeting the angels; the two young men and the donkey that accompanied Abraham and Isaac; and, as well, environmental details including bushes, trees, rocks, and distant mountains. Notice the many points of attraction Ghiberti included as a means of telling this story compared to Caravaggio's decision to focus more economically on Abraham, Isaac, and the angel in his portrayal of the same subject [152]. Ghiberti's decision to step back from the climactic moment of the angel's merciful intervention (located near the top of the frame in Ghiberti's version) results in a trade-off. Ghiberti's numerous points of attraction enabled him to flesh out the story more fully than Caravaggio did.

173

Lorenzo Ghiberti. *The Sacrifice of Isaac.* Panel from the "Gates of Paradise." Approximately 31½ x 31½" (80 x 80 cm).

174
Louise Nevelson. *Dawn's Wedding*
Chapel II. **1959. White painted**
wood. Including base
9'7⅞" x 6'11½" x 10½"
(2.94 m x 2.12 m x 26.67 cm).
Collection of Whitney Museum of
American Art. Purchase, with funds
from the Howard and Jean Lipman
Foundation, Inc.

By focusing closely on Abraham, Isaac, and the angel, Caravaggio, on the other hand, produced an image that appears more emotionally charged.

Dawn's Wedding Chapel II **[174]**, a large wooden construction by Louise Nevelson, and Lorenzo Ghiberti's *East Door* for the Florence *Baptistery* have nothing in common in terms of subject matter or representational depiction. But in terms of structure they share several fundamental characteristics. Most significantly, Nevelson's construction, like Ghiberti's door, includes numerous

geometrically divided sections or compartments that function simultaneously as component parts and as independent, fully realized compositions in themselves.

Contrasting forms, shapes, and sizes abound in *Dawn's Wedding Chapel II*, both within the individual boxes and the more irregularly edged structures that comprise the work and in the severe juxtapositions between each of these units. Each of the compartments reflects a unique scale and pattern and offers multiple points of attraction into which the viewer can enter and explore.

175
Balthus. *The Street.* 1933. Oil on canvas, 6'4¾" x 7'10½"
(1.95 x 2.40 m). Collection, The Museum of Modern Art, New York. James Thrall Soby Bequest.

Before reading the following discussion of Balthus's painting *The Street* [175], think about the image by answering these questions:

1. Would you say that the disposition of this work establishes a straightforward and commonplace statement or a complex and elusive one?

2. How would you characterize the social interactions of the inhabitants of *The Street?*

3. Although most of the people in this painting seem to be oblivious of one another, numerous visual details establish them as a tightly knit pictorial group. Explain. Consider especially the figures' related gestures, coupling, and their positioning in relation to the viewer.

4. Ambiguity plays an important role in this painting. Explain. How do you feel about the idea of artists not tying up neatly all the loose ends of their creations?

Although he is the descendant of an old Polish family, Count Balthasar Klossowski (known as Balthus) was born and spent his childhood in

France, traveled to Italy to study the Old Masters, and later went to Morocco where he was stationed for two years with the French army. Throughout his career, Balthus not only avoided affiliation with any particular movement in art, he consistently shunned public notoriety. Perhaps for this reason he is not particularly well known by the general public. Nonetheless, Balthus is one of the most influential figurative painters of the twentieth century.

The Street, which Balthus painted when he was just 25 years old, suggests influences from his youth even while it displays significant characteristics of his more mature paintings yet to come. The setting for *The Street* is based on Paris, but its muted, predominantly ochre colors are reminiscent of the tan desert tones of Morocco. The frozen, timeless pedestrians who represent the heart of the image bring to mind the timeless figures painted by the fourteenth-century Italian painters Giotto and Piero della Francesca, artists whose work Balthus studied intensely in their native country.

More like chessmen on a board than people walking, the figures in *The Street* create a strange atmosphere of unreality. It is a painting of haunting tensions, deliberately designed to keep the viewer balancing perpetually on one foot. Never can one assume a comfortable posture regarding the time sequences, the spaces, the odd juxtapositions of figures that inhabit this block. Each character is restricted to such a limited area, function, and manner of movement, that communication between them seems impossible. Or does it? Like the carved pieces of wood on a chessboard, the people in this painting trade their isolation for combination, ultimately surprising us by the unpredictability of their alliances, and the multiple points of attraction which they provide.

A young man molests an adolescent girl. The girl's gesture parallels closely that of the child chasing her ball, allowing us momentarily to view her as an older version of the chubby, dwarflike youngster who she stands a good chance of trampling. Art history has provided children like this little girl lots of running room. She makes a fleeting appearance **[176]** in Rembrandt's *The Night Watch* **[103]**. She offers the one truly active note **[177]** in Georges Seurat's otherwise serene *Sunday Afternoon on the Island of La Grande Jatte* **[133]**. In a more mysterious light, we cross her melancholic path as she races through a canvas by the twentieth-century Italian painter Giorgio de Chirico in *Mystery and Melancholy of a Street* **[178]**. On the face of it, the child has nothing in common with the couple behind her, and yet the young man, the girl, the child, and the ball form one unit. Even the reclining triangle of space comprised by this foursome **[179]** testifies to their connection. An attraction is likewise developed between the child chasing the ball and the two boys on the opposite side of the canvas. The thrust of the little girl's body points us in the direction of the boys, the general color of their clothing sets up a bond, and even the gesture of the right arm of each of the three figures ties them to one another.

Similarly, Balthus draws a parallel between the boy and girl in the right foreground and the woman carrying the little boy. The repetition of presentation (we are denied a frontal view of the women while the boys face us squarely), the relationship of age (older women, younger boys), the similarity of clothing (females wear black; the males, lighter shades of

176
Rembrandt van Rijn. *The Sortie of Captain Frans Banning Cocq's Company of the Civic Guard (The Night Watch)* (detail). 1642. Oil on canvas. Rijksmuseum, Amsterdam.

177
Georges Seurat. *Sunday Afternoon on the Island of La Grande Jatte* (detail). 1884–1886. Oil on canvas. Helen Birch Bartlett Memorial Collection, 1926.224. ©1990 The Art Institute of Chicago. All Rights Reserved.

brown), consistency of positioning (women on the right, boys on the left)—all of these echoes represent the artist's deliberate decision to compare persons who interact by ignoring, or simply neglecting to notice, one another.

Balthus manipulated gesture, color, positioning, and time to establish connections between the figures. Nonetheless, alienation prevails. Each of the pedestrians occupies a particular architectural or geometric space. The man and girl located in the bottom left corner are divorced from the others by the molding of the doorway behind them. The dark rectangular opening directly above the man's head mimics the force of the dark rectangle of the window that appears to stretch and further stiffen the gesture of the approaching boy. The red and black cap of the woman passing him is fitted into the pattern of the window directly above. The youngster being carried is first framed by the ochre door, and then firmly pinned there by the pointed lantern above, which, through its clean vertical axis, playfully objects to the tilt of the boy's head. The baker is locked into his space by the pull of the rectangular white sign above, which serves as the top left angle of the twisted triangle of space [179] that confines the carpenter. By fixing each individual into a particular space, Balthus establishes a rhythm of isolation that binds together this peculiar ensemble of characters.

178
Giorgio de Chirico. *Mystery and Melancholy of a Street.* 1914. Oil on canvas, 34¼ x 28⅛"
(87.6 x 71.4 cm). Private collection.

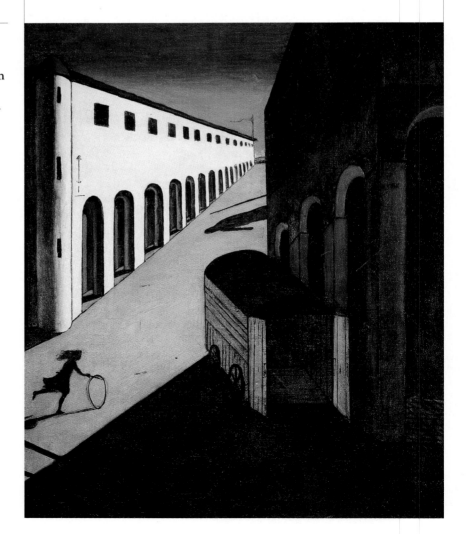

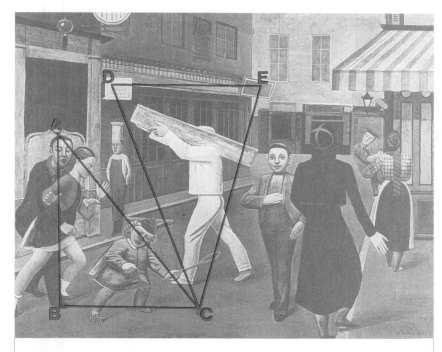

179
Balthus. *The Street* (diagram).
1933. Oil on canvas. Collection,
The Museum of Modern Art, New
York. James Thrall Soby Bequest.

The characters are so tightly bound that even the baker, who may be but a restaurant's cut-out advertisement, looks like part of the crowd. Amidst his fellow citizens he does not look especially stiff—everyone on this block looks fabricated. Can you not imagine the laborer completing his walk across the street, putting down the board he shoulders, and shouting "Go!" whereupon these highly staged actors would collide?

My imagination skips alongside the walkers. The carpenter conceals a self-satisfied grin, keeping the only smile on the street a secret. How does he manage to keep his workclothes so white, this fastidious artisan who fashions life-size figures out of wood? The boy ambling toward us is at this very moment entertaining Napoleonic delusions of grandeur. The baker is waiting for an important phone call. . . . Every one of the characters in this painting suggests a story.

Balthus provided pictorial structure to a situation that would be lost without it. The result is an ordered wonder. "On the chessboard," writes chessmaster Fred Reinfeld, "surprise is nothing more than logic that packs a wallop." So it is on the canvas. And nowhere is this better demonstrated than in *The Street*, where logic follows a strategy all its own.

CRITICAL QUESTIONS

1a. The slender vase and flowers in *The Idol* by Henri Matisse [180] appear to be the very opposite of the corpulent woman. Closer inspection suggests that they could be her counterpart. How are the figure and still life different visually? How are they related?

b. Visual echoes strengthen the structure of a painting by connecting otherwise separate areas, organizing a potentially unrelated arrangement of colored shapes and textures into a unified whole. Each of the paired areas listed below share certain visual characteristics that tighten up the structure of this painting. Explain:

woman's head—leaves and flowers
gold necklace—white flower
gold necklace—orange on table
ties of woman's dress at her chest—
 stem of flower
woman's left hand—green leaves of
 plant
woman's hands—wallpaper pattern

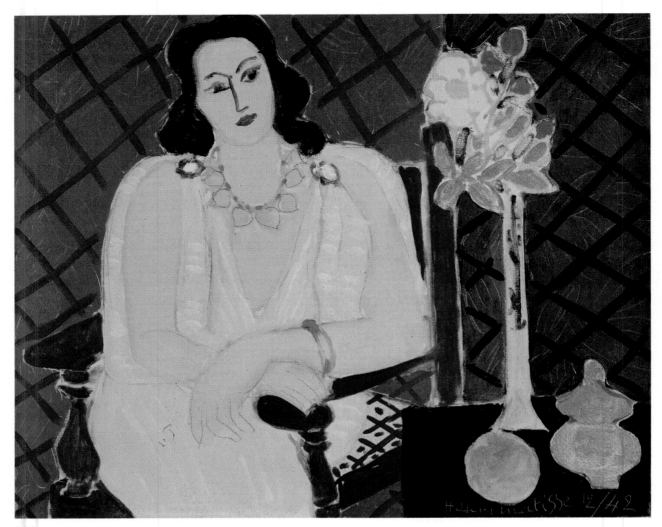

180
Henri Matisse. *The Idol.* 1942. Oil on canvas, 20 x 24" (50.8 x 61 cm). Private collection.

What are some possible reasons for mirroring so many details of the figure and still life?

c. What qualities do you associate with a flower? Do you think Matisse might have welcomed any of these associations for the woman in his painting?

d. *The Idol* represents an example of approximate symmetry. Explain.

e. As a rule, it is not a good idea to split the composition of a painting so rigorously into two parts as Matisse has done here. But often a painter poses a problem such as this for the formal resistance it offers, namely, to achieve unity despite the fact that the painting is essentially halved. Do you think Matisse succeeded in resolving the formal problem(s) he imposed on himself? How do you think the formal problem(s) he proposes in *The Idol* speaks to the content of the work? What other paintings that we have looked at in this book can you compare to the structural principle of approximate symmetry that informs *The Idol?*

2a. We began this chapter by discussing how Francisco de Goya in *The Executions of the Third of May, 1808* employed a highly controlled, pictorial structure to express an emotionally charged subject. Would you say that a similar contrast between form and content informs the contemporary American painter Jacob Lawrence's *One of the Largest Race Riots Occurred in East St. Louis* [181]? Explain. Can you cite any other contrasts evident in Lawrence's painting?

b. There are multiple points of attraction in this image. What are some of the areas that compel your attention? Why are you attracted to these areas?

c. The figures stand out boldly against the background. Why do you think the artist does not soften the edges or contours of the men's bodies,

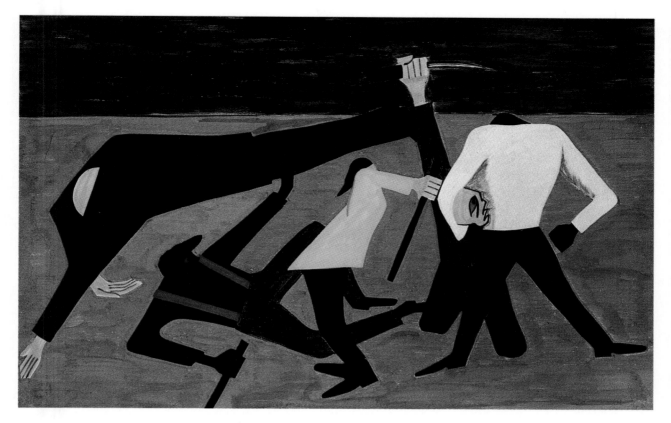

181
Jacob Lawrence. *One of the Largest Race Riots Occurred in East St. Louis,* panel 52 from the series *The Migration of the Negro.* 1940–1941. Tempera on composition board, 12 x 18" (30.5 x 45.7 cm). Collection, The Museum of Modern Art, New York. Gift of Mrs. David M. Levy.

thereby creating a gentler figure/ground relationship? Compare the sharp edges of the men's bodies in this painting to the contours in Jan van Eyck's portrait of Cardinal Niccolò Albergati. What effect does van Eyck's use of contour have on the emotional atmosphere of his drawing?

d. A quick look at the way he stylizes and choreographs the figures tells us that Jacob Lawrence is not concerned with naturalistic depiction. Regarding naturalism, what can you say about the artist's handling of line, form, color, and light?

e. The blue of the ground plane apparent between the bodies of the men has a life of its own. For some viewers these negative shapes may be as exciting as the men themselves. What makes these shapes so dynamic? What can you say about their variety?

f. Variation plays an important part in the design of this scene. Each of the men's heads, hands, and legs, for example, is positioned differently. Do you think these differences heighten the action and sense of discord that pervade this painting? Explain.

g. There are similarities between the multiple points of attraction in this image, permitting a subject rife with visual and emotional disagreement to read as a well-structured whole. Explain.

7

Space

As a child I had a recurring nightmare that involved falling from an airplane into a sky of black. What made the dream particularly frightening was that I fell upward. There was nothing to let me know where I was or how much longer I would be there. There was just constant, uninterrupted movement into empty space.

Space refers to atmosphere, distance, or expansion that can extend vertically, horizontally, and in depth. The ability to locate ourselves in space is a fundamental component of our sense of security and well-being. I am on this chair, so many feet away from those trees, which I can see through that window. The space of the room in which I am sitting is determined by the walls, floor, and ceiling. The space of any given situation can be understood as a function of relating this to that. The fear I experienced in the dream recounted above was a direct result of my being unable to locate myself in relation to anything else.

THE SHAPE AND FORM OF SPACE

Can we speak of "the shape and form of space" or is this phrase a contradiction in terms? Space is generally described as intangible and invisible, as that which exists in between tangible, visible substances. Such a description places space in the category of a "no-thing." For centuries, however, artists have confronted, in an endless range of materials and techniques, the problem of shaping space. To the extent that we as viewers are able to understand that artists manipulate the principle of space just as they manipulate the elements of volume and texture—visual elements that we can see and even feel—we are in a position to most fully appreciate the substantial role space plays in the visual arts. It is to this point that the author Henry James directed us when he described one of nineteenth-century American painter Winslow Homer's chief merits as being able to see "everything at one with its envelope of light and air."[1] Likewise, the architect Frank Lloyd Wright was acknowledging the substance of space when he declared: ". . . it isn't the roof and the four walls that make a house, but the spaces between them—the living spaces."[2]

In Donato Bramante's *Spiral Ramp* [182], which was designed for the Vatican in Rome, space seems to take on a physical presence. Bramante, a sixteenth-century Italian architect, is generally regarded as one of the most important masters of the Italian High Renaissance. In 1508 construction based on his designs began on the new church of *St. Peter's Basilica* [183], which is located in Vatican City in Rome. After his death in 1514, his designs were considerably expanded upon by artists such as Michelangelo, Raphael, and Bernini. Nonetheless, the drawings Bramante made for the

182
Donato Bramante. Spiral Ramp.
c. 1503. The Vatican, Rome.

183
Saint Peter's Basilica and the Vatican, Rome, from the southwest. Apse and dome by Michelangelo, 1547–1564. Dome completed by Giacomo della Corta, 1588–1592. Nave and façade by Carlo Moderno, 1601–1626. Colonnades by Gianlorenzo Bernini, 1656–1663.

world's largest Christian church, St. Peter's, exerted great influence on later generations of architects. *Spiral Ramp* provides a small but excellent example of Bramante's sensitivity to

architectural space. By partially enclosing the central cylinder with a band of wall and then opening it up to a series of massive but evenly distributed columns, Bramante allows us to

184
Naum Gabo. *Spiral Theme.* 1941.
Construction in plastic,
5½ x 13½ x 9⅜"
(14 x 33.7 x 23.8 cm), on base
24" (61 cm) square. Collection, The
Museum of Modern Art, New York.
Advisory Committee Fund.

Constructivism is a twentieth-century style of painting and sculpture influenced by the geometry of Cubism. Constructivist works of art, which tend to glorify technology, are characterized by industrial-like precision and the use of modern materials such as plastic and stainless steel. Important Constructivist sculptors include Naum Gabo and his brother Antoine Pevsner.

simultaneously see both the outer boundaries and the interior space of the spiral.

Every three-dimensional form takes up a certain amount of three-dimensional space. To overlook the interaction between a three-dimensional work of art and the space that surrounds that work is to look at only part of the visual experience. The twentieth-century Russian **Constructivist**

Naum Gabo's *Spiral Theme* **[184]** makes us conscious of the intimate connection that exists between intangible space and tangible object. Here, sharply delineated planes of clear plastic convert the elusiveness of air into physical form. The continuously encircling motion of the twentieth-century British sculptor Barbara Hepworth's *Pelagos* **[185]** exemplifies the conventional spiral form. Particularly noteworthy in Gabo's *Spiral Theme* is the degree of discontinuity evident within the coiling aspect of the sculpture. Nonetheless, in true spiraling fashion, the parts of Gabo's sculpture rotate around a central point. Because the material of this work is transparent, thereby allowing us to simultaneously see the physical form of the spiral and the atmosphere it occupies, *Spiral Theme* provides a vivid example of the inextricable connection that exists between a three-dimensional form and the surrounding space.

185
Barbara Hepworth. *Pelagos.* 1946.
Wood with strings,
14½ x 15½ x 13"
(368 x 387 x 330 mm).
Tate Gallery, London.

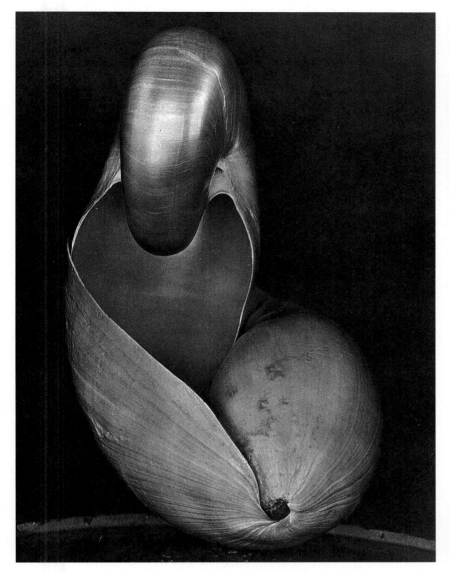

186
Edward Weston. *Shell.* **1927.**
Gelatin silver print, 9⁹/₁₆ x 7"
(24.3 x 17.8 cm). San Francisco
Museum of Art, Albert M. Bender
Collection. Bequest of Albert M.
Bender.

187
William Bailey. *Still Life.* **1984.**
Pencil on buff paper, 19 x 13"
(48.3 x 33 cm). Collection Richard
F. Kauders. Photo Courtesy of Robert
Schoelkopf Gallery, New York.

The space or atmosphere that surrounds a form plays a decisive role in twentieth-century photographer Edward Weston's *Shell* [186]. The dark tone surrounding the shell defines the outer boundary of the object, and establishes the space out of which the swelling, spiraling shell projects. Notice how the outside contours of the shell interact with the surrounding space. If the shell's contours were uniformly sharp and its surface mass was uniformly light in tone, the shell would look flat and cut out. Instead, the dark tones of the background envelop the object. The edges of the form appear intermittently sharp (usually referred to by artists as hard-edged) and blurred (soft-edged). The sensitive lighting of the form creates a dramatic yet delicate dialogue between atmosphere and volume.

Space is the invisible yet substantive context within which each of the visual elements exists. In *Still Life* [187], the contemporary American artist William Bailey recorded not only the six objects on the table; in effect, he drew the air between his eyes and the wall behind the objects. Space in this drawing is inseparably connected to and just as palpable as volumetric form.

188
Gilbert Lesser. **Poster for the play**
Equus. **1976. Collage, 14 x 22"**
(36 x 56 cm). Courtesy the artist.

FLAT SPACE AND THE FLATNESS OF THE PICTURE PLANE

Flat space involves a basic, relatively uncomplicated manner of manipulating form which reinforces the flatness of the image support. Generally speaking, works of art governed by flat space are free of any **overlapping** areas, that is, areas in which one form exists in front of, and at least partially obscures, another form. We tend to be able to take in quickly works of art that rely on flat space. For this reason, many posters and other graphic designs, which must grab the attention of their audiences and communicate their messages quickly, operate within the pictorial context of flat space. The flat, cut-out shapes of Gilbert Lesser's theater poster advertising the play *Equus* [188] and David Barnett's *The Sea Gull* [189] provide two examples by contemporary American graphic designers.

Throughout history, countless artists have communicated their ideas on a two-dimensional surface without unduly concerning themselves with creating the illusion of spatial depth.

189
David Barnett. *The Sea Gull*. 1972.
Poster for Cubiculo Theater,
22 x 30" (56 x 76 cm).
Courtesy the artist.

190
Tomb of Nakht, Thebes,
c. 1450 B.C. The Metropolitan
Museum of Art, Photography by
Egyptian Expedition.

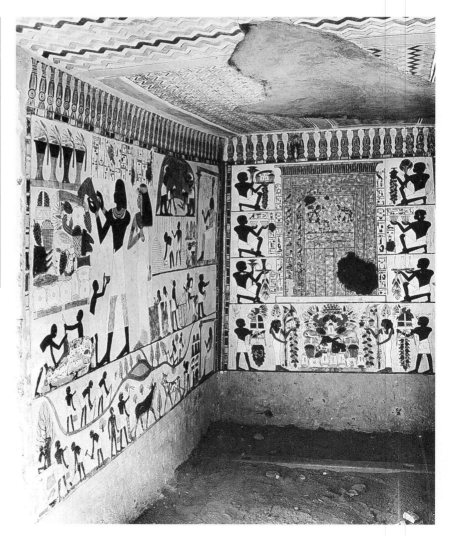

The ancient Egyptian wall painting from the *Tomb of Nakht* in Thebes **[190]**; the eighteenth-century Italian *Ketubbah* from Padua **[191]**; and Paul Gauguin's woodcut entitled *Christ on the Cross* **[192]** all represent examples of artists working with systems of pictorial space that can be described as basically flat.

The Cubists' method of arranging lines, shapes, and colors on a two-dimensional support is often referred to as "affirming the flatness of the picture plane." Like any revolution, Cubism borrowed from other sources and traditions as much as it introduced a body of new ideas. A comparison of an early painting by Picasso entitled

192
Paul Gauguin. *Christ on the Cross.* c. 1926 (posthumous impression). Woodcut, 15⅞ x 5⅜" (40 x 13.7 cm). The Metropolitan Museum of Art, Harris Brisbane Dick Fund, 1929. (29.10.2)

191
Ketubbah, **Padua, 1732.** Collection, Israel Museum, Jerusalem. Gift of Bambi and Roger Felderbaum, New York, in memory of Mr. and Mrs. William Olden. (1486.79;179/290)

193
Pablo Picasso. *Woman's Head.*
1907. Oil on canvas, 28⅞ x 23¾"
(73 x 60 cm). Private collection.

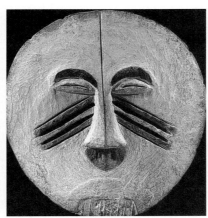

194
Mask, Mbole (?), Zaire. Painted
wood, height 19⅝" (50 cm).
Collection J. W. Mestach, Brussels.

Woman's Head **[193]** to a mask from
Zaire **[194]** or to *Reliquary Figure* from
Gabon **[195]** demonstrates the
profound influence African sculpture
exerted on Picasso's work during the
early stages of the development of
Cubism.[3] The Cubists can be credited
with having made the idea of flatness
an important concern for many of the
most important artists of the twentieth
century. Romare Bearden's *The*

Prevalence of Ritual: Baptism **[196]**
represents an example of an American
artist's work that was strongly influ-
enced by Cubist innovations involv-
ing flat space.

The Cubist interpretation of space
represents a reaction to the pictorial
tradition of treating the flat support of
an image as a clear window through
which pictorial details recede into a

195
Reliquary Figure, Kuta, Gabon.
Brass-covered wood, 25¼" (64 cm).
Lowie Museum of Anthropology, The
University of California at Berkeley.

196
Romare Bearden. *The Prevalence of*
***Ritual: Baptism.* 1964. Photome-**
chanical reproduction, synthetic
polymer and pencil on paperboard,
9⅛ x 12" (23.2 x 30.5 cm).
Hirshhorn Museum and Sculpture
Garden, Smithsonian Institution,
Washington, D.C.

197
Pablo Picasso. *The Maids of Honor
(No. 48)*. November 17, 1957 I.
Oil on canvas, 13¾ x 10⅝"
(35 x 27 cm). Museo Picasso,
Barcelona.

naturalistic (foreground/
middleground/background) space.
Rather than angling them into the
space of a composition, many of the
planar details that comprise Cubist
imagery were positioned parallel to—
and therefore reinforced the flatness
of—the work's physical surface.

Paradoxically, one of the functions of
a plane incorporated into the back-
ground of a Cubist image is to project
itself forward into the field of the
foreground. Picasso's *The Maids of
Honor* **[197]**, one of a series of
interpretations he based on Diego
Velázquez's *Las Meninas* **[198]**, offers a
clear example of this practice. In
Picasso's painting, the bold red color
of the back wall is the very same color
as that of the figure on the far right of
the canvas, which, in turn, is the same
color as that of the floor in the
foreground. The fact that each of the
colors distributed throughout the
canvas displays the exact same tone
and intensity serves to flatten out the
space. Compare Picasso's stark, flat use
of color to the subtle modulation of
the tones and intensities of the colors
in Velázquez's painting. Which of the
two artists, would you say, produces
the more atmospheric, and deeper,
quality of space?

198
Diego Velázquez. *Las Meninas*. 1656. Oil on canvas, 10'5¼" x 9'¾"
(3.18 x 2.76 m). Museo del Prado, Madrid.

199
Michelangelo Merisi da Caravaggio.
The Supper at Emmaus. **c. 1600.**
Oil on canvas, 4'7½" x 6'5¼"
(1.41 x 1.96 m). National Gallery,
London.

THE ILLUSION OF SPATIAL DEPTH

Three-dimensional works of art such as sculpture and architecture extend in every direction and exist in actual space. Two-dimensional works of art consist of a flat support on which are applied lines, tones, and colors of varying shapes, sizes, and intensities. Within this context, many artists have assumed the challenge of creating **illusionistic space** by convincing us that the actual flat support is no longer flat, but rather, that some of the details we see on that surface are close to us while other details are farther away. Works of art rarely fall into neat categories, but many works can be described in one of three ways.

1) **Shallow space** significantly limits the depth of space between the front and back planes portayed by an image or object.

2) **Allover space** is a form of shallow space where the differentiation between foreground/middleground/ background areas is negligible or even non-existent).

3) With **deep space,** the distance between the front and back planes, or spatial areas, is great. Panoramic landscape scenes fall into this category.

The principal methods artists have relied on to create the illusion of spatial depth are overlapping, size differentiation, placement, linear perspective, and atmospheric or aerial perspective.

SHALLOW SPACE

Throughout the history of art, works characterized by the limited spatial recession of shallow space have served varied purposes. In many Cubist paintings where we see a multitude of planes aggressively crowding one another, shallow space serves to

200
Emperor Justinian and Courtiers, wall mosaic, San Vitale, Ravenna. c. 547.

distance the viewer from the subject by making it difficult to enter the pictorial space. As exemplified by Michelangelo Merisi da Caravaggio's *The Supper at Emmaus* **[199]** on the other hand, sometimes artists use shallow space to enable viewers to observe a particular situation from close range, thereby intimately engaging the viewer with the action unfolding. (Notice that the out-stretched arms of the figure on the right in Caravaggio's painting provide a surprisingly precise measure of the space.)

Although predating the development of Cubism by almost 1,500 years, the artists who created the sixth-century mosaic panel *Emperor Justinian and Courtiers* **[200]** can be viewed as forming part of the tradition that has

inspired many twentieth-century artists to "reaffirm the flatness of the picture plane." The **mosaic** technique itself emphasizes flatness, involving as it does the process of embedding, side by side, for the most part parallel to the picture plane, tiny pieces of colored tiles, glass, or stones (**tesserae**) into a cementing agent. A degree of spatial depth results from the many instances of overlapping, an example of which we see in the irregular pattern of the figures' bent right arms that appear in front of and behind an assortment of other forms. Nonetheless, in keeping with the Byzantine tradition of lining up similar forms along a single plane, such as we see in the pattern of frontally posi-tioned heads stretched laterally across the image, the spatial depth in this work is severely limited.

COLONIAL CUBISM BY STUART DAVIS

201
**Stuart Davis. *Colonial Cubism.*
1954. Oil on canvas, 45 x 60⅛"
(1.14 x 1.53 m).** Collection Walker
Art Center, Minneapolis; gift of T. B.
Walker Foundation, 1955.

Before reading the text that accompanies Stuart Davis's *Colonial Cubism*
[201], think about this painting by answering the following questions:

1. Do you think that the title *Colonial Cubism* refers to any of the
influences that affect the appearance of this painting? Explain.

2. What would you say is the primary way Stuart Davis created spatial
depth in this painting?

3. This image contains many fascinating details involving color and shape
interactions. After looking carefully at the parts that make up this
composition, cite several visual incidents that you find particularly
engaging and explain what it is about them that interests you.

4. Every artist paints out of a set of personal beliefs and enthusiasms. In
this discussion we will cite some of the things, besides other paintings, that
Stuart Davis acknowledged as influencing his work. If you were a visual
artist, what details that make up your world do you think might influence
what you would create?

5. Ordinarily, artists do not draw attention to their signatures; the work of
art should be looked at, not the artist's name. But Stuart Davis's name is

written boldly across the bottom of the canvas for all to see. It adds significantly to the painting. How?

In Stuart Davis's *Colonial Cubism*, flat, colored shapes are distributed across a flat surface. Nonetheless, an undeniable sense of spatial depth is evoked. Shapes slide in and out of the space, incessantly trading places with their neighbors. Although it may look like a steamroller had its way with the composition, it is equally apparent that this painting is by no means lacking in spatial dimension. What started out in front is suddenly in back; what was behind to begin with does not stay behind for long—orange overlaps white, white overlaps black, black overlaps red, blue, and white, which, in turn, overlap black, red, orange, and blue—and on it goes.

The loud, aggressive color and the muscular, geometric drawing of the shapes fight one another for more breathing room. The fight for space is fascinating—and fun to watch. Partly, it is fascinating because it is so unnatural. This is space that comes out of the manipulation of the visual elements, space that comes out of art. *Colonial Cubism* does not relate to nature. It relates to itself—to its own particular arrangement of colors and shapes distilled through a kind of Cubistic slang—what Davis called his "New York visual dialect." Its aesthetic ancestry is part of its subject.

The subject of Stuart Davis's painting points us to the work of the Cubists. But whereas Cubism was born and bred in France, the title of Davis's painting points us straight to the United States. Besides acknowledging the impact of artists such as Picasso and Leger on his paintings, Davis credits such American influences as ". . . the brilliant colors on gasoline stations; chain store fronts and taxicabs; fast travel by train, auto, and aeroplane; electric signs; movies and radio; Earl Hines's hot piano and Negro jazz music in general."[4] But how does one describe on a canvas, and with nonrepresentational imagery, fast travel or hot piano? Not, Davis seems to say, by subtle modulations of tone and color, but by inventing a color-space equivalent that evokes the rhythm and energy of certain dynamic aspects of the American scene.

The palette is striking. Primary colors of red and blue are joined by a vivid orange and undiluted black and white. Looking at Davis's picture, one wonders why straight-out-of-the-tube black and white look so wrong in so many paintings, and why so many artists exclude them from their palette. For Davis they are simply two more colors to be put into spatial motion.

In Chapter 5 we discussed how cool colors such as blue tend to recede in space, and warm colors like red tend to advance. Stuart Davis effectively overturns this principle. Red is used here basically as background; it is almost always behind blue. However, true to its nature, red does pop forward at times, as we see it do just to the left of the white shape located near the center of the canvas. It pops because it is surrounded by blue, and because Davis plays with us by making it unclear whether this red shape is supposed to be read as a foreground or background shape.

Throughout, shapes are distinguished by their interaction with other shapes. One of the reasons an artist overlaps one form with another is to

202

**Stuart Davis. *Owh! in San Pao.*
1951. Oil on canvas, 52¼ x 41¾"
(1.33 x 1.06 m).** Collection of
Whitney Museum of American Art,
New York.

make each form more interesting, less like what what we expect it to be.
The finesse with which Stuart Davis does this here is exemplary. A
drooping, double-fingered shape of orange hangs limply over the shoulder
of a white band that speeds through the painting like an expressway
charging through a crowded parking lot. The orange star floating in the
lower left corner of the canvas pierces the side of the white plane to its
right, vigorously animating what would otherwise have been a straight,
uninteresting vertical white border. The star itself undergoes a radical shift
as the relatively quiet relationship of orange against red changes to a more
clamorous orange against white.

Within the scope of Davis's work, *Colonial Cubism* appears unusually
nonrepresentational. Many of his canvases intermingle abstract shapes
with recognizable imagery, as we see in *Report from Rockport* **[138]**.
Frequently, as we see in *Owh! in San Pao* **[202]**, he relies on painted words
". . . to offer the same reassuring check on his abstraction that bits of
realism provide."[5] But even this bit of (written) realism seems at first
glance to be absent from *Colonial Cubism*. It is not. Introducing another
level of information, the artist's name provides the juxtaposition of
realities that is Davis's special province. His name functions as a written
language that bumps conceptually against the language of pure abstraction
floating just above it—black strokes of genius. It is as if the artist com-
pleted his painting, stepped back, and decided it needed more tension. So
he signed his name, big, against a solid red field, and smiled as he saw his
verbal/visual handwriting steal attention from the even bigger run-on lines
up above. But this handwritten decision was probably not an afterthought
any more than is a comic's punch line—an unpredictable but planned
startle. Davis himself says, "In the context of a total composition you plan
a place for it (your signature) and regard it as an object."[6] Davis's signature
provides tension to the composition and a degree of resonance without
which this painting would be spatially just about as quirky, but conceptu-
ally far more flat.

ALLOVER SPACE

The more similar one area or detail of
a visual image is to another, the less
isolated the parts will appear. The
democratization of the pictorial parts
tends to create the effect of a work of
art presenting itself to a viewer all at
once. Such images, in which figure
and ground merge, are typically
characterized by repetition, homoge-
neity, and overall patterns.

Like many other art-related concepts,
issues regarding allover space and the

homogeneity of figure/ground relation-
ships have many analogies in the
world of nature. Consider, for ex-
ample, the phenomenon of camouflag-
ing in the insect world. Insects such as
day-roosting moths **[203]** avoid their
predators largely because they have
adapted to their environments to such
an extent that they can become
virtually invisible. The moth's
invisibility results from its making
itself part of an allover space—in this
case, by merging with the textures and
patterns of a lichen-covered tree
trunk.

Allover space (sometimes referred to
as overall, or universal space) is a
concept that could aptly be applied to
twentieth-century Abstract Expres-
sionist painter Jackson Pollock's
Number 1, 1948 **[204]**. In this image
there is no star that steals the show—
except, perhaps, the overall physical
and emotional performance of the
artist himself (as one writer put it:
"Pollock painting is the subject of
Pollock's paintings.").[7] Pollock is often
referred to as an Action Painter. The
art critic Harold Rosenberg, who
coined the term Action Painting,

203
Day-roosting moth (*Epipristis nelearia*) on a tree in a tropical rain forest on Mount Kinabalu, Borneo.

referred to the canvas as ". . . an arena in which to act. . . . What was to go on the canvas was not a picture but an event."[8] In *Number 1, 1948* the event put into motion by the artist translates into a rush of black and white lines lacing their way through the composition. The painting is about speed and direction of line; about the human body getting into the act of making a painting; about paint—thick, thin, dripped, thrown, juicy paint overlapping and weaving through other paint—about accident and control; about freedom and a new definition of what constitutes order.

Regarding the creative process as experienced by the writer of stories, author Flannery O'Connor's statement that: "The novelist writes about what he sees on the surface, but his angle of vision is such that he begins to see before he gets to the surface and he continues to see after he has gone past it,"[9] leaves us to ask: "So where is the surface?" By effectively dissolving the contradiction inherent in the phrase "depth of surface," O'Connor extols the profundity of what most people would, by definition, describe as altogether lacking in depth. Likewise, in his painterly example of

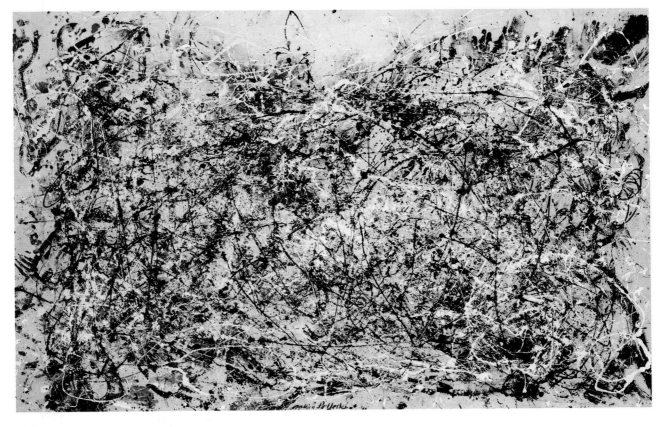

204
Jackson Pollock. *Number 1, 1948*. 1948. Oil and enamel on unprimed canvas, 5'8" x 8'8" (1.73 x 2.64 m).
Collection, The Museum of Modern Art, New York. Purchase.

205
Claude Monet. *Reflections of the Willow Water Lilies.* c. 1918–1925. Oil on canvas, 78¾ x 79⅛" (2 x 2.01 m). Musée Marmottan, Paris.

206
Façade, Rouen Cathedral, begun 1210.

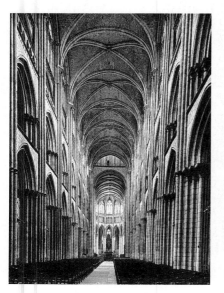

207
Nave, Rouen Cathedral.

allover space, *Reflections of the Willow Water Lillies* **[205]**, Claude Monet demonstrates just how dimensional and seductive a surface can be. In *Reflections of the Willow Water Lillies*, one of Monet's last paintings, we look downward to see what is up above. Traces of upside-down leaves, clouds, and sky color a surface that defies our touch. Even the water lilies that we see here and there floating on the pond do little to define the space, or to provide a focus for our eye. We sense the sway of the weeping willow tree, the movement of the clouds above and the fish beneath, all in relation to the surface of the water. We sense these things as we begin to empathize more and more with the true subject of this painting—nature's motion as translated into the placement of one paint stroke next to, and on top of, another.

DEEP SPACE

Deep space always entails recession and great distance. Compare the shallow space of the west façade of *Rouen Cathedral* with a view of the interior of the cathedral **[206]**. Solid, volumetric shapes or masses occupy the shallow projections and recessions of the exterior wall; a radiant sense of openness and grandeur, designed to suggest the kingdom of God, informs the space of the interior **[207]**.

One of the most famous and influential films ever made, *Citizen Kane*, derives much of its meaning and dramatic power from the way its director, Orson Welles, used space for expressive purposes. In one of the film's final images of the exorbitantly wealthy Charles Foster Kane (played by Welles), a deep focus shot **[208]** presents the aged magnate reduced to a tiny shape dwarfed by the architectural surroundings of the private universe in which he psychologically imprisoned his wife and himself. Compare the deep space of this image and how it affects your psychological response to the man, with an earlier sequence of the film **[209]** in which

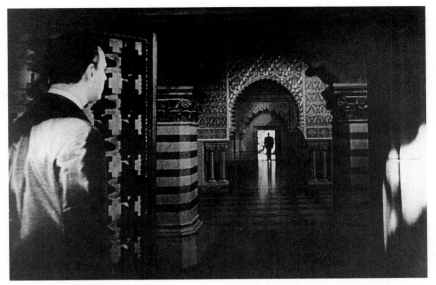

208
"Charles Foster Kane as aged magnate," still from the film *Citizen Kane,* **1941. Directed by Orson Welles.** The Museum of Modern Art, Film Stills Archive.

209
"The young Kane campaigning for office," still from the film *Citizen Kane,* **1941. Directed by Orson Welles.** The Museum of Modern Art, Film Stills Archive.

we see, from a low vantage point and within a shallow space, the young Kane energetically campaigning for the office of governor. The figures in these two images vividly demonstrate that the closer a form is to a viewer, the larger that form appears to be. In the campaign shot, we are close up to Kane. Through association with the gigantic face topped by a blown-up, wide-brimmed hat pictured behind the politician, the scale of Kane's power is further magnified. Notice that when Kane generously fills up the frame from a vantage point which forces us to look up to him, the power and life force of the man seem much greater than when we see him straight on (at eye level) from faraway.

The final example in this section demonstrates how an artist can manipulate, within a single work of art, characteristics inherent in both deep and shallow space. In Chapter 6,

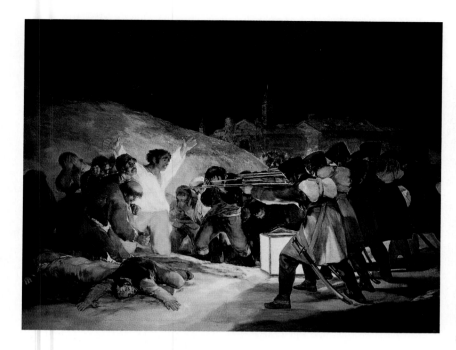

210
Francisco de Goya. *The Executions of the Third of May, 1808.* 1814–1815. Oil on canvas, 8'9" x 13'4" (2.67 x 4.06 m). Museo del Prado, Madrid.

civilians like a misshapen yellow balloon. Contrasted against this area is the seemingly endless line of soldiers vanishing into the depths of the bleak setting. The deeper space suggested by the soldiers reinforces their more anonymous presence.

LANDSCAPE SPACE

Landscape, with its unbounded vistas, provides artists with many opportunities to explore the challenge of deep space. Panoramic vistas such as the nineteenth-century landscape painter Thomas Cole's *Schroon Mountain, Adirondacks* [211] demonstrate why deep space is often associated with the glorious world of nature. Cole is generally regarded as the titular head or "father" of the **Hudson River School** of painting. The artist's words, as well as his paintings, express his reverence for the chain of mountains that was the subject of many of his canvases. "The Catskills," Cole wrote in an article entitled "Essay on American Scenery," ". . . have varied, undulating, and exceedingly beautiful outlines—they heave from the valley of the Hudson like the subsiding billows of the ocean after a storm."[10]

The nineteenth-century American painter Robert S. Duncanson was influenced by Thomas Cole, who, in the 1820s, painted views around Cincinnati, where Duncanson lived for the major portion of his adult life. Duncanson's *Blue Hole, Little Miami River* [212] presents an example of conventional pictorial space that has been divided into clearly defined areas of foreground/middleground/back-

we discussed Francisco deGoya's *The Executions of the Third of May, 1808* [210] in terms of approximate symmetry. We look now at Goya's use of space.

While there certainly are pockets and passages of varying degrees of spatial depth developed within this painting, notice that the hill on the left and the building behind close off our view, which is entirely in keeping with the suffocating, repressive atmosphere of this work. The composition is comprised of two major groups of figures: victimized civilians and cold-blooded executioners. The shallow space of the left half of the composition keeps us up close to the group of spotlighted Spanish civilians, thereby allowing us to see in vivid detail their horrified reaction to what is taking place. That the figures of this 8½- by 13-foot canvas are almost life-size adds considerably to the emotional impact they have on the viewer. The hill behind the Spanish civilians keeps us focused on their plight. Following the top edge of the hill down and around the left contour of the French soldier closest to us, to the shadow stretched diagonally across the middle of the ground plane, there is an illuminated pocket of space enveloping the

The **Hudson River School** refers to a group of nineteenth-century American landscape painters that included Asher B. Durand, Samuel F. B. Morse, and, later, John F. Kensett, Frederick E. Church, and Albert Bierstadt. The artists involved with this kind of Romantic painting of the American landscape created many (but by no means all) of their scenic works around New York's Catskill Mountains, near the Hudson River.

211
Thomas Cole. *Schroon Mountain,
Adirondacks*. 1838. Oil on canvas,
39⅜ x 63" (1 x 1.6 m). The Cleveland Museum of Art, The Hinman B.
Hurlbut Collection, 1335.17.

212
Robert S. Duncanson. *Blue Hole,
Little Miami River*. 1851. Oil on
canvas, 29¼ x 42¼"
(74.3 x 107 cm). Cincinnati Art
Museum, gift of Norbert Heerman and
Arthur Helbig.

ground. The brightly illuminated body
of water in the middleground opens up
the space between the strip of land in
the foreground and the mass of trees in
the background. Like outstretched,
welcoming arms, the top edge of the
trees, sloping down from the top
corners, and meeting near the center
of the painting, invite us into the
furthermost reaches of the landscape.

The deep space of this vista contributes to and harmonizes with the
atmosphere of unbounded peace
surrounding the fishermen situated
along the river's edge.

Considered within the context of free-
spirited individuals hiking boldly into
the untamed wilderness to paint the
grand vistas of America, it is particu-

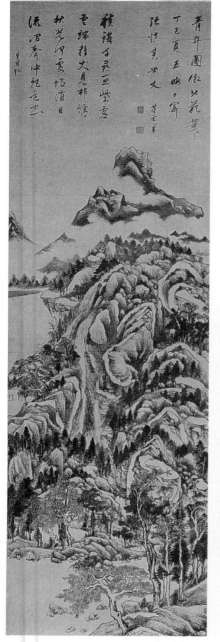

larly unsettling to discover that the actual site for the picturesque *Blue Hole, Little Miami River* served as a hiding place for fugitive slaves. Duncanson, a black man who painted pictures celebrating the unbounded beauty and free spirit of nature, was himself not free to enjoy many of the civil liberties that his white counterparts took for granted.

For artists of the Hudson River School, landscape space meant penetration *into* the illusory depths of an image. Deep space is not, however, always the most important aspect of spatial expansiveness in landscape painting. In many examples of Chinese landscape painting, we tend to enter the image from the bottom of the scroll and move *upwards along the*

213
Tung Ch'i-ch'ang. *The Ch'ing-pien Mountain.* 1617. Hanging scroll, ink on paper, 88⅜ x 26½"
(2.24 x .67 m). The Cleveland Museum of Art, Leonard C. Hanna, Jr. Fund, 80.10.

214
Kao K'o-kung. *Mountains in the Rain.* Yuan Dynasty (1279–1368). Hanging scroll, ink on paper, 48¹/₁₆ x 31¹⁵/₁₆" (122.1 x 81.1 cm). Collection of the National Palace Museum, Taipei, Taiwan, Republic of China.

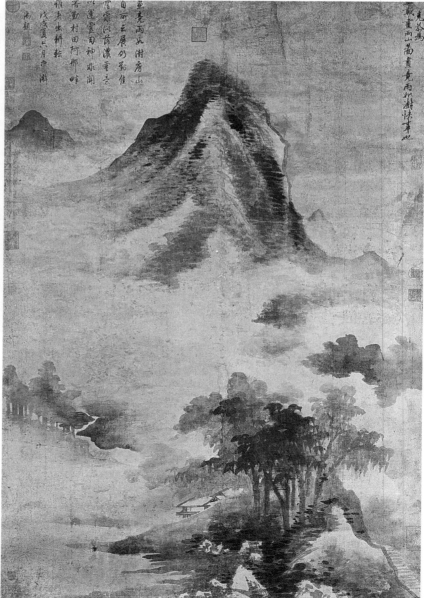

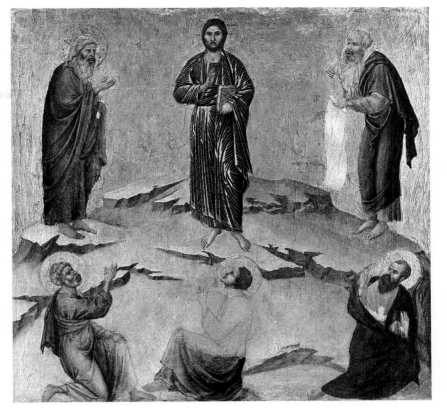

215
Duccio di Buoninsegna. *The Trans-figuration of Christ*, from the back predella of the *Maestà Altar.* 1308–1311. Tempera on panel, 18⅛ x 17⅜" (46 x 44 cm). Reproduced by courtesy of the Trustees, The National Gallery, London.

surface, not primarily back *into the space*. The Chinese painter and influential art theorist Tung Ch'i-ch'ang did not choose to create a sense of deep recession by diluting the tones of his ink with water in *The Ch'ing-pien Mountain* [213]. Nor did he make distant forms appreciably smaller as they recede. Both are methods he might well have adopted had he wanted to emphasize the deep space of the scene. Rather, he emphasized the verticality of his painting by creating a complex series of weaving passages that direct us up the mountain and then back down again. The very choice of the long, narrow format of the hanging scroll accentuates verticality over depth.

Several unpainted areas located near the top of the scroll separate the uppermost regions of the mountain from the rocky mass below. Here, the suggestion of clouds floating in front of the mountain creates a degree of depth. Simultaneously, the overlapping clouds provide a welcome horizontal contrast of relatively large proportions that stand out against the wealth of tightly woven vertical, diagonal, and curvilinear passages that otherwise dominate the landscape.

In the thirteenth-century Chinese Yuan painter Kao K'o-kung's *Mountains in the Rain* [214], a proportionately small area of the scroll has been developed into solid masses as the

intangible substance of mist over-whelms the landscape. In Chinese painting this kind of intangible mist or "empty" space (*hsu*) is understood to be substantive; it is not so much space between things as space that does not happen to contain objects (*shih*). Understood in this light, the corresponding Western term *negative space* becomes vividly inapt. There is nothing negative or absent about the empty space of *Mountains in the Rain*; a celebration of space is the subject of the painting.

METHODS OF CREATING SPATIAL DEPTH

The principal methods pictorial artists have relied on to create the illusion of spatial depth are: 1) overlapping, 2) size differentiation, 3) placement, 4) linear perspective, 5) atmospheric or aerial perspective. Earlier in this chapter we observed how the practices of overlapping and size differentiation contributed to the illusion of spatial recession. In this section we will see

how placement and several systems of perspective enable artists to create the illusion of three-dimensional space on a two-dimensional surface.

PLACEMENT

Generally speaking, the higher a detail is placed within an image, the further back in space it appears to be. In Kao K'o-kung's *Mountains in the Rain*, the sense of spatial depth stems from our inclination to read the peak of the mountain as being farther away from us than the large cluster of trees below, despite the fact that the ink tones describing the trees are significantly lighter than those describing the mountain peak.

Another example of spatial depth suggested by placing one form above another is evident in *The Transfigura-tion of Christ* [215], created by Duccio di Buoninsegna. In *The Transfiguration* none of the figures overlap. Because the three figures at the bottom of the composition are smaller in size than the three figures above, we ought to

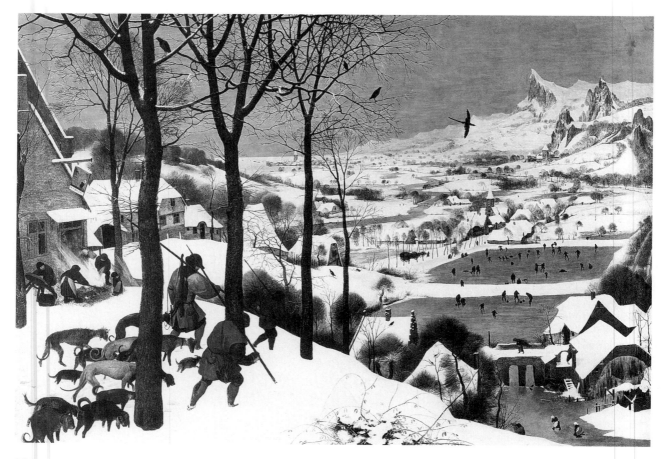

216
Pieter Bruegel the Elder. *Return from the Hunt.* 1565. Oil on panel, 3'10" x 5'¾" (1.17 x 1.54 m).
Kunsthistorisches Museum Vienna.

read the bottom figures as being located farther away from us in space. But this is not the case. We tend to associate forms or other details that are placed high within a two-dimensional composition as being located farther back in space than details placed lower in the same composition, and so we read the top row of three figures as being located farther away from us than the bottom row of disciples.

Consider, on the other hand, the sixteenth-century painter Pieter Bruegel the Elder's *Return from the Hunt* [216]. Because our vantage point is considerably elevated in Bruegel's landscape, and because the largest and closest forms are situated on a hill, most of the forms that occupy the plane of the foreground are positioned higher within the composition than the forms that spread out before us deep into the distance. This example, which contradicts the idea of

higher placement/deeper space, is included in this section not to confuse you, but to remind you that in art, general principles do not carry the absolute authority of hard and fast rules. Ultimately, we can never figure out how to look at a work of art any more than an artist can figure out how to make one. Each image or object asks to be treated as the unique experience that it is, regardless of even the most useful general principle that might serve to simplify the complex process of interpreting a work of art.

PERSPECTIVE

Perspective is a convention, or system, used by artists to create the effect of three-dimensionality or distance on a two-dimensional surface. The primary ways pictorial artists have used perspective as a means of creating spatial recession involve linear and atmospheric perspective.

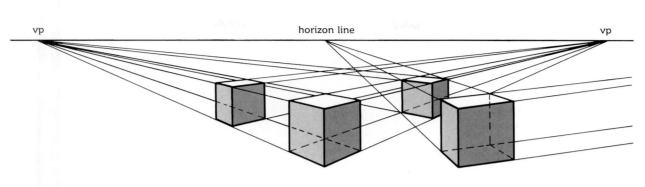

217
Two-point perspective with multiple vanishing points.

Linear Perspective

How peculiar the space of Bruegel's *Return from the Hunt* would be if the artist had painted the tiny black shapes of the skaters onto the large foreground hill, and repositioned the large forms of the hunters and dogs from the foreground to the sheets of ice in the deep middle ground. Twentieth-century sensibilities might be pleasantly intrigued by such a disorienting spatial reversal, but it is not likely that such a somersault of pictorial naturalism would have been well-received by Bruegel, his audience of viewers, or by the inventors of linear perspective. Italian Renaissance artists including Filippo Brunelleschi, Leon Battista Alberti, Massaccio, Donatello, Piero della Francesca, and Paolo Uccello developed a geometrical system that allowed them to create the illusion of recessional space with a reasonable degree of predictability. This system, known as **linear perspective,** perfectly suited their view of a world that they believed was thoroughly ordered and logical—just like the system of visual representation they invented to describe it.

There are three key factors involved in linear perspective:

1) Distant forms appear to be smaller than forms that are near. Although we know that a person standing next to us is actually the same size as that same person when he or she is standing 100 feet away, distance may cause the faraway person to appear to be smaller than the size of your hand.

2) Parallel lines that are not parallel to the picture plane (that is, parallel lines that appear to recede into the spatial depths of an image) converge at a common vanishing point positioned along a common (sometimes visible, sometimes implied) **horizon line** **[217]**. Of course, by definition, parallel lines will never converge. But here, as in many other instances of visual communication, actual fact and visual effect often amount to two different things.

3) The horizon line always conforms to the implied height of the artist's and viewer's eye level or line of sight within the image. When you are kneeling or sitting down in a room, your eye level or line of sight is relatively low. The horizon line appears to stretch out directly in front of your line of sight. When you stand up in the room, your eye level is elevated. The horizon line appears to rise with you, your eye level determining the height of the horizon line. In a picture, eye level corresponds to the vantage point from which a view is perceived.

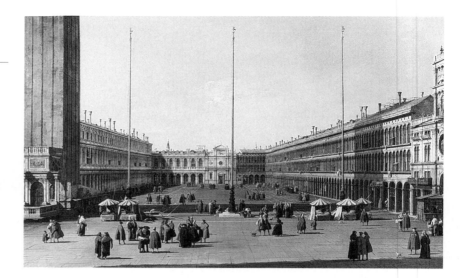

218

Antonio Canaletto. *Piazza San Marco, Venice*. c. 1735–1745. Oil on canvas, 29¾ x 46¾" (75.57 x 118.75 cm). ©The Detroit Institute of Arts, Founders Society Purchase, General Membership Fund with a donation from Edsel B. Ford. (43.38)

219

One-point perspective in Canaletto's *Piazza San Marco, Venice*.

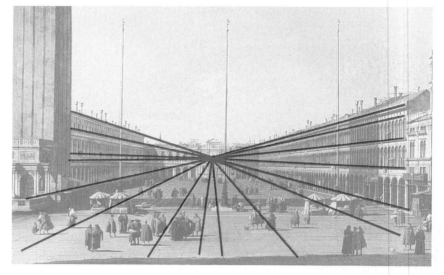

The *Piazza San Marco, Venice* [218], painted by the eighteenth-century Venetian artist Antonio Canaletto, offers a clear example of **one-point perspective.** In this geometrical system a single vantage point is established along a single horizon line. Parallel lines that could be extended from each of the forms drawn in perspective converge at this common vantage point. Notice how each of the extended lines in our diagram [219] that recede into space converge at the common vanishing point of the circular window located in the very center of the composition. The mathematical order and relative symmetry represented here create a measured sense of harmony and stability.

When a form is viewed from an angle, a system known as **two-point perspective** is applied. In this system, two vanishing points are established along the same horizon line for each form that is seen from an angle [220]. Canaletto used this system of perspective in his *View of Venice, Piazza and Piazzetta San Marco* [221]. Less steadfast in feel than *The Piazza San Marco, Venice*, in *View of Venice, Piazza and Piazzetta San Marco* the artist gives us a choice. We can take a straight route through the painting, penetrating the piazzetta to the left of the bell tower all the way to the ships docked at the Grand Canal, or, upon entering the painting, we can turn to the right and explore the wider space of the piazza. The lines established by

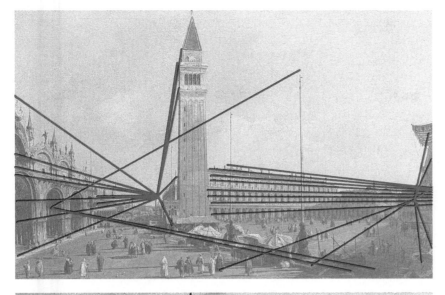

220
Two-point perspective in Canaletto's *View of Venice, Piazza and Piazzetta San Marco.*

221
Antonio Canaletto. *View of Venice, Piazza and Piazzetta San Marco.* c. 1730–1741. Oil on canvas, 26³⁄₁₆ x 40½" (66.5 x 103 cm). Wadsworth Atheneum, Hartford. The Ella Gallup Sumner and Mary Catlin Sumner Collection.

the diminishing heights of the flagpoles converge toward still another vanishing point.

Atmospheric Perspective

Based on the principle that the farther away a form is from the viewer, the less distinct it appears to be, aerial or **atmospheric perspective** offers artists another means by which to create the illusion of depth on a two-dimensional surface. Several of the images we have discussed in this chapter provide clear examples of this principle. Look at Duncanson's *Blue Hole, Little Miami River* and Bruegel's *Return from the Hunt.* In these paintings details become subdued or merge as the space recedes. In each case, the three-dimensionality of the forms, the definition of the textures and edges of the forms, and the intensity of the colors and the light appear more toned down the farther into the space we go.

As we noted in the preceding section on linear perspective, what we know to be the case in a given situation is often in conflict with what *appears* to be the case. A form does not actually change in color or tonal intensity as it recedes—it only looks like it does, which is all an artist needs to work with. Systems of perspective are artificial systems invented as a means

222
Paul Cézanne. *La Montagne Sainte-Victoire*. 1885–1887. Oil on canvas, 26⅜ x 36¼" (67 x 92 cm). Courtauld Institute Galleries, London. Courtauld Collection.

of translating space, a pictorial component that is by nature three-dimensional and intangible, onto a tangible, two-dimensional support. Strictly adhered to, systems of perspective can stifle an artist's imagination. Like any other artist's tool, however, when manipulated sensitively they can lead to inventive, moving solutions to the most demanding of artistic problems.

SPACE AND SCALE

"If one wishes to paint a high mountain," wrote the Sung painter Kuo Hsi, "one should not paint every part, or it will not seem high. When mist and haze encircle its waist, then it seems tall. . . ."[11] The empty space of the mist contributes greatly to the sense of scale that we feel when we look at the mountain in Kao K'o-kung's *Mountains in the Rain* **[214]**.

Scale is a function of separate yet related determinants: physical size—how big or small something *actually* is—and how big or small it *seems to be* as a result of its relationship to surrounding elements and, consequently, as a result of the emotion it elicits in us. In the visual arts, two plus two does not always equal four. Often a work of art will appear bigger or smaller than it actually is. Scale is what we respond to when the *impression* of a work's size and the *actual dimensions* of that work do not correspond. When a large work strikes us as particularly grand, or a small work strikes us as particularly tiny or intimate, the striking factor is scale.

223
Albert Pinkham Ryder. *Under a Cloud*. Early to middle 1880s. Oil on canvas, 20 x 24" (50.8 x 61 cm). The Metropolitan Museum of Art. Gift of Alice E. van Orden in memory of her husband, Dr. T. Durland van Orden, 1988.

Responding to Paul Cézanne's series of paintings of *Mont Sainte-Victoire* **[125]**, **[222]**, the German poet Rainer Maria Rilke endowed Cézanne's mountain—or, at least, Cézanne's vision and interpretation of the mountain—with mythic dimensions: "Not since Moses," Rilke wrote, "has anyone seen a mountain so greatly."[12] In reality, Mont Sainte-Victoire is not all that big for a mountain—from many vantage points it is little more than a hump. But once you have seen Cézanne's paintings of it, it becomes

224

Michelangelo Buonarroti. *Crucifixion of Amman* and *The Brazen Serpent* bordering *The Prophet Jonah,* detail of the Sistine Chapel ceiling. 1508–1512. Fresco. Vatican Palace, Rome.

virtually impossible to see it ever again as the large hill that it actually is. Why? Partly because Cézanne portrayed it from its most impressive angle. But more fundamentally because he captured its monumentality—its scale, not its size. He made it big not only in relation to its surroundings but in relation to itself. It was to this same sense of scale that the twentieth-century painter Marsden Hartley was referring when he described his impression of a seascape such as *Under a Cloud* [223] by the nineteenth-century American artist Albert Pinkham Ryder. The painting

was, Hartley wrote, ". . . a marine of rarest grandeur and sublimity, incredibly small in size, incredibly large in emotion."[13]

From a purely visual point of view, artists regularly use scale shifts as a means of making a composition more exciting. Like the sudden intensification or toning down of a color, the expansion or reduction in size of a shape or form often plays an instrumental role in enlivening an image or object. Placed directly against each other, large and small forms often appear to be even larger or smaller

than they actually are. Scale shifts play an important role in the overall pattern of compositions that make up Michelangelo's series of fresco panels painted for the *Sistine Chapel* [112]. Notice how the single figure of *The Prophet Jonah,* which is positioned between the triangular cloister vaults depicting *Crucifixion of Amman* and *The Brazen Serpent* [224] looms so much larger than the figures contained within the two bordering images. Because he is so much bigger than the figures immediately surrounding him, he assumes a monumental presence. Also contributing to his sense of

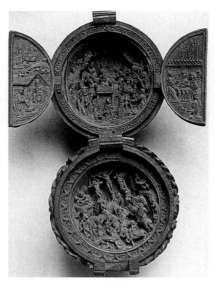

225
Rosary Bead, Flemish, 16th century.
Boxwood, diameter 2⅛" (5.4 cm).
The Metropolitan Museum of Art.
Gift of J. Pierpont Morgan, 1917.

The **Post-Modern** movement has continued to influence artists and architects since its development in the 1970s. It is characterized by an acceptance and re-examination of historical forms, which are often introduced within a given work as a complex, interacting sequence of conflicting styles. Many of the most prominent features of Post-Modern art and architecture challenge standard tenets of Modernism. For example, in contrast to the austere, undecorated exteriors of the steel-framed skyscrapers of Modernist architects Ludwig Miës van der Rohe, Post-Modern architects such as Americans Michael Graves, Robert Venturi, and Charles Moore, or Japanese Arata Isozaki and Toyokazu Watanabe, regularly incorporate moldings and ornamentation into their work.

monumentality is the fact that Jonah so thoroughly dominates the space he occupies. Unlike the two bordering images, there are relatively few details surrounding the Jonah figure that compete for our attention. By overlapping the framing device of one of the carved posts behind him, he serves notice with his arms, shoulder, and head that he is too powerful, or restless, to be contained.

Of course, scale in the visual arts plays as significant a role in small and medium-sized works as it does in works of large dimensions. Images and objects that are small in size can be big in scale, and ones that are physically big do not necessarily create big impressions. Certainly, the notion that bigger is better has as little to do with determining quality in the visual arts as it does in most other areas of life. How an artist manipulates the visual elements in relation to a particular conception determines the scale of a big, small, or medium-sized work of art. The conception of scale ranges from the monumental to the intimate. What matters is not that a given work is big or small, but that its size and sense of scale effectively contribute to a particular idea or emotion.

The importance of scale can become accentuated because an image or object is particularly small in size. The

2 ⅛ inch by 2 ⅛ inch sixteenth-century Flemish *Rosary Bead* **[225]** would fit comfortably into the hand of most adults. Despite its diminutive size, carved into the hollowed-out interior of this sphere are scenes from the New Testament featuring the Nativity and the Crucifixion—big themes to be sure. A profusion of people, animals, and environmental information is packed into this tiny space. The intricacy of these forms forces our vision down to a scale far smaller than most of us would expect given the subject matter, the medium employed, and the inordinate amount of detail included. Here, size plays a decisive role in providing the bead with the quality of intimacy that so engagingly distinguishes it.

Few of us associate skyscrapers with smallness; the word itself suggests towering height. Yet, one of the challenges assumed by the American **Post-Modernist** architect Michael Graves in designing the *Humana Building* **[226]** involved making the 26-story building look and feel small, not tall. In terms of scale the *Humana Building* functions as a transition between the buildings located on either side of it: on one side of the Humana there is a tall, Modernist tower of steel and glass; on the other side there is a row of low, nineteenth-century buildings. The most notable means by which Graves integrated his building within this pre-existing architectural environment involves his break-up of the structure into two visually related yet significantly different sections. The main entrance is located within a modest seven-story section that is closely related in scale and appearance to the row of nineteenth-century buildings. This seven-story section is attached to a much taller structure that brings us up closer to the height of the adjacent skyscraper. Graves humorously refers to the taller part of his building as the box the smaller part came in.[14] By packaging the building in this way,

and by introducing other features, such as the twenty-fifth-floor balcony with its emphatic horizontal arch, Graves diminished the sense of expansive scale that one would ordinarily associate with an uninterrupted vertical climb of a tall building.

Occasionally, when a work of art combines large size and large scale, the combination of immense physical proportions and an *impression* of immensity transforms the visual into what can best be described as a spiritual experience. Such is the achievement of an architectural structure such as the *Pantheon* [227] in Rome. The *Pantheon* is the best-preserved building from ancient times. It was designed, at least in part, by the Roman emperor Hadrian as a monument to the seven planetary gods— Jupiter, Saturn, Venus, Mars, Mercury, Apollo the sun, and Diana the moon. Standing within the expansive space of the central rotunda and looking up

to the huge dome, 144 feet in diameter, it is easy to understand why throughout the ages architects have incorporated into buildings of worship the encircling form of the dome: it readily brings to mind an image of heaven.

226
Michael Graves. The Humana Building, Louisville, Kentucky. 1982–1985.

227
The Pantheon, Rome. 118–125 A.D.

HAGIA SOPHIA
BY ANTHEMIUS OF TRALLES AND ISIDORUS OF MILETUS

228
Anthemiaus of Tralles and Isidorus of Miletus. Interior of Hagia Sophia, Istanbul. 532–537 A.D.

Before reading the text that accompanies *Hagia Sophia* [**228, 229**], designed by the architects Anthemius and Isidorus, think about this structure by answering the following questions. The exterior is shown in Chapter 3 [**82**].

1. What impression do you think the huge scale of the interior would have on you if you had the opportunity to visit this Byzantine church?

2. An unusually large number of windows punctuate this structure and saturate the interior with light. Why do you think the architects chose light as such an important element in their design?

3. This building has been described as a more noble building "than those which are merely huge." What do you think the writer meant by this?

4. Why do you think that, like the dome, all the windows of this building are arched? What effect do you think this repetition of the curved line might have on the overall unity of the building?

The most ambitious Gothic cathedral nave, or central space of a church, never spanned a width of more than 55 feet. In *Hagia Sophia* (Greek for Holy Wisdom), the most important architectural achievement of the Byzantine period, Anthemius of Tralles and Isidorus of Miletus created an open space that is 100 feet wide and 200 feet long. Particularly outstanding is the dome, which reaches a height of 183 feet. Hagia Sophia was originally built as a Christian church in Istanbul (then called Constantinople) when this city was the capital of Byzantium. The church was completed in 537 A.D. and has undergone several major architectural changes since then. None of the changes deny the overwhelming sense of unearthly scale that one feels upon entering the building.

By establishing a dramatic connection of space, scale, and feeling, *Hagia Sophia* merges the physically grand with the spiritually exalted. Although it incorporates enormous expanses of stone, there is an undeniable feeling of weightlessness to the building due in part to the inordinate number of windows that punctuate and, in effect, dissolve the walls [229]. In accord with the predominant form of the building—the dome—every one of these windows is arched. Because of this ring of light, the massive dome appears to float in mid-air. The forty windows incorporated into the architectural program of *Hagia Sophia* admit far more light than is functionally necessary to illuminate the interior of the church. Why, then, so many windows and so much light? The answer is probably connected to the notion of divine light. In many religious traditions, light functions as a symbol of divinity, or divine wisdom; the sun and its rays are thought to represent the eternity of God and His illumination of mortals. The suffusion of light in *Hagia Sophia* created what many believed was a spiritual atmosphere analogous to that of heaven, where the faithful would be bathed in God's light.[15]

One of the best descriptions of *Hagia Sophia* was provided by the critic/historian Procopius of Caesarea, who was commissioned by Justinian, the emperor of Byzantium, to glorify the church. Notice how the following excerpted statements allude to the inextricable connection between the visual principles of space and scale. *Hagia Sophia,* writes Procopius, "soars to a height to match the sky . . . it is both more pretentious than the buildings to which we are accustomed, and considerably more noble than those which are merely huge, and it abounds exceedingly in sunlight and in the reflection of the sun's rays from the marble. . . . And upon this circle rests the huge spherical dome which makes the structure exceptionally beautiful. Yet it seems not to rest upon solid masonry, but to cover the space with its golden dome suspended from heaven. All of these details fitted together with incredible skill in mid-air and floating off from each other and resting only on the parts next to them, produce a single and most extraordinary harmony."[16]

Of course, to produce such harmonious and ethereal effects on such a large physical scale takes more than just a poetic sensibility—it takes great engineering sophistication. In *Hagia Sophia,* the grandeur of the space is

229
Interior, *Hagia Sophia.* Height of dome 183' (55.78 m).

230
Construction of pendentives.

the offspring of a marriage between the science and art of architecture. Consider the challenge posed by the huge dome. Because a dome is circular it fits most comfortably on a circular or cylindrical building, as is the case, for example, in the *Pantheon* [227] in Rome. The base of the main section of *Hagia Sophia* is square. The architects of *Hagia Sophia*, Anthemius and Isidorus, solved this problem by using what is known as **pendentives [230]**, spherical triangles constructed out of masonry that distribute the weight of a dome outward rather than straight downward. By serving as a transition from a spherical dome to a square base, pendentives enable architects to design taller and more expansive domes than would otherwise be possible. Moreover, the pendentives allowed the architects to dispense with any supporting walls immediately beneath the dome, thereby allowing the space below the dome to open out into far greater dimensions than would have been possible had they not incorporated the pendentives into the design. The overwhelming scale of the interior space is, to an important degree, a result of this uninterrupted flow of space from one area to another.

CRITICAL QUESTIONS

1a. In the violently climactic scene of *Sardanapalus*, a play by the Romantic writer Lord Byron, the Assyrian monarch Sardanapalus, realizing that the fall of his empire is imminent, "commands his eunuchs and the officers of the palace to slaughter his wives, his pages, and even his favorite horses and dogs, since none of the objects that have contributed to his pleasure must survive him."[17] Eugène Delacroix based one of his largest, most magnificent, yet most repulsive works, *The Death of Sardanapalus* [231], on the protrayal of this scene. Cite some of the pictorial devices that enable Delacroix to evoke the frenzy of the moment.

b. The traditional interpretation of the female nude in art is brutally overturned in *The Death of Sardanapalus*. Typically, the female nude has been portrayed as epitomizing qualities such as grace and tranquility, as we saw, for example, in Ingres's *La Grande Odalisque* [95]. Such is not the case here. Of course, *The Death of Sardanapalus* and *La*

Grande Odalisque differ in many ways other than those involving the portrayal of the female nude. Characterize some of the differences between Delacroix's portrayal of space in *The Death of Sardanapalus* and Ingres's portrayal of space in *La Grande Odalisque*. How does the particular portrayal of space in each of these paintings affect the overall spirit or emotion conveyed in these works?

c. Cite examples of the following methods by which Delacroix created spatial depth in *The Death of Sardanapalus*: 1) overlapping, 2) size differentiation, 3) placement, 4) linear perspective, and 5) atmospheric perspective.

d. Where would you say the horizon line is located in this painting? Cite an example of a form portrayed in two-point perspective in this painting.

e. The twentieth-century Spanish painter Joan Miró once compared his small paintings to tales and his large paintings to dramas.[18] In this respect,

how would you characterize Delacroix's *The Death of Sardanapalus*, which measures 12'1" in height by 16'3" in length? Explain what is meant by the statement that the scale, as well as the size, of *The Death of Sardanapalus* is large.

f. Examine your feelings regarding the idea of an artist portraying in exquisite detail and in rigorously considered compositional and technical terms a subject as horrifyingly offensive as Delacroix's painting.

2a. In the contemporary American artist Judy Pfaff's mixed media environmental installation, *Kabuki (Formula Atlantic)* [232], the space that she manipulates is physical, not solely illusionistic. The format within which Pfaff portrays her vision is not a flat easel painting that she can hang on a wall, nor a single object that she can carve or in some other way fashion into a descriptive or expressive form. Rather, her canvas is the walls, floor, and ceiling of a corner of a room in the Hirshhorn Museum, and her

paint strokes or chisel marks or
collaged materials are the wires, tree
branches, and the reflections and cast
shadows of a wide assortment of other
materials. But despite the
untraditional format and materials of
Kabuki (Formula Atlantic), Pfaff's
formal or artistic challenge is not
actually that different from the
challenge faced by more traditional
artists. Faced with a blank piece of
paper or a canvas, traditional artists
attempt to activate the picture plane
by applying lines, shapes, colors,
textures, and so on, in such a way as to
create an exciting visual arrangement
that will engage the mind and/or heart
of a viewer. There is no picture plane
in Pfaff's installation. Nonetheless, she
is faced with essentially the same set of
problems as are more traditional
artists. Explain.

b. With traditional pictorial
imagery, our eyes enter the work of art,
but our bodies remain physically
outside the illusion. With *Kabuki
(Formula Atlantic)* we can walk all
around the elements of the installa-
tion, our bodies physically activating,
in effect, the negative spaces of the
work. In this sense, would you say that
Kabuki (Formula Atlantic) is like a
three-dimensional painting? Explain.

c. Although the bright colors,
scribbly lines, and extravagantly
diverse materials that comprise *Kabuki
(Formula Atlantic)* create a hectic, or

erratic, sense of movement, an overall
sense of harmony informs the work.
Explain.

d. An aquatic subject is suggested
by the many blue, blue-green, and
violet colors of Pfaff's installation, as
well as by the title of the work. Yet,
Kabuki (Formula Atlantic) certainly
does not look like a traditional
seascape. Does Pfaff's highly interpre-
tive solution to the challenge of an
aquatic theme excite your imagination
or disturb your sense of convention?

8

Rhythm

Rhythm in the visual arts can be defined as a sometimes regularized, sometimes unruly movement or flow that is created by an actual or implied connection between the parts of a composition. Because it brings together separate parts of a composition, rhythm functions as a means by which artists create unity in their work. Repetition and interval, components of the element of pattern (see Chapter 4), play key roles in creating rhythm in the visual arts, but that does not mean that rhythm is another word for pattern. Repetition with uniformity results in a **pattern,** while repetition with variation plays a prominent role in a rhythmical passage. In this sense, the intertwining lines of the Emperor Hui-Tsung's *Calligraphy of the Five-Colored Parakeet* **[233]**, and the multi-layered and multi-colored brushstrokes of the contemporary American painter Joan Mitchell's *Sans Niege* **[234]** are more appropriately described as rhythmical than patterned.

The parts of a pattern function primarily as members of a larger arrangement, but this is not a requirement for a rhythmical passage. Although Antonio Pollaiuolo's *Battle of Ten Naked Men* **[235]** is relatively free of pattern, it displays significant rhythmical unity. The forms of the men's bodies, and details such as the three centralized, upraised swords create unifying, rhythmical passages because of their visual similarities (of shape, tone, etc.). Despite the fact that the combatants look like they all worked out at the same gym, there are significant differences in the gesture and angling of each of their bodies. Likewise, each of the weapons they brandish is uniquely handled.

絹膺紺趾誠端雅為賦新篇步武吟

飛鳴似怜毛羽貴徘徊如飽稻梁心

體全五色非凡質惠吐令言更好音

天產乾皋此異禽遐陬來貢尤重深

因賦是詩焉

種態度縱目觀之宛勝圖畫

翔翥其上雅諒容與自有一

於苑囿間方中春繁杏遍開

纂馴服可愛飛鳴自適往來

五色鸚鵡來自嶺表養之禁

233
Emperor Hui-Tsung. Calligraphy from *The Five-Colored Parakeet*. Handscroll, ink and colors on silk, 21 x 49¼" (53.3 x 125.1 cm). Maria Antoinette Evans Fund. Courtesy, Museum of Fine Arts, Boston.

234
Joan Mitchell. *Sans Niege*. 1969. Oil on canvas, 102 x 198¼" (259.1 x 503.6 cm). The Carnegie Museum of Art, Pittsburgh; Gift of The Hillman Foundation, Inc., 1970.

Every set of related circumstances establishes some kind of rhythm. The greater the likeness between the circumstantial details, the more readily apparent the rhythm will be. Conversely, the more the parts differ, the more unpredictable and complicated a particular rhythmical passage will appear. In a given set of related circumstances, a rhythm holding them together can always be discerned.

The following non-art experience represents one of many incidents that shaped my understanding of the organizational element of rhythm in the visual arts. As a commuting college student I was often late for class. This time I was running late for a final exam. Mostly out of nervous energy, partly to try to hear the time, I fidgeted with the dials of the car radio. As I waited to pay a toll, I heard portions of a half-dozen rock songs; the results of the previous night's basketball scores; a news report; a caller complaining to an impatient talk show host that he, the caller, couldn't make friends; and a commercial.

After passing the toll booth, traffic began to move and I made up as much time as I could by weaving from lane to lane on the highway. Traffic was first light, then congested, then light again. My heartbeat accelerated whenever the traffic came to a halt.

235
Antonio Pollaiuolo. *Battle of Ten Naked Men.* c. 1460. Engraving, 15⅛ x 23³⁄₁₆" (38.4 x 58.9 cm). The Metropolitan Museum of Art, Purchase, 1917, Joseph Pulitzer Bequest. (17.50.99)

236
Paleolithic cave painting of a horse, Lascaux, Dordogne, France. c. 15,000–10,000 B.C.

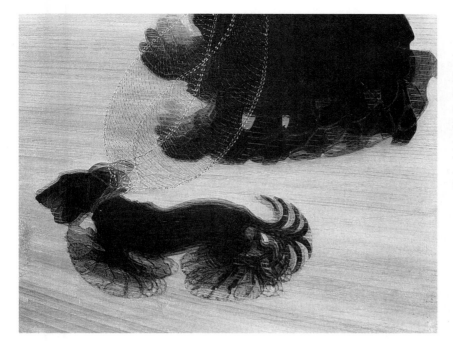

237
Giacomo Balla. *Dyanamism of a Dog on a Leash*. 1912. Oil on canvas, 35⅜ x 43¼" (89.9 x 110 cm). Albright-Knox Art Gallery, Buffalo, New York. Bequest of A. Conger Goodyear and Gift of George F. Goodyear, 1964.

As I approached school I seemed to slip into a steady pattern of slow-motion driving that was governed by the blink of a traffic light. Myrtle Avenue. Stop. Willoughby Avenue. Stop. Dekalb. Stop. Arriving at school, I parked the car, ran to class, and began my exam.

It was quiet. But instead of focusing on the exam, I thought about the drive to school with all its conflicting speeds, noises, tensions, stops and starts, repeating patterns, and seemingly arbitrary juxtapositions of charged movements and moments. The separate incidents formed an overall stop-and-go rhythm. The friendless caller did not live alone in my memory, but rather, as part of several songs, a commercial, and a news report. I had changed lanes on the highway the way I had changed radio stations—anxiously and often. I had brought the rhythms of the highway and the city into the classroom with me.

In a way, this is what artists do all the time, except that their classrooms are their studios. They translate the rhythms of the world into sculptural, architectural, environmental, or pictorial form. The works in this chapter provide a few examples.

MOVEMENT

Movement—either of the viewer's eye in connecting visual details, or of the subject matter itself—is one of the primary components of rhythm. Movement has played a prominent role in visual expression for as long as individuals have been making images and objects. The subject of much prehistoric art is movement. We can only conjecture as to the meaning and function that the herds of beasts painted onto cave walls had for the individuals who created them. What is certain, however, is that many of these painted beasts are in motion **[236]**. If the **Futurist** painter Giacomo Balla's *Dog on a Leash* **[237]** is any indication, time has not tired the muscles of less-ancient beasts or other more domesticated animals. Movement plays a part of every work of art, whether or not the literal subject portrayed, or the conception that informs an **abstraction**, involves action or inaction. In the eighteenth-century Indian miniature entitled *Lady from Lord Clive's Album* **[238]**, a rhythm of stillness established by the framed insert, and the individual, vertical flowers decorating the border, reinforces the stabilized pose of a solitary woman. Compare this image to that of another Indian miniature,

Futurism, an early twentieth-century movement in painting and sculpture, was greatly influenced by the writings of the Italian poet Filippo Tomasso Marinetti. Marinetti's ideas were further developed by a group of Italian artists that included Umberto Boccioni, Giacomo Balla, Carlo Carra, and Gino Severini. At the heart of this movement was an abhorrence of the past and a wholehearted acceptance of technology and the future, the idea that artists must dedicate themselves to portraying what the Futurists referred to as the "universal dynamism," the speed and movement that governs all things.

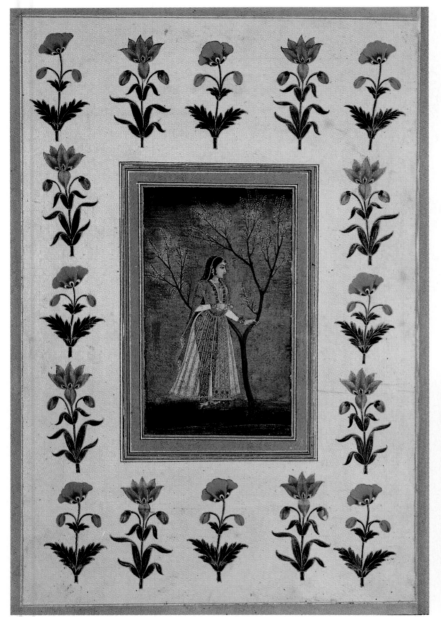

238
**Lady from Lloyd Clive's Album,
Mogul miniature, 18th century.**
Victoria and Albert Museum, London.

239
**Two Dancing Girls, Mogul
miniature, 17th century.**
Courtesy Indian Museum, Calcutta.

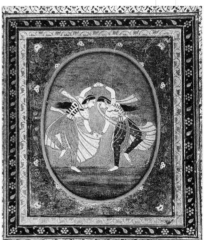

Two Dancing Girls **[239]**. The subject of the second image is motion, and the pictorial details of the two figures, as well as the surrounding borders, establish a rhythm that is appropriately active in nature. The artists of *Lady from Lord Clive's Album* and *Two Dancing Girls* both provided pictorial movement for the eyes of their audience: in one work the pictorial movement is slow, in the other, the movement is quick.

Movement, or more specifically, dance, is the literal subject of Henri de Toulouse-Lautrec's poster entitled

Moulin Rouge (La Goulue) **[240]**. Here, representational imagery and **typography** (a printing process based on the arrangement and design of letter characters or type) work together to create a lively, rhythmical advertisement for the Moulin Rouge, "the gayest music hall in Paris." Although La Goulue receives individual billing on the poster, she regularly performed with a dancing partner (the man in the foreground) who was popularly known as Valentin. Valentin leans decidedly backwards. He is in motion, as are the curving contours of his body that seem to

move in rhythmic response to the music that fills the air. His two hands, so separately realized, further distinguish the profiled man, while the two legs (no hands), the red and white polka-dotted blouse, and the billowing petticoats distinguish La Goulue, whose coiffure bounces along the skyline of silhouetted top hats and fancy hairdos.

This irregular black silhouette stretches across the width of the poster, reminiscent of a line of script. The peopled silhouette serves as a visual transition between the written

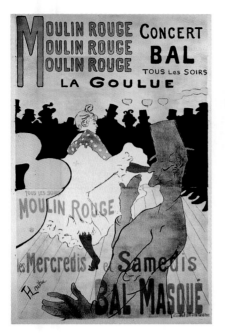

word and the illustrated figure. Above, repeated three times, the name "Moulin Rouge" establishes the beat. Below, as if in accord with the lilt of the music to which the dancers are performing, another "Moulin Rouge" floats across the white petticoats of the dancer. Words and pictures interact everywhere, creating a lively atmosphere of dancing and song.

Presumably, the young woman who posed for Henri Matisse's *Odalisque with Tambourine* **[241]** was paid to stand perfectly still. Yet her body appears to be in motion—due not just to the soft S-curve of her body, but to something more abstract. Depending upon the music you project into this painting, you may see the model shimmy, or shake, or undulate. In any case, there is movement. Her hips swing back and forth; her angled arms stretch; her skirted thighs sway; while her oversized feet simultaneously plant her firmly in place and shuffle restlessly atop a flower-covered carpet. Am I reading into this painting? Probably—the responsive viewer always does. But, basically, the artist persuades me to see as I do. The breasts, or more precisely, the nipples, are little red brushstrokes, small-scale reminders of the vermillion pattern dotting the partition. Look at how

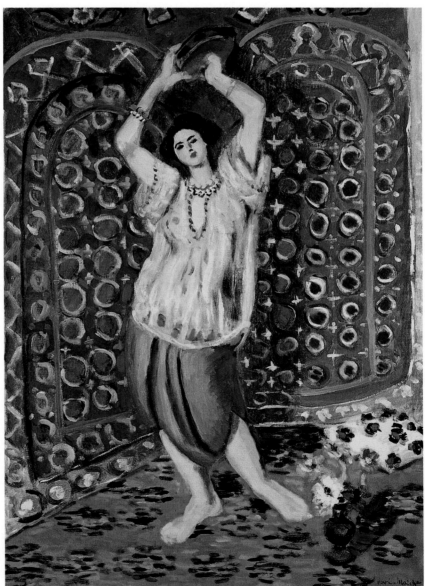

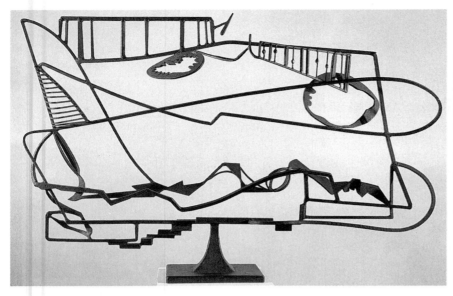

242
David Smith. *Hudson River Landscape*. 1951. Welded steel, 49½" x 63" x 16¾" (125.73 x 190.5 x 42.55 cm). Collection of Whitney Museum of American Art. Purchase. 54.14.

they join, through visual analogy, the circles slanting the background, making her breasts look like they bob up and down, back and forth. Notice how the dancer's low-slung belt slopes in the opposite direction from the out-of-kilter partition, jerking her lower body into motion. Slightly out of focus because of the movement of the see-through blouse, the belt and the dancer's hips wriggle gaily between the two sides of the backdrop. Her left foot points us toward the black and white flower. From there it is a short hop to the black and white throw pillow lying on the floor, which, in turn, leads up to the pattern (of similar scale) on the screen. The aggressive circles and dots exert an almost magnetic attraction on the jostling left foot. Even the floral embellishment on the carpet energizes the figure by suggesting footprints, or some kind of choreo-graphed system of steps. Her arms, too, get into the act. Her bracelets overlap the inner lines of the partition, thus connecting with them and being drawn into their pull. And her lower arms continue the arc of the outer lines of the screen. Like wings, the patterned panels seem to propel her body gracefully through the space.

But not only does the odalisque dance; she is a music maker as well. She rattles her tambourine and the twittering rushes through her body. It seems to invigorate what is outside her body as well. The red circles rain down around her when seen from the vantage point of the tambourine, the largest of the many red circular shapes inundating the painting.

Patterns comprised of no apparent variation are apt to be as monotonous as wallpaper. For Matisse, even flat, decorative patterns display rhythmical vitality. Look, for example, at the decoration of the screen: the lines, shapes, sizes, and color intensities of the pattern of circles are ever chang-ing.

Like every great artist, Matisse investigated ideas selectively. He was not particularly concerned with modeling three-dimensional form, as was Caravaggio, or describing three-dimensional space, as were Nicolas Poussin and Thomas Cole. From painting to painting, Matisse re-examined his obsession with color and rhythm, exploring the depths of decoration, the grace of movement, and the joy of life.

RHYTHM OF GESTURE

A component of movement is gesture. The rhythm of gesture involves one significant gesture relating to another, or to some other rhythmical passage within a work of art. In Chapter 2 we described gesture as the dynamic spirit, feeling, or attitude demonstrated by a

particular pose or motion. Such poses or motions extract a single moment from a sequence that unfolds over time. In figurative works of art, the gesture conveyed implies movement, often because our imaginations fill in what came before and after. Given the gesture of Matisse's *Odalisque with Tambourine*, we can anticipate how her feet, arms, or hips might move next. The before and after of more abstract works of art involve the way a viewer's eye is led from one area distinguished by a particular line, shape, form, tone, color, or texture—or a combination of these visual elements—to the gesture of another element. Examples of this kind of abstract gestural movement are evident in the twentieth-century American sculptor David Smith's *Hudson River Landscape* [242] and the contemporary American artist Frank Stella's *Thruxton 3X* [243]. In Smith's *Hudson River Landscape*, one's eye is led along a connecting series of visually meandering steel rods punctuated by a wide variety of shapes and gestural lines. In Stella's *Thruxton 3X*, a more extravagant series of garishly colored and textured shapes—each one displaying a particular gesture—winds us dizzyingly through the composition.

On a far darker, more funereal note, we see that the rhythm of gesture structures *The Burghers of Calais*

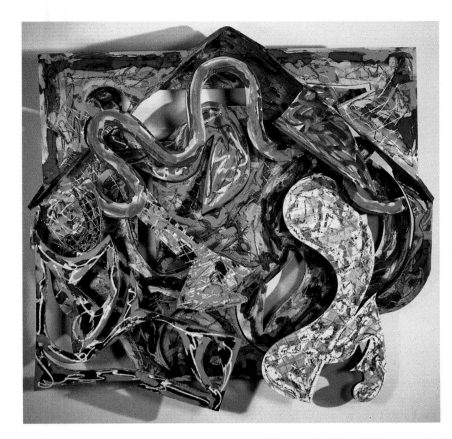

243
Frank Stella. *Thruxton 3X.*
1982. Mixed media on etched
aluminum, 75 x 85 x 15"
(1.90 x 2.16 x 3.8 m). The Shidler
Collection, Honolulu, Hawaii.

244
Auguste Rodin. *The Burghers
of Calais.* 1884–1886.
Bronze, 7'1" x 8'2⅛" x 6'6"
(2.16 x 2.49 x 1.9 m). Hirshhorn
Museum and Sculpture Garden,
Smithsonian Institution, Gift of
Joseph H. Hirshhorn, 1966.

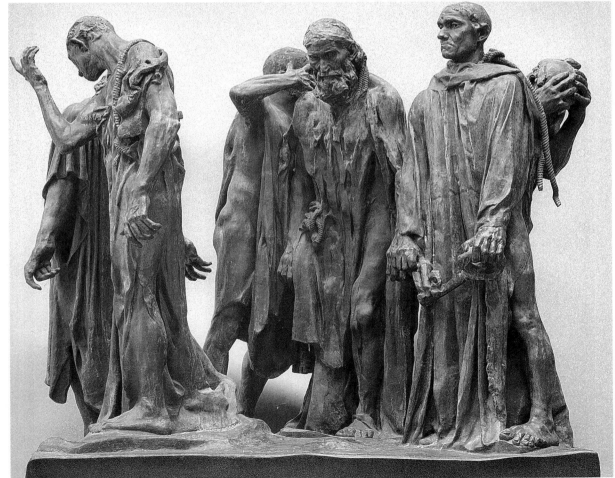

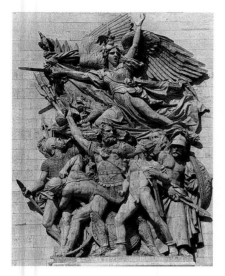

245
François Rude. *Departure of the Volunteers of 1792 (La Marseillaise).* 1833–1836. Stone relief, approx. 42 x 26'. Arc de Triomphe, Paris.

[244], created by the most important sculptor of the nineteenth century, Auguste Rodin. During the Hundred Years' War, the English held the French town of Calais under siege for nearly a year. In 1347, six wealthy burghers offered to sacrifice their lives in return for the promise that the rest of the city's population would be spared. The English agreed, provided that the hostages, wearing nothing but sackcloth and halters and carrying the keys of the city, humbled themselves before the king of England.

Rodin chose not to follow the accepted practice of honoring heroism and sacrifice in war by creating a sculpture that glorified or romanticized the individuals involved. He rejected the noble gestures, and smooth, finished surfaces traditionally associated with public monuments such as

we see, for example, in *La Marseillaise* [245] by France's most important sculptor of the early nineteenth century, François Rude. He rejected the kind of pomp and ceremony governing the subject of *Surrender at Breda* [246], Diego Velázquez's monumental homage to the protocol of the resolution of a military conflict. Instead, Rodin portrayed the heroes of Calais just after they had suffered an eleven-month-long siege. He describes their misery as they are about to sacrifice their lives (actually, Edward III's wife convinced her husband to pardon them). Rodin wanted his audience to be moved by the portrayal of human suffering, of courage tempered by honest, mortal emotions of regret and fear—not by the rhetoric of idealized, abstract ideas. "I have not shown them grouped in a triumphant apotheosis . . ." Rodin wrote, defending his decision not to portray the heroes more heroically.

> The more frightful my representation of them, the more people should praise me for knowing how to show the truth of history. . . . I have, as it were, threaded them one behind the other, because in the indecision of the last inner combat which ensues, between their devotion to their cause and their fear of dying, each of them is isolated in front of his conscience. They are still questioning themselves to know if they have the strength to accomplish the supreme sacrifice—their souls push them onward, but their feet refuse to walk.[1]

Each figure reflects a slightly different emotion. Every individual seems to be immersed in his own thoughts, yet they are a unit enacting what one critic has described as a medieval Dance of Death.[2] The character of each of these six burghers becomes measurable by his step and stance and

246
Diego Velázquez. *Surrender at Breda.* 1635. Oil on canvas, approx. 10 x 12'. Museo del Prado, Madrid.

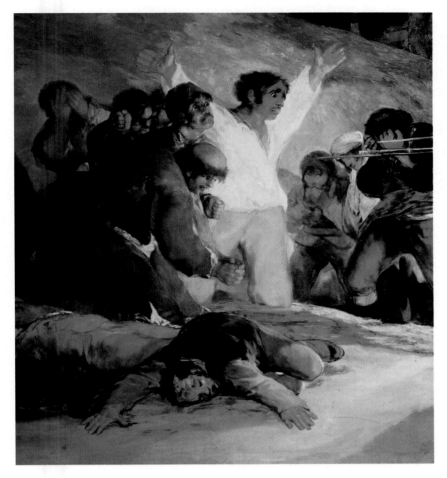

247
Detail of *The Executions of the Third of May, 1808* by Francisco de Goya, 1814. **Oil on canvas.** Museo del Prado, Madrid.

no longer by his words or his name as each drags himself off to die. By facing each of the burghers in a different direction; by carefully adjusting the intervals between them; by relating the downward pull of the varied but repeating folds of sackcloth worn by each of the men; and by using identical, or very similar, casts of certain body parts on several of the figures, Rodin merges the group within an overwhelming rhythm of despair.

Gesture also plays a prominent role in creating a rhythm of death and despair in Goya's *The Executions of the Third of May, 1808* **[162]**. The repeated gesture of the soldiers' bodies, the shapes of the shadows the soldiers cast onto the ground, the negative shapes between their legs, and the interaction of their hats and backpacks are rhythmical, like music—like death

tolls. The bright white shirt of the man with the upraised arms strikes the single most resounding note.

On the left-hand side of the composition, Goya grouped the Spanish citizens by establishing a dramatic rhythm of gesture **[247]**. This area can be broken down into three time zones: individuals awaiting execution, those being slain, and the already fallen. The seams of this area are stitched together by several figures whose gestures roughly mimic one another. The man covering his face in the very center of the canvas reacts to the horror surrounding him very much like the man on the far left. And the pose of the highlighted figure in the white shirt embodies a still-breathing, but otherwise close, variation of the man lying in his own and his fellow victims' blood.

The group of Spaniards who are being slain tell a story with their hands alone. We see a monk with his hands clasped in prayer; a peasant, his fists clenched in defiance; a Christ-like figure bravely meeting his fate (a close look at his palms reveals the kind of holes that the New Testament tells us were made in Christ's hands when he was nailed to the cross), and a terrified individual who covers his eyes from the death which for him is too frightening to face. As is compellingly exemplified by this one area, throughout this painting Goya masterfully merged rhythm and gesture with humanistic concerns involving anonymity and individuality. *The Executions of the Third of May, 1808* graphically demonstrates that armies wage war; individuals die.

THE RESURRECTION BY EL GRECO

248
El Greco (Domenikos
Theotokopoulos). *The Resurrection.*
1600–1605. Oil on canvas,
9'1¼" x 4'5" (2.75 x 1.35 m).
Museo del Prado, Madrid.

Before reading the following discussion of *The Resurrection* **[248]** by El Greco, think about the work by answering these questions:

1. Gesture, movement, and contrast play an important part in both the structure and meaning of this painting. Explain.

2. The figures of Christ and the sprawling soldier located directly beneath are positioned along a central vertical axis around which the rest of the encircling figures are distributed. These two figures differ in several significant ways. Explain. The vertical axis of this painting plays a fundamental role in the structure and the meaning of the image. Explain.

3. Why do you think El Greco included the small figure of the sleeping, feather-helmeted sentry? Do you feel this figure's gesture is a distraction, or does it add to your enjoyment of the painting?

4. Jesus is the brightest, clearest, and most complete figure on the canvas, and the white banner and red cape bordering him on each side are two of the most outstanding shapes in the painting. Regarding movement and direction, what effect do you think the shapes and forms of Jesus, the cape, and the banner have on the soldiers?

In El Greco's *The Resurrection*, violent emotions erupt within a group of soldiers who behold in fear, amazement, and veneration the tranquil body of Christ rising. Compare the upside-down soldiers at the bottom of the canvas with the omnipotent figure above and it will be apparent that diametrically opposed qualities are embodied by their two gestures. The limbs of the shaken man below flail awkwardly as he collapses at the overwhelming sight of Christ ascending from His tomb. While we see the full countenance of Jesus, whose eyes calmly meet ours, we must imagine the fever coloring the face of his counterpart since only the back of this figure's head is visible.

The faces of the other guards are not hidden. We circle the group, our ever changing vantage point revealing a different profile on each guard. With his upraised saber, the overturned soldier pointedly leads our attention to the only figure (a feather-helmeted sentry) who remains unmoved. El Greco tucks him into a cozy pocket of space and blankets him with an event no one would want to miss. Nonetheless, the sentry snores through the proceedings. Whether we interpret his presence as comic relief or as a symbol of man's indifference to his surroundings, we should recognize the expressive potential of a thoughtfully considered gesture of repose such as this one. By creating a contrast, his stillness emphasizes the turbulence around him, just as his compressed body is dwarfed all the more by the stretching bodies. Some of these gestures are woven together to form a virtual obstacle course of arms and legs that lead the viewer across a rapid diagonal into the painting. A more rhythmic or challenging entrance is hard to imagine. This passage is embellished with variations of scale, direction, and interval. Beginning at the bottom left corner of the canvas with the hand and arm of the upside-down soldier, and continuing up to the sleeping sentry, human limbs recede and advance like crackling branches in a fire. The strip of fringe stumbling across the waist of the toppled soldier's tunic restates the rythmical passage as a whole.

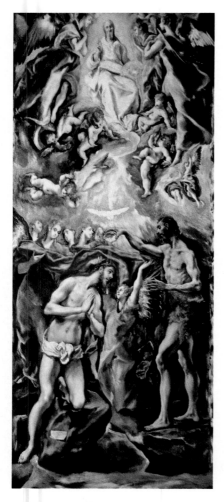

249
El Greco (Domenikos Theotokopoulos). *The Baptism of Christ.* 1608–1614. Oil on canvas, 11'6" x 4'9" (3.5 x 1.45 m). Museo del Prado, Madrid.

But the most significant thrust of *The Resurrection* is not the diagonal of this passage, nor the encircling guards. The most commanding movement is the upward motion of Christ. This is the point of the work. The pronounced vertical format of the canvas itself emphasizes its importance. The painting measures over nine feet in height. Hanging, it looms well above the viewer's head. El Greco placed Jesus at the very top of the image, forcing us to look up in order to see him. In doing so, the viewer physically mimics the ascending motion of Christ's flight.

Still other devices are employed to create this upward lift. The body of Jesus is the brightest, clearest, and most complete figure on the canvas. And the white banner and red cape fluttering marvelously around him like the wings of an angel or the petals of a radiant flower are two of the most outstanding shapes in the painting. Like powerful magnets, these shapes, and the compelling figure of Christ, overshadow and absorb much of the charged energy below.

In order to more fully appreciate the formal considerations that create the upward thrust of *The Resurrection*, let us examine the downward plunge apparent in another important painting by El Greco, *The Baptism of Christ* [**249**]. Here, the artist highlights the moment when John anoints the head of Jesus with holy water. Appropriately, it is through downward motion that the central statement of the picture is revealed. Christ has been sent down from the kingdom of heaven. Water pours down on the head of Jesus as the naming of God's representative on earth takes place. The shell from which the water flows occupies the very center of the painting. Notice how this shape marks the immediate point below which the most aggressive pictorial activity takes place. The foreground is firmly claimed by the group of figures commanding the bottom half of the canvas. The forms here are the largest, most precise, most three-dimensional forms of the painting. As we see in El Greco's interpretation of the Resurrection, such forms tend to dominate the structure of an image, causing the viewer to be drawn toward them, thus resulting in the upward movement of *The Resurrection* and the downward direction of *The Baptism of Christ*.

Returning to *The Resurrection*, we notice that Christ's pose is full of grace, a model of idealized form to which the foreshortened and twisted guards beneath him can only aspire. Through the language of his body, Christ conveys the distance that separates him from his beholders.

THE VISUAL ELEMENTS AND THE ORGANIZATIONAL PRINCIPLE OF RHYTHM

As a means of simplifying the language of visual expression, the visual elements are separated from the visual principles in this book. Normally they interact: the visual elements are organized by the visual principles. The principle of rhythm demonstrates this interaction particularly well. Each of the visual elements has the capacity to organize itself in a rhythmical fashion peculiar to its individual characteristics. These characteristics, in turn, produce a particular quality of rhythm.

RHYTHM OF LINE

Talismanic Shirt with Koranic Verses [**250**], an undergarment made of white linen and embroidered with white cotton and rose-colored silk facings, was most likely owned by Sultan Suleiman (known as Suleiman the Magnificent) who ruled the powerful Ottoman Empire between

250
Talismanic Shirt with Koranic verses. Second quarter of 16th century. Topkapi Sarayi Müzesi, Istanbul.

251
Detail of Talismanic Shirt.

1520 and 1566. The linear rhythms that decorate the surface of this shirt reflect an extreme degree of variety, intricacy, delicacy, and care. In many areas, what appear at first to be pure decoration are, in reality, Arabic letters [251] spelling out verses from the Koran, the sacred book of Islam. These letters are so tiny you must virtually press your nose up against the fabric to discern the details—and even then it would be helpful to have a magnifying glass.

Aside from Koranic verses, the lines that decorate this shirt functioned as prayers and magical squares with numbers and letters whose numerical values were used for predicting the future. The shirts were worn next to the skin to protect the wearer from misfortunes such as sickness, accidents, and attack by evil forces.[3]

Flowers are both literally and figuratively pictured throughout the shirt. Where the floral stem and bloom is

252

Vincent van Gogh. *Cypresses*. 1889.
Bamboo, reed, and steel pens over
pencil, 18½ x 24¾" (47 x 63 cm).
Kunsthalle, Bremen (war loss).

253

Leonardo da Vinci. *Cataclysm*
(also called *Drawing for the Deluge*).
c. 1516. Chalk and ink on paper,
6⅜ x 8" (16.2 x 20.3 cm).
The Royal Library, Windsor Castle,
Berkshire. Reproduced by gracious
permission of Her Majesty Queen
Elizabeth II.

not delineated literally, the sense of
flowering or growing is suggested by
the fluid, curling movement of the
script. The rhythm of variously
detailed lines overlapping the white
field color the surface of the garment
by creating an optical mixture, which
is very different from creating color by
thoroughly covering a surface with
pigment that was mixed first on a
palette. The lines applied to the white
field create color, tone, and motion by
virtue of how much, and in what
manner, the field was covered.

In several important respects, the lines
of Vincent van Gogh's *Cypresses*
[252] function in a similar manner to
the way lines function in *Talismanic
Shirt with Koranic Verses*. In both cases,
the white negative spaces, or
interspaces, were linearly activated by
rhythms of differing speeds, scales,
directions, and intensities which
bewilder the eye. In *Cypresses*, each
area is portrayed by a distinct linear
rhythm. The sky in the majority of
artists' drawings is portrayed by the
blank page of the drawing surface.
This is certainly not the case in this
drawing. Van Gogh's sky seems to be
set in motion by the same violent

forces of nature that propelled the
explosive waves of Leonardo da
Vinci's deluge drawing, also known as
Cataclysm [253]. "We take a train to
reach a city," van Gogh wrote, and
"death to reach a star."[4] The interac-
tion of many separate rhythms and
movements sets this drawing spinning,
creating, if not a journey toward
death, a scene that is certainly
informed by disturbance.

RHYTHM OF SHAPE

Visual details that are similar exert a
tension or pull on one another. These
varied but related details create
rhythms, or eye patterns, that lead us
through a composition. One of the
most effective means of relating
otherwise different visual details is by
clearly delineating their shapes. The
rhythmical relationship established
between the shapes ties together the
composition of *Page from the Codex*

254
**Page from the Codex Borgia
(Nahua-Mixtec culture). Parchment.**
Vatican Library, Rome.

255
**Wassily Kandinsky. *Division-Unity*.
1943. Oil and tempera on cardboard,
22⅞ x 16½" (58 x 42 cm).** Private
collection, London. Photo Courtesy
Musée National d'Art Moderne, Paris.

Borgia **[254]**, one page of a book from
the Nahua-Mixtec culture of native
Mexicans. Codex painters first
outlined what they wanted to paint
and then filled inside the lines with
flat, contrasting colors. This page,
which has been organized into a
grid, displays individual symbols in
some frames and more complicated
compositions and activities in
others. Sometimes the rhythms are
regularized through the repetition of
self-contained details, such as in the
two vertical rows of six circles that
border the gods of Texcatlipoca in the
upper section and the ballgame players
portrayed further below. Other times,
the rhythms are the result of differ-
ently colored shapes of unlike sizes,
such as we see in the individual figures
of the gods and the ballplayers.
Unifying this elaborately decorated
composition is a rich assortment of
interwoven flat shapes.

Many of the principles that we observe
in *Page from the Codex Borgia* are
apparent, as well, in Wassily
Kandinsky's *Division-Unity* **[255]**.
This Russian-born artist is considered
by many authorities to be one of the
most important artists of the twentieth
century; they credit him with creating
the first, or at least one of the first,
completely nonrepresentational
paintings in 1910. Within each strip
and rectangle of *Division-Unity*,
Kandinsky established a different
rhythm, or bounce. There is a wide
and whimsical assortment of abstract
characters floating alongside and
occasionally overlapping one another
in this painting. Unifying all of the
separate ensembles are the lively
rhythms of flat shapes.

RHYTHM OF FORM

Rhythm can also be created by visually connecting a series of three-dimensional forms that provide pathways for the eye. In *Lintel 25* **[256]**, a masterpiece of Mayan art, intricately detailed and varied forms lead rhythmically into one another. This limestone carving in high relief was originally the top member of a door. It tells the story of a ritually induced hallucination that takes the form of a double-headed serpent. In the bottom right corner of the lintel is the woman who is experiencing the hallucination. An armed warrior emerges out of the mouth of the serpent's front head. Visible along the top border and continuing a short distance down the left-hand side of the lintel is the carved inscription (**glyph**) that provides, among other things, information explaining the action taking place.

The hallucinatory vision portrayed in *Lintel 25* was, to a large extent, the result of bloodletting that the woman portrayed here performed on herself. The procedure that she followed is depicted on another lintel located near this one. In this series of carvings,

256
Lintel 25 from Chiapas, Mexico. c. 725 A.D. Limestone, 51¼ x 33 x 4"
(130.1 x 83.6 x 10.1 cm).
Reproduced by courtesy of the Trustees of the British Museum.

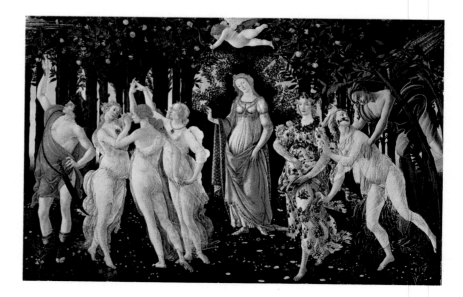

257
Sandro Botticelli. *Primavera* or *Allegory of Spring*. c. 1478. Tempera on wood, 6'8" x 10'4"
(2.03 x 3.15 m). Uffizi, Florence.

form and content enjoy a tangled alliance inasmuch as the subjects are gruesome and frightening, while the compositions, which display a keen sensitivity to the rhythm of form, are elegant and beautiful.

There is no disagreement between form and content in the late fifteenth-century Italian painter Sandro Botticelli's *Primavera* [257]. The subject involves fertility and earthly pleasures, for which the charming, buoyant rhythms of form created by Botticelli seem particularly well-suited.

Eight figures and a blind cupid with bow and arrow in hand stretch out across the painting. Venus, the goddess of love, occupies the center. To the right of Venus is the wind god Zephyr, who is pursuing the nymph of springtime, Cloris, who, at the touch of Zephyr, is transformed into Flora, the goddess of flowers. To Venus's left are the Three Graces (Beauty, Chastity, and Passion) and Mercury, their leader. Mercury is also god of the winds, and as such, he brings us back to Zephyr, thereby suggesting an ongoing series of transformations, like the changing of the seasons.

The relationships Botticelli established between the ensemble of figures are somewhat disconnected. The rhythms he created between isolated groupings, however, are among the most lyrical in all of art history. The rhythm of the subtly modeled forms that comprise the Three Graces [258] and those comprising Zephyr, Cloris, and Flora tie each group together so harmoniously that it takes a determined leap of the imagination to picture these figures assuming any other gestures—ever. Observe, for example, how marvelously intertwined even the fingers of the Three Graces are. But there is a peculiar collage-like quality to the way they occupy the shallow space of their arcadian setting.

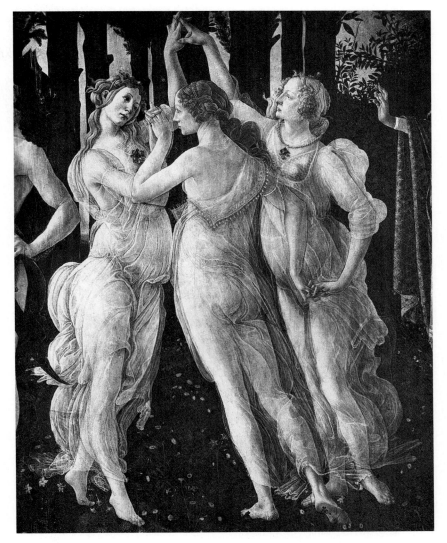

258
Sandro Botticelli. Detail of *Primavera* showing the Three Graces.

Many of the figures look like they were pasted onto the landscape rather than painted within it. The landscape itself, on the other hand, goes a long way toward unifying the composition. The row of cylindrical tree trunks and the silhouetted shapes of leaves (especially the archway of leaves surrounding the head of Venus) create magnificent, rhythmical passages. The spherical volumes of the oranges on the trees, and the tiny, but vivid shapes of the flowers dotting the grass also contribute to the unification of the composition. The kind of shallow, not particularly atmospheric, space that we see in this Early Renaissance homage to spring (*primavera* is the Italian word for spring) will soon bow to the deeper, far more atmospheric space developed during the High Renaissance by artists such as Michelangelo and Leonardo da Vinci.

259

John Constable. *The Haywain.*
1821. Oil on canvas, 4'2½" x 6'1"
(1.28 x 1.85 m). Reproduced by
courtesy of the Trustees, The National
Gallery, London.

260

Josep Grau-Garriga. *Calitja de
Tardor (Autumn Mist).* 1977.
Tapestry of linen, jute, hemp,
and wood, 72¹³/₁₆ x 104⁵/₁₆"
(185 x 265 cm). Arras Gallery,
New York.

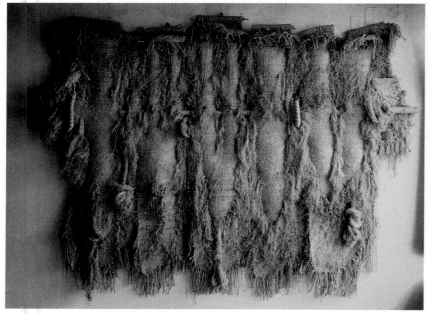

portrayed. Examples of this are
apparent in the large forms of the
clouds which were modeled in subtle
tonal gradations, as opposed to the
pond in the foreground that is painted
in shorter strokes of more broken
colors and tones.

Natural, seasonal textures are brought
to mind by *Autumn Mist* **[260]**,
created by the twentieth-century
Spanish artist Joseph Grau-Garriga. In
this irregularly shaped work, the artist
does not appear to be concerned with
the wild, sumptuous colors of early
autumn, but rather, with the coarse
textures of its waning weeks, when the
dryness and decay of fallen leaves
cover the ground. Diverse textures of
woven linen, jute, hemp, and wood
create three horizontal rhythms that
stretch across six major vertical
movements. Diverse fibers account for
part of the textural richness of this
work. The other part is the result of
each one of these distinctly woven
materials creating its own particular
rhythm. In one area the material is
relatively neatly wrapped around
hidden wooden rods; elsewhere, it is
knotted tightly; and in still other
places the loose ends of the fibrous
medium, looking like countless
tentacles projecting outward into the
world, establish a tangled linear
rhythm that further animates this
organic, three-dimensional tapestry.

Rhythm of Texture

Judging by all the leaves on the
trees, it must be a summertime sky
that lights the country setting of
nineteenth-century English painter
John Constable's *The Hay Wain*
[259]. In this painting, the artist
picks out the textures of, among other
things, trees, leaves, water, bricks,
wood, earth, and clouds. *The Hay
Wain* captures the rhythms and
textures of nature because the artist
seems to understand something
important about them. Just as every
rhythm has a particular nature—

the rhythm of a bird in flight, for
example, is different from the rhythm
of water moving in a lake or of a dog
walking along an open stretch of
land—every texture embodies a
distinct series of characteristics. Artists
such as Constable, who wish to evoke
in a naturalistic manner the feel of a
specific texture, must invent a visual
equivalent to evoke that particular
quality of surface. In order to suggest
each of the textures that we see in
The Hay Wain, Constable invented
distinct color and tonal rhythms for
each of the shapes and forms he

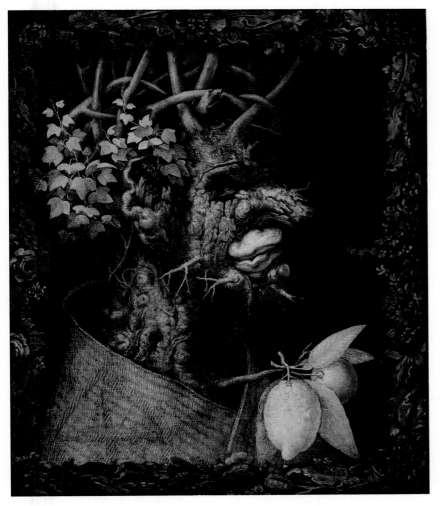

261
Giuseppe Arcimboldo. *Winter*.
1573. Oil on canvas, 30 x 25³/₁₆"
(76 x 64 cm). Louvre, Paris.

The sixteenth-century Italian **Mannerist** painter Giuseppe Arcimboldo's portrait entitled *Winter* [261] offers an unpredictable climax to our brief investigation of the calendar. As each of the artists did in the preceding studies, Arcimboldo developed specific textures in order to evoke a particular season. What a great distance there is between Arcimboldo's winter and Botticelli's spring! And yet, considered from the vantage point of nature's cycle, the two seasons are, of course, never very far apart. Arcimboldo's bizarre human configuration appears coarsely textured—especially when compared to the surfaces of Botticelli's figures. In the Botticelli, the surfaces of the forms are smooth and the movement is graceful, lyrical—qualities of form and movement conspicuously absent in the rather repulsive profile Arcimboldo pictures. In *Primavera*,

each of the figures appears to be about twenty years of age. Arcimboldo, on the other hand, portrays winter as an old, grotesquely wrinkled man whose skin is made out of a gnarled and decomposing tree. Here, each texture contrasts sharply with the next, creating a rhythm of interacting textures that is rough and choppy.

RHYTHM OF PATTERN

Many people confuse rhythm and pattern as one and the same thing. They are not. Patterns are areas of relatively constant repetition. Rhythmical areas, on the other hand, are distinguished by variation. In many works of art the element of individual patterns or interwoven patterns plays a part in the development of the less tangible and larger organizational principle of rhythm.

Mannerism extended roughly from 1520-1600. Until recently it was widely considered to be a corruption of the art of the Italian High Renaissance. Today it is more commonly seen as a significant and conscious reaction to the rationality of the High Renaissance. The style of Mannerist painters such as Pontormo, Tintoretto, and El Greco is marked by spatial ambiguities, distortions of form, and exaggerated gestures and movements, resulting in a heightened sense of spirituality and emotionalism.

262

Jean-Auguste-Dominique Ingres. *Portrait of Napoleon I in Coronation Regalia.* 1806. Oil on canvas, 8'6⅜" x 5'4³⁄₁₆" (2.60 x 1.63 m). Musée de l'Armée, Paris.

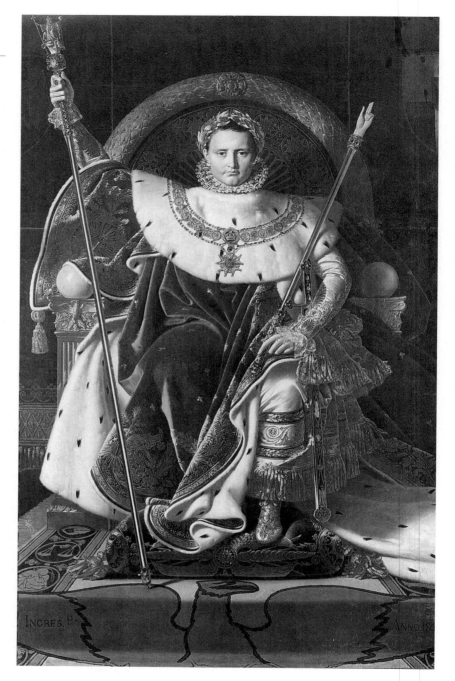

In Jean-Auguste Dominique Ingres's portrait of Napoleon as emperor [**262**], the rhythm and pageantry of separate patterns contribute significantly to the formality and great authority of this portrait. From the rug beneath the throne, to the many glimpses of the patterns decorating Napoleon's robe, to the series of patterns carved into what we see of the throne surrounding the young emperor's head, all the way up to the ornamentation on the handle of the scepter, pattern plays a major role in leading us through the composition. The bold, crisp manner in which Ingres weaves these individual patterns throughout his composition accounts for the sure, powerful sense of rhythm that pervades this painting.

Even within the context of death, the rhythm of patterns has often been used as a kind of exaltation through exorbitantly expensive embellishment. An example of this is a gold inlaid coffin (one of four) that contained the Egyptian king Tutankhamen's internal organs [**263**]. Particularly impressive are the overlapping patterns that decorate the section that would have corresponded to the upper back of the boy king.

Of course, pattern does not only lend itself to the expression of majestic subject matter. The subject of the twentieth-century American photographer Alfred Stieglitz's *Sun Rays*

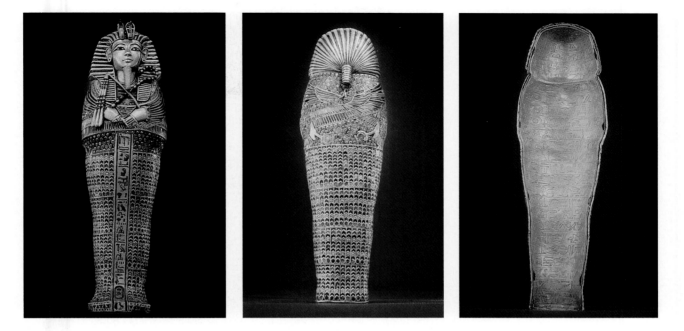

263
Gold inlaid coffin that contained the internal organs of Tutankhamen. c. 1350 B.C.
Beaten gold inlaid with colored glass and carnelian, height 8⅞". Cairo Museum.

264
Alfred Stieglitz. *Sun Rays (Paula)*.
1889. Gelatin silver print. National
Gallery of Art, Washington, D.C.,
Alfred Stieglitz Collection.

[264] (sometimes called *Paula*) is
relatively unremarkable: a friend of
the photographer is writing a note
while sitting in the quiet of her home.
The lighting that the subject receives,
however, is quite remarkable. A
pattern of diagonal stripes caused by
light streaming through the open
shutters of venetian blinds dramati-
cally highlights a small section of the
room. This patterning of light, in
conjunction with the masterful
retention of detail in the darker

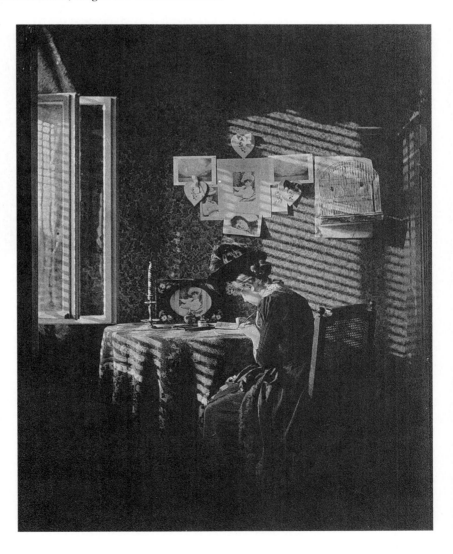

Henri Matisse. *Interior with Goldfish.* 1911. Oil on canvas, 4'9⅞" x 3'2⅝" (1.47 x .98 m). Pushkin State Museum of Fine Arts, Moscow.

surrounding area, not only visually invigorates an otherwise simple scene, it ennobles the scene by granting it such special attention.

Many interacting patterns of light combine to produce a rich, rhythmical effect. There is the subdued pattern of the wallpaper, the pattern of the metal bars of the birdcage, the pattern of the caning on the back of the chair, and, of course, the pattern of the stripes caused by the venetian blinds. And there are other less obvious patterns, such as the pattern of hanging folds from the tablecloth which leads

directly into the folds of Paula's dress, and the almost symmetrical arrangement of photographs pinned to the back wall (two prints of Stieglitz's photograph *The Approaching Storm* can be seen at the top right and left of the arrangement). These active patterns, many of which overlap one another, introduce an element of tension that counters the stillness of the subject.

The open window and bright sunlight suggest space and freedom. The birdcage and the stripes that even overlap the young woman suggest confinement. Tensions such as these

contribute to the conceptual depth and pictorial complexity of the photograph.

Artistic influences also contribute to these qualities. This photograph might be said to represent a kind of pictorial conversation between Stieglitz, Vermeer, and Caravaggio. Vermeer is evident in the subject, the domestic setting, and the kind of quiet that belies an individual sitting alone near an open window. The heightened drama of light brings to mind the *chiaroscuro* of Caravaggio. And, of course, Stieglitz, early in his career,

Sandy Skoglund. *Revenge of the Goldfish.* 1981. Cibachrome print, 30 x 40" (76 x 102 cm). Courtesy Lorence-Monk Gallery, New York.

took the photograph. We do not ordinarily associate the charm and delicacy of a Vermeer with the fever and passion of Caravaggio. In *Sun Rays*, the hint of two such disparate sensibilities compatibly merge within a single image.

RHYTHM OF COLOR

I have always associated Matisse's *Interior with Goldfish* **[265]** with fireworks, the kind that start by grabbing your attention and then keep squeezing more and more color out of each new burst like echoes getting louder. Of course, the central subject of fish swimming in *Interior with Goldfish* is quiet, and unlike the polychromatic range of fireworks, there are variations of only two colors—red and green. Nonetheless, the painting's rich juxtapositions of colored shapes are explosive.

Mimicking the swirling movement of fish, the artist has developed a series of rhythms that weave and wind around the bowl. The fish themselves account for very little of this movement. None of the sweeping arabesques and

intricate rhythms brought to the gesture of the shapes, the spacing, or the startling scale shifts occurring outside the bowl are allowed to intrude on the fragile glass-framed interior nor its inhabitants. Even the mirrorlike reflection of the fish on the surface of the water, with all its possibility for distortion, remains not only subdued, but actually quite static. But the space outside the bowl swims.

Every corner of the painting is alive. Small, bubbly green leaves floating before a red-violet background open up the top left area of the canvas, while the blue-green lines of a wrought iron chair curve and soften the angle of the bottom left corner. Perhaps the most fast-paced and chaotic section, the top right corner, diminishes in size, but maintains in color, the looping lines of the bottom left area. The violet blooms within the cluster of leaves on the bottom right represents a less aggressive version of the darker violet flowers directly above.

Interior with Goldfish is a translation of a simple still life into an exhilarating

animation. Matisse nudges the red variations in this painting from the intense red-orange of the fish to the assortment of red-violets that excite the table, wall, and flowers. So, too, he plays with the green, mixing more yellow into some leaves, blue into others, permitting much of the white ground of the canvas to make some petals translucent, in contrast to the more opaque quality he allows in the rest. Everywhere, Matisse re-evaluates what he has previously stated. He twists it around, inverts it, alters the tempo, shifts the vantage point, exaggerates the size, sharpens a point, rounds an edge, hypes up the color, intensifies the tone, blurs a mass, defines and isolates a line.

In the contemporary American artist Sandy Skoglund's photograph *Revenge of the Goldfish* **[266]**, the confinement of the cylindrical fishbowl of Matisse's painting is replaced by the straight lines and sharp angles of a spacious bedroom. Instead of the four central-ized goldfish of Matisse's painting, in *Revenge of the Goldfish*, we must contend with a whole school of fish. Some of the fish are dead. Normally,

267
Edward Hopper. *Early Sunday Morning.* **1930. Oil on canvas, 2'11" x 5' (89 x 152 cm).** Collection of Whitney Museum of American Art.

goldfish live in small glass containers, conveniently separated from people. Here, the fish inhabit the very same space, outnumber, and totally surround the mother and child who, in turn, appear to be surprisingly undaunted by the turn of events. Only in the world of our dreams (and, often, not even there) do we take such circumstances as are pictured here for granted.

Sandy Skoglund did not accidentally happen upon this scene and quickly snap the shutter of her camera. Like Judy Pfaff's environmental installation, *Kabuki (Formula Atlantic)* **[232]**, this beguiling and slightly perverse image was painstakingly staged. "Mine has to be the slowest way in the world to make a photograph"[5] the artist has stated. The surreal quality of the subject is especially reinforced by the color. The goldfish are colored as we might expect, and so are the mother and son, but look at the room. Because every inch of the environment has been painted in cool shades of aquatic blue, the warm flesh tones of the people, and the warm, chromatically

intense fish stand out. This contrast, matched with the sheer inundation of the orange fish, so liberally dispersed, captures our eye (and imagination) and leads us through every corner of the room. Compared to the boldly contrasting shapes that so actively dominated Matisse's *Interior with Goldfish,* the shapes and sizes of the dominant element in Skoglund's photograph—the fish—are fairly predictable. In contrast to the bizarre nature of the scene, the rhythm established by the repeated color of the fish is an easy-going one, like the motion that we might expect of fish dreamily swimming in a large expanse.

RHYTHM OF LIGHT

In Chapter 4 we discussed how light makes the world visible. In this section we will see that light is capable of organizing the visible world into rhythmical arrangements. Regardless of the literal subject, by accentuating selected details, an artist can create tonal passages that serve to merge the parts of a composition into a unified whole.

268
Donald Judd. *Untitled*. 1983.
Plywood, four parts, overall 39
x 216½ x 19⅝" (99 x 550 x 50 cm);
each 39 x 39 x 19⅝" (99 x 99
x 50 cm). The Gerald S. Elliot
Collection of Contemporary Art.

In Edward Hopper's *Early Sunday Morning* [267], light not only unifies the image, it transforms a commonplace experience into an unforgettable one. The potential monotony of the long row of repeated store and apartment windows, which parallels the top and bottom edges of the canvas, is replaced by a rhythmically orchestrated row of varied shapes and colors. An early morning sun, positioned outside and to the right of the composition, directs our attention to a limited array of streetside details that cast shadows across the scene. The subsequent highlighted and obscured rhythms subtly enliven a calm, quiet, seemingly uneventful moment in time.

The contemporary American Donald Judd's **minimal art**; untitled plywood construction [268], consists of decidedly few visual incidents. Although each of the boxes is the same size, their internal divisions are different, causing each box to capture the light differently. As is the case in Hopper's *Early Sunday Morning*, cast shadows govern the visual experience, providing a tonally rich and varied scan of shallow space.

Minimal Art developed in the 1960s as a reaction to the emotionalism and ambiguity inherent in the Abstract Expressionist sensibility. In an attempt to divorce form from implied content, Minimal artists such as Frank Stella, Donald Judd, and Carl Andre rejected any sense of illusionism or representationalism, maintaining that their work was nonreferential inasmuch as what they created referred to nothing beyond its own spare, overtly visible properties. Minimal artists favored precise, geometric shapes and forms presented either in an isolated manner or in the simplest of arrangements when presented in combination with other shapes and forms.

269
**Paul Cézanne. *Château de Medan.*
1880. Oil on canvas, 23¼ x 28½"
(59 x 72.4 cm).** The Burrel
Collection, Glasgow Museums
& Art Galleries.

Before reading the following discussion of *Le Château de Medan* **[269]** by
Paul Cézanne, think about the work by answering these questions:

1. Can you cite at least three separate but related rhythmical movements
that constitute the structure of this painting?

2. The rhythmical movements alluded to above offer balanced, satisfying
compartments of color and shape. Nonetheless, these compartments also
function as interdependent passages within the larger whole. Cite some of
the ways Cézanne leads our eye from the individual sections into the
overall composition.

3. The series of horizontal bands represents an important part of the
structure of *Le Château de Medan*. Onto this rhythm of horizontality,
Cézanne introduced a rhythm of verticals. What form do these verticals
take, and in what way(s) do they enliven the painting?

4. The application of the paint itself offers another important instance of
rhythm with variation. Explain.

5. Basically, this is a very organic painting. A rhythm of geometry,
however, also plays a prominent role in the composition. Explain.

Do not only look at Cézanne's landscape *Le Château de Medan*, listen to it. It is a quiet painting, to be sure, but there are the sounds of barely moving water, soft breezes, and the tapping of sunlight against the walls and rooftops of houses and along the trunks of trees. Built like a symphony, Cézanne's painting is divided into separate movements, each reflecting a different rhythm. Overhead is a large stretch of sky. This extensive, horizontal shape is gridded into smaller sections by a series of trees which, continuing below, melt into an expanding barrier of leaves. The deep green of the leaves is supported by a line of tree trunks, the one major rhythm of the painting that does not stretch the entire length of the canvas. Directly behind, a group of houses and a row of tree trunks introduce a rhythmical passage of geometry. Below the houses, a long, thin embankment slopes down to the final strip, a slice of water. Each strip separates from the next, and yet, choice details soften each division, allowing for a fluid reading of the whole. A gentle counterpoint prevails as part harmonizes with part.

To fully appreciate the rhythmic intensity and invention Cézanne brought to this landscape, you must look with care at the individual passages. The handling of the sky is distinguished by its relative simplicity. Its five unequal segments result in an irregular pattern of rather sharply delineated shapes. The beat is direct and neatly stated. A towering cypress tree, located in the very center of the canvas, splits the plane of the sky in half, potentially destroying the motion and unity of the image. Perhaps anticipating this breakup, Cézanne floats puffs of green across the vertical divide, once again emphasizing the basic lateral thrust. A long cloud also crosses the vertical, further accentuating the horizontal. This latter detail is unfortunate. It undermines the impact of the centralized tree, and it looks artificial and forced. While the rest of the painting appears to be a direct response to a perceived situation, the cloud looks made up, too obviously a compositional device.

But who could object to the artist's handling of green which permeates every portion of this canvas? Even where it is not present directly, such as in the blue sky and yellow houses and sand, its existence is implied through its components. If you mentally mix the ultramarine of the sky with the yellow (ochre) of the embankment, you will arrive at the green hue of the foliage. The towering cypresses ignore the basic horizontality of the image, and introduce a welcome vertical pattern of green into the expanse of the ultramarine up above. The tiny, cloudlike notes of viridian dotting this same area do more than cap the sharp outline of the trees; they provide a transition from the dense foliation of the middle band to the middle realm of the sky. Above all, they energize an otherwise idle space. Continuing downward through the central division, green pours through the buildings, over the sand, and into the lake.

Cézanne's brushstrokes shift direction when they reach the lake. Everywhere else the application of the paint is relentlessly repeated, short diagonal mark against short diagonal mark. Cézanne interprets the water with horizontal paintstrokes. The shift is sudden and convincing. Surely, the altered touch indicates the artist's response to a different texture and to an abrupt bending of the foreground space, but the change in markmaking creates, as well, a change in direction and rhythm—which

produces a definite sense of movement. Notice that the reflected shapes in the lake are indefinite, as they would be if the water was in motion.

The most vigorous activity, however, is reserved for the central horizon of buildings, the heart of the painting. The rhythm of this line is enhanced by overlapping trees and bushes which further break up this architectural passage. Theoretically, architecture is stationary. Yet look how planes of light undulate across the buildings, setting this carefully modulated strip into motion. The house on the far right is the most fully decorated with windows and chimneys. If this landscape represents a crossing either from left to right, or from water to land, I suspect that the residence with red shutters is the point of destination. It occupies a private, remote space, but it beckons.

CRITICAL QUESTIONS

270
Donatello. *Cantoria*. 1433–1439. Marble with gold and colored mosaic inlay, 38½ x 205½ x 52" (98 x 522 x 132 cm). Museo dell' Opera del Duomo, Florence.

1a. Donatello, considered by many authorities to be the most important sculptor of the Early Italian Renaissance, created the *Cantoria* **[270]** to fulfill a commission involving the design of a series of panels for the Singing Gallery of the Cathedral (*Duomo*) in Florence. Pattern and rhythm play important roles in this work. Explain.

b. Pattern and rhythm are related in certain respects. Nonetheless, there are significant differences between them. Some of these differences are apparent in Donatello's *Cantoria*. The

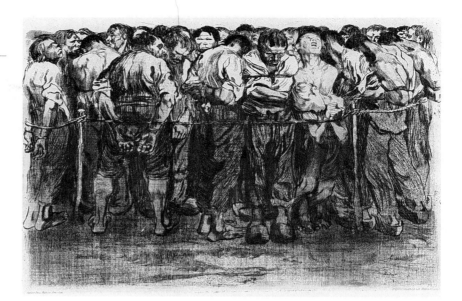

271
Käthe Kollwitz. *The Prisoners (Die Gefangenen).* **Plate 7 from** *Bauernkrieg.* **1908. Etching and soft ground etching, 12⅞ x 16⅝"** **(32.7 x 42.2 cm).** Print Collection, Miriam & Ira D. Wallach Division of Art, Prints and Photographs, The New York Public Library. Astor, Lenox and Tilden Foundations.

rows of tiny circles of color decorating the background wall, and the band of slender columns that stretch across the width of the work, provide clear examples of *pattern.* The frolicking *putti* (plump, young angels or cupids), on the other hand, represent an example of fluid *rhythms.* Explain the difference between pattern and rhythm. Do they have anything in common?

c. In what ways would you say that this relief represents an example of visual movement? Of the rhythm of gesture? Of form?

d. How would you describe the spirit of movement that informs this relief? In this respect, do you see any connection between the form and content of the *Cantoria?* The *Cantoria* has been described by one critic as: "bacchantic joy of life in rushing, overpowering movement."[6] Is this description consistent with your response?

e. Rhythm has been described as repetition with variation. The bodies of the *putti* embody several interrelated rhythms. There are, for example,

rhythmical passages created by the heads, arms, legs, torsos, and drapery, which, in turn, are all woven together into a larger comprehensive rhythm. Select one of the components (such as the legs) that comprise the overall rhythmical flow of this work, and describe how Donatello manipulated that component through a sustained series of variations.

2a. In *The Prisoners* [271], the last of seven etchings that comprise a print cycle known as *The Peasant's War* by the twentieth-century German artist Käthe Kollwitz, the rhythm of light plays an important role in both the organizational and expressive power of the image. Explain.

b. Look at the detailing of the horizontal row of heads. Cite some of the methods, or artistic decisions, by which Kollwitz distinguished this remarkably realized area. Cite several ways in which this area is handled differently from the row of feet which also can be said to establish a distinctive rhythmical passage. Can you cite any ways in which these two areas are handled similarly?

c. The kind of twisted, almost gnarled, rhythms created especially by the heads and torsos of the prisoners reinforce the overall feeling conveyed by this image. Explain.

d. During her life, Käthe Kollwitz experienced the calamitous impact of the Franco-Prussian War (1870-1871), World War I (in which she lost a son), and World War II (where she lost a grandson). Although many of her drawings and prints portray the joy of motherhood, much of her work addresses poverty, oppression, suffering, and death. Do you think that the kind of rhythms created especially by the heads and torsos of the prisoners suggest a sense of suffering and struggle? Explain.

PART four

Materials
and
Techniques

9

Two-Dimensional Materials and Techniques

Works of art are communicated through specific media or materials which give visible shape and form to an artist's ideas and emotions. The term **medium** refers to the type of material an artist uses for artistic expression. Painters, for example, may employ the media of oil, watercolor, or acrylic paint. Sculptors may employ the media of clay, stone or metal. The medium itself is neither good nor bad, artistic or inartistic. The key issue

where choice of medium is concerned is how that medium is used, and how effectively its particular properties serve the subject, idea, or emotion that invigorates a given work of art.

A fundamental challenge for every artist is to come to terms with just which medium most expressively sets into motion his or her particular strengths, insights, and eccentricities. Most artists tend to be associated with

272

Paul Gauguin. Letter to Vincent van Gogh (sketches including *Christ in the Garden of Olives*). November 1889. Vincent van Gogh Foundation/National Museum Vincent van Gogh, Amsterdam.

one medium. Nonetheless, it is not at all unusual for an artist to be proficient in several media. In such cases, the artist's decision to work in one medium rather than another is often based on practical considerations. Perhaps most important in this respect is the suitability of a given medium to satisfy the requirements of a given artistic project. If, for example, a project required the decoration of a large wall that was to be viewed from a distance, an artist equally proficient in silverpoint drawing (which lends itself well to the creation of small images characterized by subtle, faint tones) and fresco painting (which is well-suited to the creation of large colorful images) would surely carry out the project in fresco.

This chapter considers two-dimensional materials and techiques; Chapter 10 covers three-dimensional media. In these two chapters we will examine different materials employed during a wide range of historical time periods. In both chapters we will consider not only the characteristics that distinguish diverse methods and materials, but the way those methods and materials affect a work's basic structure, spirit, and appearance.

DRAWING

Many artists regard drawing as the most fundamental and personal means of expression of any of the visual artforms. "Drawing, " proclaimed Ingres, "includes three and a half quarters of the content of painting. If I were asked to put up a sign over my door I should inscribe it: *School for Drawing*, and I am sure that I should bring forth painters."[1] Testifying to its tendency to capture an artist's most intimate thoughts and feelings, the nineteenth-century French painter Paul Gauguin described his reaction to a critic's interest in his drawings as follows: "A critic at my house sees some paintings. Greatly perturbed, he asks for my drawings. My drawings? Never! They are my letters, my secrets. The public man—the private man."[2] We can take Gauguin's comment literally: as a page from one of his letters to his friend and one-time roommate Vincent van Gogh shows, his letters and drawings often merged [272]. In some languages, such as Japanese, the word for drawing and writing are the same.

273

Giovanni Battista Tiepolo. *Psyche Transported to Olympus*. 18th century. Pen and brown ink with brown wash over black chalk, 9¾ x 9" (24.8 x 22.9 cm). Private Collection, New York.

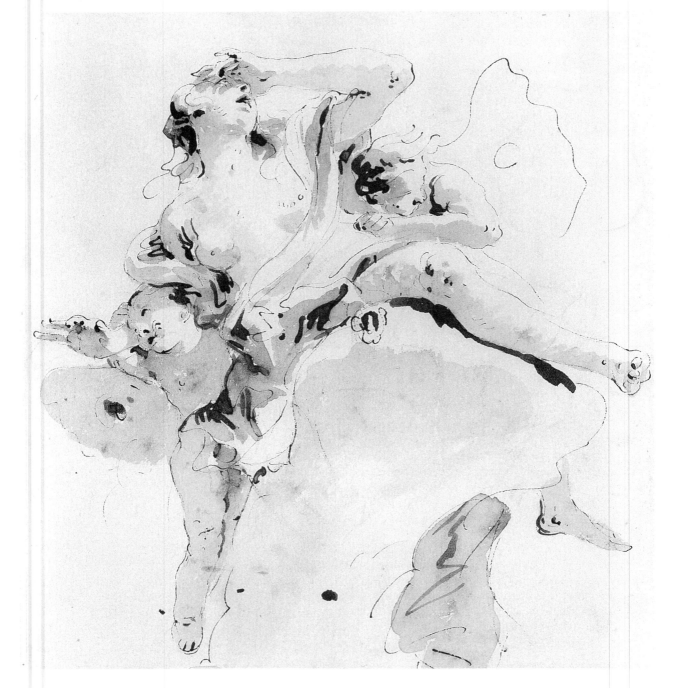

Drawing traditionally refers to a two-dimensional image that consists of a series of marks distributed across a paper support. Of course, this is a very broad, generalized definition—it must be since drawing encompasses a broad range of styles, materials, and functions. A drawing can be very sketchy like eighteenth-century Venetian artist Giovanni Battista Tiepolo's *Psyche Transported to Olympus* [273], or it can be meticulously detailed and finished in appearance like twentieth-century Spanish Realist Antonio Lopez-García's *Studio Interior* [278]. Drawings serve numerous purposes:

1) They allow artists to investigate ideas quickly.
2) Drawings enable artists to work out visual problems that later will be more thoroughly realized in another medium. For example, Georges Seurat's *Child in White* [274] is a value study of one of the figures [275] located near the center of the methodically planned *Sunday Afternoon on the Island of La Grande Jatte* [133].
3) Artists create drawings as a quick way of accumulating or recording information that may or may not be employed in the near future.
4) Some drawings are created as ends in themselves. In the twentieth century this procedure has become a more and more popular practice.

SILVERPOINT

Before the development of the pencil, artists who wished to make drawings with a fine-pointed tool worked with a medium known as metalpoint. Metals such as copper and gold were used, but not as frequently as silver. The medium of **silverpoint,** which was especially popular during the Renais-

274
Georges Seurat. *Child in White.*
1884. Conté crayon with chalk,
12 x 9¼" (30.5 x 23.5 cm).
Solomon R. Guggenheim Museum, New York.

275
Georges Seurat. *Sunday Afternoon on the Island of La Grande Jatte* (detail). **1884–1886.** Oil on canvas. Helen Birch Bartlett Memorial Collection, 1926.224. Photograph ©1990 The Art Institute of Chicago. All Rights Reserved.

sance, involves drawing a silver wire across a smooth, dry surface that has been prepared with a layer of white pigment (historically, artists mixed bone dust and glue to produce this layer; today the most popular ground or prepared surface is Chinese watercolor [zinc] white). The slight roughness of the support surface catches metal particles, which, if not promptly protected by some form of fixative, soon oxidize and tarnish. This tarnished line endows silverpoint drawings with a tonal quality for which they are especially prized. As is evident in Verrocchio's *Woman's Head* [276], silverpoint drawings tend to be distinguished by a refinement and delicacy of tone and touch. In silverpoint drawings, tonal gradations are often created by clustering the marks in order to cover differing amounts of the white paper. Sometimes one set of lines is overlapped by another set angled in another direction. This technique, which is employed in other drawing and printmaking media as well, is called **crosshatching.**

276
Andrea del Verrocchio. *Woman's Head.* c. 1470. Silverpoint heightened with gray and white on orange-pink prepared paper, 10½ x 9³⁄₁₆" (26.7 x 23.3 cm). Louvre, Paris. ©Photo RMN.

Before reading the text that accompanies *Woman's Head* by Andrea del Verrocchio [276], think about the drawing by answering the following questions:

1. What traits would you say best describe the personality of the woman in Andrea del Verrocchio's silverpoint drawing? How does the artist's choice and use of materials affect your response? How does the fact that the sitter averts her eyes from ours affect your response?

2. How does Verrocchio evoke different textures in this drawing?

3. Do you notice any differences between the way the artist handled the circular brooch adorning the woman's dress and the way he handled the rest of the details in this drawing? If so, why do you think he chose to handle this area so differently?

4. Although the overall impression made by Verrocchio's portrait drawing is one of calm, the artist continually surprises us with the unpredictability of his pictorial decisions. Can you point to two examples of this in *Woman's Head?*

In *Woman's Head,* Verrocchio portrays his subject in a manner as restrained as it is varied. The variety involves materials and techniques as much as pictorial invention. The orange-pink ground forms the background for the woman's image, which is created with delicate, abbreviated, precise, marks. Notice how little is needed to transform this flat piece of paper into rippling hair or smooth, contoured flesh. A slow silverpoint line momentarily defines the right side of the model's face before disappearing as it cups her chin and jaw. The artist does not complete the line on the paper; we complete the line in our mind. Faint tones of shadow, coupled with more striking washes of white gouache laid in with a brush, economically describe the woman's face and hair. A single curved white line located below her chin is sufficient to describe the turn of her throat. Likewise, the bodice of her dress and the lace veil resting against her forehead are only barely suggested.

This veil is an offhand generalization; it does not appear to be the product of a specific, patiently perceived situation, as does almost everything else in the drawing. Compare its cursive line to the line that separates the woman's upper and lower lips. Verrocchio carefully contours this juncture, defining here the bottom of the top lip, there the top of the bottom lip. Does the artist's handling of the bodice and veil change so unreasonably from his handling of the other forms in this portrait that a visual contradiction occurs? Not really. Verrocchio has prepared us all along for such shifts by interpreting everything—air, skin, hair, fur, lace, and metal—separately and distinctly. He invents a new mark, a new weight, and a new degree of resolution for almost every form, texture, and subtle change of medium that he introduces.

On the other hand, echoes occur where we would not expect to find them. The circular brooch is closely related in tone to the dark mass of curls surrounding the young woman's left ear. Besides this tonal connection these two areas have little in common. The pin is heavy, self-contained, and geometric; the cluster of waves is buoyant, open-ended, and organic. The brooch, like the woman's skin, has been modeled with a brush, while her hair is more linear, inscribed with a sharp tool. We can only speculate

why the artist chose to depict the pin with such definition and flash. One possibility is that Verrocchio wanted to further emphasize the delicacy and reticence of his sitter through contrast with the sharply defined piece of jewelry. Perhaps he meant to contrast the permanence and inflexibility of the brooch with the modulations and frailties of human nature. Did he mean the ornament to be seen as a metaphor, as an outward reflection of the elegant, jewel-like qualities he sensed in his model? Maybe his goldsmithing background got the better of him and he simply got carried away when he portrayed this detail. Precisely what lay behind Verrocchio's decision to emphasize the pin is unclear. Suffice it to say that its prominence is unpredictable and that it, along with many other details in this drawing, greatly affects the characterization of the young woman.

277
Amedeo Modigliani. *Portrait of Jacques Lipchitz*. 1916. Graphite pencil, 12¾ x 9" (32 x 23 cm). Private Collection.

PENCIL

There are many different drawing materials, but perhaps the most common, least messy, and most economical one is the pencil. Pencil lends itself naturally to a concise linear description of a subject, as we see, for example, in the Italian artist Amedeo Modigliani's portrait of the twentieth-century sculptor Jacques Lipchitz [**277**]. Drawing pencils made of lead or graphite are designated as hard, producing a light mark, and soft, producing a darker mark. Artists often begin their drawings with harder pencils because these lines are more easily erased. As they become more definite regarding the precise placement, tone, texture, and so on, of the forms that comprise a given image, these artists move to softer pencils. A drawing in pencil, such as Antonio Lopez-García's *Studio Interior* [**278**], can produce an extremely subtle range of tones, which, in turn, can produce a wide range of textures. In *Studio Interior*, a few well-chosen details such as the door handles and the surrounding hardware activate the space closest to us, transforming the white of the paper support into the illusion of tiled wall and door moldings. But the focus of the artist's attention was reserved primarily for the dramatically lit area visible beyond the doorway. The richness of the tones and Lopez-

García's loving attention to detail compel us to investigate the mystery of this back room. The grim, desolate nature of the room itself is less inviting. The resultant tension between an exquisite artistic performance (it is hard to believe that the point of a pencil created such palpable forms and surfaces) and the squalor of the subject is thoroughly captivating.

CHARCOAL

Charcoal is produced by burning sticks of wood, and, like pencil, it comes in hard and soft varieties. Made from a special kind of vine wood that is heated in a kiln until only the carbon remains, charcoal lends itself especially well to covering a surface broadly and quickly. In this respect, the inherent properties of charcoal are significantly different from those of the precision medium of silverpoint. Unlike the limited range of tones available to the artist working in silverpoint, charcoal naturally enables artists to produce sweeping tones that range from a light, pale quality to velvety blacks. In *Self Portrait with a Pencil* [**279**] by the twentieth-century German artist Käthe Kollwitz, the artist's hand and the back of her head are lightly indicated, while the features of her face and the stretch of her shoulder and arm are more boldly toned. Kollwitz executed most of this

278
278
Antonio Lopez-García. *Studio
Interior.* **1970. Pencil on paper,
44 x 41⅛" (1.12 x 1.04 m).**
Hamburger Kunsthalle, Hamburg.

279
Käthe Kollwitz. *Self Portrait with a
Pencil.* **1933. Charcoal on brown
laid paper, 18¾ x 25"
(.477 x .635 m).** National Gallery of
Art, Washington, D.C. Rosenwald
Collection.

280
Mary Cassatt. *Nurse Reading to a Little Girl.* 1895. Pastel on paper, 23¾ x 28⅞" (60.3 x 73.3 cm). The Metropolitan Museum of Art, New York. Gift of Mrs. Hope Williams Read, 1962. (62.72)

drawing by applying in broad strokes the side of the charcoal stick to the paper. However, in select areas of the fingers, in the changing position of the ear, and in the contour defining the back of the head, faint, relatively precise lines created by the tip of the charcoal stick are visible.

In order to control what is being produced on a sheet of paper, the artist's hand must do what the eye sees or intends: this is what is meant by hand/eye coordination. One way of interpreting the broad, dark charcoal marks zigzagging across the center of Kollwitz's drawing is to see them as representing the profound connection

that exists between the artist's hand and eye. From the point of view of volumetric description, Kollwitz's handling of the shoulder and arm contradicts the language of form that describes the subject's face and hand. But from the point of view of idea or content, this energized line, an offbeat but engaging choice on the artist's part, assumes meaningful implications.

PASTEL

Pastel has many important similarities to charcoal. Like charcoal, it comes in stick form and does not rely on a liquid substance to thin it out. In this respect it is similar to many drawing

materials. Moreover, like charcoal, it is a particularly effective medium for covering areas quickly and broadly. It is unlike charcoal mainly in terms of color, and in this respect it rivals many properties normally associated with painting.

Pastels—dry chalks composed of colored pigments and a nonwaxy binder—come in an exceptionally wide variety of colors and shades. This can be both a blessing to the artist and a detriment. It is a blessing because it offers the pastel artist a great degree of freedom regarding color. But this plus can rapidly turn into a minus. A box of pastel sticks is to an insensitive

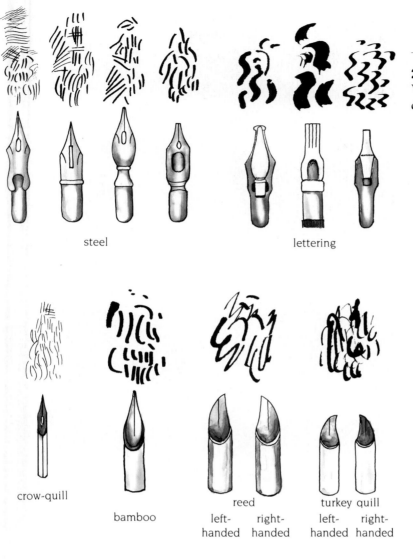

steel lettering

crow-quill

bamboo

reed
left-handed right-handed

turkey quill
left-handed right-handed

practitioner of this medium what a box of candy is to a reluctant dieter. Every stick of color in the box must be tried at once, an aesthetic shortcoming which inevitably produces pretty rainbow interpretations of whatever subject happens to be at hand. In the hands of a master such as Mary Cassatt, however, the pastel medium represents for the artist one of the most vibrant, immediate means of describing a visual situation, as seen in *Nurse Reading to a Little Girl* **[280]**.

PEN AND INK

Pen and ink offers the artist a direct, flexible means of applying a wide variety of lines or marks to a paper support. Factors affecting the specific nature of the artist's mark include: (1) the pen point, (2) the makeup or consistency of the paper (including the texture or "tooth" and the degree of absorbency of the paper), (3) the amount and type of ink used, (4) the types of lines adopted (including crosshatchings), and (5) the pressure exerted by the artist in applying the pen and ink to the paper. Our diagram **[281]** displays an assortment of pen points available to the artist and the kinds of marks these pen points are apt to make. Notice that artists' pen points are made out of various materials. Distinct materials produce distinct marks. Likewise, each pen point will feel different to the artist when the artist applies the ink to the paper.

282
Vincent van Gogh. *The Zouave.*
1888. Reed pen and ink, 12⅝ x 9½"
(32.1 x 24.1 cm). The Justin K.
Thannhauser Collection, Solomon R.
Guggenheim Museum, New York.

Expressionist art takes many forms.
It is characterized by distortion of
form, color, and space, and a willing-
ness on the artist's part to replace
naturalistic description with emotional
expression. Two of the earliest groups
of 20th-century artists to be termed
"Expressionist" were the German-based
Blaue Reiter (Blue Rider) and Die Brucke
(The Bridge). The Blue Rider group
include Franz Marc, Wassily Kandinsky,
August Macke, and Paul Klee.
Die Brucke artists include Ernst Ludwig
Kirchner, Karl Schmidt-Rottluff, and
Erich Heckel.

A careful appraisal of Vincent van
Gogh's *The Zouave* **[282]** reveals the
wide range of marks that an artist is
capable of achieving in pen and ink.
The sitter's face, hair, and coat are so
distinctively handled that we can
almost see different colors and feel
different textures in each of these
areas. Judging especially from the
varied width of the ink strokes, it is
likely that these diverse effects of
texture and color result, in part, from
van Gogh's use of assorted pen points.

BRUSH OR WASH DRAWING

Pen drawings and wash drawings both
involve the application of ink, or a
single water-based color, to a sheet of

paper. The main difference between
these two drawing techniques involves
the means of application. In **wash
drawings** such as the seventeenth-
century French artist Claude Lorrain's
*The Tiber above Rome: View from
Monte Mario* **[283]**, and the Swiss-
born **Expressionist** artist Paul
Klee's *Young Man at Rest (Self-Portrait)*
[284], the images are created with
brushes. A drawing created solely with
a pen point tends to be linear in
nature, which may or may not be the
case in a wash drawing. Generally,
only one colored ink is applied to a
given wash drawing (this color is
usually black, although brown inks
known as *sepia* or *bistre* are frequently
used as well). The darker or more

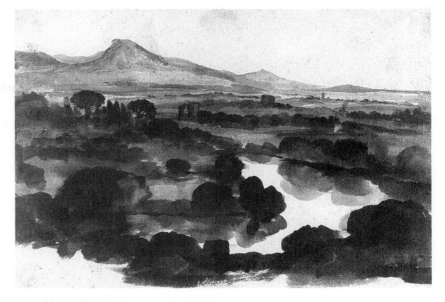

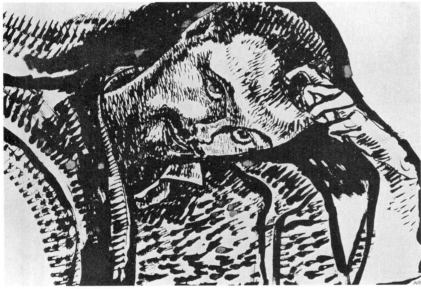

intense the tone required, the less water is added to the ink; the more the ink is diluted with water, the lighter the tone will be. Wash drawings represent a bridge between drawing and painting.

PAINTING

Almost all forms of paint are made from the following components: 1) pigment, 2) a binding agent, and 3) a solvent or thinner. **Pigment** is a dry coloring substance. Most painting processes involve fixing or suspending colored pigments in a liquid or emulsion (called a **vehicle**) that

consists of a **binder** (a sticky substance) and a solvent or thinner that allows the mixture to be spread across a surface more or less easily by altering the paint's viscosity. The fixing agent or vehicle of paint often lends its name to the medium; thus we refer to oil, watercolor, or acrylic paint.

Various surfaces or supports, including paper, canvas, silk, animal hide, plaster, and wood panels, can be used as the area onto which an artist applies the paint medium. Certain types of paint work best on certain types of surfaces. Watercolor, for example, works well on paper and poorly on

285
Altar for Male Shootingway, Fish People. Navajo sand painting, reproduced on cloth. Made by Hostin Claw, Navajo medicine man, c. 1905–1912, near Tuba City, Arizona. 33½ x 35¼" (85 x 89.5 cm). Smithsonian Institution National Anthropological Archives, Bureau of American Ethnology Collection.

Social Realism developed in the 1920s and 1930s in countries such as the United States, Mexico, the Soviet Union, and Germany. Social Realist art, which is generally associated with leftist politics, is often intended to criticize the injustices perpetrated against the underprivileged members of society. Important Social Realist artists include the American Ben Shahn and Mexican muralists such as Diego Rivera.

wood panels. The earth itself is occasionally used as a support for paint, as is the case in *Altar for Male Shootingway, Fish People*, an example of Native American sand painting [285].

Each paint medium has its own peculiar set of properties and characteristics. One paint medium is not better or worse than another, yet unquestionably, the advantages and disadvantages of a given medium are apt to bring out the individual strengths or weaknesses of a given artist. It remains for each artist to choose the paint medium best-suited to carry out his or her ideas.

FRESCO

Before oil paint became such a widely used painting medium, many works were carried out in **fresco,** an Italian term that means "fresh." This method of painting involves working a mixture of pigment and lime water (the solvent) into a freshly plastered wall (the binder). In the case of a painted canvas, the painting is hung on a wall; with fresco, the painting becomes part

of the wall itself. Fresco presents several significant demands for the working artist. Perhaps most important is the quick drying time of the plaster support. Once dried, correcting or repainting an area is difficult if not impossible without removing the old plaster and starting over. Consequently, only a small area at a time can be worked on during any given session and much preplanning in the form of sketches and preliminary drawings is usually required. Aside from manual dexterity, fresco painting demands the development of a keen sense of timing on the part of the artist. If the plaster is too wet it will not accept the paint properly; if it is too dry the paint will not be absorbed by the wall and will wind up as colored flakes powdering the floor. A properly executed fresco is one in which the plaster sucks the paint in just below the surface of the wall and locks it there.

The paintings of fifteenth-century Italian painter Piero della Francesca that decorate the Church of San Francesco in Arezzo [286] represent masterful examples of the fresco technique. Some of the most important examples of twentieth-century fresco painting were created by the Mexican **Social Realist** artists Diego Rivera, José Clemente Orozco, and

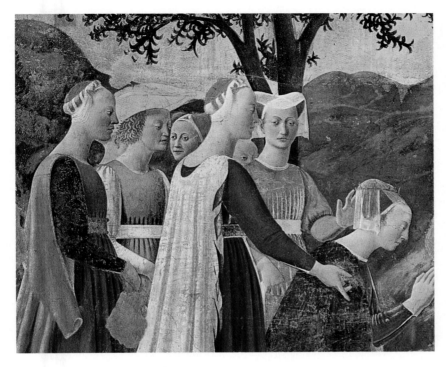

286
Piero della Francesca. *The Queen of Sheba* (detail). 1452–1466. Fresco. Church of San Francesco, Arezzo.

David Alfaro Siqueiros. The subject matter portrayed by these artists is often decidedly social and political in nature, as we see in Diego Rivera's *Liberation of the Peon* [287].

TEMPERA

Tempera paint consists of pigments suspended in binders such as egg yolk, gelatin, cheese, blood, or gum arabic. Although it is still used by artists today, it does not enjoy the popularity among contemporary artists that it did during Medieval and early Renaissance periods. Historically, the most popular form of tempera paint is water-based egg tempera. This medium consists of approximately equal parts of colored pigment, egg yolk, and water. When egg tempera dries, the inflexible paint film it forms is particularly prone to cracking or flaking if it is not on a rigid backing. Traditionally, the support preferred by the majority of artists who worked with the medium of egg tempera—or at least the support that has enabled

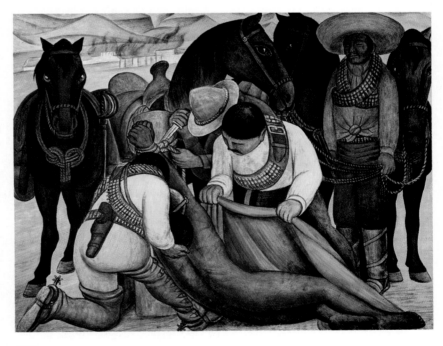

287
Diego Rivera. *Liberation of the Peon.* 1931. Variation of a fresco in Ministry of Education, Mexico City, 1923–1927. Fresco, 74 x 95" (1.88 x 2.41 m). Philadelphia Museum of Art. Gift of Mr. and Mrs. Herbert C. Morris.

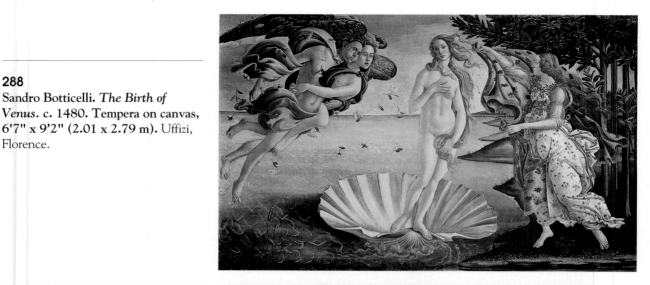

288
Sandro Botticelli. *The Birth of Venus.* c. 1480. Tempera on canvas, 6'7" x 9'2" (2.01 x 2.79 m). Uffizi, Florence.

289
Fra Filippo Lippi. *Madonna and Child.* 1440–1445. Tempera on wood, 31⅜ x 20⅛" (.80 x .51 m). National Gallery of Art, Washington, D.C. Samuel H. Kress Collection.

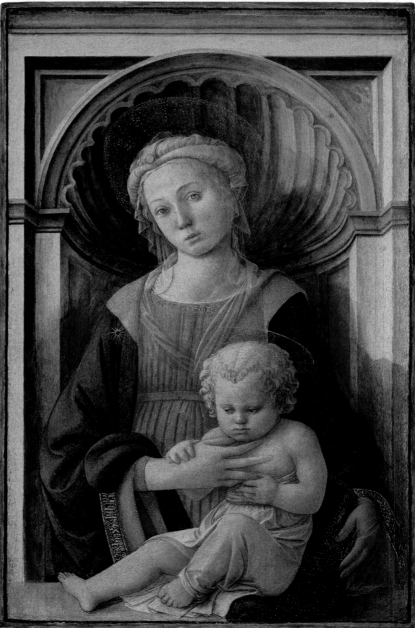

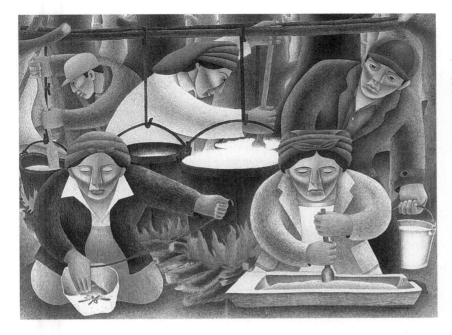

290
Patrick Desjarlait. *Maple Sugar Time*. 1946. Tempera on paper, 15 x 20" (38.1 x 50.8 cm). Philbrook Museum of Art, Tulsa.

this medium to withstand the ravages of time—is the wood panel. Nonetheless, artists occasionally used canvas (often glued over a wood panel) as a suppport for this medium, as is the case in Sandro Botticelli's *The Birth of Venus* [288].

Before tempera is applied, careful preparation of the support surface is always required. The support should be covered or prepared with **gesso,** a white substance such as chalk or plaster mixed with a water-based binder such as a solution of animal glue, gelatin, or casein. Traditionally, the support surface was prepared with several coats of gesso. Between coats the panel was sanded so that the final surface that received the paint was as smooth as an eggshell. Such a surface is especially conducive to the creation of detailed, meticulously painted images such as the early Renaissance artist Fra Filippo Lippi's *Madonna and Child* [289].

Twentieth-century artists do not use tempera paint as frequently as artists from previous centuries did, but it still is an important medium. In *Maple Sugar Time* [290] by the twentieth-century Chippewa artist Patrick Desjarlait, compositional details such as the two foreground figures and the horizontal bar that extends across the top of the painting serve to flatten out the illusion of space in the painting, Nonetheless, a distinct impression of three-dimensionality pervades the image as a result of Desjarlait's careful modeling of each form.

Like fresco, tempera dries quickly, thereby limiting the artist's ability to blend the colors and tones. With this medium, the effect of blending is often accomplished by applying two or more layers of paint in short, fine brushstrokes that are carefully placed next to one another. These superimposed layers mix together optically, thereby creating the effect of blending. Unlike fresco, changes can be effected relatively easily by painting over previously painted areas.

Oil Paint

Oil is the binding agent for **oil paint,** and turpentine is the traditional solvent used for thinning this mixture, which is applied to supports such as canvas and wood panels. The support is usually prepared with a ground or primer coat of *gesso* (a mixture of glue and chalk) before the paint is applied, to enable the oil paint to adhere properly.

Of all painting media, oil paint has enjoyed the greatest degree of popular-

291

Jan van Eyck. *Marriage of Giovanni Arnolfini and Giovanna Cenami.* 1434. Oil on wood, 33 x 22½" (84 x 57 cm).
Reproduced by courtesy of the Trustees, The National Gallery, London.

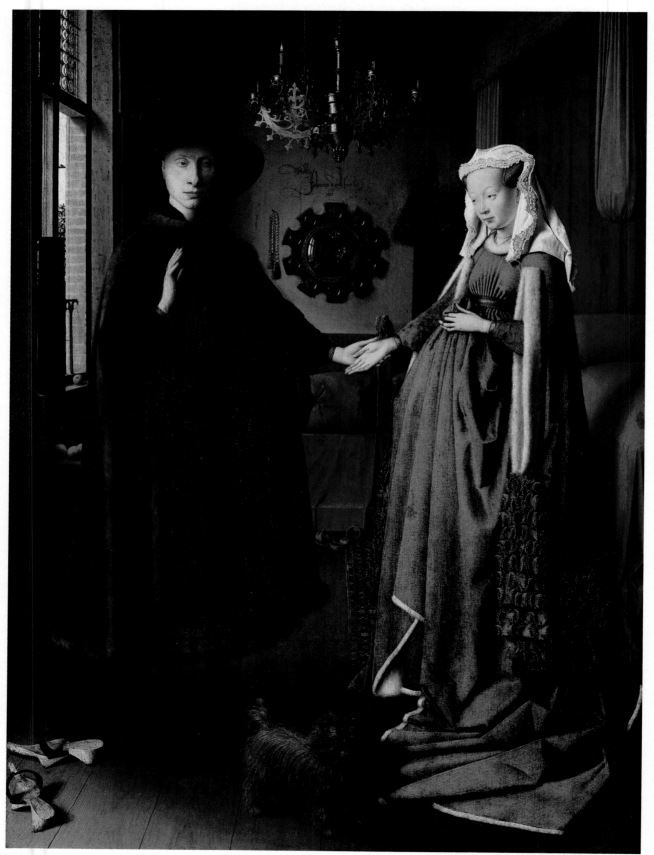

ity among practicing artists since its perfection by the fifteenth-century Flemish artist Jan van Eyck. There are several possible reasons for this. Its relatively slow drying speed enables artists to easily and unhurriedly work back into painted areas while those areas are still wet. This, in turn, allows the artist to be extremely subtle in terms of blending the masses and edges of forms.

The paint lends itself naturally to a wide range of painting techniques. It can be applied in thin, transparent glazes so as to allow previously applied layers of paint to show through the top layer. This technique, known as glazing, produces subtle effects of color and luminosity that cannot be achieved any other way. A glazed color, such as orange, for example, produced by applying a thin coat of red over yellow or yellow over red, emits a very different quality of light than does an orange mixed from the same yellow and red colors before it is applied to a support. Many paintings such as Jan van Eyck's meticulously textured *Marriage of Giovanni Arnolfini and Giovanna Cenami* [291] rely on the technique of glazing to model painted forms.

Other artists prefer to apply oil paint thickly in a technique known as **impasto** painting. *Woman and Bicycle* [292] created by the Dutch-born leader of the Abstract Expressionists, Willem de Kooning, represents a clear case of this technique, as does van Gogh's *Crows over a Wheatfield* [132]. As our detail of de Kooning's painting shows [293], in the case of impasto, the physicality of the paint itself (sometimes aggressively, sometimes delicately, but always sensually applied in de Kooning's paintings) can take on a substance and even a meaning that rivals the subject of the work in importance and emotional impact.

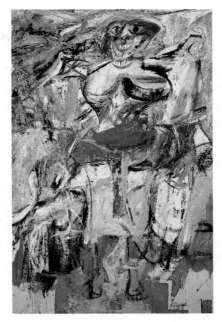

292
Willem de Kooning. *Woman and Bicycle*. 1952–1953. Oil on canvas, 6'4½" x 4'1" (1.94 x 1.24 m). Collection of Whitney Museum of American Art.

293
Willem de Kooning. *Woman and Bicycle* (detail). 1952–1953. Oil on canvas. Collection of Whitney Museum of American Art.

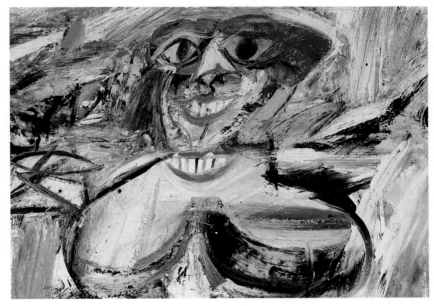

WATERCOLOR

The medium of **watercolor** consists of transparent pigments ground to a very fine consistency in a water-soluble binder such as gum arabic, a gummy plant substance. The thinning agent is water, which can be added to watercolor mixtures in great quantities without destroying the chemical or physical integrity of the paint. The more water the artist adds to the watercolor mixture, the more transparent this inherently translucent medium becomes. When watercolors are handled in a traditional manner, white paint is not used. Rather, the white of the underlying paper—the preferred support for watercolor—serves as the white or the lightest color. The term **aquarelle** refers to this transparent type of watercolor painting.

There are several characteristics that have endeared the medium of

294
Bernard Chaet. *Blueberries I*. 1984.
Watercolor and pencil on paper,
22¾ x 30". Hirshhorn Museum and
Sculpture Garden, Smithsonian
Institution, The Joseph H. Hirshhorn
Bequest, 1981.

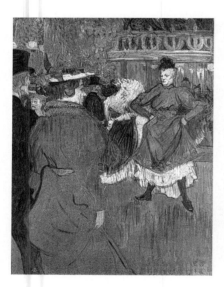

295
Henri de Toulouse-Lautrec. *Quadrille at the Moulin Rouge*. 1892.
Gouache on cardboard, 31½ x 23¾"
(.801 x .605 m). National Gallery of
Art, Washington, D.C. Chester Dale
Collection.

watercolor to artists. From a practical standpoint it is a particularly convenient and portable medium, placing minimal demands on the artist regarding preparation, equipment, and clean up. A brush, a small nonporous surface that serves as a palette, a container of water, and a sheet of paper are all that is needed. Ideally the paper should be made from linen rags, or it should at least contain a significant percentage of rag content to enhance its durability and accentuate the quality and brilliance of the paint.

From an aesthetic standpoint, watercolor is inherently predisposed to create fresh, lively effects. A single subject (blueberries randomly distributed across a tabletop), accompanied by a host of delicate variations, governs twentieth-century American painter Bernard Chaet's *Blueberries I* [294]. Subtle color variations enliven the economy of circular bluish blotches of paint that dot the pure white of the paper. Chaet mixes more green into some berries, more red into others; he greatly dilutes the watercolor here, he applies the medium in concentrated form elsewhere. The warm and cool colored marks of widely varied degrees of transparency and opacity, intermittently clustered and isolated into unpredictable

arrangements, invigorate this finely orchestrated still life with an improvisatory, playful sparkle.

GOUACHE

When opaque white is added to watercolors the resultant mixture is called **gouache**. Unlike watercolor, which stains the paper support onto which it is applied, gouache, like tempera and oil paint, forms a layer of color on its support. Because gouache paints are naturally opaque and contain distinctive light-reflecting qualities, gouache, unlike watercolor, does not depend on the white of the underlying paper to heighten the brilliance of its colors. For this reason, many gouache paintings are painted over a colored ground, which often serves to further enrich the color or "colored light" of subsequent paint layers. Artists also use this middle-toned ground as a unifying factor in their paintings, as we see, for example, in Toulouse-Lautrec's *Quadrille at the Moulin Rouge* [295]. Here the artist allows the warm ochre color of the cardboard to show through between many of the individual brushstrokes. The colored ground unifies the image and affords Toulouse-Lautrec the luxury of working from this middle tone both toward lighter areas such as

the petticoats of the dancers, and toward darker areas such as the men's suits and top hats.

ACRYLIC

Acrylic came into prominence as a painting medium during the second half of the twentieth century and now challenges oil paint as the medium of choice among contemporary painters. **Acrylic** paint, which, like oil paint, can be packaged in tubes or jars, is made by suspending colored pigments in an acrylic emulsion. The paint can be thinned with water or with a polymer medium. When dry, the resin particles unite to form a tough but elastic film which is completely waterproof. Several factors involving its flexibility account for its popular acceptance by artists:

1) It dries much more quickly than oil paint.
2) If desired, its drying speed can be slowed by adding substances known as retarders.
3) When acrylic paint is greatly diluted with water and, as is the case in twentieth-century American painter Morris Louis's *Saraband* [296], soaked into the fibers of unprimed canvas, its appearance approximates watercolor in many respects.
4) Undiluted, many of the acrylic colors are extremely vibrant.
5) When combined with compatible gel mediums, *impasto* effects paralleling oil paint can be achieved.
6) Acrylic lends itself naturally to flatly covering large areas.
7) It can be applied effectively to a wide range of surfaces including canvas, paper, and wood panels.
8) One layer of paint can be covered easily and completely by another layer.
9) Being water soluble, there are no odors such as those associated with oil paint, and it allows for easy clean up.

296
Morris Louis. *Saraband.* 1959. Acrylic resin on canvas, 100½ x 149" (2.55 x 3.78 m). Solomon R. Guggenheim Museum, New York.

297
Robert Colescott. *Feeling His Oats.* 1988. Acrylic on canvas, 7'6" x 9'6" (2.29 x 2.90 m). Courtesy Phyllis Kind Gallery, New York.

In *Feeling His Oats* [297], contemporary American painter Robert Colescott exploits the wide range of effects achievable with acrylic paint. Rich *impasto* effects are clearly visible in areas such as that of the bathing beauty located in the bottom left-hand corner of the composition. The alley leading to the detail of a Superman in flight is painted flatly and brightly; the skin of many of the other figures is patiently modeled in more subdued, subtle tones.

In this semi-serious/semi-satirical and altogether painfully contradictory interpretation of "the black experience," Colescott combines a black man's dreams of wealth, power, and advanced technology with images of poverty and tribal roots. The top half of the painting includes such details as money, a black Superman, men in suits and ties, bare hands bending a steel pipe, and a computer keyboard and screen. The bottom of the composition consists of a black janitor holding his broom, an old wet nurse holding a white child, a masked figure partially camouflaged by a bush, and a seemingly ineffectual weight lifter in a sleeveless T-shirt struggling to impress the thickly painted bathing beauty. The stereotypes and simplistic icons that comprise Colescott's contradictory world are paralleled by the contradictory nature of the composition. The colors and the modeling of the forms of this jam-packed painting are, in turn, garish, expressionistic, cartoonish, and subtle. The manipulation of the paint medium parallels these characteristics.

PRINTMAKING

Printmaking is closely related to drawing in many ways. Like drawings, prints—whether woodcuts, etchings, or lithographs—consist of a series of marks distributed across paper supports. There are, however, significant differences between drawing and printmaking, the most important of which involves numbers or multiplicity. A drawing is a one-of-a-kind image; a print is usually produced as part of a series of identical, or nearly identical, images. For this reason prints are often referred to as multiples. The series of impressions derived from a master image is commonly referred to as an **edition.** Although there are numerous materials and methods by which an artist can create an edition of essentially identical prints, each of these processes shares a common principle: a

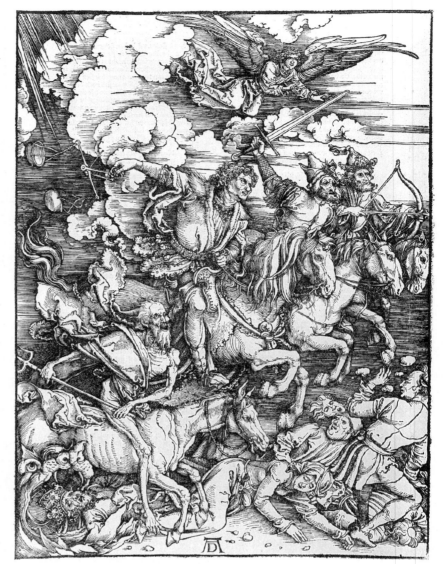

298
Albrecht Dürer. *The Four Horsemen* (Apocalypse Series). **Woodcut, 15½ x 11" (39.6 x 28.1 cm).** The Art Museum, Princeton University. Gift of Donald B. Watt.

master image is recorded onto a particular surface, and from that surface multiple impressions are produced. Artists usually sign their prints in a margin below the image. Along with their signatures, artists often include the date the print was completed, the number of prints created or "pulled" from a master image (that is, the number of prints produced in a given edition) and the number of each print within the sequence of that edition. For example, "12/50" written in the margin below a

print indicates that this particular print was the twelfth in an edition of fifty prints.

The artist usually plays an important role in creating an original print. Artists either create the print themselves or they supervise its handmade production. Such images, despite the fact that they are not one-of-a-kind, are regarded as works of art and are highly prized. On the other hand, reproductions such as those included in this book, no matter how fine they

are in terms of the quality of their tones, color, or linear details, are no more than purely mechanical copies of an original image. They are not produced directly from the artist's original plate, and they are not works of art in themselves.

There are many different forms the printmaking process can take, and artists often combine differing printmaking techniques within a single image. Three categories into which the wide diversity of print-making techniques can be placed are relief, intaglio, and planar.

RELIEF PRINTING

The oldest printmaking technique, practiced in ancient Egypt, China, and India, is relief printing. **Relief printing** refers to a process in which the marks or visual details the artist wishes to record are raised—that is, they stand out in physical relief—above the level of the rest of the wood, linoleum block (in which case the print is called a linoleum cut), or some other surface that serves as the support for the drawn image. When the artist rolls ink across the image and then presses a piece of paper over this area, only the raised portions are inked. In turn, only the inked areas are transferred or recorded onto the paper. The most common method of relief printing is the woodcut.

Woodcut

In order to create a **woodcut** print the artist first draws an image onto the plank side of a piece of wood. Areas that the artist does not want to show up on the final print are cut away with special knives and gouges. The block is then inked and the paper onto which the artist wishes to transfer the image is pressed against this inked block.

Generally considered to be a Chinese invention dated sometime between the fifth and seventh centuries A.D., the woodcut is the earliest form of

printmaking. The oldest example of woodblock printing survives in the form of a Buddhist charm distributed in 770 A.D. by the Empress Shotoku to temples throughout Japan. One million of these charms are believed to have been distributed at that time. From such early beginnings as these, the technique of woodblock printing spread throughout the Orient, becoming increasingly more sophisti-cated. By the late 1300s woodblock printing had made its way to Europe, and by the 1400s, when paper became more available, European artists began investigating with greater frequency the aesthetic merits of woodcuts. By the end of the century one of history's greatest practitioners of the medium, Albrecht Dürer, was producing intricately detailed images such as *The Four Horsemen* [298].

Although printmaking developed in the East, few Western artists experi-enced Eastern aesthetics until the nineteenth century when an Ameri-can naval officer, Commodore Matthew Perry, opened Japan to world trade in 1854. Distrusting foreigners, the Japanese had, prior to Perry's campaign, isolated themselves from the outside world for about 300 years. By the end of the century, Western artists—especially those working in Paris—discovered the Japanese print. In particular, the **ukiyo-e** style print exerted a major influence. Among the many artists who became influenced by Japanese woodcuts at this time were: Edouard Manet, Edgar Degas, Henri de Toulouse-Lautrec, and Paul Gauguin from France; the American Mary Cassatt; the Norwegian **Sym-bolist** Edvard Munch; and German Expressionist artists such as Ernst Ludwig Kirchner and Karl Schmidt-Rottluff. Some artists made direct copies of Japanese prints; van Gogh's *The Bridge* [299], a copy of Ando Hiroshige's *Rain Shower on Ohashi Bridge* [47], is a case in point. More often, the Japanese influence on Western artists was less literal, but it

299
Vincent van Gogh. *The Bridge.* c. 1886–1888. Oil on canvas, 21⅝ x 18⅛" (54.9 x 46 cm). Vincent van Gogh Foundation/ National Museum Vincent van Gogh, Amsterdam.

Japanese **ukiyo-e** paintings and prints (produced between the early 1600s through the mid-1800s) portray a fleeting world, the world of daily life. Basic themes and characteristics of *ukiyo-e* include festival scenes of common men and women; scenes of the Kabuki theater; courtesans; figures portrayed in contemporary dress— often richly colored and patterned; and, especially in the work of Hokusai and Hiroshige, landscape.

Symbolism was a movement in painting and literature that developed during the last two decades of the nineteenth century. Symbolists wished to visualize such weighty yet amor-phous ideas as love, hate, fear, and God. The images they created are often characterized by intense colors and a decorative arrangement of shapes. Important Symbolists include French artists such as Paul Gauguin, Odilon Redon, and Edvard Munch from Norway.

300
Kitagawa Utamaro. *Courtesan Writing a Letter*. Early 19th century (Kyowa Period). Color woodblock print, Oban size. Uragami Collection, Tokyo.

301
Mary Cassatt. *The Letter*. c. 1891. Color etching, 13⅝ x 9" (34.6 x 22.8 cm). Bibliothèque Nationale, Paris.

was equally significant. When you compare one of the most important *ukiyo-e* artists, Kitagawa Utamaro's *Courtesan Writing a Letter* [300] with Mary Cassatt's *The Letter* [301], do you not see a strong relationship between the works? The subject matter of these images is closely related. But more importantly, the compositions of both prints are governed by interacting patterns and

clearly delineated shapes of flat color—pictorial characteristics particularly well suited to expression through the woodcut technique.

INTAGLIO

The term **intaglio** comes from the Italian verb *intagliare* meaning "to incise." Contrary to the woodcut technique where artists cut away the portions of the wood block they do not want to be tranferred to the printed page, the lines or marks incised into the copper, zinc, or steel plate of an intaglio print are the marks that will ultimately be reproduced.

302
Antonio Pollaiuolo. *Battle of Ten Naked Men* (detail). c. 1460. Engraving. The Metropolitan Museum of Art, Purchase, 1917, Joseph Pulitzer Bequest.

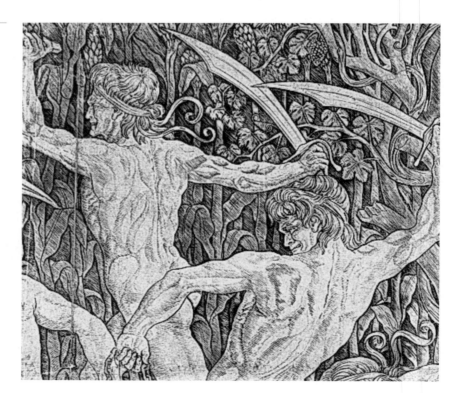

303
Rembrandt van Rijn. *Shell*. 1650.
Etching, 3¾ x 5¼" (9.5 x 13.3 cm).
Bibliothèque Nationale, Paris.

D A B C

304
Graduation of tones in Rembrandt's *Shell*.

Engraving

In an **engraving** an image is cut into a metal plate with a tool called a graver or burin. The entire plate is then inked, with the artist taking special care to work the ink into these sharp, shallow grooves. Then all the ink is wiped off the plate except where it fills the incised lines. The final step involves covering the plate with a sheet of paper and pressing the paper with extreme pressure into the inked lines in order to transfer the inked image from plate to paper.
Battle of Ten Naked Men [235], one of the earliest and most famous examples of engraving, was created by fifteenth-century Florentine artist Antonio Pollaiuolo. As our detail demonstrates [302], many of the print's meticulously incised lines closely parallel one another. The darkest lines are the widest and most deeply engraved lines.

Etching

The main difference between the technique of etching and that of engraving has to do with the way in which the incised lines are sunk into the metal plate. In order to create an **etching,** an artist must first cover the polished surface of the metal plate with an acid-resistant, waxlike substance called the "resist." Using a needle-like point, the artist then scratches the lines of the image into the "ground." When the plate is immersed in acid the exposed areas are eaten away or etched permanently into the bare metal. (The term etching comes from the German word *essen,* "to eat.") Repeated immersions of the exposed areas in the acid bath create progressively deeper tonalities when the plate is inked and printed.

Lighter areas can be maintained, or "stopped out," by removing the plate from the acid and covering those areas once again with the resist before the plate is re-immersed.

For many art lovers, the term *etching* and the name Rembrandt are inseparable. His more than 300 prints consist mainly of etchings and drypoints (which we will discuss next). His *Shell* [303] demonstrates the poetic, yet precise, quality of light and form achievable through a sensitive handling of this medium. The darkest areas of this tiny etching (which is smaller than the open hand of most adults) were created in two ways: these areas spent the longest period of time exposed to the acid of the bath, and they were created by eliminating (through crosshatching) the largest percentage of the white of the paper support onto which the image was printed. Notice, in this respect, the masterly graduation of tones Rembrandt achieved [304] between the white highlight of the shell (A), the light tone of the table top (B), the various middle tones of the shell body (C), and the velvety blacks of the deepest shadows (D).

305
Max Beckman. *Dostoevsky I.* 1921.
Drypoint, 6⅝ x 4⅝"
(16.8 x 11.7 cm). Collection, The
Museum of Modern Art, New York.
Larry Aldrich Fund.

Drypoint

Another form of intaglio printing is
the technique of **drypoint,** which is
often used in combination with other
intaglio processes. In this technique
the metal cut out of the plate (usually
copper) is not altogether removed.
Instead, a raised, somewhat ragged
edge, or burr, cut with an instrument
called a drypoint needle or etching
needle, remains alongside the incision.
If the tool is held perpendicular to the
plate, burrs can form on both sides of
the incision creating a furrow or plow-
like effect. If the needle is held at an
angle to the plate (the typical writing
position) the burr forms on one side of
the cut. The incision itself counts for
less in the final print image than does
the burr. When ink is applied and
then wiped off the plate, a ridge of ink
is trapped under the burr. As is
evident in twentieth-century German
Expressionist artist Max Beckman's
Dostoevsky [305], this trapped ridge
of ink creates a velvety, slightly
blurred line when the ink comes
into contact with the sheet of paper
pressed against it.

PLANOGRAPHIC

In relief printing techniques, the
image to be printed is raised *above* a
given surface. Intaglio printing

306
Pierre Bonnard. *La Revue Blanche.*
1894. Lithograph printed in four
colors, 31½ x 24⅜" (80 x 62 cm).
Baltimore Museum of Art.

307
José Clemente Orozco. *The Farmer (Grief)*. 1923. Lithograph, 11⅞ x 9⅞" (30.2 x 25.1 cm). San Francisco Museum of Modern Art. Albert M. Bender Collection, Gift of Albert M. Bender.

involves incising lines *into* a metal plate. **Planographic** printmaking techniques involve printing images off flat surfaces.

Lithography

By far the most popular form of planographic printing is lithography. The word **lithography** stems from a Greek term meaning "stone writing." Bavarian limestone remains the preferred ground upon which lithographs have been created since the invention of this printing process in the 1790s by the German actor-playwright Alois Senefelder. Primarily because they are less expensive and more readily available, in recent years artists have begun using zinc and aluminum plates as an alternative ground on which to make their prints.

Unlike the printmaking processes we have discussed up to this point, lithography is based on chemical rather than physical properties. The governing phenomenon underlying this process is the principle that grease and water do not mix. Lithographs are created by drawing an image on a flat (but roughened or grained) surface with a grease pencil or by painting with a brush dipped in a greasy substance such as *tusche* (lithographic ink). Occasionally, needles and other implements are used to create varied effects. The rough surface permits the ground to "hold" the drawing. The entire surface is next covered with an

acidic solution that "fixes" the image onto the ground. Then the surface is dampened with water and inked with a roller. Because oil and water do not mix, those areas of the ground covered with the image drawn in a waxy substance repel the water and accept the oil-based ink. A printed impression is transferred onto a sheet of paper when the paper is laid onto the inked image and run through a press.

When we compare the flat, sharply edged, simplified shapes that dominate the French **Nabi** painter Pierre Bonnard's poster *La Revue Blanche* [306] with the more gradual, tonal variations that govern José Clemente Orozco's print *The Farmer (brief)* [307], we begin to appreciate how versatile a technique lithography is. Orozco handles the technique of lithography as loosely as he might

The **Nabis,** a small group of French artists painting during the late nineteenth century, added a kind of moodiness to the light and color bequeathed them by the Impressionists. The subjects portrayed by Nabi artists tended to be less literary and weighty than the subjects portrayed by the Symbolists who were working at approximately the same period. Artists such as Pierre Bonnard and Edouard Vuillard, who painted atmospheric, often elaborately patterned, yet modest French interior scenes, are sometimes referred to as Intimists, a branch of the Nabi movement.

Alex Katz. *The Red Coat.* 1983.
Silkscreen, 58 x 29" (147 x 74 cm).
Co-published by the artist and Simca
Print Artists, Inc.

handle the medium of charcoal on paper. Here, the forms that comprise the mourning man's body are modeled in three-dimensional relief. Notice how broad the litho crayon strokes are that comprise this lithograph compared to the pinpoint precision of the strokes of Albrecht Dürer's woodcut [298], Pollaiuolo's engraving [302], and Rembrandt's etching [303]. And notice, too, that despite the fact that no facial features are visible, the expression on the mourning man's face communicates to us with urgency, clarity, and power from behind his tightly interlocked fingers.

SERIGRAPHY

The most recently developed of the popular printmaking procedures is serigraphy (also known as screenprinting and silkscreening). **Serigraphy,** a term that means literally "silk writing," is the term artists apply to the commercial and industrial process of silkscreening, which artists began to adapt to their own needs in the 1930s. Serigraphy refers to a process in which a stencil is adhered to a silk screen (the screen can also be made of other open-mesh materials such as nylon, dacron, or organdy) that has been tightly stretched on a frame. The stencil can be cut from a special type of film, it can be created by photographic means (a technique known as photoserigraphy), or it can be created by painting directly onto the silk with a special type of glue or shellac. When ink, dye, or paint is forced with a rubber-bladed tool (known as a

"squeegee") through the fine mesh of the screen, the stencil does not allow the paint to penetrate onto the support surface beneath. (Paper is the most common support, but almost any other relatively flat material such as cloth, masonite, or plastic can be used as well.) Any area not covered by the stencil is printed with the color forced through the screen. In order to create a multi-colored print a separate screen must be prepared for each color. For the screen in which green is to be printed, for example, all areas except those intended to be printed green are covered ("stopped out") by the stencil or glue. The same process is repeated on separate screens for each of the other colors to be printed. Each screen must then be accurately "registered" or aligned before it is printed, one at a time, so that each color is consistently and properly positioned when it is printed. Colors can be printed next to one another or in transparent films one over the other. Compared to other printmaking processes, the ability to create multi-colored serigraphs is relatively simple and inexpensive. For this reason it is not unusual for an artist to incorporate twenty or more screens (separate colors) in the creation of one image.

Although many serigraphs are informed by a wide range of extremely subtle color modulations and degrees of opacity and transparency, serigraphs created with cut-out stencils are often characterized by bright colors and flat shapes bordered by hard edges, as is the case in *The Red Coat* [308] by contemporary American painter Alex Katz. Images created by stencils brushed onto the screen with **tusche,** a black, greasy material that comes in both liquid and crayon form, are often more gestural and organic in nature. *Tusche* brushes onto the screen easily, and allows the artist to see what the finished print will look like in black.

Several factors make serigraphy particularly appealing to the artist:

1) It is a relatively inexpensive printmaking technique because no press is required.
2) It allows for a wide range of transparent, opaque, shiny, dull, and thickly or thinly applied color or tonal variations.
3) Images can be printed onto a wide range of materials.
4) Stencils can last for thousands of impressions.
5) Serigraphy can be used in combination with other media such as painting, drawing, and photography.

PHOTOGRAPHY

In the early 1800s, the prototype of our modern-day camera and the principle of chemically fixing images onto light-sensitive materials were discovered by individuals such as the Frenchmen Joseph Nicéphore Niépce and Louis-Jacques-Mandé Daguerre (after whom the daguerreotype, one of the earliest methods of producing a permanently fixed photographic image, was named). Nonetheless, for years, many otherwise advanced

thinkers regarded photography as either a threat to traditional methods of image-making, or as an unwelcome second cousin within the family of disciplines that comprise the traditional fine arts. Because the camera can so accurately record visual phenomena, photography was initially derided by some people as being to the visual arts what a dictionary or an encyclopedia is to literature: that is, nothing more than a dispassionate means by which information is mechanically recorded. It took more than a century before photography gained a secure, respectable foothold in the world of art. Like many other painters of the time, van Gogh apparently found no artistic merit in photography: ". . . accurate drawing, accurate colour, is perhaps, not the thing to aim at because the reflection of reality in a mirror, if it could be caught, colour and all, would not be a picture at all, no more than a photograph."[3] His friend, the Symbolist writer G. Albert Aurier, declared that any attempt at reproducing an image with total accuracy—what is called Realism in the twentieth century— was not art any more than photography was: "The myopic recording of everyday anecdotes, the stupid imitations of peep-hole views of nature, straightforward observation, illusionism, the distinction of being just as faithful, just as banal as the daguerreotype, will not satisfy any painter or any sculptor worthy of the name."[4] Even twentieth-century artist Charles Sheeler, who worked extensively and sensitively with photography as a medium, both as an independent artform and as a source for many of his drawings and paintings [309, 310], viewed photography within narrowly drawn lines. "Photography," Sheeler wrote in 1937, "is nature seen from the eyes outward, painting from the eyes inward. Photography records inalterably the single image while painting records a plurality of images willfully directed by the artist."[5]

309
**Charles Sheeler. *The Upper Deck.* c. 1928. Gelatin silver print, 10 x 8"
(25.4 x 20.3 cm).** Gilman Paper Company Collection, New York.

310
**Charles Sheeler. *Upper Deck.* 1929. Oil on canvas, 29⅛ x 22³⁄₁₆"
(74 x 56.3 cm).** Courtesy of The Fogg Art Museum, Harvard University, Cambridge, Massachusetts. Louise E. Bettens Fund.

311
Cindy Sherman. *Untitled.* 1983.
Color photograph, 74½ x 45¾"
(1.89 x 1.16 m). Courtesy Metro
Pictures, New York.

Developed in the 1960s, **Feminist art**
addresses issues regarding the female
in society. Much Feminist art includes
subjects involving concerns such as
sexuality, sexism, ritual, storytelling,
autobiography, decoration, and
elements of popular culture such as
advertising. Important Feminist artists
include Miriam Schapiro, Judy Chicago, Nancy Spero, Faith Ringgold,
Cindy Sherman, and Barbara Kruger.

The **Photorealist** school of painting
gained national attention in the late
1960s. These painters (including Richard
Estes, Don Nice, and Audrey Flack)
created images that rivaled the
photographic image in terms of the
kind of detached depiction and
precision of detail commonly associated with photography. Indeed,
achieving the look of a photograph,
more so than capturing the essence of
the subject being portrayed, appears
to be the goal of many Photorealists.

Opinions change. Many of today's
artists willfully alter the photographic
images they record. Today many artists
enthusiastically incorporate photographs into their paintings, collages,
assemblages, installations, and other
artforms, to say nothing of the
penetrating, often introspectively
oriented work being done within the
traditional medium of photography
itself. Despite Sheeler's comment to
the contrary, photographers can use
the camera to look inward as well as
outward. *Untitled* **[311]**, one of a long
series of self-portraits created by
contemporary American photographer
Cindy Sherman, whose work many
critics have linked to the **feminist**
movement in art, is a case in point.

In his paintings, Sheeler worked
closely from the information included
in his photographs. In this respect he
anticipated the work of perhaps the
most interesting of the **Photorealist**
painters, American Richard Estes
[312]. But there are also many
contemporary painters who depart
greatly from their photographic
sources. In *Study after Velázquez's
Portrait of Pope Innocent X* **[313]**, the
contemporary English artist Francis
Bacon loosely interpreted the famous
Odessa Steps scene from the early film
classic *Potemkin* **[314]** by the Russian
filmmaker Sergei Eisenstein. Interestingly, as the title indicates, another
source of inspiration for Bacon's
painting was Diego Velázquez's
Innocent X **[315]**, which Bacon only
knew from a black and white photograph when he painted the picture.
Since the advent of photography, such
appropriations or translations have
become common practice.[6]

In recent years the outstanding
advances affecting an ever-widening

312
Richard Estes. *Diner.* 1971. Oil on canvas, 3'4½" x 4'2" (1.03 x 1.27 m).
Hirshhorn Museum and Sculpture Garden, Smithsonian Institution,
Washington, D.C.

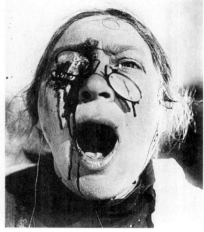

range of affordable equipment and technically accessible photographic processes have enabled virtually anyone with a little bit of extra money to "take pictures." This popularization of the photographic process may create the false impression that photography is easy—at best a push-button art—not at all like the inspired, difficult to create works of art by gifted masters of such disciplines as painting, drawing, and sculpture. Of course, there is a big difference between the intent and artistic sophistication of photographers such as Ansel Adams or Cindy Sherman and the untrained individual who uses the camera to make a photographic souvenir of an event or situation, asking nothing more from the image.

Machinery (along with the technical expertise of the individual operating the machine) may indeed be the most important factor as far as the mechanical production of a photograph is concerned. As is the case with any artform, however, the most important factors determining the artistic merits of a photograph involve the vision and imagination of the person who snaps the shutter of the camera or develops the photographic image in the darkroom. It is in this sense that we should interpret the following statement made by nineteenth-century Englishman Henry Peach Robinson, one of history's earliest, most sensitive practitioners of the art of photography. "My aim is to induce photographers to think for themselves as artists," Robinson wrote, "and to learn to express their artistic thoughts in the grammar of art. . . . The materials used by photographers differ only in degree from those employed by the painter and sculptor."[7]

THE PHOTOGRAPHIC PROCESS

The word *photography* is derived from the Greek words *phos*—"light"—and *graphos*—"writing." The appropriateness of the term (*light writing*) becomes apparent when we recognize the supreme importance of light to the photographic process. Today's standard camera is a box that mechanically allows only a precise amount of light (controlled by the photographer) to project upon the **film,** a sheet or strip of transparent plastic that has been coated with a thin layer of light-sensitive emulsion. Through exposure to light, an image is recorded onto the film. Light enters the otherwise totally blackened camera interior through an opening called an **aperture.** A **diaphragm** controls the amount of light that passes through the aperture by regulating the size of the aperture opening. By regulating the length of time the aperture remains open, a **shutter** controls the amount of light that enters the camera. The operation of the camera's aperture has much in common with the normal function of the iris of the human eye, which automatically changes in size to accommodate differing amounts of light. The iris, like the diaphragm, expands when the light is low and contracts when there is more light. A **lens** throws refracted light onto the film which is positioned on the back wall of the camera.

After the exposed film is removed from the camera it is developed and printed in the darkroom. Photographic paper is graded by the degree of contrast it provides. The lower the contrast, the greater its potential to record a wide range of tonal variations; the higher the contrast, the more apt the paper is to deepen or enrich the blacks, to brighten the whites, and to eliminate the tonal variations in

between. Sometimes, as in Imogen Cunningham's *Magnolia Blossom* [316], the wide range of tones offered by low-contrast paper contributes to the luminous, sensuous spirit of the subject and the resonance of the experience portrayed. Other times, as in Cunningham's *Leaf Pattern* [317], which was printed on higher contrast paper, the sharp contrasts and limited tonalities create a stark, dramatic effect that could not be achieved any other way.

Photography involves a great assortment of machinery, chemical solutions, and other paraphernalia. Artist/ photographers must become proficient not only in the art, but the science of photography, just as painters, archi-

tects, and sculptors must be trained in the mechanics of their disciplines. A clear, even brilliant, concept can produce a dull visual statement if the photographer's command of either materials or technique is inadequate. But the reverse is just as true: emphasizing the importance of idea over technique where the art of photography is concerned, Ansel Adams, a master technician as well as artist, once wrote: ". . . there is nothing more disturbing than a sharp image of a fuzzy concept!"[8]

VIDEO ART

Since the 1960s, artists have been exploring an extension of photography: video art. The medium and

technology of video allows individuals to create relatively easily and inexpensively what could only have been accomplished previously (in media such as television and cinema) through the expenditure of far larger amounts of money and labor. Fundamental to the development of the video medium were the development of the portable video camera, video tapes, and the appropriation of the television set or video monitor on which tapes are viewed. Because of the affordability, portability, and immediacy of this medium (video art can be, and often is, viewed in its finished form even while it is in the process of being created), video art has captured the imagination of many of our most creative contemporary artists.

The Korean-born artist Nam June Paik is the individual most commonly associated with the development of video art. His explorations with the medium often point beyond both the single experience of the videotape and the object of the video monitor. Paik's creations have included not only single and multi-monitor arrangements, but also items such as live fish, individuals performing live outside the video image, a statue of a Buddha figure, furniture, plants, and musical instruments. Manipulating the object of the television set the way a painter might use oil paint or a sculptor might use clay or stone, Paik has explored a wide range of images, objects, and ideas involving sculpture, music, pictorial expression, time, and performance. Paik's interest in humanizing, demystifying and reinventing the conventions, meaning, and use of television is exemplified in one of his best known works, *TV Cello* and *TV Glasses* [318]. Here, Paik enlisted the aid of cellist Charlotte Moorman, whose musical instrument is a transformation of three video monitors arranged in such a way as to suggest a cello. As Moorman plays the "video cello" a video camera records her activity directly onto the screens. The *TV Glasses*, a Paik invention, enables the cellist to watch herself as she performs.

Less sculptural but far more dazzling than *TV Cello* and *TV Glasses* is the more recent *Fin de Siècle II* [319], a video installation in which Paik combined the services of almost 300 monitors to create a richly patterned, animated wall of interacting, brightly colored video tapes and computer-generated images and sounds. To view

318
Nam June Paik. Charlotte Moorman with *TV Cello* and *TV Glasses* at the opening of *Electronic Art III* at Galeria Bonino, New York, November 23, 1971.
©1971 Peter Moore.

319

Nam June Paik. *Fin de Siècle II*. 1989. Video installation: approximately 300 television sets, 3-channel color video with sound, dimensions variable. Private Collection.

this huge, quiltlike vision of changing and repeating shapes and colors is to be immersed in an experience altogether unlike the conventional television viewing experience to which most of us have grown accustomed (and become numbed by). For Paik, viewing a television screen need not be a passive affair in which the images or program being viewed dictate everything from where, to how long you sit in relation to the screen. There is no beginning and end to *Fin de Siècle II*. The flashing, synchronized, out-of-sync, composite, individualized, big, small, close up, faraway, right-side up, upside-down, speeded up, slowed down, repeating images of *Fin de Siècle II* surround the viewer's vision and encourage one to move forward and back, to move to one side of the installation and then to another area in order to experience the work in its entirety. You can walk away and then later on return to see what you missed. In this respect, *Fin de Siècle II* offers a physical and temporal experience not unlike that of viewing a traditional painting, sculpture or collage.

COLLAGE

Collage, the French word for pasting, denotes a collection of various materials (paper, cloth, postage stamps, string, coins, nails, photographs, mirrors, matches) taken from their natural environment and pieced together (usually pasted) onto a two-dimensional support. Collage enables artists to achieve a wide range of surface effects quickly and convincingly. In collage, the physical or material make-up of the work of art plays a dual role: 1) the materials provide the means by which artists portray their ideas, and 2) the materials themselves communicate ideas. In media such as painting and photography, the relatively anonymous materials usually function behind the scenes. In collage, the materials comprising the image often communicate a sense of their own evocative history. The challenge for the collagist is to succeed in causing the pasted material to simultaneously function as what it actually is, and as an integral and integrated part of a pictorial invention.

320
Kurt Schwitters. *Merz Picture 32A. Cherry Picture.* 1921. Collage of cloth, wood, metal, gouache, oil, cut-and-pasted papers, and ink on cardboard, 36⅛ x 27¾" (91.7 x 70.4 cm). Collection, The Museum of Modern Art, New York. Mr. and Mrs. A. Atwater Kent Jr. Fund.

Dada is a movement developed at the height of World War I by a group of artists who, in reaction to the breakdown of social and political order as a result of the war, set out to create a form of art that willfully overturned the values and order of traditional thinking in general and of art in particular. Dadaists celebrated chance and chaos and repudiated any kind of convention. Important Dada artists include Marcel Duchamp, Hans (Jean) Arp, Francis Picabia, Man Ray, Max Ernst, Kurt Schwitters, Raoul Hausmann, and Hanna Hoch.

Although for centuries designers and folk artists had practiced it as a decorative technique, Pablo Picasso and Georges Braque are credited with establishing collage as an important artform. But if Braque and Picasso reinvented collage, Kurt Schwitters, a German painter, poet, sculptor, architect, and typographer, is the individual most commonly associated with the medium. Schwitters is categorized by most historians as a **Dadaist** because he regularly incorporated debris and commonplace materials into his collages. "I could not see the reason," Schwitters once wrote, "why old tickets, driftwood, cloakroom tabs, wires and wheel parts, buttons, and old rubbish found in the attic and in refuse dumps should not be material suitable for painting."[9]

Sometimes, as in *Cherry Picture* [320], Schwitters painted over portions of the image in order to soften the contrasts between the different textures, thereby achieving a sense of unity. Other times he relied on the natural colors and textures of these collaged fragments to animate his compositions. The contrasting materials energized his work, providing distinct shapes and surfaces that merged the rubble of everyday life with the order of a work of art.

MIXED MEDIA

Throughout history, artists have regularly combined numerous two-dimensional media within the context of individual works of art. Verrocchio's drawing entitled *Woman's Head* [276],

for example, was created not only with the medium of silverpoint, but with white highlights laid in with the medium of gouache and washes of gray applied to orange-pink prepared paper. Today, individual works which incorporate numerous media are often defined as **mixed media.**

Puerta de Alcala Wrapped, Project for Madrid **[321]** by the Bulgarian-born twentieth-century artist Christo (Javacheff), incorporates many of the two-dimensional materials and techniques we have previously discussed. Inasmuch as some parts are affixed to other parts of the same two-dimensional surface, *Puerta de Alcala Wrapped, Project for Madrid* can be described as a collage. However, by incorporating diverse media and

picture-making techniques as well as diverse items, this work embraces the idea of mixed media more thoroughly than do many collages. Christo attached elements such as fabric, twine, and a map onto a flat surface, and he introduced the medium of photography, as well as drawing media such as charcoal, pastel, and pencil. Works such as this serve Christo in several ways. They "map-out" in miniature what he wants to carry out on a huge scale in three dimensions (in this case he intended to wrap fabric completely around an architectural structure in Spain). And studies such as this one serve as products that he can sell in order to finance his Environmental Installations such as *Running Fence* **[388]**.

322
Susan Rothenberg. *Untitled*. 1986. Flashe, acrylic, charcoal, oil, and graphite, 60 x 144" (1.52 x 3.66 m). Collection of Mr. and Mrs. Robert F. Fogelman.

Before reading the text that accompanies *Untitled* by Susan Rothenberg [**322, 323**], think about the drawing by answering the following questions:

1. This work was drawn and painted on a single sheet of heavy rag paper. Do you think the thickness of the paper support had any bearing on the artist's working procedures? Explain. Do you think the long, narrow proportions of the paper had any bearing on Rothenberg's underlying idea and pictorial choices?

2. Do you think the artist's intention in this work involved the naturalistic depiction of the human figure or the evocation of human motion? How do you think the manner in which Rothenberg manipulated her working materials contributes to the fulfillment of her intentions?

3. The execution of *Untitled* represents a decidedly physical performance on the part of the artist. Bearing in mind that this image measures 12 feet in length, try to visualize the movement of the artist's body as she covered the paper of this mixed-media work. If we can presume that the movement of Verrocchio's body was focused mainly in his fingertips and wrist when he executed the intimate silverpoint drawing *Woman's Head* [**276**], how would Rothenberg's body have been set in motion in order to wield the materials that comprise *Untitled*?

In Susan Rothenberg's untitled painting/drawing [**322**], swirling figures appear to be embedded in a mass of two-dimensional media. Drawn and painted marks stretch out across the length of a 12-foot sheet of heavy rag paper. The substantial weight and thickness of this durable paper support allowed the artist the freedom to work and rework the image with a wide range of marks and physical manipulations of the media [**323**]. A thinner, less high quality sheet of paper would not have held up as well to the artist's aggressive approach which included working one medium into and over another. At times the manipulation of the media results in almost recognizable individual figures; other times the marks and materials dissolve into a thick atmosphere comprised of oil and acrylic paint, *flashe* (a French vinyl paint), charcoal, and graphite. Although no clearly indicated outside light source illuminates the forms within the image,

323
Detail of Susan Rothenberg's
Untitled.

nonetheless, a striking sense of illumination informs the work. The light is a result of how much, and in what manner, the white of the paper is covered up. The light that results from the congestion of figures, or dark markings, that fill the right-hand quarter of the image creates a very different quality of light, for example, than that of the more open space of the work's center.

If you look carefully you can make out a guitar player located near the far left side of the paper. Perhaps this is where the movement is meant to begin. The rest of the figures look like dancers, or perhaps like one animated dancer moving through space and time. A relatively constant row of heads of varying states of resolution stretch across the top edge of the paper. Along the paper's bottom edge, legs assume many different positions. The dancers' bodies spin across the page, apparent here, disintegrated there.

If you have the opportunity to view this image in person you can walk up close to it and immerse yourself in the hectic layering of the numerous interwoven materials. From a distance of about 3 feet or less, the marks dissolve into a quagmire of motion. No longer is the figure identifiable. Like trying to follow a distant conversation in an overcrowded room, in Rothenberg's *Untitled,* individual details tend to dissolve into an overall buzz. From close up, we become particularly aware of the motion of the artist's arm and hand and the spirited, probably mainly intuitive, working of the materials. A gray-black tone and a spirited yet ordered arrangement of marks and forms prevail when we view the image from a distance of 10 feet or more. From this distance we can more cerebrally take in the entire image at once—an image that from up close reveals itself as an incredibly rich, multi-colored surface comprised of impastoed, as well as greatly diluted oil, acrylic, and flashe paint, smeared charcoal, and fine, yet sweeping, pencil lines, bathed beneath many accidental splatters and drips.

324
Giorgio Morandi. *Still Life*. 1956.
Pencil drawing on paper, 7¾ x 11"
(197 x 280 mm). Private collection.

325
Giorgio Morandi. *Still Life with Four
Objects and Three Bottles*. 1956.
Etching, 7¹³⁄₁₆ x 8" (199 x 203 cm).
Private collection.

CRITICAL QUESTIONS

1a. Compare the pencil drawing, etching, and oil painting still lifes [324, 325, 326] by the twentieth-century Italian artist Giorgio Morandi. Can you identify the medium with which each of these works were executed without referring to the caption underneath the images? In these still lifes Morandi posed many of the same tightly grouped objects. Cite several features that these works have in common with one another. Cite several ways in which they differ.

b. One of the most seductive aspects of creating a still life painting is setting up the subject in the first place. It takes more time for some artists to arrange a still life than to paint it. For an artist like Morandi, whose sensibilities were finely tuned to appreciate the subtle differences that distinguish similar visual situations, slight adjustments regarding the positioning or lighting of one of his objects mattered greatly. Cite several differences between the arrangements of each of these groupings. Look, for example, at how the artist played with the way the back edge of the table plane interacts with the objects on the table. Is this interaction the same in each work?

c. What kinds of factors and considerations might have caused Morandi to portray over and over again the same basic arrangement of objects? Do you think that adopting different media for each of these works enabled the artist to address different aspects of his subject? Explain. Do you think the artist might have felt that simply by moving a form a few inches to the right or left, or more forward or backward on the table, new pictorial inventions could be made, and new visual insights discovered? Explain.

d. When they cast for parts, many film directors use the same actors and actresses in one film after another. Robert De Niro, for example, plays a leading role in many of the films directed by Martin Scorsese, including *Mean Streets* (1973), *Taxi Driver* (1976), *New York, New York* (1977), *Raging Bull* (1980), *King of Comedy* (1982), and *GoodFellas* (1990). By working repeatedly with the same actor over a series of different projects, actor and director develop a professional rapport, thereby intensifying the creative achievements of all the artists concerned. Do you think that the objects in Morandi's still lifes, many of which appear over

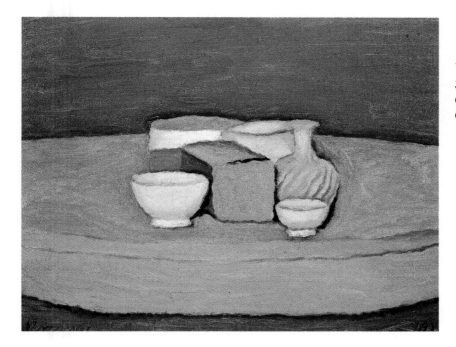

and over again in his work, can be regarded as his cast of characters? Can you think of any other connections between a still life artist like Morandi and a film director like Scorsese?

2a. The charming, seductive, yet fast-paced nature of the twentieth-century Swiss-born artist Paul Klee's *Monument in Fertile Country* **[327]** is a direct result of the lush washes of watercolor that illusionistically fracture the plane of the page. Would you say that the white of the underlying paper contributes in any way to the vibrancy and luminosity of the color? Explain.

b. The middle-toned and more darkly colored areas create spatially recessive pockets that seem to absorb light rather than emit it. How would

you describe the yellow shapes distributed across this image?

c. The insistent beat of horizontal strips creates a kind of counterpoint to the vertical and diagonal thrusts that cut through the page. Contributing to the action as well is the cross fire that takes place between the relatively straight, precise edges of the shapes and the softly modulated application of the colors. Would you say that the light touch of the artist's water-soaked brush unifies the dynamic proceedings or further antagonizes the harmony of the image?

d. Cite several differences between the way the medium of watercolor was handled in this painting and Bernard Chaet's *Blueberries I* **[294]**.

CHAPTER

10

Three-Dimensional Materials and Techniques

Historically, the materials an artist chose for a project were determined by three primary factors: the material resources at hand; the inherent properties of that material to fulfill the requirements of a given project; and that the material employed was considered an acceptable art material by the community within which the work of art would be viewed. Consider, for example, the case of the *Mortuary Temple of Queen Hatshepsut* **[328]**, one of several structures built by the ancient Egyptians to house the remains of pharoahs, rulers who were regarded not only as kings but as gods. (Although the position of pharoah was reserved for men, Hatshepsut became pharoah when, at the death of her husband Thutmose II, there were no legitimate male heirs). For ancient funerary monuments such as this that were designed to last forever, stone

was the material determined by these three primary factors: 1) huge stones were readily accessible, as were vast armies of slave labor which were required to transport the stones from one site to another; 2) stone was a good choice as far as permanency was concerned; and 3) since it was used for everything from pyramids and mortuary temples to carved statues such as *Queen Hatshepsut* **[329]**, stone was clearly acceptable to Egyptian society.

Belief systems and societal conventions inevitably affect how a work of art is produced and evaluated, but it is up to the individual artist to make the most of his or her particular vision and skills. In order to do this, artists must discover what media or materials best suit their needs and strengths. Then they must master their chosen media.

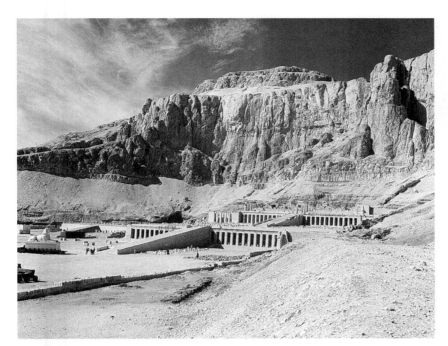

328
Mortuary Temple of Queen
Hatshepsut, Deir el Bahari, Egypt.
c. 1485 B.C.

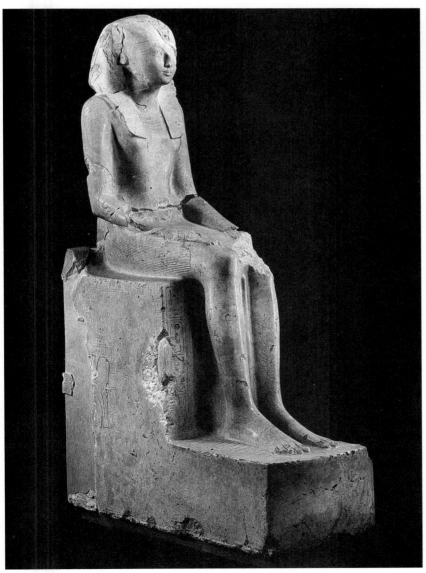

329
Queen Hatshepsut. c. 1490–1480
B.C. **Marble, height 77" (1.96 m).**
The Metropolitan Museum of Art,
Rogers Fund and Edward S. Harkness
Gift, 1929. (29.3.2)

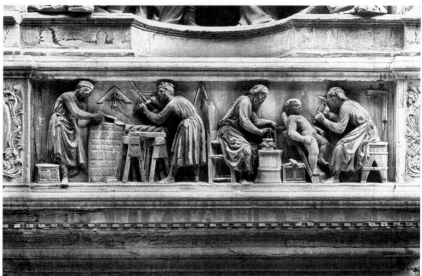

SCULPTURE

When the twentieth-century American painter Ad Reinhardt defined sculpture as "something you bump into when you back up to look at a painting,"[1] he irreverently touched on a fundamental aspect of sculpture—its three-dimensionality. The physical nature of sculpture is traditionally divided into two categories: relief and freestanding. Sculptural **reliefs** (works that protrude in varying degrees from a background plane or support) are categorized as either **bas-relief,** that is, low or shallow relief, or **haut-relief,** which is high or deep relief. *Dying Lioness* [330], an Assyrian carving that decorated the palace of Ashurbanipal at Nineveh, can be described as bas-relief; the forms of the animal physically protrude from the wall only slightly, and the forms are more drawn than sculpted. The fifteenth-century artist Nanni di Banco's *Sculptor's Workshop* [331] is an example of haut-relief. Here, the forms that comprise the scene are still physically attached to a back plane, but they are far more thoroughly modeled into three dimensions. On the other hand, in the case of what is known as freestanding sculpture, or sculpture in the round, there is no evidence of any background support. One can walk all around the object, each view offering something new. The fourteenth-century Italian sculptor Giovanni Pisano's *Pisa Cathedral Pulpit* [332] includes examples of bas-relief and haut-relief, visible in the carved panels decorating the upper portion of the pulpit, and freestanding sculpture, exemplified by several figures and animals distributed along the pulpit's base.

There is another fundamental physical aspect of sculpture besides its three-dimensionality: the sustained physical exertion expended by the sculptor. As banal as it may sound, the fact remains that carving a complex, elaborate structure such as the *Pisa Cathedral Pulpit* or even a single figure such as Michelangelo's *Moses* [333] takes a long time and a lot of physically arduous work. For this reason, artists such as Giovanni Pisano were in

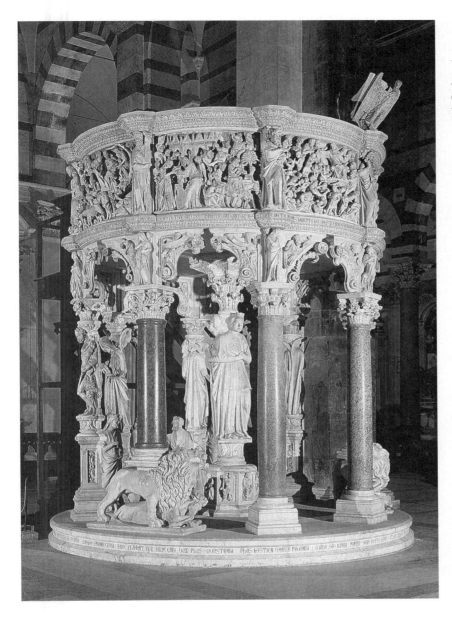

332
Giovanni Pisano. Pisa Cathedral
Pulpit. c. 1302–1310.

charge of workshops that included assistants who carried out many technical labors for the master artist. Especially during the Medieval and Renaissance periods, artists of a wide range of disciplines provided instruction for and benefitted from the assistance of apprentices. Nanni di Banco's *Sculptor's Workshop* portrays a typical stonecarvers' *bottega* or workshop. Here, the team on the left is carving an architectural molding while the team on the right is carving a figure. Almost every piece of work carved in this kind of workshop is a team effort.[2]

333
Michelangelo Buonarroti. *Moses.*
1513–1515. Marble, height 8'4"
(2.54 m). San Pietro in Vincoli,
Rome.

Sometimes sculptors emphasize their working procedures, as is the case in Michelangelo's *Boboli Captive* [334] where the chisel marks left by the sculptor as he freed the form of the figure from the marble are readily apparent [335]. Other times, as in his *Moses*, obvious traces of the sculptor's process are suppressed. But whether or not it is obvious, the artist's technical performance and expertise play a particularly important role in the art of sculpture. "Sculpture is such a physical thing," twentieth-century American sculptor Richard Stankiewicz insists, "that you must have manipulative ability—hit a nail with a hammer— cut metal and join metal. The better you know how to make things, the better you are as a sculptor."[3]

SCULPTURAL PROCEDURES

Carving (in stone, wood, or any other material) is often referred to in sculptural terms as a **subtractive** process which involves removing unwanted material from one shape or form in order to define a new shape or form. Cast or welded sculptures are **additive** methods, where an artist starts with nothing, adding material(s), in effect, from the inside out. The subtractive and the additive processes constitute the two major categories under which traditional three-dimensional works of art were constructed.

The Subtractive Process

The subtractive method of carving involves starting with a chunk of material of some kind and continuously eliminating from the outside in. Tools such as chisels, rasps, and hammers are commonly used for carving and shaping stone. For Michelangelo, sculpture and the subtractive method were one and the same thing. "By sculpture," he once wrote, "I mean the sort that is executed by cutting away from the block: the sort that is executed by building up resembles painting."[4]

The subtractive process often demands a significant degree of preplanning in the form of preparatory drawings or small three-dimensional studies since the material cannot be replaced after it is removed. One poorly controlled strike of the sculptor's hammer to the chisel could destroy months of work. Michelangelo is said to have been able to see the subject within the stone. The sixteenth-century artist Benvenuto Cellini described Michelangelo's process of carving as a process that involved drawing the principal view on the block and then removing the marble from the sides as if he were working a relief.[5] Michelangelo believed that the image was waiting for him within the marble; he simply had to expose it. It sounds easy, doesn't it? Of course, few individuals in the history of art can be compared to Michelangelo in their ability to see an image within a chunk of stone and then possess the ability to translate that inner vision so expressively into three dimensions. Surely most creative enterprises, no matter how problem-free they may seem from a distance—and no matter how brilliant they may appear when complete—provide artists with their share of doubts and frustations, on-the-spot judgments, and unexpected discoveries while the work is in progress. Writing about his *Kyōko-san* [336], Isamu Noguchi, the twentieth-century Japanese-American sculptor,

explained: "The wonder of stone is that through its working, the possibilities are discovered. As the artist delves ever deeper, perception reveals itself and finally leads his hand to his secret understanding."[6]

The other most common material associated with the subtractive method of sculpture is wood. Towering as high as 60 to 70 feet, some of the largest wooden sculptures ever carved are the totem poles created by artists living along the Pacific Northwest coast [337]. Many of these poles were carved from red cedar trees which grow to over 200 feet in these northern forests. Red cedar, a firm yet easily cut wood, lends itself well to the process of carving. It is a fine-textured, straight-grained wood that is free from knots over huge lengths.[7] This linearity makes the poles naturally suitable material for rendering sequences of images that are intended to be read or scanned as single works. The serial arrangement allowed artists to document the legend, history, or lineage, of a family or clan.

336
Isamu Noguchi. *Kyōko-san*. 1984. Andesite, 64 x 21 x 12" (1.63 x 53 x .30 m). Photo by Shigeo Anzai, Courtesy of The Isamu Noguchi Foundation, Inc.

337
Haida Totem, northwest coast, Canada.

ASMAT ANCESTOR POLES

338
Asmat Ancestor Poles, New Guinea.
Wood, paint, sago palm leaves,
height approx. 18' (5.49 m).
Metropolitan Museum of Art,
New York.

Before reading the text that accompanies *Asmat Ancestor Poles* [338], think about the sculptures by answering the following questions:

1. To the Asmat people of Irian Jaya, mystical forces are thought to animate all things. The Asmats share a particularly intimate connection with the spirit of trees. Trees are believed to have souls and the capacity for the same kinds of action and reaction as human beings. The form of totemlike sculptures such as *Asmat Ancestor Poles* is also intimately related to the prominent role trees play in the Asmat culture inasmuch as these sculptures were carved from trees. Explain.

2. Would you describe the method by which the *Asmat Ancestor Poles* were carved as subtractive or additive? Explain.

3. Notice the large forms projecting from the bodies of the uppermost figures of each column. Would you say that these forms are carved in the same manner as the forms that comprise the rest of the sculpture? If your answer is no, describe how you think these projecting forms differ.

4. Based on your response to *Asmat Ancestor Poles*, would you say that wood is a material that lends itself well to the process of carving? What would you say are some of its most appealing characteristics where carving is concerned? Can you think of any shortcomings regarding wood (as opposed to stone, for example) as a sculptural material?

Of all tribal art forms, one of the most beautiful and provocative is the carved ancestor poles (*bis*) created by the Asmat people of Irian Jaya (Indonesia). A traditional ancestor pole, which usually takes several weeks to carve, consists of several squatting or standing men balancing one on top of another. Although the bodies of each of the figures are comprised of stylized, simplified forms, the human heads included in each pole represent specific ancestors.

Frequently 15- to 20-feet tall, these sculptures directly correspond to the height of the fully grown mangrove tree trunks from which they are carved. Mangrove trees, which thrive in certain muddy swamps of the lowlands of Irian Jaya, have numerous projecting aerial roots. In order to create an ancestor pole, all of these roots except the largest and preferably the most sweepingly upcurved are cut away. From this one remaining root an artist/woodcarver carves out the sculpture's most detailed and outstanding feature, a swirling, tracerylike expanse which represents the *jemen*, the Asmat word for penis. Usually projecting from the topmost figure, the huge shape of the *jemen* may originate from the man's knees, chest, or even head. The basically linear, two-dimensional quality of the *jemen* pierces the sense of roundness created by the otherwise decidedly cylindrical forms that make up these sculptures. Another way in which the *jemen* differs from the rest of the sculpture involves the extravagant visual activity of the *jemen* as opposed to the far more restrained forms of the rest of the pole. These contrasts, coupled with the fact that the *jemen* sticks out so far and so abruptly from the straight-up climb of the rest of the sculpture causes the *jemen* to look at first as if it was added or attached later. They are not; Asmat ancestor poles are always carved from one piece of wood.

Until recently, stone axes, animals' teeth, and shells were the woodcarvers' only tools. Since stone is virtually nonexistent in Asmat regions, stone axes (which are regarded as sacred) had to be acquired through trade with highland tribes. Today, metal tools such as iron axes and chisels are more commonly used than stone axes, although shells and animal and fish teeth are still used for scraping surfaces smooth.[8] Asmat ancestor poles represent vivid examples of the way in which available resources will often directly determine the materials in which a given work of art will be executed, and how the very material an artist adopts (in this case the tall, slender trunk of the mangrove tree) will often directly affect the overall form a work of art will take.

In some villages a completed ancestor pole is placed inside a *yeu*, a large ceremonial house, where it serves as one of the four columns that surround the family hearth. In such cases the roof of the *yeu* slows down the

deterioration process of the wooden pole by protecting it from tropical rains, while the smoke of the fireplace protects the pole from woodworms. Such indoor living conditions inevitably affect the appearance of the pole: the smoke from the fireplace turns the wood of the pole a dark brown, and the bottom of the pole becomes polished as a result of people leaning against it.

But most Asmat ancestor poles remain outdoors for their relatively brief life. They are created primarily for one specific *bis* ceremony or ritual for which more than one pole is usually carved. After this one-day ritual the poles are displayed for a short time outside the *yeu* house and then taken to the forest where the poles are left to decay so that their supernatural power will advance the growth of other trees.

Scholarly opinion is divided regarding the precise meaning of the Asmat ancestor poles. One meaning ascribed to these poles is that they represent fertility symbols devoted to crops as well as children. Ancestor poles are also regarded as homages to ancestors who were killed by acts of violence which, in turn, had to be avenged by violence in head-hunting. This latter interpretation may explain why many of these sculptures include one or more of the figures holding a human head in front of the more normal sized phalli of the figures positioned lower on the pole.[9] The Asmat believe that death is seldom, if ever, the result of natural causes. They believe that people are killed by their enemies, either in actual fighting or through magical means. Ancestor poles stand as pledges to dead relatives that their deaths will soon be avenged.

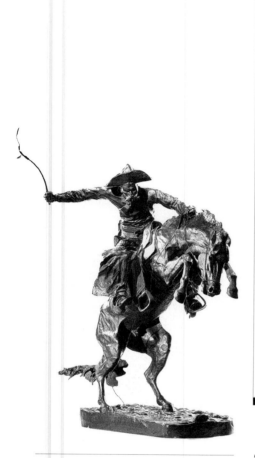

339
Frederic Remington. *The Bronco Buster.* 1895. Bronze, height 24" (61 cm), cast no. 32. Amon Carter Museum, Fort Worth, Texas.

The Additive Process

The additive process involves creating a three-dimensional shape or form by joining together separate pieces of a given material or combination of different materials. Often, artists create small studies through a relatively quick, additive process—a process sculptors refer to as modeling—using materials such as clay or wax. Such processes allow artists to work out visual and conceptual problems with a greater degree of flexibility than when they interpret their ideas through the more time-consuming and less flexible subtractive process of carving. In this respect, the clay model functions for the sculptor in much the same way as a working drawing functions for a painter. However, just as artists often intend their drawings (particularly in the twentieth century) to be viewed as finished works of art in their own

right, many modeled clay or wax sculptures were intended to be viewed as finished works, not as mock-ups or studies for larger, more polished sculpture. Such is the case in nineteenth-century Italian sculptor Medardo Rosso's *The Bookmaker* **[389]**.

Another example of a small-sized sculpture executed through additive methods and intended to stand on its own rather than as a study for a larger, more sustained sculpture, is Frederic Remington's (1861—1909) *The Bronco Buster* **[339]**. Remington was born in upstate New York but came to artistic maturity in the western United States where he traveled extensively throughout Indian Territory and even managed his own mule ranch. *The Bronco Buster,* the first of Remington's twenty-two bronze sculptures, met

HARPER'S WEEKLY. VOLUME XXXVI, NO. 1842.

A PITCHING BRONCHO.

340
**Frederic Remington. *A Pitching
Bronco*. Illustration from *Harper's
Weekly*, April 30, 1892.** University
of North Texas Libraries, Rare Book
and Texana Collections.

with immediate popular success. This
2-foot-high bronze statuette can be
traced back to *A Pitching Bronco*
[**340**], an illustration Remington
executed for the popular publication
Harper's Weekly. To translate his ideas
into three dimensions, he surrounded
an **armature** (a framework made out
of wood, metal, or some other
relatively rigid material) with the
malleable materials of either clay or
plasticine (a clay substitute that air
does not dry out). As muscles and skin
are supported by an underlying
skeleton, an armature provides a
sculptor with a hidden structure onto
which the clay adheres. Without such
armatures, thinly formed areas of clay,
such as the legs of the horse and the
arms of the cowboy in *The Bronco
Buster*, would have collapsed before
the sculpture was completed. After the
model was finished, Remington made
a plaster mold, and cast the sculpture
in bronze. In a letter to a friend, which
includes a pen drawing of the sculp-
ture [**341**], Remington's enthusiasm
regarding the permanency of bronze is
vividly expressed. "My watercolors will
fade," he wrote, "but I am to endure in
bronze. . . . I am doing a cowboy on a
bucking bronco and I am going to
rattle down through all the ages,
unless some Anarchist invades the old
mansion and knocks it off the shelf."[10]

Today, eighty years after Remington's
death, it would take a very determined
anarchist to silence Remington's
rattling. During Remington's lifetime
approximately 300 bronze casts of *The
Bronco Buster* were produced. The
majority of these casts were produced
by the lost-wax process. This process is
frequently categorized separately as a
sculptural *replacement* process whereby
one material replaces another. We
place it here under the category of
additive sculptural procedures because
it is intimately associated with
modeling.

341
**Frederic Remington. Sketch of *The Bronco Buster*. c. October 1895.
Pen and ink, in a letter to Owen Wister.** Courtesy of the Library of Congress.

342
Benvenuto Cellini. *Perseus.*
1545–1554. Bronze with marble
base, height 18' (5.49 m).
Loggia dei Lanzi, Florence.

The Lost-Wax Process (Cire Perdue)

In order to make their art more permanent, sculptors who worked in the fragile materials of clay and wax developed casting techniques. Through this process, sculpture modeled in clay or wax could be converted into the solid, permanent form of metal. In general, **casting** refers to any process whereby a liquid substance is converted into a solid, permanent form by pouring it into a mold and allowing it to harden. Glass, for example, when heated to a molten state, can be blown into a mold. When the glass cools, it hardens and assumes the shape determined by the mold. A popular metal-casting technique is the lost-wax process, also known by the French term **cire perdue.** This complex technique, which effectively converts a clay, plaster, or wax model into an other-wise identical model in metal, includes numerous steps that can be outlined as follows:

1) An original sculpted model is covered with plaster or gelatin (today, synthetic rubber is often used) which, when hardened and removed from the model, serves as a mold.
2) A layer of about one-eighth to three-eighths of an inch of wax is applied to the inside of the mold.
3) This wax-coated area is filled with plaster or some other heat-resistant material. The plaster is held together by a system of rods or pins.
4) Another system of rods is attached to the outside of the mold, and the whole mold is baked at high temperatures in a kiln, a specially designed oven built of fire brick and other materials.
5) The baking melts the wax, which drains out through the rods attached to the outside of the mold. This is where the term *lost wax* originates.

6) Molten metal (usually bronze) is poured into the thin space left behind by the drained wax. For large works it may take several days for the bronze to harden.
7) The plaster is removed, leaving a hollow bronze cast. The hollowness of the cast greatly reduces the cost of reproducing the original model in solid metal, and, of course, it lightens the weight of the cast.
8) The rods are cut from the sculpture and the sculpture is smoothed.

A significant feature of the casting process in general is that it enables the sculptor to produce numerous copies of a single sculpture. In this respect, the process of casting offers the sculptor what etching or lithography offer the printmaker: multiples from an original model. Well-known works of art that were produced by the lost-wax process include the sixteenth-century Italian artist Benvenuto Cellini's *Perseus* [342] and Andrea del Verrocchio's *Monument to Bartolommeo Colleoni* [34]. With relatively few changes, the lost-wax process remains based on essentially the same principles as it did when Chinese artists employed it in 900 B.C.

Welded Sculpture

A popular twentieth-century sculptural medium is based on the technique of welding. **Welding** refers to the act of fusing separate pieces of metal together through heat. Like sculpture cast in bronze, welded metal sculpture is particularly well-suited to withstand the potentially destructive effects of the outdoors. The Spanish sculptor Julio Gonzales is generally credited with introducing the art world in the 1920s to welding, a procedure which was originally designed for industrial purposes. Shortly thereafter, Picasso, a close

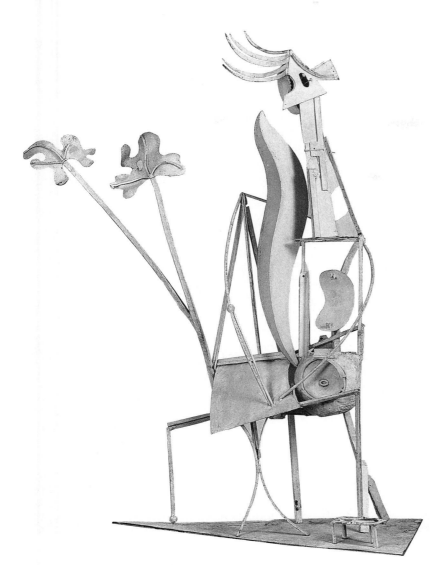

344
Anthony Caro. *Table Piece LXXXVIII (The Deluge)*. 1969–1970. Painted steel, 39⅝ x 62¼ x 35¾" (1 x 1.58 x .9 m). Collection, The Museum of Modern Art, New York. Gift of Guido Goldman in memory of Minda de Gunzburg.

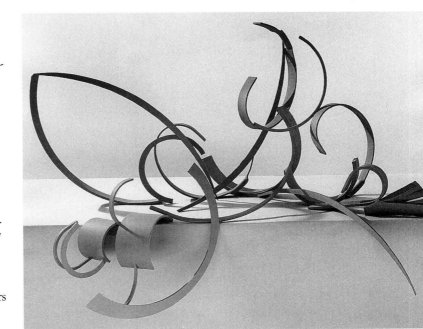

friend of Gonzales's, adapted the medium to his Cubist explorations, producing an inventive, often witty series of sculptures such as *Woman in the Garden* [**343**].

One of the most important contemporary artists working in welded metal is English sculptor Anthony Caro. His *Table Piece LXXXVIII (The Deluge)* [**344**] clearly illustrates the additive nature of this medium. Notice how insistently Caro focuses on the curve. Over and over again, always newly directed, and with a wide range of long, short, and medium-sized lines, the artist creates a rolling, active beat. Comparing this work with almost any one of Leonardo da Vinci's tiny, yet furious Deluge drawings such as *Cataclysm* [**253**] demonstrates how significantly the art of the Old Masters impact on even the most innovative artists working centuries later.

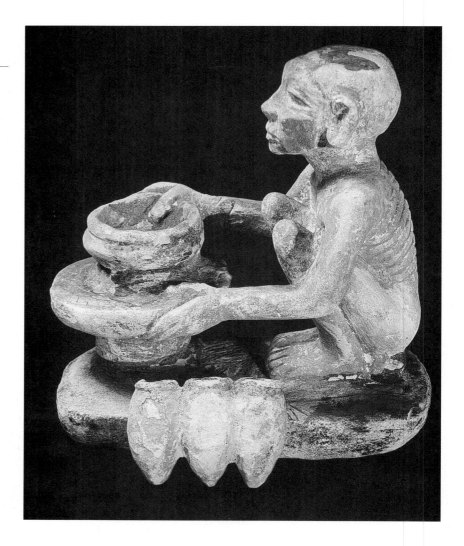

345
*Egyptian Artisan Forming a
Pot on a Wheel,* **from Giza (?).
Third millenium B.C. Limestone
carving, 5³⁄₁₆ x 2⁵⁄₈ x 5"
(132 x 67 x 125 mm).**
Oriental Institute, University
of Chicago.

CERAMICS

Ceramics is a three-dimensional
artform restricted to baked works in
clay. When clay is fired (baked in a
kiln), it becomes virtually impervious
to the elements. Unlike wood, for
example, fired clay does not rot.
Consequently, ceramic objects
represent some of the oldest works of
art to have survived from ancient
times. Thanks to works such as
*Egyptian Artisan Forming a Pot on a
Wheel* [345], we even have visual
evidence of the ways in which some of
these ancient ceramic vessels were
made. But while ceramic objects do
not rot, they can break. Many
clayworks survive in fragmented or
pieced-back-together form.

Perhaps the most common image
people have of a ceramic object is that
of a vessel-like form which serves the
practical function of holding liquids,
foodstuffs, or any other substance that
fits within the dimensions of the
container. Such objects are generally
formed in one of four ways: *pinching,
slab method, coiling,* or *throwing.* A
ceramicist or potter can pinch clay
into a particular form by pressing or
squeezing one piece of clay into
another. In the slab method the
ceramicist builds up the walls of a form
by first rolling or leveling out a sheet
of clay, cutting it into the desired size,
and then attaching it to other cut
slabs. Not surprisingly, the slab
method is a particularly popular one
for creating rectilinear forms. Coiling
involves rolling out a snake or rope-
like strip of clay that is then added to
other coils before being smoothed into
a more even surface. The twentieth-
century Pueblo Indian potter Maria
Martinez's *Black on Black Jar* [346]
provides an excellent example of the
elegance that can be achieved through
this simple, manual method of shaping
clay. **Throwing** refers to a method by
which a potter centers a lump of clay
on a potter's wheel, hollows out the
inside of the lump of clay, and then
proceeds to form outside walls or sides
of the vessel by pulling the continu-
ously moistened clay from the bottom
up as the wheel spins.

After the vessel is created, it is left
exposed to the air so that all the
moisture is removed. At this stage the
hardened form is referred to as
greenware. Greenware is especially
prone to cracking and breakage. To
further harden the vessel, it is then
fired in a kiln, after which it is referred
to as *bisque* or *bisqueware.* It is then

346
Maria Martinez. Black on Black
Jar. 1930–1940; cat. #18888.
Earthenware, height 7⅜" (18.7 cm).
From the School of American
Research Collections in the Museum
of New Mexico. Photo by Blair Clark.

ready to be decorated or colored with
glaze if the artist so desires. Glaze is a
thin, glasslike coating that makes the
vessel water-resistant and more
durable. Metallic oxides contained in
the glaze produce a wide range of
colors. After the vessel is glazed it is
fired again at higher temperatures
which serves to fuse the glaze to the
vessel.

The line between ceramics and
sculpture is often a difficult one to
draw. Clay is, of course, one of the
most popular materials of traditional
sculptors. Ceramic objects serve many
ends. Many works commonly referred
to as ceramics, such as *Moche Pottery
Figure of a Warrior* **[347]**, are
nonfunctional, like sculpture and
painting. In recent times, important
artists such as California-based Robert

347
Moche Pottery Figure of a Warrior, c. 400–800 A.D. Height 8" (20.3 cm).
Reproduced by courtesy of the Trustees of the British Museum.

348
Robert Arneson. *Current Event.*
1973. Glazed ceramic, 9 x 175 x 85"
(22.8 x 445 x 216 cm). Collection
Stedelijk Museum, Amsterdam.

Like Pop Art, the **Funk Art** movement, which developed in California in the early 1960s, took popular culture, rather than the influence of so-called serious "high art," as its starting point. The accessibility, whimsy, and even corniness that could be derived from advertising, cartoons, and television were among the popular elements that Funk Artists enthusiastically embraced. Many of these artists incorporated nontraditional materials into their work or, like Arneson, used a traditional material such as clay in an innovative manner. Important Funk Artists include Robert Arneson, William T. Wiley, and Roy De Forest.

Arneson have done much to undermine the presumption that ceramics is a craft rather than an artform. Relying on the traditional materials of ceramics (such as clay and glazes), Arneson, whose creations in the 1960s greatly influenced the development of the **Funk Art** movement, has created a large body of inventive, often whimsical works that challenge many conventions traditionally associated with this artform. In *Current Event* **[348]**, for example, Arneson incorporates the floor as an integral part of the work. He asks us, in effect, to think of the 177 amorphous pieces of hard, glossy, glazed clay as water. Like a puzzle, these individual shapes of clay were placed next to one another to form a triangular stream within which the artist included an unglazed, shorthand configuration of himself as a swimmer—perhaps swimming resolutely against the tide of ceramic traditions.

METAL

Artists have worked in metal throughout the ages. One of the most important reasons for this is because, unlike wood, it does not rot, and unlike ceramics, it does not shatter or chip. Although it is not completely impervious to the elements (it can rust and corrode), in some respects the aging process actually enhances its

beauty, as we see, for example, in the appealing effect weather can have on the surface color, or patina, of metal. Each metal, including precious metals such as gold and silver and more common metals such as tin and copper, permits a distinct type of manipulation. Some of the ways in which artists fashion metal into the shapes, forms, and surfaces they desire include: *forging*, heating one of the hard metals like iron until it is red-hot and then hammering it into a particular shape; *raising*, hammering a flat, cold piece of one of the softer metals like gold or tin into a hollowed form; *casting* (which we discussed earlier in this chapter); *repoussé* (from the French word meaning "to push back"), striking rounded tools with a hammer against the back side of a thin, cold piece of metal, thereby creating a series of bumps or raised lines; and *chasing*, striking rounded tools with a hammer against the front side of a thin, cold piece of metal, thereby creating a series of indentations.

Each metal embodies distinct properties. Gold, for example, is an incredibly malleable substance that can be flattened to the thickness of one-three-hundred-thousandth of an inch. Mycenean artists of ancient Greece exploited this property by using it to create paper-thin funerary face masks

349

Mask of Agamemnon from Grave Shaft V, Mycenae. c. 1500 B.C. Beaten gold, 10¼ x 10½" (26 x 27 cm). National Museum, Athens.

for some of their royalty, as we see, for example, in the famous *Mask of Agamemnon* **[349]**.

Traveling even farther back in time than Classical Greece, the Chinese were creating works of art in metal as long ago as the sixteenth century B.C.

The bronze *Tiger* **[350]**, created sometime between 900 and 600 B.C., is remarkable not only because of its refinement of form and richness of surface pattern, but because it has defied time by remaining in excellent condition for so many centuries.

350

Tiger, from China. c. 900–600 B.C. Bronze, length 29⅝" (75.2 cm). Courtesy of the Freer Gallery of Art, Smithsonian Institution, Washington, D.C.

351
Albert Paley. *Portal Gates.*
1974. Hand-wrought and forged
steel, brass and copper, 90¾ x 72"
(230.5 x 182.9 cm). National
Museum of American Art,
Smithsonian Institution, Commissioned for the Renwick Gallery.

Of course, works of art created in metal are not only the province of the ancients. Like a huge drawing in line, a wroughtiron work such as *Portal Gates* [351] by Albert Paley, one of today's most important contemporary American metalsmiths, demonstrates the incredibly fluid and elaborate lengths to which metal can be manipulated. As Claude Blair, the former Keeper of Metalwork for the Victoria and Albert Museum in London has written: "Iron, glowing red or white hot, has a plasticity that is in astonishing contrast to its extreme hardness and rigidity when cold, and the blacksmith works it on his anvil with the hammer much as the potter works clay with his hands, though with infinitely more labor."[11] In Paley's *Portal Gates*, a fanciful series of sinuous and swirling lines move freely about as they create a precise symmetrical structure, exemplifying the kind of tension between formality and improvisation that informs much of his work.

GLASS

Glass is regarded by many authorities to be the world's oldest synthetic or manmade material. Artists have developed numerous means of shaping or forming glass. In the earliest stages of its development, glass was manipulated in a manner closely related to the coil method used in forming pottery: rods of hot, softened glass were wound around a core of sand (one of the primary components of glass). Another method of shaping glass involved dipping molded sand into a vat of molten glass.[12] It was through these kinds of techniques that vessels like *Egyptian Vase* [352] were created.

Perhaps the single most important contribution to the art of glassblowing was the development of the blowpipe [353], which dates back to the Roman era during the first century B.C. The blowpipe, which has changed minimally over the past two thousand years, is a thin, hollow rod about four feet long that contains a mouthpiece at one end. The glassblower dips up a small amount of molten material with the end opposite the mouthpiece, forms the material into a rough cylinder by rolling or pressing it against a paddle or metal plate, then

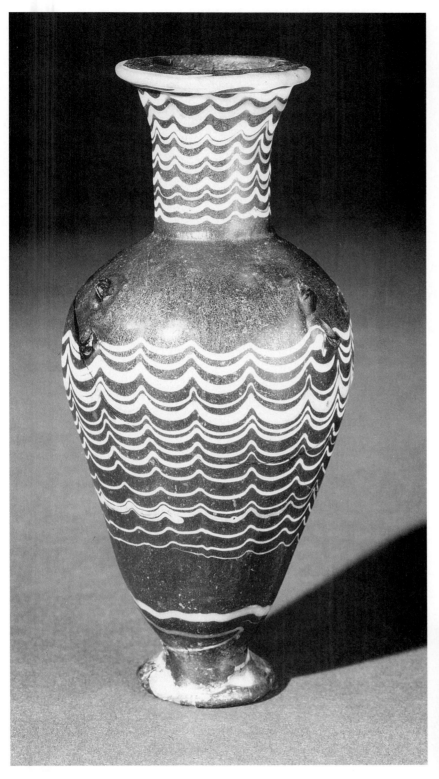

352
Egyptian Vase. 18th dynasty,
c. 1400–1360 B.C. Opaque deep
blue glass, white and yellow glasses;
core-formed, trail decorated and
tooled, height 4⅝" (11.8 cm).
The Corning Museum of Glass,
Corning, New York.

353
Blowing glass by hand.

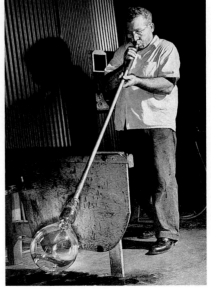

blows into the mouthpiece, producing
a bubble of glass. The form of the glass
is controlled by twisting the pipe,
rolling with a paddle, cutting, shaping
with a caliper, or adding more molten
glass.[13]

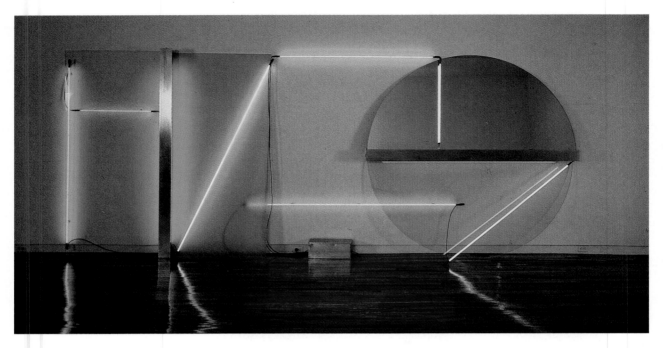

354
Keith Sonnier. *BA-O-BA*.
**1972–1988. Neon, glass, mirror,
aluminum, 91 x 217 x 12½"
(2.31 x 5.51 x .32 m).** ©Keith
Sonnier. Courtesy of Leo Castelli
Gallery, New York.

Contemporary artists such as Keith
Sonnier continue to investigate, in
new forms, the challenge of working
with glass. Depending on your
orientation, *BA-O-BA* **[354]** can be
described as a modernistic, electrified
relief, a painting, a sculpture, or an
installation. Here, Sonnier incorpo-
rates glass in the form of neon light
bulbs, glass panes, and mirrors to
create a geometric, primary-colored,
electrified arrangement of shapes and
forms that simultaneously press against
a back wall plane and generate their
elusively colored auras throughout the
open space of the room.

ARCHITECTURE

Like all artforms, the art of architec-
ture is built on a foundation of the
visual elements (shape, volume,
texture . . .). But it takes more than
visual elements to hold up a building.
Among other things, it takes a firm
understanding, on the part of the
architect, of the materials and
techniques that contribute to the
building's physical structure. No
matter how beautiful a building is, if it
is incapable of fulfilling the practical
functions for which it was designed, it
is not a fully successful creation. As
the contemporary American architect

Louis Kahn has written: "A painter
can paint square wheels on a cannon
to express the futility of war. A
sculptor can sculpt the same square
wheels. But an architect must use
round wheels."[14]

A building's form and function will
always be greatly determined by the
architect's choice of materials and
techniques. Later in this section we
shall see that the materials of metal
rods and concrete, for example, and
the technique of embedding the rods
into the concrete (creating what is
referred to as ferroconcrete or **rein-
forced concrete**) had to be devel-
oped before tall office buildings and
skyscrapers that are such a familiar
part of the American landscape could
become a reality. But despite the
profound importance of architectural
materials and techniques on the
construction of any building, many of
our most satisfying experiences of
works of architecture are, in part,
dependent on the degree to which we
see beyond the techniques and
materials out of which the building
was constructed.

To be moved by a deep emotional/
spiritual feeling while standing inside
the lofty space of a building such as

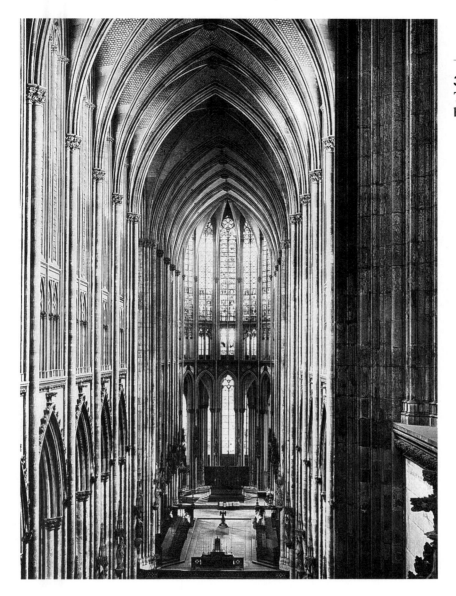

the *Cologne Cathedral* [355], for example, is to a certain extent dependent on the degree to which stone, glass, and the many other materials that comprise the building are transcended. During such transcendent moments, the materials that comprise the building become less impressive and assertive than the effects of those materials. "You employ stone, wood and concrete," wrote the twentieth-century Swiss-born architect Le Corbusier (Charles Edouard Jeanneret), "and with these materials you build houses and palaces; that is construction. Ingenuity is at work. But suddenly you touch my heart, by the use of inert materials and starting from conditions more or less utilitarian you have established certain relationships which have aroused my emotions. This is architecture."[15]

Whether we appreciate it on a conscious level or not, the fact remains that architects fashion their creations out of particular materials and with techniques which exhibit particular properties and characteristics. These materials and techniques are not the ends for the architect, but they are an indispensable means by which a building arouses an emotion. Not surprisingly, the availability of new materials often makes new building procedures possible. New building procedures often inspire, or at least permit, new architectural styles. In this section we will examine some of the most popular materials and techniques employed by architects throughout the ages.

POST AND LINTEL CONSTRUCTION

The most basic form of architectural construction is the simple "stacking and piling" method wherein walls are built up by layering materials such as brick, stone, adobe, and ice blocks one on top of another. With this method, the layers of material are usually thickest at the bottom of the pile;

356
The Pyramids at Giza. c. 2500 B.C.

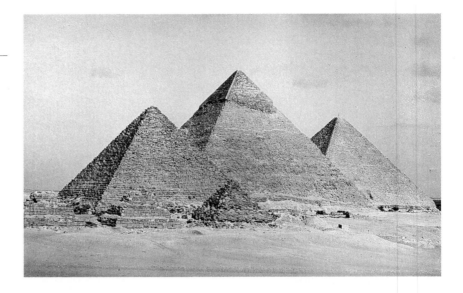

357
Post and lintel.

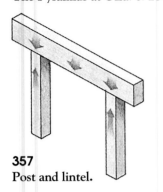

subsequent layers usually taper in as the walls rise. The Great Pyramids in Egypt **[356]** exemplify this method of construction.

Perhaps the most basic form of architectural construction and spanning a space is that of post and lintel **[357]**. Using different materials, peoples from almost every part of the world and from as long ago as 2700 B.C. (Egyptian temples) have relied on this method of building. One of the world's most famous structures, the *Parthenon* **[358]**, situated on the *Acropolis* **[359]** which rises high above the city of Athens in Greece, is based on post and lintel construction. The **post** refers to the vertical column, or some other form of upright support such as a wall, above and across which is extended a horizontal crosspiece usually referred to as a beam or **lintel.** Many posts were required to support the long expanse of lintels because the *Parthenon* is made of stone, a heavy, durable, fireproof material. A great disadvantage of stone where building purposes are concerned, is its limited tensile strength. **Tensile strength** refers to the capacity of a given material to span an unsupported horizontal expanse without giving in to the physical stress exerted on it by its own weight or the weight of another element that rests on it. In order for the stone lintels of the *Parthenon* to span the distances required of them, they must be

supported by a host of columns, which, of course, results in a significant reduction of usable space inside the building.

GREEK ARCHITECTURE AND ITS ORDERS

The reduction of usable interior space of buildings like the *Parthenon* did not greatly interfere with the buildings' function because these shrinelike temples were not built to be lived in. Rather, they served primarily to house or protect statues of Greek gods. The *Parthenon* was dedicated to *Athene Parthenons* (the virgin Athene; the Greek word *parthenon* means virgin). The rituals associated with the most significant architectural structures in Greece took place *outside* the buildings.

The Greeks developed three different types of columns or orders: Doric, Ionic, and Corinthian **[360]**. The term *order*, when used in reference to Classical Greek styles of architecture, alludes to the proportions and decorative handling of the entire columnar unit (including the base or platform below and entablature above). Each of these orders determined the proportions and overall design system of the structures they comprised. The Doric order is the plainest, sturdiest-looking of the three orders. Because it is massive, weighty, and severe in appearance, it is often

characterized as embodying attributes of masculinity. The Ionic order, on the other hand, has been characterized by many scholars as feminine because of its slimmer, more elegant and graceful presence. Ionic columns are most notably characterized by the scroll-like, spiraling forms (*volutes*) that comprise each capital, and the narrow fluting (*grooves*) that emphasize the verticality of the column's shaft. Many individual Greek buildings, such as the *Parthenon,* as well as more expansive building sites, such as the *Acropolis*, bring together both the Doric and the Ionic orders, thereby, some scholars assert, giving expression to what the Athenians believed were two extremes of their nature: abstinence and luxury; strength and grace.[16] The Corinthian order, with its elaborate capital carved to simulate acanthus leaves, is even more ornate than the Ionic. The Corinthinan order, which was developed later (around 400 B.C.) than the Doric and Ionic orders, was used far more by Roman architects than by the Greeks.

EXPANSIONS IN SPACE

Eventually the Greek emphasis on columns and post and lintel construction yielded to a Roman emphasis on the arch, which, in turn, led to the development of the vault and the dome. These innovations allowed architects to span increasingly wider and more open spaces.

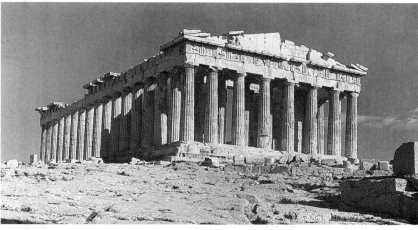

358
Ictinus and Callicrates. Parthenon, Athens. 447–432 B.C. Marble, height of columns 34' (10.36 m).

359
Model of the Athenian Acropolis (from the northwest). Original reconstruction and scale model (1:200) by G. P. Stevens; additions and color by Sylvia Hahn of Royal Ontario Museum, Toronto, and J. Walter Graham. Courtesy of the Royal Ontario Museum, Toronto, Canada.

360
Orders of architecture.

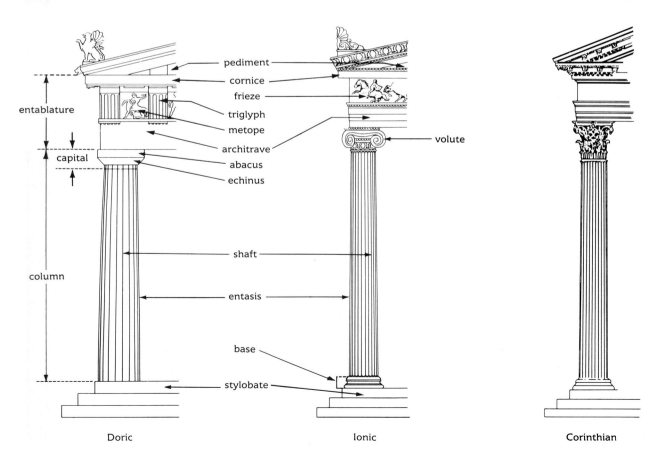

pediment
cornice
frieze
triglyph
metope
architrave
abacus
echinus
volute
entablature
capital
shaft
entasis
column
base
stylobate

Doric Ionic Corinthian

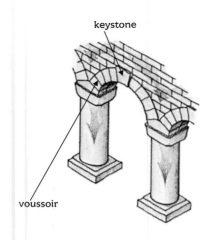

keystone

voussoir

361
Round arch.

Arch and Vault

The limited tensile strength of stone is overcome through the use of the arch. Unlike the long, straight, horizontal expanse of the lintel which places great tension on a single beam, the **arch** makes use of many small, wedge-shaped stones or blocks (*voussoirs*) which combine to bridge an expanse by means of curving the space **[361]**. The gravitational forces of an arch direct pressure downward and outward. Counterbalancing pressures are simultaneously exerted toward a central, elevated point (the keystone). Like two hands that come together to make the sound of a clap, an arch depends on the joining of two separate forces that exert pressure on one another.

The Romans, who commanded the most powerful empire of the ancient world, are appreciated today more for their mastery of constructional or architectural engineering than for the artistry of their buildings. However, in the case of many architectural creations such as the *Colosseum* **[92]**, the division rapidly dissolves between architectural engineering and fine art.

Although its earliest use was probably by the Mesopotamians, the arch was most fully developed by the Romans in the second century B.C. For the Romans, the arch was a primary architectural motif, used for modest doorways as well as for ornately decorated, monumental structures commemorating important wartime victories, as is the case in the *Arch of Constantine* **[362]**. A well-preserved example of the Roman's practical use of the arch is the *Roman Aqueduct* in Segovia, Spain **[363]**. Aqueducts such as this one were not built for purposes of shelter; they were designed to transport water that flowed through a trough or conduit along the topmost section of the structure.

Tunnel-like **barrel vaults [364]**, on the other hand, which are essentially fused arches extended in space,

362
Arch of Constantine, Rome. A.D. 312. Height 67'7" (20.6 m), width 82' (25 m).

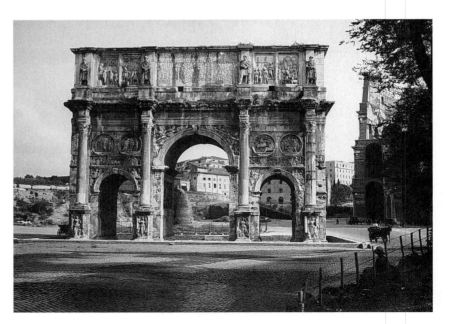

363
Roman Aqueduct, Segovia.
c. A.D. 10.

364
Barrel vault.

365
Ribbed vault.

represent structures based on the arch that are designed for purposes of shelter. A **cross vault** or **ribbed vault** **[365]** results when two barrel vaults intersect.

The Romans developed the **basilica** (derived from a Greek word meaning "royal portico," alluding to the audience-rooms of the Greek kings), a rectangular building comprised of rows of pillars or columns that divide the space into a high central aisle or area (nave) and two lower side aisles. The *Basilica of Constantine* **[366]**, with its series of arches dividing the side aisles from the nave, exemplifies the basilica form. The Romans used the basilica primarily as an assembly hall or for law courts. Eventually this type of building served as the model for Early Christian churches.

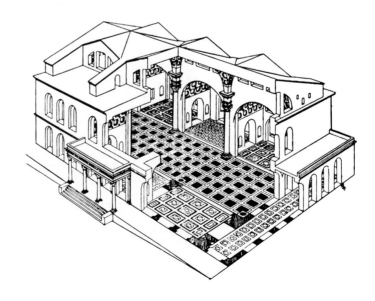

366
Reconstruction drawing of the Basilica of Constantine (after Huelsen), Rome. c. A.D. 319–320.

Romanesque architecture (so called because it was a style (roughly dating from 1000—1150) that attempted to revive characteristics of ancient Roman art) is distinguished by round-headed arches, barrel vaults, small door and window openings, richly varying columns and capitals, and rectangular ground plans. Romanesque architecture, which is almost always church related, tends to evoke a sense of stillness, fortification, and strength through its basic austerity and thick, massive walls.

The interiors of **Romanesque** architecture, such as the barrel-vaulted *Church of Saint Sernin* [367], tend to be dark because it was feared that any significantly sized, light-admitting openings in the thick walls of the buildings would dangerously weaken the building's physical structure. Luminosity and expansive spaces distinguished by intriguing interior vistas and perspectives, on the other hand, are integral to **Gothic** architecture. This is so because technical innovations such as the pointed arch, the ribbed vault, and the flying buttress, permitted it to be so—a supreme example of the interdependence of aesthetics and mechanics.

The **pointed arch** [368] was an architectural innovation that was invented in the Middle East but was not truly developed until the great power and wealth of the Christian Church enabled Gothic artists to explore its spatially liberating possibilities. The pointed arch differs from the rounded arch in two significant respects: the pointed arch enabled architects to vary the height of the arch (and therefore the domed ceiling of any given building) simply by varying the angle of its slope. Because the taller, pointed arch directs its weight more downward than outward as the rounded arch does, it requires less support. Consequently, the

Gothic architecture, which flourished between the twelfth and sixteenth centuries, is characterized by tall, light-filled buildings in which the arts—especially sculpture and stained glass—are thoroughly integrated with the overall building program. Unlike Romanesque abbeys which were often built in isolated settings, Gothic cathedrals usually occupied a geographically central position within the cities where they were located, assuming a central role in the spiritual, artistic, and intellectual life of the community.

367
Interior of the Church of Saint Sernin, Toulouse. c. 1080–1120.

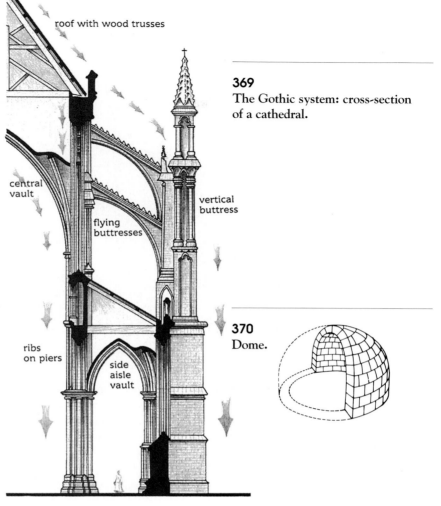

369
The Gothic system: cross-section of a cathedral.

roof with wood trusses

central vault

flying buttresses

vertical buttress

ribs on piers

side aisle vault

368
Pointed arch.

pointed arch enabled architects to design buildings that enclosed a far greater degree of open interior space.

By reinforcing the areas where the vaults were joined, Gothic architects became freed even further from the need to rely on heavy masses of material to support the curve of the vaults they designed. These structural (usually stone) lines of intersection are known as ribs. Ribbed vaults are visible in the ceiling of the *Cologne Cathedral* [355].

Another architectural innovation contributed by Gothic designers was the flying buttress [369]. **Flying buttresses** (often taking the form of a series of half arches located at key positions along the outside walls of a building) absorb much of the outward pressure created by the weight of a ceiling. Flying buttresses reinforce the strength of outside walls. Consequently, without fear of weakening the physical structure of the building, this innovation permitted architects the freedom to break into the solidity of the wall with large light-admitting window expanses. As much as anything else, the flying buttress, in

370
Dome.

this respect, can be credited with making possible the colorful, luminous art of the stained glass window which Gothic artists developed to a level that has never been surpassed.

DOME

A **dome** [370] can be described as an arch rotated 360 degrees on its axis. During the **Renaissance**, magnificent architectural feats involving the construction of huge domes were accomplished. Consider, for example, the creation of the pointed dome (that did not depend on any external buttressing) designed by Filippo Brunelleschi for the *Cathedral of*

The majority of Italian **Renaissance** architects concerned themselves more with aesthetic problems such as proportion, balance, stability, symmetry, and harmony than with the development of new architectural techniques such as those developed by Gothic architects. As was the case with Renaissance painters and sculptors (many of whom were also architects), Renaissance architects derived great inspiration from, but did not merely copy, their ancient Greek and Roman predecessors. The most important Italian Renaissance architects include Bramante, Raphael, Michelangelo, and Brunelleschi.

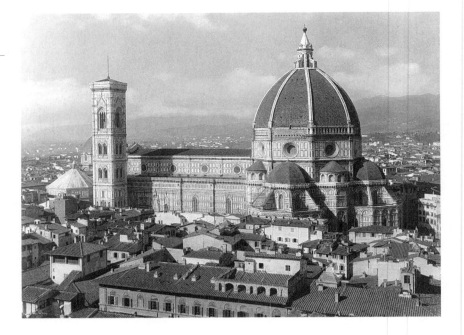

371
Cathedral of Florence. 1296–1436.
Dome by Filippo Brunelleschi,
1420–1436.

Florence [371]. The grand scale of the
dome's dimensions—matched only by
the domes of *Hagia Sophia* [82] and
the *Pantheon*—were regarded by his
contemporaries as nothing short of
miraculous.

Unlike architectural details such as
the clearly visible ribbed vaults of
Gothic cathedrals, in **Baroque**
architecture, overtly structural
elements are generally concealed from
sight. And unlike the grand simplicity
of structures such as Brunelleschi's
dome for the *Cathedral of Florence*,
domes designed by Baroque architects
such as Francesco Borromini are
marked by overtly complicated, often
confounding clashes of convex and
concave forms that seem to continu-
ously wind in and out of themselves.
Such is the case in an interior view of
the dome, or cupola of Borromini's
San Carlo alle Quattro Fontane [372],
where a potentially serene dome of
heaven is transformed into multiple
pockets of convoluted space.

POST-INDUSTRIAL REVOLUTION ARCHITECTURAL METHODS AND MATERIALS

Most of the Western European
buildings created during the periods
we have just examined were con-

structed out of stone, brick, or, the
least durable material, wood. As we
have seen, specific materials made
possible the development of specific
methods of construction which were,
in turn, directly related to the
inherent characteristics of the
materials themselves. Although
architects throughout history inge-
niously devised means of stretching
the range of what could be accom-
plished with any given building
material, there are limitations beyond
which any material simply cannot be
pushed. With the advent of the
Industrial Revolution in the eigh-
teenth century, new materials—and
consequently, new building tech-
niques and new challenges—became
available to architects.

Iron

Like the arch, which led to the
development of the vault and the
dome, the exploitation of iron
initiated profound, revolutionary
developments regarding the ways and
means of architectural design. Iron has
been used for thousands of years to
make tools and other objects, as well
as for such building purposes as
binding together masonry. It is only
since the Industrial Revolution,
however, that iron (and its alloys such
as steel) came into its own as a

372
Francesco Borromini. Interior of the Dome of San Carlo alle Quattro Fontane, Rome. 1637–1641.

373
Ange-Jacques Gabriel. Garden façade of the Petit Trianon, Versailles. 1761–1764.

building material, distinguishing itself especially through its relative lightness, extreme strength, and its natural fire-resistant properties. Although used primarily for making railroad tracks at first, and then later in the construction of bridges, nineteenth-century architects soon came to appreciate the great potential of iron for the construction of buildings. The adoption of iron as a building material was accompanied by the advent of functionalism as a primary architectural concern. This notion of functionalism was influenced, in part, by the ideas of individuals such as the eighteenth-century French **Neo-Classical** theorist Marc-Antoine Laugier who derided the ambiguity of Baroque space and the excessive ornamentation of the final phase of Baroque, known as Rococo. Theorists like Laugier preferred the kind of plain surfaces, straight lines, simple forms, and functional load-bearing columns-in-the-round (instead of "fake" **pilasters,** decorative columnar forms that project relief-like from a wall) that can be seen in buildings such as the French eighteenth-century architect Ange-Jacques Gabriel's *Petit Trianon* **[373]**.

Neo-Classicism, an architectural style which is characterized by plane surfaces, symmetry, and geometric clarity, covers a period roughly from 1750 to the early 1800s. As its name implies, Neo-Classicism was influenced greatly by the art of ancient Greece and Rome, prominently reintroducing, for example, such classical features as Doric, Ionic, and Corinthian columns.

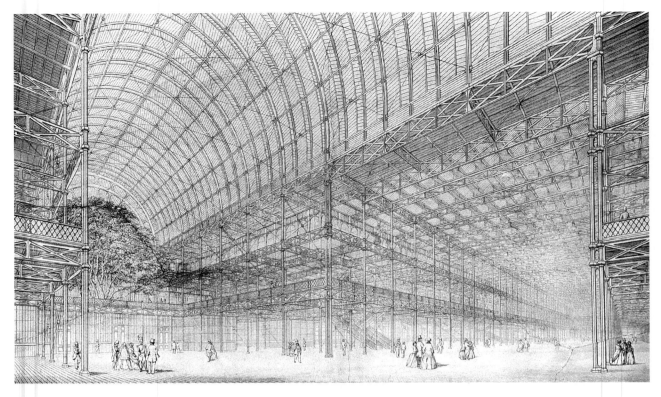

374
Joseph Paxton. Crystal Palace,
London. 1851.

The **Chicago School** (or Style) of Architecture refers to work created by architects based in Chicago from about the 1880s through the first few decades of the twentieth century. Architects associated with the Chicago School include William Le Baron Jenney, Daniel Burnham, John Wellborn Root, Louis Sullivan, and Sullivan's assistant for five years, Frank Lloyd Wright.

The great tensile strength of iron and steel permitted nineteenth-century architects to enclose vast architectural spaces. The first completely prefabricated building, Joseph Paxton's *Crystal Palace* [374], with its wide-open interior, revolutionized architectural practices. Because the iron-frame and glass construction of this building was made to order in factories, the building was erected in only six months, even though it covered 17 acres of land! Imagine the impression this virtually transparent building must have made on viewers accustomed to architectural structures dominated by solid walls and continuously interrupted expanses of space.

Steel

In the late 1800s, steel, which is even stronger, lighter, and more fire-resistant than iron, began to replace iron as the architectural material of choice for framing large buildings. Steel frame construction [375] and the invention of the elevator gave rise to the skyscraper, which has changed the face and functioning of cities throughout the world. The individual most commonly linked with the

introduction of the American skyscraper is the leading architect of what is known as the **Chicago School**, Louis Sullivan. Breaking with earlier architectural traditions, Sullivan allowed the skeletal frame of his most important buildings, such as the *Wainwright Building* [376], one of the world's first skyscrapers, to remain clearly visible. The resultant pattern of vertical brick piers emphasizes the building's height, as long rows of windows open up the building's exterior.

Traditionally, walls participated in the load-bearing responsibilities of a building. As architects grew to fully appreciate the structural benefits of steel frame construction, they began to explore the possibilities of non-load-bearing glass walls—walls that were not assigned a skeletal role involving the building's underlying structure, but rather that served primarily as an outer covering or skin. In the *Wainwright Building*, Sullivan, who often compared buildings to the human body, could describe the brick sheathing as the "muscle" that is organically attached to the steel "bone."[17] Later

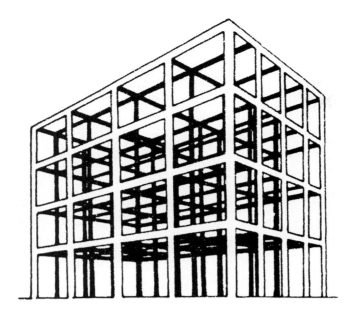

375
Steel frame construction.

376
Louis Sullivan. Wainwright
Building, Saint Louis, Missouri,
1891.

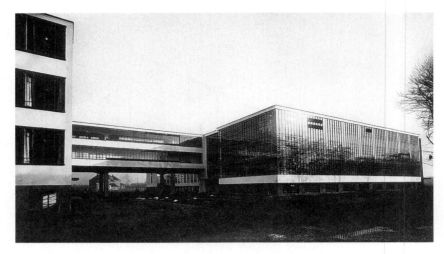

377
Walter Gropius. Bauhaus School, Dessau, Germany. 1925–1926.
Photograph courtesy The Museum of Modern Art, New York.

The **International Style** is a style of architecture developed roughly between the 1920s and 1940s. Skeletal supports not only allow architects greater freedom in designing the interior space of a building, but allowed exterior walls to consist primarily of glass. Designs were motivated mainly by a building's underlying structure and function. These buildings are also characterized by clean, geometrical planes and a conspicuous absence of ornament. Leaders of the International Style include Walter Gropius, Le Corbusier, and Miës van der Rohe.

architects, such as one of the leading members of the **International Style,** Walter Gropius from Germany, took this idea a step further. In his workshop wing of the Bauhaus **[377]**, an important art school where Gropius was the director, the walls are comprised primarily of continuous sheets of glass, supported and interrupted only by thin steel strips. No longer merely an opening in a wall, the window had become the wall itself.

Reinforced Concrete

Like stone, concrete—a mixture of cement, gravel, and water—has low tensile strength. Unlike a stone beam, however, reinforced concrete, or ferroconcrete—concrete which has hardened after being poured over steel rods or mesh **[378]**—has great tensile strength. In keeping with its versatile, durable, fire-resistant properties, this twentieth-century technique of reinforcing concrete with metal has

been put to a wide range of architectural uses, including the creation of **cantilevered** structures that are supported only at one end and extend significantly beyond supporting walls or columns.

One of the most famous examples of the reinforced concrete cantilever is Frank Lloyd Wright's *Kaufman House* **[379]**, popularly known as *Falling Water* because it was built over a waterfall. Wright regarded the cantilever as a profoundly natural principle, comparable to a human being's outstretched arm or a branch growing from a tree. The cantilever, Wright believed, was potentially the most romantic and free of all principles of construction, an architectural device that liberated space.[18]

Concrete was not a building material to which Wright was naturally drawn. He found it passive and without intrinsic aesthetic character. But

378
Reinforced concrete beam and slab.

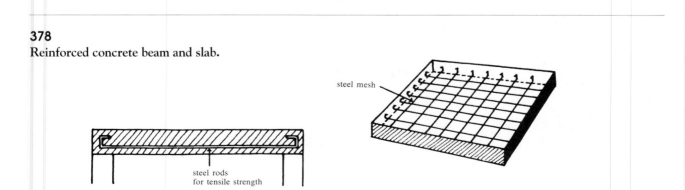

steel mesh

steel rods for tensile strength

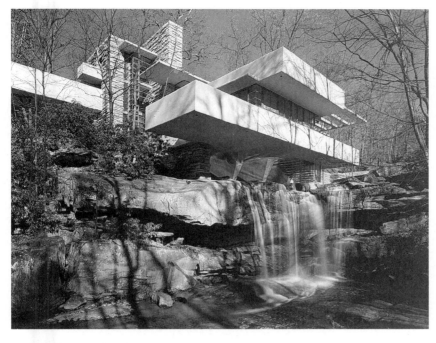

379
Frank Lloyd Wright. Falling Water
(Kaufman House), Bear Run,
Pennsylvania. 1936–1937.

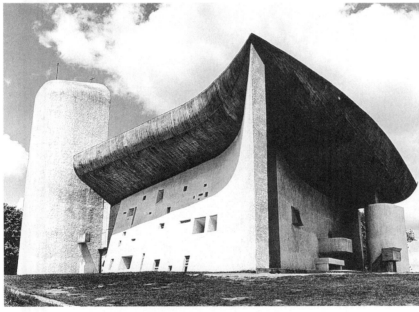

380
Le Corbusier. Notre Dame du Haut,
Ronchamp, France. 1950–1955.

because it could be cast into any form, had the exceptional property of growing stronger as it aged, and, when reinforced with steel, became extraordinarily resistant to physical stress, concrete served the purposes of many of his designs.

Wright has credited the site itself with being the inspiration for the design of this house. But, clearly, his aggressive use of the reinforced concrete cantilevered form must also be seen as

a crucial component that enabled Wright to create the impression of concrete floating in mid-air, thereby allowing him to translate into three-dimensional reality his desire to make "the landscape more beautiful than it was before that building was built."[19]

Poured concrete can take almost any shape the architect requires of it. One of the most architecturally eccentric uses of poured concrete is seen in *Notre Dame du Haut* [380], a chapel

designed by Le Corbusier after he had moved away from the rigidity of the International Style. In what is considered by many authorities to be the most outstanding, most revolutionary building of the mid-twentieth century, bold, sweeping curves lead us to reconsider the validity of the divisions we so wholeheartedly accept regarding the separation between artforms such as architecture and sculpture.

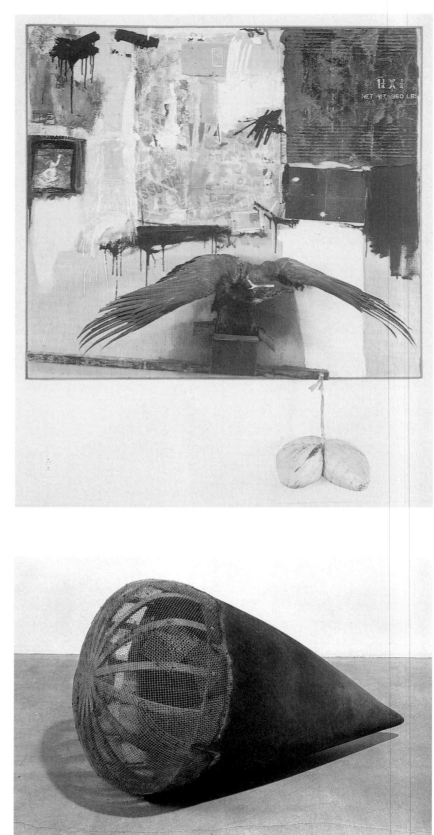

381
Robert Rauschenberg. *Canyon.*
1959. Mixed media on canvas with
assemblage, 86½ x 70½ x 23"
(2.20 x 1.79 x .58 m). Courtesy
Sonnabend Collection, New York.

ASSEMBLAGE, MIXED MEDIA, AND THE BREAKDOWN OF CATEGORIES

One of the characteristics that
distinguishes the art of the twentieth
century concerns the liberal, often
extravagant intermingling of media
and materials and the resultant
tendency of one artform to merge with
another. By enthusiastically embracing
unpredictable technical solutions to
visual problems, some of today's artists
have succeeded in expanding our
outlooks regarding what we consider
acceptable ways and means of creating
art. The contemporary American
artist Robert Rauschenberg is well
known for incorporating into his work
such unconventional elements as
mattresses, stuffed goats, clocks,
umbrellas, and thermometers—
anything at all that he felt would
contribute to the form or content of
his creations. The term applied to
many of these creations is assemblage.
An **assemblage** is a work of art in
which the foreign matter that is
attached to a surface projects signifi-
cantly outward into the space occu-
pied by the viewer. In *Canyon* **[381]**,
Rauschenberg employed the tradi-
tional medium of oil paint on canvas,
but he also used such three-dimen-
sional elements as a stuffed eagle and a
fluffy pillow, thereby creating a work
that exists somewhere between
painting and sculpture.

382
Martin Puryear. *Mus.* **Painted wood and wire mesh, length 44" (1.12 m),**
diameter 26" (.66 m). Private collection, Rancho Santa Fe, California.
Courtesy of Margo Leavin Gallery, Los Angeles, California.

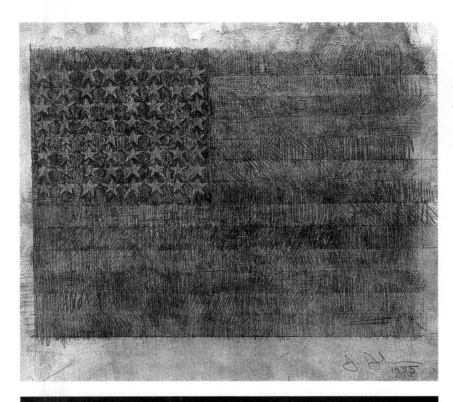

In *Mus* [382], a patched, crude-
looking, yet carefully handcrafted
wood and wire-mesh creation, the
contemporary American artist Martin
Puryear brings drawing into the realm
of sculpture. Puryear alluded to this
idea when he explained that part of
his attraction toward the material of
wire mesh, which he incorporates into
many of his works, is the quality of
drawing—or more specifically,
crosshatching—that it suggests.[20]

Overlapping one plane of wire mesh
with another plane, he has stated, can
create rich, dark tones like drawn,
crosshatched lines, not unlike the
effect achieved, for example, in *Flag
(with 64 Stars)* by Jasper Johns [383].

How are we to categorize contempo-
rary American artist Donna Dennis's
lifelike *Deep Station* [384]? Certainly
it incorporates many elements of
architecture, yet its slightly diminutive

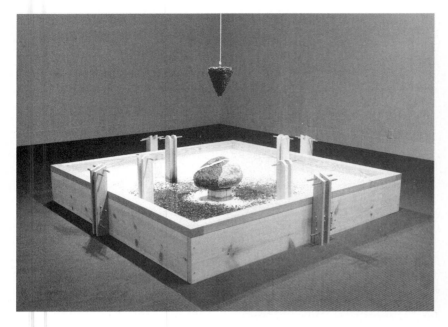

dimensions, cut-off walls, and other
structural abbreviations undermine its
ability to operate as a functional space
on any real practical level. Just as
surely, however, it resists categoriza-
tion into the exclusory context of pure
sculpture. Actually, how we choose to
categorize this work is of little
importance. Far more interesting is the
artist's sensitive amalgamation of a
wide range of materials to create an
environment that so convincingly
alludes to a real space.

In Mineko Grimmer's *Seeking for the
Philosopher's Stone* [385], the Califor-
nia-based artist draws on her Japanese
heritage to create a mixed media work
that includes wood, stone, wire, ice,
brass, and water. It is at best beside the
point, and at worst misleading, to
definitively place *Seeking for the
Philosopher's Stone* into a particular
category of art. A primary element
here is the upside-down pyramid
suspended above the centralized stone
that sits on a wooden base. This
pyramid is made of pebbles embedded
in ice. As the ice melts, the pebbles
drop and ping one by one against the
stone. Precise geometric structures
such as the enframing wooden box
and the less rigid pyramid of pebbles
are combined with organic forms and

387
Edward Hopper. *House by the Railroad*. 1925. Oil on canvas, 24 x 29" (61 x 73.7 cm).
Collection, The Museum of Modern Art, New York. Given anonymously.

materials such as stone and water. Silence, sound, sight, stillness, and movement each play a role in this contemplative/visual experience.

A Concluding Thought

It is fitting that this book should end with a discussion of mixed media and the breakdown of categories. After all, as I have repeatedly pointed out, art represents, perhaps, the most universal of languages, and as such, it bridges gaps by opening up broad avenues of provocation and communication. These avenues can lead to deeper understandings of your world and of yourself.

This kind of communication begins to happen when you enter the world of another's time, place, feeling, or thought. Consider the mixed media installation *The Man Who Flew into Space from His Apartment* **[386]** by the contemporary Russian artist Ilya Kabakov. The apartment dweller is absent, yet his presence stimulates our imagination. A short text provided by the artist informs us that the missing man has somehow succeeded in fulfilling a dream by catapulting himself through the ceiling of his room, straight through the attic and

roof above. We are led to envision this unpictured man floating in unbounded space. Where exactly is he? Why did he do this? How will he fare? Could that ridiculous, catapulting creation of strings and straps suspended from the ceiling of his room actually have worked? Kabakov creates a personless portrait, and he constructs an expansive world within the confines of a small, claustrophobic, marvelously detailed room. Our imagination enters the room and then soars out the ceiling.

Perhaps, to some degree, we all contain a little of the spirit of Kabakov's apartment dweller. After all, are we not all driven to some degree by the impulse to imagine, to reach toward what lies beyond the commonplace, the known, to a place that is at once far away and yet within us? Are we not all capable of imaginative soaring, an activity that is, of course, a fundamental aspect of the creative process for both artist and audience alike?

In another sense, the creative spirit need not leave home to experience a genuine and moving flight of the imagination. Giorgio Morandi seldom traveled far from his home in Bologna,

Italy, and the subjects of his art included little more than surrounding countryside and a few very familiar objects that he continuously arranged and rearranged in the familiar surroundings of his studio. Morandi's remarkably penetrating inventiveness evolved from his ability to assemble in a personal manner the seemingly unremarkable details of his vision. Relatedly, the art of looking at art involves an ability to assemble in a personal manner the visual details that fill our vision. Stimulated by the common ground of a single work of art, each of us is free to imagine and explore within our own limits. The following example of creative viewing demonstrates how rich and individualized the experience of looking at art can be.

Loneliness and isolation—I assumed this was what Edward Hopper had in mind when he painted *House by the Railroad* **[387]**. I assumed this is how everyone read the image. The unyielding geometry of the building is unobstructed by trees or bushes. The sky is empty; the tracks are silent; no cars are parked nearby; no discarded child's toy recalls the playful shouts of the day; no neighboring homes suggest companionship; nobody is sitting on

the front porch. In the foreground, railroad tracks come and go with a haste equaled only by the steadfastness of the house, as the sides of the canvas cut the tracks off at both ends. The tracks have no past and no future because we have no idea where they come from or where they go. Yet they are the one element Hopper included that could have connected the residence to a life of community. The tracks separate the viewer from the house, further contributing to a sense of remoteness. The house feels unfamilied; the setting looks forsaken.

This is how I saw the painting. I was therefore taken aback when, during my first year of teaching, a student in my basic painting course talked about the house in this painting as "inviting," as an ideal place to live. He said that he liked the way the artist was able to transform such simple forms into such a compelling situation of contentment and cheer. Hopper's house, he said, reminded him of the castles he used to make with his building blocks when he was a child. "We see the tracks from eye level," he said, "but we look up to the house. It towers above us. That's one of the things that makes the buiding look so powerful and proud. Yeah, that's one of the things this painting is really about—pride."

"Pride? Yes, I understand what you mean," I said. "But inviting? The kind of place you'd like to live? I've never seen this painting like that. It's a lonely, isolated . . ." But before I could finish my sentence, he interrupted:

"Why not?" he countered. "It's quiet and peaceful, which is not the same as lonely—at least not for me. I would walk up and down the tracks, smiling, able to think because no one would be around to confuse my thinking. Walking on train tracks is different from any other kind of walking. Train tracks bordered the backyard of the house I grew up in. I used to walk them every day. They tell time better than clocks. With clocks, the past disappears. With train tracks, the past just gets smaller. Any time you want, you can retrace your steps and bring the past back up to size. Walking along tracks like the ones in Hopper's painting gets you to bring things up to yourself that you don't ordinarily think about because you don't ordinarily have the time or the peace of mind.

"As far as the house itself is concerned—I would love to just sit quietly inside the house in Hopper's painting and look at the rectangular slap of sun on the living room wall. That's something Hopper could paint better than anyone. No furniture, or people, or anything at all—nothing but sunlight on a wall. Yeah, I'd sit there and think about the other people before me who lived here and looked at the same part of the same wall, lit by the same sun at the same time of day, and I'd feel a part of things. I'd hear the train coming, and I'd go outside onto the porch and wave to the old man driving the locomotive,

and he'd wave back, shaking his cap and steamwhistling hello to his friend who he never met at less than thirty miles an hour, but who he could count on to be there, every day, shaded by the porch of the grand Victorian house, and my wave would make his day, just like his wave, and the afternoon quiet, and the house, and the bright sun would make mine."

The student made his point, and for that afternoon he was my teacher. His idiosyncratic, yet genuine response to *House by the Railroad* convinced me of Hopper's sincerity when he played down the importance of what he sarcastically referred to as "the loneliness thing" that people saw in his paintings. My student taught me the difference between aloneness and loneliness. More generally, he demonstrated for me how profoundly our individual experiences determine our response to a work of art, whether that work of art causes our imagination to walk meditatively up and down a strip of railroad tracks in the United States, stand still among a carefully composed gathering of bottles in Bologna, Italy, or catapult into space through a ceiling in Russia. There are no limits to the joys and insights that await the individual who embraces both the observable signals as well as the felt impressions that tremble just beneath the threshold of visibility, of those images, objects, and ideas that comprise the world of visual art.

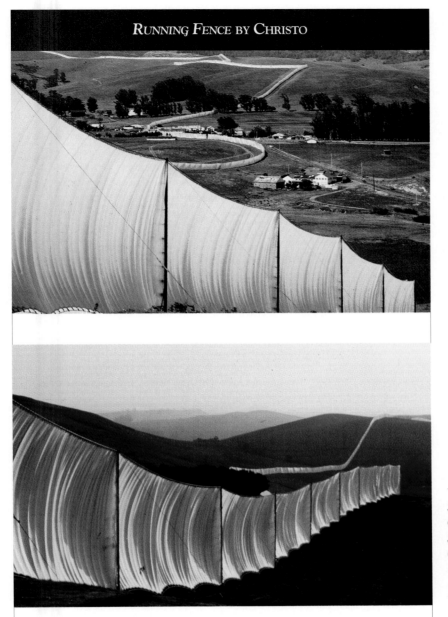

RUNNING FENCE BY CHRISTO

388
Christo. *Running Fence,*
Sonoma and Marin Counties,
California. **1972–1976. Height 18'**
(5.49 m), length 24½ miles
(39.43 kilometers). Photographs by
Wolfgang Volz. ©1976 Christo.

Before reading the text that accompanies *Running Fence* **[388]** by the twentieth-century Bulgarian-born artist Christo, think about the work by answering the following questions:

1. Christo's *Running Fence*, a 24 ½-mile-long ribbon of white nylon material, was dismantled two weeks after it was erected. It challenges certain traditional notions regarding the nature of a work of art, including, among other things, permanency and the artist's choice of materials. Explain. Think about how and in what kinds of spaces works of art are typically displayed. *Running Fence* challenges traditional notions regarding the exhibition of a work of art. Explain.

2. In certain respects *Running Fence* celebrates the physical materials out of which it was constructed; in other respects it denies its material nature. Explain.

3. In describing conceptual art, the art critic Dore Ashton stated: " The idea itself, even if not made visible, is as much a work of art as any finished product . . . art is made to engage the mind of the viewer rather than his eye or emotions."[21] What do you think of this statement? Bearing in mind that Christo's *Running Fence* no longer exists (except in documentation form), how would you relate Dore Ashton's statement to Christo's work?

In Christo's *Running Fence*, a three-dimensional white line, 18 feet high and 24 ½ miles long, swept and billowed its way across two counties in northern California. While it remained standing, its form was ever changing, as rocky terrain, wind, clouds, the sun, and the sea continuously transfigured 165,000 yards of white nylon fabric; 2,050 steel poles; approximately 13,000 steel anchors; about 90 miles of steel cable; and 350,000 hooks into a living, gigantic work of art.

Another important factor underlying the creation of *Running Fence* involves the project's huge workforce. So integral a part of the process was the crew of more than 400 students and workers who assisted Christo that a theme song, "Onward, Christo Soldiers," was even proposed.

This project represents a fascinating example of what we have referred to previously as the inextricable connection between the creative elements of the premeditated and the accidental. Forty-two months of planning, bargaining, patience, invention, craftsmanship, sweat, and talent created something that was impractical, ridiculous even, exorbitantly expensive (it cost between two and three million dollars which the artist raised through the sale of his own work), and incredibly beautiful. This was something that needed to be done precisely right in order for it to withstand the constant demands of the environment that surrounded it. Nature, the frame for *Running Fence*, could at any time rain on Christo's white nylon parade.

Photographs which document the two weeks of its life reveal the beauty of the everchanging linear sprawl of *Running Fence*. From a distance, its line could be seen traveling straight for miles. It lightly humped over hills and dipped into valleys. Sometimes it disappeared beneath a rise or among a grove of Monterey pines, only to reappear acres or miles beyond, wandering through a grove of eucalyptus. Sometimes it stopped completely, interrupting itself to make way for traffic. It traversed miles of flat farmland, passed through or outside four towns, and finally completed its march by streaming into the ocean to bathe.

Running Fence is often described as an example of Conceptual Art. But in many ways it ought not be confined to such a categorization. *Running Fence* was constructed and was breathtakingly visual. What is left of this project are documents such as written notes and statements associated with its construction, a film, two books, a scale model, and assorted two-dimensional drawings and photographs that can be satisfactorily apprehended with the eyes. Moreover, this work existed in three-dimensional space, and like any sculpture or architectural structure, to be fully appreciated it needed to be experienced with the whole body. One needed to walk, drive around, or fly above it to truly see it. But it was designed for only two weeks of existence. The eyes play less of a role today in the appreciation of this work than does the imagination. *Running Fence* exists today primarily as a memory, an idea, a concept.

389
Medardo Rosso. *The Bookmaker*.
1894. Wax over plaster,
17½ x 13 x 14"
(44.5 x 33 x 35.6 cm).
Collection, The Museum of
Modern Art, New York.
Acquired through the
Lillie P. Bliss Bequest.

1a. In *The Bookmaker* **[389]**, as in each of the small-scale wax sculptures created by the Italian artist Medardo Rosso (1858-1928), the impalpable element of light appears to overwhelm the solidity of three-dimensional substance. By melting wax (a translucent material) over a plaster core, Rosso achieved visual results similar to those of the Impressionist painters. Explain.

b. Generally speaking, would you say that the Impressionist aesthetic

(in which a flickering, luminous atmosphere represents the fundamental subject of a painting no matter what the work is about from a more literal point of view) is more easily expressed in the form of a two-dimensional image than in the form of a three-dimensional object? Explain your answer.

c. Despite the obvious dissolution of the human form, in *The Bookmaker* we can identify body parts such as hands and legs. What do you think

accounts for our ability to identify such amorphous forms? What part would you say our imagination plays in this identification? What part does our knowledge of human anatomy play? How important do you think the artist's spare but strategically placed details are to our reading of this sculpture?

d. Would you say that *The Bookmaker* exemplifies an additive or subtractive sculptural process?

390
Richard Artschwager.
Up and Across. 1984–1985.
Polychrome on wood,
61 x 144 x 35"
(1.55 x 3.66 x .89 m).
Courtesy Leo Castelli Gallery,
New York.

2a. There is a kind of relieflike quality suggested by the contemporary American artist Richard Artschwager's *Up and Across* **[390]**. Explain.

b. Morris Louis's manner of handling acrylic paint in *Saraband* **[296]** is altogether different from the way Artschwager uses it in *Up and Across*. In what ways do they differ? The forms that these two artists develop in their work differ significantly from one another as well. Explain.

c. Artschwager systematically covers the wooden support of his forms in flat, opaque shapes of black, white, and gray paint, which contributes to the decorative, whimsical quality of the piece. *Up and Across*, a peculiar, stepped-up plank of punctuation, leaves us guessing as to what is being punctuated—that is, where exactly the artist takes us from and leads us to. But the hard-edged, machinelike paint handling, which is matched by precision form-making, asserts its case with confidence and exactness, perhaps suggesting that, ironically, with an artist like Artschwager, clarity often accompanies even the most puzzling of statements. Explain.

d. There is a furniturelike quality to *Up and Across*. Yet the work is distinctly functionless. How do you feel about this seeming contradiction?

timeline

Artists and works of art do not lend themselves naturally to categorization. Consequently, some of the art historical periods under which a particular artist or work of art is listed below are necessarily imprecise. For example, although an artist may typically be associated with a particular art historical period, some of the characteristics frequently demonstrated by that artist's work may not conform to important qualities that characterize a given art movement. Moreover, some of the artists listed below (especially twentieth-century artists) played an important part in the development of more than one movement. The following chart provides a general chronology for the artists and works of art discussed in this book.

30,000 B.C.	25,000 B.C.	20,000 B.C.	15,000 B.C.	10,000 B.C.	5,000 B.C.	B.C./A.D.	1000 A.D.

PREHISTORIC ART

✤ 30,000–25,000 B.C. Venus of Willendorf

✤ 19,000–15,000 B.C. Horse (cave painting, Lascaux, France) ★

11,000 B.C. Ibexes Associated with a Mammoth (cave painting, Sanctuary of Rouffignac, Dordogne, France) ★

ANCIENT ART

3400 B.C. Hermes with Dionysus Boy ✤

2700 B.C. The Standard of Ur ✤

2nd century B.C. Laocoon and His Two Sons ✤

1500 B.C. Mask of Agamemnon ✪

1485 B.C. Mortuary Temple of Queen Hatshepsut ◆

1490-1480 B.C Queen Hatshepsut ✤

1422–1411 B.C. Tomb of Nakht ★

1400–1360 B.C. (19th Dynasty) Egyptian Vase ◗

c. 1330 B.C. Golden inlaid coffin of Tutankhamen ✤

III Millenium B.C. Harpist ✤

III MIllenium B.C. Egyptian Artisan Forming a Pot on a Wheel ✤

900—600 B.C. Tiger ✤

6th century B.C. Vix Vase ◗

650 B.C. Dying Lioness ✪

550 B.C. "Basilica" ◆

447–432 B.C. Parthenon ◆

72—80 A.D. The Colosseum ◆

70—25 B.C. Great Stupa ✤

1st century A.D. Four Horses of St. Mark's Basilica ✤

12 A.D. Pantheon ◆

10 A.D. Roman Aqueduct ◆

6th Century A.D. Seated Buddha from Ghandhara ✤

3rd century A.D. Marianos and Hanina, The Sacrifice of Isaac ✤

c. 725 A.D. Lintel 25 ✪

KEY

◆ Architecture
✤ Assemblage
◗ Ceramics
✛ Collage
▲ Drawing
● Film
■ Installation
✤ Mosiac

★ Painting
✦ Performance
☐ Photograph
✱ Print
✪ Relief
✤ Sculpture
○ Video

B.C./A.D. 200 400 600 800 1000 1200 1400 1600

MEDIEVAL ART

- 310—320 A.D. Basilica of Constantine ◆
- 312 A.D. Arch of Constantine ◆
- 400—800 A.D. Moche Pottery Figure of a Warrior
- 532—537, 553—563 Hagia Sophia ◆
- 547 Emperor Justinian and Courtiers ❖
- Early 6th century The Sacrifice of Isaac (floor mosaic from Israel) ❖
- 9th—10th century Ivory Carving Showing Celebration of the Mass (book cover) ❖❖❖
- begun 1210 Rouen Cathedral ◆
- 1225—1299 Rheims Cathedral ◆◆◆◆
- begun 1248 The Choir of Cologne Cathedral ◆
- middle of 13th century Temple of Surya (India) ◆
- 1309—1354 Court of the Lions, Alhambra Palace ◆◆◆

PROTO RENAISSANCE

- 1285 Duccio di Buonesegna, "Rucellai" Madonna ★
- 1308—1311 Duccio di Buonesegna, The Transfiguration of Christ (Maesta Altar) ★
- 1310 Giotto, Madonna Enthroned ★

EARLY RENAISSANCE

- 1296—1436 Filippo Brunelleschi, The Cathedral of Florence ◆◆◆◆◆◆◆
- 1425—1452 Lorenzo Ghiberti, East Doors of the Baptistry of Florence ❖❖
- 1425 Lorenzo Ghiberti, Abraham and Isaac (from the East Doors of the Baptistry of Florence) ❖
- 1430—1432 Donatello, David ❖
- 1433—1439 Donatello, Cantoria ❖
- 1440—1445 Fra Fillipo Lipp, Madonna and Child ★
- 1452—1466 Piero della Francesca, The Queen of Sheba ★★
- c. 1465 Antonio Pollaiuolo, Battle of Naked Men ✳
- 1483—1488 Andrea del Verrochio, Equestrian Monument of Colleoni ❖
- c. 1475 Andrea del Verrochio, Woman's Head ▲
- c. 1475 Leonardo da Vinci, Study of Drapery for a Seated Figure ▲
- 1478 Sandro Botticelli, Primavera ★
- 1480 Sandro Botticelli, The Birth of Venus ★
- c. 1480—1482 Leonardo da Vinci, Compositional Study for the Adoration of the Magi ▲
- c. 1485—1490 Leonardo da Vinci, Study of Human Proportions According to Vitruvius ▲
- 1502 Bramante, The Tempietto ◆
- 1503 Bramante, Spiral Ramp ▲
- 1516 Leonardo da Vinci, Cataclysm ▲

KEY

- ◆ Architecture
- ❖ Assemblage
- ▲ Ceramics
- ✚ Collage
- ● Film
- ■ Installation
- ❖ Mosiac
- ★ Painting
- ◆ Performance
- ☐ Photograph
- ✳ Print
- ▲ Drawing
- ✿ Relief
- ❖ Sculpture
- ○ Video

1400	1450	1500	1550	1600	1650	1700

HIGH RENAISSANCE

✤ 1501—1503 Michelangelo Buonarroti, *David*
★★ 1508—1512 Michelangelo Buonarroti, *Ceiling of Sistine Chapel*
✤ 1513 Michelangelo Buonarroti, *Moses*
✤ 1530—1534 Michelangelo Buonarroti, *The Awakening Slave*
◆ 1547 Michelangelo Buonarroti, *Apse and Dome of St. Peter's Basilica*
★ 1559 Titian, *The Entombment*
★ 1595 Raphael, *Madonna and Child Enthroned*

NORTHERN RENAISSANCE

▲ 1431 Jan van Eyck, *Cardinal Nicolo Albergati*
★ 1434 Jan van Eyck, *Marriage of Giovanni Arnolfini and Giovanna Cenami*
★ 1438 Rogier van der Weyden, *The Descent from the Cross*
★ 1479 Hans Memling, *The Madonna with Child on the Throne*
★ 1497 Albrecht Durer, *The Four Horsemen of the Apocalypse*
★ 1565 Pieter Bruegel the Elder, *Hunters in the Snow*

MANNERISM

✤✤✤ 1545—1554 Benvenuto Cellini, *Perseus*
★ 1563 Giuseppe Arcimboldo, *Winter*
★★ 1600—1605 El Greco, *The Resurrection*
★★★ 1608—1614 El Greco, *The Baptism of Christ*

BAROQUE

1600—1601 Michelangelo Merisi da Caravaggio, *Supper at Emmaus* ★
1603 Michelangelo Merisi da Caravaggio, *Sacrifice of Isaac* ★
1635 Diego Velázquez, *Surrender at Breda* ★
1636—1639 Gianlorenzo Bernini, *Costanza Buonarelli* ✤
1642 Rembrandt van Rijn, *The Nightwatch* ★
1645—1652 Gianlorenzo Bernini, *The Estacy of St. Theresa, Cornaro Chapel* ✤✤✤✤
1650 Diego Velazquez, *Innocent X* ★
1650 Rembrandt van Rijn, *Shell* ★

Timeline years: 1700 · 1725 · 1750 · 1775 · 1800 · 1825 · 1850 · 1875 · 1900

ROCOCCO

◆◆◆◆◆ 1734–1739 Francois Cuvilles, *The Mirror Room of the Amienburg*

▲ c. 1740 G. B. Tiepolo, *Psyche Transported to Olympus*

NEO-CLASSICISM

★ 1814 Jean-Auguste Dominique Ingres, *La Grande Odalisque*

▲ 1814 Jean-Auguste Ingres, *Study for La Grande Odalisque*

★ 1814 Jean-Auguste Dominique Ingres, *Napoleon as Emperor*

ROMANTICISM

★ 1814–1815 Francesco Goya y Lucientes, *The Executions of the Third of May*, 1808

★ 1826 Eugene Delacroix, *The Death of Sardanapalus* ✿

1833–1836 Francois Rude, *Departure of the Volunteers of 1792* ✿✿

1840 Joseph Mallord William Turner, *The Slave Ship* ★

1863 Francesco Goya y Lucientes, *What More Can One Do?* (from the Disasters of War series) ✹

HUDSON RIVER SCHOOL

1838 Thomas Cole, *Schroon Mountain, Adirondacks* ★

UKIYO-E

early 1800s Kitagawa Utamaro, *Courtesan Writing a Letter* ✹

1857 Ando Hiroshige, *Mitsumata Wakarenofuchi* ✹

1857 Ando Hiroshige, *Rain Shower on Oneshi Bridge* ✹

REALISM

1865 Honoré Daumier, *The Strongman* ★

1871 Winslow Homer, *The Country School* ★

IMPRESSIONISM

★ 1870 Auguste Renoir, La Promenade
★ 1873 Berthe Morisot, The Artist's Sister, Madame Pontillon, Seated on Grass
★ 1891 Claude Monet, Haystack in Winter
★ 1891 Claude Monet, Haystack at Sunset
★ 1891 Mary Cassatt, The Letter
★ 1894 Claude Monet, Rouen Cathedral: Sunset
▲ 1895 Mary Cassatt, Nurse Reading to a Little Girl
★ 1898 Mary Cassatt, Mother's Kiss
1918—1925 Claude Monet, Reflections of the Willow-Water-Lillies ★★★★★★★

POST-IMPRESSIONISM

★ 1880 Paul Cézanne, La Chateau at Medan
★★★★★★ 1884—1886 Georges Seurat, Sunday Afternoon on the Island of the Grande Jatte
▲▲▲▲▲▲ c. 1884—1886 Georges Seurat, Child in White
★★★★★★ 1885—1887 Paul Cézanne, Mont Saint-Victoire
★★★★★★ 1886—1888 Vincent van Gogh, Copy of Ando Hiroshige's Rain Shower on Oneshi Bridge
▲ 1888 Vincent van Gogh, The Zouave
▲ 1889 Paul Gaugin, Letter to Vincent Van Gogh
★ 1890 Vincent van Gogh, Crows Over a Wheatfield
★★★★★ 1890—1894 Paul Cézanne, Basket of Apples
★ 1891 Toulouse-Lautrec, La Goulue at the Moulin Rouge
★ 1892 Toulouse-Lautrec, Quadrille at the Moulin Rouge
❖ 1894 Medardo Rossi, The Bookmaker
★ 1895 Paul Cézanne, The Basket of Apples
c. 1926 Paul Gaugin, Christ on the Cross ★

NABI

1893 Edouard Vuillard, Mother and Sister of the Artist ★
1894 Pierre Bonnard, La Revue Blanche ★

FAUVISM

1908 Piet Mondrian, Woods Near Oele ★
1918 Henri Matisse, Self Portrait ★
1926 Henri Matisse, Odalisque with Tambourine ★

KEY

◆	Architecture	★	Painting
❖	Assemblage	◆	Performance
◗	Ceramics	▢	Photograph
✚	Collage	✳	Print
▲	Drawing	✪	Relief
●	Film	❖	Sculpture
■	Installation	○	Video
❖	Mosiac		

EXPRESSIONISM

* 1908 Käthe Kollwitz, *The Prisoners*
▲ 1911 Paul Klee, *Young Man at Rest*
✤ 1914 Ernst Barlach, *The Avenger*
▲ 1916 Amadeo Modigliani, *Portrait of Jacques Lipchitz*
* 1921 Max Beckman, *Portrait of Dostoevsky*
* 1926 José Clemente Orozco, *Mourning Figure*
★ 1931 Diego Rivera, *Liberation of the Peon*
▲ 1933 Käthe Kollwitz, *Self Portrait with a Pencil*
★ 1940—1941 Jacob Lawrence, *One of the Largest Race Riots in East St. Louis*
★ 1953 Francis Bacon, *Study After Velázquez's Portrait of Pope Innocent X*

CUBISM

★ 1907 Pablo Picasso, *Woman's Head*
✤ 1914 Henri Gaudier Brzeska, *Portrait of Ezra Pound*
✤ 1918 Georges Braque, *Musical Forms*
✤✤ 1929—1930 Pablo Picasso, *Woman in the Garden*
★ 1940 Stuart Davis, *Colonial Cubism*
★ 1957 Pablo Picasso, *Maids of Honor*

DADA, SURREALISM, AND FUTURISM

★ 1912 Giacomo Balla, *Dog on a Leash*
★ 1914 Giorgio de Chirico, *Mystery and Melancholy of a Street*
✤ 1921 Kurt Schwitters, *Cherry Picture*
✤ 1936 Meret Oppenheim, *Object*

MODERN ARCHITECTURE

◆ 1891 Louis Sullivan, *Wainwright Building*
◆ 1907 Antonio Gaudí, *Casa Mila*
◆ 1908—1909 Frank Lloyd Wright, *Robie House*
◆ 1925 Walter Gropius, *The Bauhaus*
◆ 1936—1937 Frank Lloyd Wright, *Fallingwater*
◆◆◆◆◆ 1950—1955 Le Corbusier, *Notre Dame du Haut*
◆ 1968 Kallman, McKinnell & Knowles, *Boston City Hall*
◆ 1975 I. M. Pei and Partners, *Christian Science Center Complex*
◆ 1982—1985 Michael Graves, *Humana Building*

MODERN SCULPTURE AND CERAMICS

1880 · 1890 · 1900 · 1910 · 1920 · 1930 · 1940 · 1950 · 1960 · 1970 · 1980 · 1990

❖ 1884—1886 Auguste Rodin, *The Burghers of Calais*

❖ 1895 Frederick Remington, *The Bronco Buster*

❖ 1928 Constantin Brancusi, *Bird in Space*

❖ 1928 Jacques Lipchitz, *The Harp Player*

1930-1940 Maria Martinez, *Black on Black Jar*

❖ 1941 Naum Gabo, *Spiral Theme*

❖ 1949 Alberto Giacometti, *Tall Figure*

1951 David Smith, *Hudson River Landscape* ❖

1956 Louise Nevelson, *Dawn's Wedding Chapel* ✪

1959 Louise Nevelson, *Case with Five Balusters* ✪

1963 Lucas Samaras, *Untitled Box No. 3* ❖

1950-1964 James Hampton, *Throne of the Third Heaven of the Nation's Millenium General Assembly* ❖■■■

1966 Eva Hesse, *Laocoön* ❖

1969—1970 Anthony Caro, *Table Piece LXXXVIII* ❖❖

1973 Robert Arneson, *Current Event* ❖ ➤

1974 Albert Paley, *Portal Gates* ❖

1977 Joseph Grau-Garriga, *Autumn Mist* ✪

1981 Isabel McIllvain, *Venus* ❖

1982 Frank Stella, *Thruxton 3X* ✪

1983 Donald Judd, *Untitled* ✪

1984 Isamu Noguchi, *Kyoko-san* ❖

1984 Martin Puryear, *Mus* ❖

1988 Richard Artschwager, *Up and Across* ❖

KEY

◆ Architecture
❖ Assemblage
➤ Ceramics
✚ Collage
▲ Drawing
● Film
■ Installation
❖ Mosaic

★ Painting
✦ Performance
□ Photograph
✱ Print
✪ Relief
❖ Sculpture
○ Video

ABSTRACT EXPRESSIONISM AND COLOR FIELD

1952 Franz Kline, *Untitled* ★

1953 Marc Rothko, *Green and Maroon* ★

1953 Willem de Kooning, *Woman and Bicycle* ★

1959 Morris Louis, *Saraband* ★

1969 Joan Mitchell, *Sans Niege* ★

1982—1988 Helen Frankenthaler, *Gateway* ★★★★★★★★

POP ART

1959 Robert Rauschenberg, *Canyon* ❖

1964 Andy Warhol, *Twenty Jackies* ✱

NEO-EXPRESSIONISM AND POST-MODERNISM

1979 Susan Rothenberg, *Pontiac* ★
1979 Susan Rothenberg, *Untitled* ★
1982 Anselm Kiefer, *Wayland's Song (With Wing)* ❖
1982 Elizabeth Murray, *Keyhole* ▲
1983 Howie Lee Weiss, *Events Leading to the First Born* ▲
1984 George McNeil, *Everyman #2* ★
1986 Roger Brown, *Surrounded By Nature* ★
1988 Keith Haring, *Growing* ✳
1988 Robert Colescott, *Feeling His Oats* ★

TWENTIETH-CENTURY REPRESENTATIONAL ARTISTS

★ 1925 Edward Hopper, *House by the Railroad*
★ 1929 Charles Sheeler, *Upper Deck*
★ 1930 Edward Hopper *Early Sunday Morning*
★ 1933 Balthus, *The Street*
★ 1940 Edward Hopper, *Gas*
★ 1946 Patrick Desjarlait, *Maple Sugar Time*
★ 1956 Giorgio Morandi, *Still Life With Four Objects and Three Bottles*
▲ 1956 Giorgio Morandi, *Still Life*
★ 1957 Giorgio Morandi, *Still Life*
✠ 1964 Romare Bearden, *The Prevalence of Ritual: Baptism*
1970 Antonio Lopez-Garcia, *Studio Interior* ★
1974 Jacob Lawrence, *Builders* ★
1983 Alex Katz, *The Red Coat* ★
1984 Bernard Chaet, *Blueberries I* ★
1984 Willaim Bailey, *Still Life* ▲
1989 Jack Knox, *Kitchen* ★

PHOTOREALISM

1971 Richard Estes, *Diner* ★

1880 · 1890 · 1900 · 1910 · 1920 · 1930 · 1940 · 1950 · 1960 · 1970 · 1980 · 1990

PHOTOGRAPHERS

- 1889 Alfred Stieglitz, *Sun Rays*
- 1925 Imogen Cunningham, *Magnolia Blossom*
- 1927 Edward Weston, *Shell*
- c. 1928 Charles Sheeler, *Upper Deck*
- 1929 Imogen Cunningham, *Leaf Pattern*
- 1940 Barbara Morgan, *Letter to the World*
- 1946 Arnold Newman, *Igor Stravinsky*
- 1947 Ansel Adams, *Dead Tree, Sunset Crater National Monument, Arizona*
- 1981 Sandy Skoglund, *Revenge of the Goldfish*
- 1983 Cindy Sherman, *Untitled #122*

PERFORMANCE, CONCEPTUAL, EARTHWORKS, INSTALLATION ART

- 1972–1976 Christo, *Running Fence*
- 1972–1978 Keith Sonnier, *BA-O-BA*
- 1974 Joseph Beuys, *Coyote: I Like America and America Likes Me*
- 1980 Christo, *Puerta de Alcala Wrapped/Project for Madrid*
- 1980 Judy Pfaff, *Kabuki (Formula Atlantic)*
- 1985 Mineko Grimmer, *Seeking the Philosopher's Stone*
- 1987 Donna Dennis, *Deep Station*
- 1988 Ilya Kabakov, *The Man Who Flew Into Space from His Apartment*

FILM AND VIDEO

- 1919 Robert Wiene, *The Cabinet of Dr. Caligari*
- 1925 Sergei Eisenstein, *Battleship Potemkin*
- 1931 Charles Chaplin, *City Lights*
- 1939 Vincent Minnelli, *The Wizard of Oz*
- 1941 Orson Welles, *Citizen Kane*
- 1971 Nam June Paik, *TV Cello and TV Glasses*
- 1972 Francis Ford Coppolla, *The Godfather Part 1*
- 1974 Francis Ford Coppolla, *The Godfather Part II*
- 1989 Nam June Paik, *Fin de Siecle II*
- 1990 Barry Levinson, *Avalon*

KEY

- ◆ Architecture
- ❖ Assemblage
- ◗ Ceramics
- ✢ Collage
- ◀ Drawing
- ● Film
- ■ Installation
- ❖ Mosiac
- ★ Painting
- ✦ Performance
- ❑ Photograph
- ✱ Print
- ✪ Relief
- ❖ Sculpture
- ○ Video

glossary

Abstract Expressionism
A style of painting that became the dominant international force in the world of painting in the 1950s. An important characteristic of this style of painting involves an aggressive, gestural handling of the brushstroke in particular and the paint medium in general.

abstraction
A nonrepresentational or non-naturalistic interpretation of a given subject.

acrylic
A synthetic resin made into paint by suspending colored pigments in an acrylic emulsion that can be thinned with water or with a polymer medium.

actual space
The type of space occupied by artforms such as sculpture and architecture, in which the work of art extends in every direction and exists in three-dimensional, as opposed to illusionistic, space.

actual texture
A tactile surface that can be detected through the fingertips as well as the eyes.

additive sculpture
A sculptural process involving the creation of a three-dimensional shape or form by joining together separate pieces of a given material or combination of different materials.

allover space
A kind of visual structure that greatly reduces or flattens out contrasts so that an all over effect is achieved.

analogous colors
Hues that are located near each other on the color wheel, such as yellow, yellow-orange, and orange, and that share a common color.

aperture
An opening in a camera through which light enters.

approximate symmetry
A type of asymmetrical structure in which two clearly differentiated halves of a composition allude to a centralized axis.

aquarelle
Transparent watercolor painting.

arch
An architectural element that uses small, wedge-shaped stones or blocks to bridge an expanse by means of curving the space.

Archaic style
A style of Greek art prevalent during the seventh and sixth centuries B.C.

assemblage
A work of art in which the foreign matter that is attached to a surface projects significantly outward into the space occupied by the viewer.

asymmetry
Not symmetrical. The arrangement of dissimilar parts to achieve a balanced whole.

atmospheric perspective
A means by which artists create the illusion of depth on a two-dimensional surface. Atmospheric perspective is based on the principle that the farther away a form is from the viewer, the less distinct it appears to be.

axis
The predominant visual direction that runs through the longest, most centralized part of a form. An axial line is not an actual, but rather an imagined or implied line.

balance
The sense of equilibrium resulting from a harmonious arrangement of the visual elements.

Baroque art
A style popular in the seventeenth and early eighteenth centuries that was governed by sweeping spatial thrusts, restless movement, exaggerated emotional expression, dramatic lighting effects, rich ornamentation, and often, an overall sense of theatricality.

barrel vaults
Fused arches extended in space.

basilica
A rectangular building comprised of rows of pillars or columns that divide the space into a high central aisle or area (nave) and two lower side aisles. The Romans used the basilica primarily as an assembly hall or for law courts.

bas-relief
see *relief sculpture*.

The Bauhaus
An important German art school founded in 1919 by the architect Walter Gropius.

binder
A sticky substance that binds colored *pigments* together to make paint.

Body Art
see *Performance Art*.

Byzantine art
A style that takes Christianity as its subject. Its conventions include the display of flat or shallow space, resplendent, decorative patterns, and simple, opaque (often gold) backgrounds.

cantilever
An architectural building technique in which a structure such as a beam or floor slab extends significantly beyond supporting walls or columns.

casting
A process whereby a liquid substance is converted into a solid, permanent form by pouring the liquid into a mold and allowing it to harden.

charcoal
A drawing medium produced by burning sticks of wood.

chasing
Striking rounded tools with a hammer against the front side of a thin, cold piece of metal, thereby creating a series of indentations.

chiaroscuro
A pictorial convention of modeling a form through gradual tonal modulations.

Chicago School
Chicago-based architects working from about the 1880s through the first few decades of the twentieth century, who developed technological procedures involving steel-frame construction which resulted in the development of the skyscraper.

chroma
see *intensity*.

Classical style
A style of Greek art popular during the fifth and early fourth century B.C. Classical Greek sculpture is characterized by idealized, relatively lifelike representations of freestanding, graceful figures. These figures usually display refined proportions and an overall sense of physical, intellectual, and emotional balance.

collage
A collection of various materials taken from their natural environment and pieced together (usually pasted) onto a two-dimensional support.

color
An aspect of light (or wavelengths of light) that involves hue, value, and intensity.

composition
The ordered arrangement of the visual components that comprise a work of art.

complementary colors
Two hues that are located directly across from one another on the color wheel such as yellow and violet, red and green, and blue and orange.

conception
The originating intentions and ideas, as well as the underlying emotions, that generate a work of art.

Conceptual Art
An artform developed in the 1960s out of the belief that the process of making art, and the ideas or concepts underlying the work of art, were more important than actual images or objects.

Constructivism
A twentieth-century style of painting and sculpture influenced by the geometry of Cubism. Constructivist works of art, which tend to glorify technology, are characterized by industrial-like precision and the use of modern materials such as plastic and stainless steel.

content
The basic meaning of a work of art.

contrapposto
An Italian word meaning "counterpoise," which refers to the positioning of the standing human body along a central vertical axis. Most of the weight is placed on one leg, causing the hips and shoulders to slant in opposite directions.

contrast
The relationships established between different elements or forces.

contour line
The outside edge of a substance that reflects the three-dimensionality of the form.

cool colors
Green, blue, and violet hues.

crosshatching
A drawing or printmaking technique in which one set of lines is overlapped by another set angled in another direction.

cross vault
The structure that results when two barrel vaults intersect.

Cubism
A style of art developed by Pablo Picasso and Georges Braque during the early part of the twentieth century that involved a radically new conception of geometricized form and space.

Dada
A movement developed at the height of World War I by a group of artists who, in reaction to the breakdown of social and political order as a result of war, set out to create a form of art that willfully overturned the values and order of traditional thinking in general and of art in particular.

deep space
A type of pictorial space that entails recession and great distance.

diaphragm
A mechanical devide that controls the amount of light that passes through the aperture of a camera.

dome
An arch rotated 360 degrees on its axis. During the Renaissance, magnificent architectural feats involving the construction of huge domes, or hemispherical roofs, were accomplished.

drawing
A two-dimensional image that consists of a series of marks distributed across a paper support.

drypoint
A form of intaglio printing in which the metal cut-out of the plate results in a raised edge, or burr. When ink is applied and then wiped off the plate, a ridge of ink is trapped under the burr creating a velvety, slightly blurred line when the image is printed.

earthwork
An art form developed in the 1960s and 1970s in which artists rejected traditional methods and materials for those such as bulldozers and dirt. As the name implies, earthworks are created in close association with the earth.

edition
In printmaking, the series of impressions derived from a master image.

empathy
The capacity to project one's feelings and imagination onto an outside stimulus.

engraving
A form of intaglio printing in which a linear image is cut into a metal plate. After ink has been worked into these sharp, shallow grooves, all the ink is wiped off the plate except where it fills the incised lines. The ink from these lines is transferred from plate to paper.

etching
A form of intaglio printing in which a metal plate is coated with an acid-resistant substance through which the artist scratches an image with a needle-like point. When the plate is immersed in acid the exposed areas are eaten away or etched permanently into the bare metal. These areas are subsequently filled with ink and then transferred to a sheet of paper.

Expressionist art
Expressionist art developed in the early twentieth century, characterized by distortion of form, color, and space, and a willingness on the artist's part to replace naturalistic description with emotional expression.

façade
Exterior viewpoint or elevation (usually the front) of a building.

Fauvism
A style of painting developed between approximately 1904 and 1907 by a group of Paris-based painters. Fauve paintings are characterized by brilliant, clearly delineated shapes of color.

figure/ground
The interaction of positive/negative or foreground/background shapes in a two-dimensional image.

film
In photography, a sheet or strip of transparent plastic that has been coated with a thin layer of light-sensitive emulsion, which records images when light is projected onto the film.

flat space
A basic, relatively uncomplicated manner of manipulating form that reinforces the flatness of the image support.

flying buttress
An architectural innovation developed by Gothic designers. This structural system reinforces the strength of outside walls by absorbing much of the outward pressure created by the weight of a ceiling.

focal point
A particular spot or part of a work of art that seems to hold together the rest of the composition; something that everything else can be seen in relation to.

forging
Heating one of the hard metals, like iron, until it is red-hot and then hammering it into a particular shape.

form
Form, as in the expression "form and content" refers to the elements and principles that comprise the language of visual art. Volumetric form is but one of the visual (or formal) elements.

fresco
A painting that involves working a mixture of pigment and lime water into a freshly plastered wall.

Futurism
An early twentieth-century movement in painting and sculpture that wholeheartedly accepted technology and the future. The Futurists were especially preoccupied with portraying speed and movement.

geometric forms
Three-dimensional solids such as cubes, spheres, cylinders, cones, and pyramids.

geometric shapes
Shapes that are usually bordered by straight lines, precise angles, or uniform curves, as is the case in such simplified, geometric shapes as squares, circles, and triangles.

gesso
A mixture of glue and chalk applied to a surface in order to prepare that surface for the application of paints such as tempera or oil. The gesso enables the paint to adhere properly.

gestural line
Lines that disregard unnecessary details, describing instead the large, underlying motions or thrusts of a visual circumstance.

gesture
The dynamic spirit, feeling, or attitude demonstrated by a particular pose or motion.

glyph
Derived from the Greek word *glyphein*, to carve or cut. Carved inscriptions that take the form of pictographs or some other symbolic visual character or sign.

Gothic
A style of architecture, developed approximately between the twelfth and sixteenth centuries, that is characterized by tall, expansive, light-filled buildings in which the arts—especially sculpture and stained glass—are thoroughly integrated with the overall building plan.

gouache
A painting medium created by adding opaque white to watercolors.

grid
An orderly system of implied or actual geometric lines within which a visual composition is organized.

Happening
see *Performance Art*.

haut-relief
see *relief sculpture*.

Hellenistic style
A style of Greek art of the third and second centuries B.C. Hellenistic sculpture is characterized by more dramatic, emotionally expressive figures than those of Classical Greek sculpture.

horizon line
The actual or implied height of the artist's and viewer's eye level or line of sight within the image.

Hudson River School
A style of painting developed by a group of nineteenth-century American landscape painters who created many of their scenic works around the New York area of the Catskill Mountains along the Hudson River.

hue
The common names by which we identify colors. Every hue has a different wavelength of light.

illusionistic space
The sense of space in two-dimensional works of art such as paintings and photographs, which have height and width but do not embody any appreciable degree of actual, three-dimensional depth.

impasto
Paint that is applied thickly to its support.

implied texture
A flat surface that, because of visual indications, creates the illusion of being physically textured.

implied line
A line that is imagined, not actual, such as an eye glance or the axis of a shape or form.

Impressionism
A late nineteenth-century style of painting that originated in France. Impressionist paintings by Paris-based artists such as Monet, Pissaro, Morisot, and Renoir focused on transitory, commonplace activities, on-the-spot portrayals of landscapes, and luminous, flickering surfaces.

intaglio
A form of printmaking in which artists cut away the portions of the copper, zinc, or steel plate that they do not want to be transferred to the printed page. The lines or marks incised into the plate are the marks that will ultimately be reproduced.

intensity
The relative brightness or dullness of a color. Sometimes referred to as chroma or saturation.

International Style
A style of architecture developed roughly between the 1920s and 1940s in which skeletal supports not only allowed architects greater freedom than before regarding the interior space of a building, but also enabled architects to create exterior walls consisting primarily of glass. Designs, characterized by clean, geometrical planes and a conspicuous absence of ornament, were motivated mainly by a building's underlying structure and function.

lens
In photography, a lens throws refracted light onto the film which is positioned on the back wall of the camera.

line
A mark or extended point in space that is noticeably longer than it is wide.

linear perspective
A mechanical system involving the creation of the illusion of three-dimensionality on a two-dimensional surface.

lintel
A horizontal crosspiece that extends across two or more vertical supports.

lithography
The most popular form of planographic printmaking. In lithography, an image is drawn on a flat but roughened surface with a greasy substance. An acidic solution then fixes the image onto the ground. Then the surface is dampened with water and inked with a roller. Because oil and water do not mix, those areas of the ground on which the image is drawn repel the water and accept the oil-based ink.

lost-wax process (Cire Perdue)
A popular, traditional metal-casting technique developed during the Renaissance. This complex technique effectively converts a clay, plaster, or wax model into an otherwise identical model in metal.

Mannerism
A style of art, extending roughly from 1520 to 1600, that is marked by spatial ambiguities, distortions of form, and exaggerated gestures and movements, resulting in a heightened sense of spirituality and emotionalism.

mass
Volumetric form.

medium
The material or method used in the creation of a work of art. Also, the material, such as water or turpentine, used for thinning out paint.

mixed media
The mixing together of two or more media or materials within one work of art.

mosaic
A medium that consists of imbedding small pieces of colored glass, ceramic tile, or stone into a background material of cement or plaster.

multiple points of attraction
A way of structuring a work of art which relies on more than one point of focus to bring the component parts into an ordered whole.

Nabis
A small group of French artists painting during the late nineteenth century, who added a kind of moodiness to the light and color bequeathed them by the Impressionists.

naturalistic
Visual description that closely resembles phenomena in the natural world.

negative shape
The area surrounding or enclosed within other, more solid, shapes or volumes.

Neo-Classicism
In architecture this style covers a period roughly from 1750 to the early 1800s. It is characterized by plane surfaces, symmetry, and geometric clarity. As its name implies, Neo-Classicism was influenced greatly by the art of ancient Greece and Rome, prominently reintroducing, for example, such classical features as Doric, Ionic, and Corinthian columns.

Neo-Expressionism
A wide-ranging style of painting developed at the end of the 1970s and in the early 1980s, that is characterized by a spirited paint handling, figurative (often narrative) imagery, a concern for myth, investigations into the workings of the subconscious mind, and an emphasis on the passionate (as opposed to the intellectual).

Neo-Plasticism (also called De Stijl)
A movement developed in approximately 1917 that is characterized by simplified, abstract shapes, rigidly ordered geometry, and bright colors.

nonrepresentational
Works of art not based on a resemblance to natural visual phenomena.

oil paint
A painting medium in which pigment is combined with one of several possible oil mixtures.

one-point perspective
In this geometrical system, a single vantage point is established along a single horizon line.

organic form
A three-dimensional solid with irregular contours that is usually curvilinear.

organic shapes
Shapes that display irregular outlines or contours and are usually curvilinear in nature.

organizational line
A line that orders, or organizes the individual parts of a work of art, into a cohesive unit, which, in turn, forms a significant part of the work's overall structure.

outline
Flat, diagrammatic lines that are primarily intended to define where one thing ends and another begins.

overlapping
A technique in which one form exists in front of, and at least partially obscures, another form.

papier collé
A form of collage in which cut papers are pasted onto a flat support.

pastels
Dry chalks composed of colored pigments and a non-waxy binder.

pattern
The product of a relatively constant repetition of a visual detail or motif.

pendentives
Spherical triangles that distribute the weight of a dome outward rather than straight downward.

Performance Art
Artwork in which the focus is not on one single image or object, but rather, on an act or series of actions which the artist or other participant(s) perform, usually in front of an audience.

perspective
A convention or system used by artists to create the effect of three-dimensionality or distance on a two-dimensional surface.

Photorealism
Developed in the 1960s, the Photorealists created images that rivaled the photographic image in terms of the kind of detached depiction and precision of detail commonly associated with photography.

pigment
A dry coloring substance that is mixed with a *binder* to make paint.

pilaster
A decorative columnar form that projects relief-like from a wall.

planographic

Printmaking techniques that involve printing images off flat surfaces as opposed to raised surfaces (relief printing) or depressed surfaces (intaglio).

pointed arch

An architectural innovation that enabled Gothic artists to vary the height of the arch (and therefore the domed ceiling of any given building) simply by varying the angle of its slope. The taller, pointed arch enabled architects to design buildings that enclosed a far greater degree of open interior space than that permitted by the rounded arch.

Pop Art

A style of art developed in the late 1950s and early 1960s that focused on subject matter and styles of representation that addressed issues involving popular mass culture.

pose

The manner in which someone or something is placed or arranged.
positive shape—Any tangible or solid shape that appears in front of, and encloses, an area (negative shape) of the background.

post

The vertical column or some other form of upright support such as a wall, above and across which is extended a horizontal crosspiece usually referred to as a beam or *lintel*.

Post-Impressionism

This term refers more to a time period (roughly between the 1880s and 1906) than to a specific movement of art. The Post-Impressionists were active just after the heyday of Impressionism and just before the development of the movements of Fauvism and Cubism.

Post-Modernism

A movement developed in the 1970s that is characterized by an acceptance and re-examination of historical forms which are often introduced within a given work as a complex, interacting sequence of conflicting styles. Many of the most prominent features of Post-Modern art and architecture challenge tenets of Modernism.

primary colors

Red, yellow, and blue. All other colors can be mixed from the primaries, but a primary color cannot be created by mixing any other colors.

raising

Hammering a flat, cold piece of one of the softer metals, like gold or tin, into a hollowed form.

Realism

A mid-nineteenth-century style of art in which the appearance of everyday subject matter was portrayed in a straightforward, true-to-life manner.

reinforced concrete

Concrete which has hardened after being poured over steel rods or mesh. A building material that has great tensile strength.

relief printing

The oldest printmaking technique in which the marks or visual details the artist wishes to record are raised above the level of the rest of the surface that serves as the support for the image that is to be printed.

relief sculpture

Sculptural works that protrude in varying degrees from a background support. Reliefs are categorized as either *bas-relief* (low or shallow relief) or *haut-relief* (high or deep relief).

Renaissance

The word *renaissance* means rebirth in Italian and refers to the revival of interest during the fourteenth, fifteenth, and sixteenth centuries in the arts and sciences of classical antiquity.

repouseé

Striking rounded tools with a hammer against the back side of a thin, cold piece of metal, thereby creating a series of bumps or raised lines.

rhythm

A sometimes regularized, sometimes unruly movement or flow that is created by an actual or implied connection between the parts of a composition.

ribbed vault

A vault that is reinforced by slender, arched (usually stone) lines that support the stone webs between the ribs.

Rococo

A style of art characterized by profuse and intricate (often curvilinear) ornamentation, soft colors, gracious movements, and, above all, by a lighthearted, decidedly delicate and charming atmosphere.

Romanesque

Style of art and architecture dating from approximately 1000 to 1150 A.D. that attempted to revive characteristics of ancient Roman art. This style is distinguished by round-headed arches, barrel vaults, small door and window openings, thick, massive walls, richly varying columns and capitals, and rectangular ground plans.

Romanticism

A style of art that lasted roughly form the middle 1700s through the middle of the 1800s. Romantic painting is characterized by exotic or picturesque subject matter; settings reflecting untamed nature; exaggerated, passionate emotions; and rebellious, often heroic, sometimes violent rejection of authority and oppression.

sandpainting (Native American)

Carefully prescribed colored design created as a means of, among other things, controlling dangerous elements, re-establishing harmony, curing sickness, and blessing a new home.

saturation

see *intensity*.

scale

The *impression* a work of art makes on a viewer regarding size, which may not correspond to the *actual dimensions* of that work.

secondary colors

Colors produced by combining any two primary colors.

serigraphy

A printmaking process in which a stencil is adhered to an open-mesh material that has been tightly stretched on a frame. When ink, dye, or paint is forced through the screen, the stenciled areas do not allow the paint to penetrate through the screen onto the support surface (usually paper) beneath.

shallow space

As its name implies, shallow space involves a limited spatial recession between the front and back planes of an image or object.

shape

A two-dimensional area that displays both width and length and that has relatively clear boundaries.

shutter

A mechanical device that regulates the length of time the aperture of a camera remains open.

silverpoint
A drawing medium in which a silver wire is drawn across a smooth, dry surface that has been prepared with a layer of white pigment.

space
Atmosphere, distance, or expansion that can extend vertically, horizontally, and in depth.

structure
The particular arrangement or organization of the visual elements in a work of art.

subtractive sculpture
Sculptural process that involves removing unwanted material from one shape or form in order to define a new shape or form.

Surrealism
An avant-garde art movement developed in the 1920s that especially affected the fields of drama, literature, and the visual arts. The subjects of many Surrealist works of art were inspired by the kinds of incongruities and extraordinary relationships that we often associate with unconscious thought processes such as dream states.

Symbolism
A movement in painting and literature that developed during the last two decades of the nineteenth century. Symbolists wished to visualize such weighty yet amorphous ideas as love, hate, fear, and God.

symmetry
The mirror-like repetition of the two sides of an image or object.

tempera
A paint medium that consists of approximately equal parts of colored pigment, egg yolk, and water.

tensile strength
The capacity of a given material to span an unsupported horizontal expanse without giving in to the physical stress exerted on it by its own weight or the weight of another element that rests on it.

tertiary colors
Colors produced by combining a secondary color with an adjacent primary color.

tesserae
Tiny pieces of colored tiles, glass, or stones that are embedded in a cementing agent to form a mosaic.

texture
The surface quality of an actual or represented substance.

throwing
A method by which a potter centers a lump of clay on a potter's wheel, hollows out the inside of the lump, and then proceeds to form outside walls or sides of the vessel by pulling the continuously moistened clay from the bottom up.

tusche
A black, greasy material that comes in both liquid and crayon form. When tusche is applied to a screen fabric, it acts as a stencil in the creation of serigraphs.

two-point perspective
A geometrical system that artists use for creating the illusion of recessional space. In this system, two vantage points are established along the same horizon line for each form that is seen from an angle.

typeface
A style of lettering.

typography
A printing process based on the arrangement and design of letter characters or type.

Ukiyo-e
A style of Japanese painting and printmaking produced between the early 1600s through the mid-1800s. Basic themes and characteristics of Ukiyo-e include festival scenes of common men and women; scenes of the kabuki theatre; courtesans; figures portrayed in contemporary dress; and especially in the work of Hokusai and Hiroshige, landscape.

unity
The balance or sense of equilibrium achieved through the interaction of the visual components in a work of art.

value
The lightness or darkness of a color.

vehicle
The liquid or emulsion (consisting of a *binder* and a solvent or thinner) that holds the grains of paint pigments together and allows paint to be spread across a surface more or less easily by altering the paint's viscosity.

volumetric form
A three-dimensional solid that displays a significant proportion of breadth, width, and length. It is the three-dimensional equivalent of two-dimensional shape.

warm colors
Red, orange, and yellow hues.

wash drawing
A drawing technique that uses a brush and ink.

watercolor
A painting medium consisting of pigments ground to a very fine consistency in a water-soluble binder.

welding
The act of fusing separate pieces of metal together through heat.

woodcut
A form of relief printing in which a print is made from an image that has been cut into a flat piece of wood.

notes

CHAPTER 1

1 John Gross, ed., *The Oxford Book of Aphorisms* (Oxford: Oxford University Press, 1983), 20.

2 Bernard S. Meyers, ed., *Encyclopedia of Painting,* 3rd ed. (New York: Crown Publishers, Inc., 1970), 399—400.

3 *Pablo Picasso: Meeting In Montreal* (Montreal: Montreal Museum of Fine Arts, 1985), 123.

4 Albert E. Elsen, *Purposes of Art,* 4th ed. (New York: Holt, Rinehart and Winston, 1981), 366.

5 Charles Earle Funk, *Funk & Wagnalls New College Standard Dictionary* (New York: Funk & Wagnalls, 1961), 625.

6 Ibid., 618.

7 Diane Kelder, *The Great Book of French Impressionism* (New York: Abbeville Press, 1980), 282.

8 Charles S. Moffett, *Impressionist and Post-Impressionist Paintings in the Metropolitan Museum of Art* (New York: Harry N. Abrams, 1985), 74.

9 Robert Goldwater and Marco Treves, *Artists on Art* (New York: Pantheon Books, 1972), 308.

10 Louise Nevelson, *Dawns and Dusks* (New York: Charles Scribner's Sons, 1976), 119.

11 Selden Rodman, *Conversations with Artists* (New York: The Devin-Adair Co., 1957), 6.

12 Sir Roland Penrose and Dr. John Golding, *Pablo Picasso: 1881—1973* (New York: Portland House, 1973), 161.

13 Ananda K. Coomaraswamy, *The Dance of Shiva,* rev. ed. (New York: Noonday Press, 1957), 84.

14 Selden Rodman, *Artists In Tune With Their World* (New York: Simon and Schuster, 1982), 85.

15 Herbert M. Cole and Chike C. Achebe, *Igbo Arts: Community and Cosmos* (Los Angeles: Museum of Cultural History and University of California, 1984), ix.

16 Warren L. d'Azevedo, "Sources of Gola Artistry," in *The Traditional Artist in African Societies,* ed. Warren d'Azevedo (Bloomington, Ind.: Indiana University Press, 1973), 332.

17 *Ansel Adams: An Autobiography* (Boston: Little, Brown, 1985), 9.

18 Hilton Kramer, *The Age of the Avant-Garde: An Art Chronicle of 1956—1972* (New York: Farrar, Straus, and Giroux, 1973), 210.

19 Joyce Carol Oates, comp., *The Best American Short Stories* (Boston: Houghton Mifflin, 1979), xvi.

20 Goldwater and Treves, *Artists on Art,* (New York: Pantheon Books, 1972), 70.

21 Richard Phipps and Richard Wink, *Invitation to the Gallery* (Dubuque, Iowa: Wm. C. Brown Publishers, 1987), 180.

22 Elizabeth Wynne Easton, *The Intimate Interiors of Edouard Vuillard* (Washington, D.C.: The Smithsonian Institution Press, 1989), 35.

23 Alfred H. Barr, *Matisse: His Art and His Public* (New York: The Museum of Modern Art, 1951), 63.

24 Diane Kelder, *The Great Book of French Impressionism* (New York: Abbeville Press, 1980), 183—184.

25 Daniel Halpern, ed., *Writers on Artists* (San Francisco: Nort Point Press, 1988), 115.

26 Clive Bell, *Art* (New York: Capricorn Books, 1958), 27.

27 Rodman, *Conversations,* (New York:The Devon-Adair Co., 1957), 213.

28 Svetlana Alprin, *The Art of Describing* (Chicago: University of Chicago Press, 1983), 159.

29 Hilton Kramer, *The Revenge of the Philistines: Art and Culture, 1972—1984* (New York: The Free Press, A Division of Macmillan, Inc., 1985), 175.

[30] Gary Schwartz, *The Luminous Image* (Amsterdam: Stedelijk Museum, 1984), 69.

[31] Frank Elgar, *Cézanne* (New York: Harry N. Abrams, 85.

[1] John Burchard, *Bernini is Dead? Architecture and the Social Purpose* (New York: McGraw-Hill, 1976), 103.

[2] Roy Sieber and Roslyn Adele Walker, *African Art in the Cycle of Life* (Washington, D.C.: Smithsonian Institution Press, 1987), 103.

[3] Robert Farris Thompson, *Flash of the Spirit* (New York: Vintage Books, 1983), 9.

[4] David Waterhouse, *Images of Eighteenth-Century Japan* (Toronto: Royal Ontario Museum, 1975), Fig. 72, p. 124. David Waterhouse may, in fact, substantiate his interpretation elsewhere, but if so, I am unfamiliar with this information.

[5] Paul Gardner, "When is a Painting Finished?", *Art News*, Nov. 1985, 90.

[6] Diane Kelder, *The Great Book of French Impressionism* (New York: Abbeville Press, 1980), 288.

[7] Robert Goldwater and Marco Treves, ed., *Artists on Art* (New York: Pantheon Books, 1972), 308.

[8] Sam Hunter, *Modern French Painting* (New York: Dell Publishing Co., 1964), 15.

[9] *Preamings: The Art of Aboriginal Australia*, edited by Peter Sutton, (New York: George Braziller Publishers in association with the Asia Society Galleries), notes on the inside front cover.

[10] Ibid., 55.

[1] Pat Booth, ed., *Master Photographers* (New York: Clarkson N. Potter, 1983), 176.

[2] Roberta Smith et al., *Elizabeth Murray: Paintings and Drawings* (New York: Harry N. Abrams, 1987), 58.

[3] Ibid.

[4] Heinz Kahler and Cyril Mango, *Hagia Sophia* (New York: Frederick A. Praeger, Publishers, 1967), 11.

[5] Charles A. Jencks, *Late-Modern Architecture* (New York: Rizzoli International Publications, 1980), 42.

[6] Susan Sontag, *On Photography* (New York: Farrar, Straus, and Giroux, 1977), 15.

[7] David Robinson, *Chaplin: His Life and Art* (New York: McGraw-Hill, 1985), 395.

[1] Robert Goldwater and Marco Treves, ed., *Artists on Art* (New York: Pantheon Books, 1972), 217.

[2] Eudora Welty, *The Eye of the Story: Selected Essays and Reviews* (New York: Random House, 1977), 161.

[3] Henry John Drewal, "Object and Intellect: Interpretations of Meaning in African Art," *Art Journal* (Summer 1988): 72.

[4] William Rubin, ed., *"Primitivism" in 20th Century Art*, vol. II (New York: The Museum of Modern Art, 1984), 661.

[5] Ibid.

[6] Edmund Burke Feldman, *The Artist* (Englewood Cliffs, N.J.: Prentice-Hall, 1982), 2.

[7] Rubin, *"Primitivism" in 20th Century Art*, vol. II, 683.

[8] Amy Goldin, "Patterns, Grids, and Painting," *Artforum* (Sept. 1975): 50—54.

[9] Cindy Nemser, "An Interview With Eva Hesse," *Artforum* (May 1970): 62.

[10] Carter Ratcliff, *Warhol* (New York: Abbeville Press, 1983), 46.

[1] Rudyard Kipling, *How the Leopard Got His Spots* (New York: Walker and Company, 1973), 1.

[2] Robert Goldwater and Marco Treves, ed., *Artists on Art* (New York: Pantheon Books, 1972), 134.

[3] John Russell, *The Meanings of Modern Art* (New York: Harper & Row, 1981), 46.

[4] Gerald Vizenor et al., *American Indian Art: Form and Tradition* (Minneapolis: Walker Art Center/The Minneapolis Institute of Arts, 1972), 20.

[5] Joseph Campbell, *The Mythic Image* (Princeton: Princeton University Press, 1974), 165.

[6] Robert Farris Thompson, *Flash of the Spirit* (New York: Vintage Books, 1984), 5.

CHAPTER 2

CHAPTER 3

CHAPTER 4

CHAPTER 5

7 This statement is quoted from a conversation I had in 1988 with Dr. Richard Kalter about the paintings of Mark Rothko. Although I have refrained from quoting him in other instances in this book, Dr. Kalter's insights and observations regarding many of the ideas presented in this text have provided me with an invaluable source of inspiration and information.

8 John Stewart Collis, *The World of Light* (New York: Horizon Press, 1960), 35.

9 H. W. Janson, *History of Art*, 18th ed. (Englewood Cliffs, N.J.:Prentice-Hall, and New York: Harry N. Abrams, 1974), 268.

10 Goldwater and Treves, *Artists on Art*, 50.

11 J. M. Cohen, trans., *Life of St. Theresa* (Harmondsworth, England: Penguin, 1957), 210.

12 William Fleming, *Arts & Ideas*, 7th ed. (New York: Holt, Rinehart and Winston, 1986), 395.

13 Jean Leymarie, *The Jerusalem Windows* (New York: George Braziller, 1967), 51.

CHAPTER 6

1 F. David Martin, *Sculpture and Enlivened Space: Aesthetics and History* (Lexington: University Press of Kentucky, 1981), 122.

2 Kenneth Clark, *Civilization: A Personal View* (New York: Harper & Row, 1969), 293.

3 Judith Higgins, "Heroes of Myth and the Morning After," *Art News* (Sept. 1986): 99.

4 William G. Bywater, Jr., *Clive Bell's Eye* (Detroit: Wayne State University Press, 1975), 47.

CHAPTER 7

1 Henry James, "On Some Painters Lately Exhibited," *Galaxy* 20 (July 1875): 94.

2 Selden Rodman, *Conversations With Artists* (New York: The Devin-Adair Co., 1957), 48.

3 *"Primitivism" in 20th Century Art*, edited by William Rubin, offers a comprehensive examination of the influence of African art on the work of Picasso. My reference to the relationship of Picasso's *Head* to the mask from Zaire and to the reliquary figure from Gabon is derived from examples reproduced in Rubin's text, *"Primitivism" in 20th Century Art* (New York: Museum of Modern Art, 1984), 270, 302—303.

4 Brian O'Doherty, *American Masters: The Voice and the Myth* (New York: Random House, 1973), 74—75.

5 Ibid., 78.

6 Ibid., 79.

7 John Updike, *Just Looking: Essays on Art* (New York: Alfred A. Knopf, 1989), 115.

8 Harold Rosenberg, "The American Action Painters," *Art News* (Dec. 1952): 22.

9 Flannery O'Connor, *Mystery and Manners* (New York: Farrar, Straus, & Giroux, 1969), 131—132.

10 John W. McCoubrey, *American Art, 1700—1960, Sources and Documents* (Englewood Cliffs, N.J.: Prentice-Hall, 1965), 107.

11 Roger Groepper, *The Essence of Chinese Painting* (Boston: Boston Book and Art Shop, 1963), 177.

12 Rainer Maria Rilke, *Letters on Cezanne* (New York: Fromm International Publishing Corporation, 1985), viii.

13 Marsden Hartley, "Albert P. Ryder," *The Seven Arts 2* (May 1917): 94.

14 Charles Jencks, *Post-Modernism: The New Classicism in Art and Architecture* (New York: Rizzoli International Publications, 1987), 310.

15 Lawrence Cunningham and John Reich, *Culture and Values*, alternate ed. (New York: Holt, Rinehart and Winston, 1985), 137.

16 Heinz Kahler and Cyril Mango, Hagia Sophia, (New York: Fredrick A. Praeger, Publishers, 1967), 16-17.

CHAPTER 8

1 John L. Tancock, *The Sculpture of Auguste Rodin* (Philadelphia: David R. Gordine, in association with the Philadelphia Museum of Art, 1976), 388—389.

2 Albert E. Elsen, *Purposes of Art*, 4th ed. (New York: Holt, Rinehart and Winston, 1981), 356.

3 Esin Atil, *The Age of Sultan Suleyman the Magnificent* (New York: Harry N. Abrams, 1987), 196.

4 William Fleming, *Arts & Ideas*, 7th ed. (New York: Holt, Rinehart and Winston, 1986), 407.

5 Sandy Skoglund, personal interview at the artist's studio, New York, Dec. 1, 1989.

6 Alfred Gotthold Meyer, *Donatello* (Bielefeld and Leipzig, 1904), 84.

[1] Robert Goldwater and Marco Treves, ed., *Artists on Art: From the XIVth to the XXth Century* (New York: Pantheon Books, 1972), 217.

[2] Ibid., 374.

[3] Ibid., 251.

[4] Scharf, *Art and Photography* (New York: Penguin Books, 1986), 250.

[5] John Arthur, *Spirit of Place: Contemporary Landscape Painting & the American Tradition* (Boston: Bulfinch Press, Little, Brown, 1989), 33.

[6] Many examples of artists' appropriations of photographs are included in an excellent study of this subject by Van Deren Coke, *The Painter and the Photograph*, 4th ed. (Albuquerque: University of New Mexico Press, 1972).

[7] H. P. Robinson, "Picture Making by Photography," in Margaret F. Harker, *Henry Peach Robinson* (Oxford: Basil Blackwell Ltd., 1988), 64.

[8] Ansel Adams, *The Camera* (Boston: New York Graphic Society, 1980), 73.

[9] Werner Schmalenbach, *Kurt Schwitters* (New York: Harry N. Abrams, 1967), 96.

[1] F. David Martin, *Sculpture and Enlivened Space: Aesthetics and History* (Lexington: University Press of Kentucky, 1981), 32.

[2] Edmund Burke Feldman, *The Artist* (Englewood Cliffs, N.J.: Prentice-Hall, 1982), 77.

[3] Stella Pandell Russell, *Art in the World*, 2nd ed. (New York: Holt, Rinehart and Winston, 1984), 94.

[4] Robert Goldwater and Marco Treves, ed., *Artists on Art: From the XIVth to the XXth Century* (New York: Pantheon Books, 1972), 66.

[5] Albert E. Elsen, *Purposes of Art*, 4th ed. (New York: Holt, Rinehart and Winston, 1981), 142.

[6] Isamu Noguchi, *The Isamu Noguchi Sculpture Museum* (New York: Harry N. Abrams, 1987), 84.

[7] David Attenborough, *The Tribal Eye* (New York: W. W. Norton & Company, 1976), 27.

[8] Adrian Gerbrands, ed., *The Asmat of New Guinea: The Journal of Michael Clark Rockefeller* (New York: The Museum of Primitive Art, 1967), 24.

[9] Phillip Rawson, *Primitive Erotic Art* (New York: G. P. Putnam's Sons, 1973), 279. Several of the ideas included in my discussion of Asmat Ancestor poles were influenced by Phillip Rawson's presentation of this subject.

[10] Ben Merchant Vorpahl, ed., *My Dear Wister!, The Frederick Remington-Owen Wister Letters* (Palo Alto, Calif.: American West, 1972), 160.

[11] Penelope Hunter-Stiebel et al., *Albert Paley: The Art of Metal* (Springfield, Mass.: Museum of Fine Arts, 1985), 20.

[12] Ray Faulkner et al., *Art Today*, 6th ed. (New York: Holt, Rinehart and Winston, 1987), 204.

[13] Marjorie Elliot Bevlin, *Design Through Discovery*, 4th ed. (New York: Holt, Rinehart and Winston, 1984), 188.

[14] Louis Kahn, "Structure and Form," Voices of America Forum Lectures, 1960, in Vincent Scully, Jr., *Louis I. Kahn* (New York: George Braziller, 1962), 118.

[15] Albert E. Elsen, *Purposes of Art*, 4th ed. (New York: Holt, Rinehart and Winston, 1981), 61.

[16] R. Furneax Jordan, *A Concise History of Western Architecture* (New York: Harcourt, Brace & World, 1969), 30—31.

[17] H. W. Janson, *History of Art*, 18th ed. (Englewood Cliffs, N.J.: Prentice-Hall, and New York: Harry N. Abrams, 1974), 561.

[18] Donald Hoffman, *Frank Lloyd Wright's Fallingwater: The House and its History* (New York: Dover Publications, 1978), 18.

[19] Bruce Brooks Pfeiffer and Gerald Norland, ed., *Frank Lloyd Wright: In the Realm of Ideas* (Carbondale: Southern Illinois University Press, 1988), 40.

[20] Martin Puryear addressed this point during a lecture he presented at the Baltimore Museum of Art, October 21, 1990.

[21] Dore Ashton, *American Art Since 1945* (New York: Oxford University Press, 1982), 144.

recommended readings

ARCHITECTURE

Burchard, John. Bernini is Dead? Architecture and the Social Purpose. New York: McGraw-Hill Book Company, 1976.

Cole, Doris. From Tipi to Skyscraper: A History of Women in Architecture. Cambridge, Massachusetts: M.I.T. Press, 1978.

Gropius, Walter. The New Architecture and the Bauhaus. Boston: Branford, 1965.

Jordan, R. Furneaux. A Concise History of Western Achitecture. New York: Harcourt, Brace, Jovanovich, Publishers, 1985.

Kahn, Louis. "Structure and Form." Voices of America Forum Lectures, 1960, in Vincent Scully, Jr., Louis I. Kahn. New York: George Braziller, 1962.

Giedion, Sigfried. Space, time, and Architecture. 5th ed. Cambridge, Mass.: Harvard University Press, 1973.

Gloag, John. Guide to Western Architecture. Spring Books, London: The Hamlyn Publishing Group Ltd., 1969.

Jencks, Charles. Post-Modernism: The New Classicism in Art and Architecture. New York: Rizzoli International Publications, Inc., 1987.

Jencks, Charles. The Language of Post-Modern Architecture. 4th ed. New York: Rizzoli International Publications, Inc., 1984.

Le Corbusier, Towards a New Architecture, New York: Praeger,1959.

Macdonald, William L. The Architecture of the Roman Empire. New Haven, Conn.: Yale University Press, 1965.

Muschenheim, William. Elements of the Art of Architecture. New York: Viking, 1964.

Pehnt, Wolfgang. Expressionist Architecture. New York: Praeger Publihers, 1973.

Pfeiffer, Bruce Brooks and Gerald Norland. eds. Frank Lloyd Wright: In the Realm of Ideas. Carbondale and Edwardsville: Southern Illinois University Press, 1988.

Pope, Arthur Upham. Persian Architecture. New York: George Braziller, 1965.

Scully, Vincent J.. Modern Architecture: The Architecture of Democracy. New York: Braziller, 1982.

Stern, Robert, A. M.. New Directions in American Architecture. New York: Braziller, 1977.

Swaan, Wim. The Gothic Cathedral. Doubleday, New York: Garden City, 1969.

Taddei, Maurizio. Monuments of Civilization: India. New York: Grosset& Dunlap Publishers, 1977.

Venturi, Robert. Complexity and Contradiction in Architecture. New York: Museum of Modern Art, 1967.

Venturi, Robert, Denise Brown, and Steven Izenour. Learning From Las Vegas. Cambridge, Mass.: M. I. T. Press, 1977.

ART HISTORY

Arnason, H. H. History of Modern Art. Prentice-Hall, New Jersey: Englewood Cliffs, 1968.

Atil, Esin. The Age of Sultan Suleyman the Magnificent. New York: Harry N. Abrams, Inc., 1987.

Canaday, John. Mainstreams of Modern Art. New York: Henry Holt and Co., 1959.

Clark, Kenneth. Civilization: A Personal View. New York: Harper & Row, Publishers, 1969.

Gardner, Helen. Art Through the Ages. Harcourt Brace Jovanich, New York: Publishers, 6th ed., 1986.

312

Gilbert, C. History of Renaissance Art: Painting, Sculpture, Architecture Throughout Europe. Abrams, New York, 1972.

Goldberg, R., Performance: Live Art 1909 to the Present. New York: Abrams, 1979.

Hauser, Arnold. The Social History of Art, 4 Vols. New York: Vintage, 1957.

Herbert, Robert L. Impressionism: Art, Leisure, and Parisian Society. New Haven: Yale University Press, 1988.

Hughes, Robert. The Shock of the New. New York: Knopf, 1981.

Hunter, Samuel. American Art of the 20th Century. New York: Harry N. Abrams, 1972.

Janson, H. W. History of Art. 18th ed. New Jersey: Prentice-Hall, Inc., and New York: Harry N. Abrams, Inc., 1974.

Livingston, Jane and John Beardsley. Black Folk Art in America: 1930-1980. Jackson, Mississipp: University Press of Mississippi, 1982.

Lucie-Smith, Edward. Late Modern: The Visual Arts Since 1945. New York: Praeger Publishers, 1969.

Malraux, Andre. trans. by Stuart Gilbert and Francis Price. Museums Without Walls. New York: Doubleday, Garden City, 1967.

Panofsky, Erwin. Meaning in the Visual Arts. Garden City. New York: Doubleday, 1955.

Rose, Barbara. American Art Since 1900. New York: Praeger, 1967.

Rosenblum, Robert. Cubism and Twentieth-Century Art. Englewood Cliffs, New Jersey: Prentice-Hall, 1966.

Russell, John. The Meanings of Modern Art. New York: Harper & Row, Publishers, 1981.

Willets, William. Foundations of Chinese Art: From Neolithic Pottery to Modern Architecture. New York: McGraw-Hill Book Co., 1965.

Wittkower, Rudolph. Idea and image: Studies in the Italian Renaissance, London: Thames and Hudson, 1978.

Barr, Alfred H., Jr. Matisse: His Art and His Public. New York: The Museum of Modern Art, 1951.

Barr, Alfred H., Jr., Picasso: Fifty Years of His Art, Reprint, First Published 1946, New York: The Museum of Modern Art, 1974.

Berger, John. The Success and Failure of Picasso. New York: Pantheon, 1980.

Cartier-Bresson, Henri. The Decisive Moment. New York: Simon & Shuster, 1952.

Clearwater, Bonnie, et al. Mark Rothko. London, Tate Gallery Publications, 1987.

Fine, Elsa Honig. The Afro-American Artist: A Search for Identity. New York: Hacker, 1982.

Flam, Jack, D. Matisse On Art. New York: Phaidon, 1973.

Glimcher, Arnold, B. Louise Nevelson. New York: Praeger, 1972.

Gogh, Vincent van. The Complete Letters of Vincent van Gogh. Boston: New York Graphic Society, Reprint 1958 ed. 1978.

Goldwater, Robert and Marco Treves, eds. Artists on Art, New York: Pantheon Books, 1972.

Hofmann, Hans. Search for the Real and Other Essays, Cambridge, Mass.: MIT Press, 1967.

Kandinsky, Wassily. Concerning the Spiritual in Art and Painting in Particular. 1912, New York: Wittenborn, 1970.

Klee, Paul. The Thinking Eye: The Notebooks of Paul Klee. New York: Wittenborn, 1961.

Lippard, Lucy, Eva Hesse, New York: New York University Press, 1976.

Louise Nevelson. Dawns and Dusks. New York: Charles Scribner's Sons,

Penrose, Roland. Portrait of Picasso. New York: The Museum of Modern Art, 1971.

Rilke, Rainer Maria. Letters on Cézanne. New York: Fromm International Publishing Corporation, 1985.

Rodman, Selden. Conversations with Artists. New York: The Devin-Adair Co., 1957.

BY OR ABOUT ARTISTS

Vasari, Giorgio. The Lives of the Painters, Sculptors, and Architects. New York: E. P. Dutton, 1927.

Washington, M. Bunch. The Art of Romare Bearden: The Prevalence of Ritual, New York: Harry N. Abrams, Inc., 1971.

Wheat, Ellen Hawkins. Jacob Lawrence: American Painter, Seattle: University of Washington Press, 1986.

Winston, Richard and Clara, trans., Diaries and Letters of Kathe Kollwitz, Chicago: Henry Regnery Co., 1955.

CERAMICS

Kenny, John B. Complete Book of Pottery Making, New York: Chilton, 1976.

Munsterberg, H. The Ceramic Art of Japan. Rutland, Vermont: Tuttle, 1964.

Nelson, Glen, C. Ceramics: A Potter's Handbook. 5th ed. New York: Holt, Rinehart and Winston, Inc., 1984.

CINEMA AND VIDEO

Arnheim, R. Film as Art. Berkeley and Los Angeles: University of California Press, 1967.

Clair, Rene. Cinema, Yesterday and Today. New York: Dover Publications, Inc., 1972.

Edmonds, Robert. The Sights and Sounds of Cinema and Television. New York: Teachers College Press, 1982.

Eisenstein, S. Film Form: Essays in Film Theory. New York: Harcourt, Brace & Co., 1942.

Geduld, Harry M. Film Makers On Film Making. Bloomington: Indiana University Press, 1968.

Hanhardt, John G. Nam June Paik. New York: W. W. Norton & Co., 1982.

Mast, Gerald. A Short History of the Movies. New York: Macmillan Publishing Co., 1986.

Youngblood, Gene. Expanded Cinema. New York: E. P. Dutton & Co., 1970.

DESIGN ELEMENTS AND PRINCIPLES

Albers, Joseph. Interaction of Color. New Haven: Yale University Press, 1975.

Bates, Kenneth F. Basic Design: Principle and Practice. New York: Funk & Wagnalls, 1975.

Bevlin, Marjorie Elliot. Design Through Discovery. 4th ed. New York: Holt, Rinehart and Winston, Inc., 1984.

Birren, Faber. Color and Human Response. New York: Van Nostrand Reinhold Company, 1978.

Canaday, John. What is Art?. New York: Alfred A. Knopf, 1980.

Faulkner, Ray, and Edwin Ziegfeld. Art Today. 5th ed. New York: Holt, Rinehart and Winston, Inc., 1969.

Itten, Johannes. The Art of Color. New York: Van Nostrand Reinhold Company, 1974.

Itten, Johannes. The Elements of Color, New York: Van Nostrand Reinhold Company, 1970.

Lauer, David. Design Basics, New York: Holt, Rinehart & Winston, Inc., 1979.

Ocvirk, Otto G., et. al. Art Fundamentals: Theory and Practice. 6th ed. Dubuque, Iowa: Wm. C. Brown Publishers, 1990.

DRAWING

Betti, Claudia, and Teel, Sale. A Contemporary Approach: Drawing. New York: Holt, Rinehart & Winston, Inc., 1980.

Chaet, Bernhard. The Art of Drawing. New York: Holt, Rinehart & Winston, Inc., 1970.

Goldstein, Nathan. The Art of Responsive Drawing. Englewood Cliffs, New Jersey: Prentice-Hall, 1977.

Mendelowitz, Daniel M. A Guide to Drawing. New York: Holt, Rinehart & Winston, Inc., 1976.

Nicolaides, Kimon. The Natural Way to Draw: A Working Plan for Art Study. Boston: Houghton Mifflin, 1975.

Greenberg, Clement. Art and Culture: Critical Essays, Boston: Beacon Press, 1961.

Halpern, Daniel. ed.Writers on Artists, San Francisco: North Point Press, 1988.

Herbert, Robert L. Modern Artists on Art: Ten Unabridged Essays, Englewood Cliffs, New Jersey: Prentice-Hall, 1964.

O'Doherty, Brian. American Masters, Random House, New York, pg. 74-75.

Porter, Fairfield, Art In Its Own Terms. New York: Taplinger Publishing Co., 1979.

Robsjohn-Gibbings, T.H. Mona Lisa's Mustache. New York: Alfred A. Knopf, 1947.

Rosenberg, Harold. Art on the Edge: Creators and Situations. Chicago: University of Chicago Press, 1983.

Rubin, William, ed. "Primitivism" in 20th Century Art, New York: The Museum of Modern Art, 1984.

Updike, John. Just Looking: Essays on Art. New York: Alfred A. Knopf, 1989.

Welty, Eudora. The Eye of the Story: Selected Essays and Reviews. New York: Random House, 1977.

ESSAYS ON ART

Chadwick, Whitney. Woman, Art, and Society. London: Thames and Hudson, 1990.

Clark, Kenneth. The Nude: A Study in Ideal Form. New York: Doubleday & Company, Inc., 1956.

Harris, Anne Sutherland, and Linda Nochlin. Women Artists. 1550-1950. New York: Knopf, 1977.

Hobhouse, Janet. The Bride Stripped Bare. New York: Weidenfeld and Nicolson, 1988.

Lippard, Lucy Rowland. From the Center: Feminist Essays on Women's Art. New York: Dutton, 1976.

Munro, Eleanor. Women Artists, Originals. New York: Petersen and Wilson, 1976.

Petersen, Karen and J. J. Wilson. Women Artists: Recognition and Reappraisal from Early Middle Ages to the Twentieth Century. New York: Harper & Row, 1976.

Rawson, Phillip. Erotic Art of the East: The Sexual Theme in Oriental Painting and Sculpture. New York: G. P. Putnam's Sons, 1968.

Rawson, Phillip. Primitive Erotic Art. New York: G. P. Putnam's Sons, 1973.

Walters, Margaret. The Nude Male: A New Perspective. New York: Penguin Books, 1978.

GENDER AND SEXUALITY IN THE VISUAL ARTS

Campbell, Joseph. The Mythic Image. New Jersey: Princeton University Press, 1974.

Coomarswami, A., K., The Dance of Shiva, New York: Farrar Straus and Giroux, 1937.

Kris, Ernst, and Otto Kurz. Legend, Myth, and Magic in the Image of the Artist. New Haven, Connecticut: Yale University Press, 1979.

Malinowski, Bronislaw. Magic, Science, and Religion. Garden City, New York: Doubleday & Co., Inc., 1954.

Pfeiffer, John E. The Creative Explosion: An Inquiry into the Origins of Art and Religion. New York: Harper & Row, 1982.

MYTH, MAGIC, AND RELIGION IN THE VISUAL ARTS

Barnes, Albert C. The Art in Painting. 3rd ed. New York: Harcourt, Brace, & World, Inc., 1965.

Berenson, Bernard. Italian Painters of the Renaissance. 2 vols. London: Phaidon, 1982.

Chaet, Bernhard. An Artist's Notebook: Techniques and Materials. New York: Holt, Rinehart and Winston, 1979.

Cuttler, Charles D. Northern Painting: From Pucelle to Bruegel. New York: Holt, Rinehart and Winston, Inc., 1968.

Friedlander, M. J. Landscape, Portrait, Still Life. Oxford: Cassirer, 1949.

Groepper, Roger. The Essence of Chinese Painting. Boston: Boston Book and Art Shop, 1963.

Howatt, John K. American Paradise: The World of the Hudson River School. New York: The Metropolitan Musem of Art, 1987.

PAINTING

Hulten, Pontus, et. al. The Arcimboldo Effect. New York: Abbeville Press, 1987.

Mayer, Ralph. The Artist's Handbook of Materials and Techniques. New York: Viking Press, 1981.

Rodriguez, Antonio. A History of Mexican Mural Painting. New York: G. P. Putnam's Sons, 1969.

Rowley, G. Principles of Chinese Painting. Princeton, New Jersey: Princeton University Press, 1947.

Seitz, William C. Abstract Expressionist Painting in America. Cambridge, Massachusetts: Harvard University Press, 1983.

Shannon, Joseph. Representation Abroad. Washington, D.C.: Smithsonian Institution Press, 1985.

Silberman, Arthur. 100 Years of Native American Painting. Oklahoma City: The Oklahoma Museum of Art, 1978.

Stella, Frank, Working Space. Cambridge, Massachusetts: Harvard University Press, 1986.

Sterling, Charles. Still-Life Painting: From Antiquity to the Twentieth Century, 2nd rev. ed. New York: Harper & Row, 1981.

Welch, Stuart Carry. Persian Painting: Five Royal Safavid Manuscripts of the Sixteenth Century. New York: George Braziller, 1976.

PERCEPTION

Alprin, Svetlana. The Art of Describing: Dutch Art in the Seventeenth Century. Chicago: University of Chicago Press, 1983.

Arnheim, Rudolph. Art and Visual Perception. Berkeley, California: University of California Press, 1954.

Berger, John. Ways of Seeing. New York: Viking, 1972.

Gombrich, E. H. Art and Illusion. 12th ed. London: Phaidon, 1972.

Merleau-Ponty, Maurice, The Essential Writings of Merleau-Ponty, Harcourt, Brace & World, Inc., New York, 1969.

PHOTOGRAPHY

Adams, Ansel. The Camera. Boston: New York Graphic Society, 1980.

Bayer, Jonathan. Reading Photographs: Understanding the Aesthetics of Photography. New York: Pantheon Books, 1977.

Coke, Van Deren. The Painter and the Photograph: From Delacroix to Warhol. Albuquerque: University of New Mexico Press, 1972, 4th ed.

Diamondstein, B. Visions and Images: American Photographers on Photography. New York: Rizzoli International Publications, Inc., 1981.

Grundberg, Andy, and Kathleen McCarthy Gauss. Photography and Art: Interactions Since 1946. New York: Abbeville Press Publishers,

Newhall, B. The History of Photography. New York: Museum of Modern Art, 1964.

Scharf, Aaron. Art and Photography. New York: Penguin Books, 1986.

Sontag, Susan. On Photography. Farrar, New York: Straus and Giroux, 1977.

Swedlund, Charles. Photography: A Handbook of History, Materials, and Processes. 2nd ed. New York: Holt, Rinehart and Winston, Inc., 1981.

Tucker, Anne. The Woman's Eye. New York: Knopf, 1973.

PREHISTORIC AND ANCIENT ART

Alfred, Cyril. Egyptian Art. New York: Thames & Hudson, 1985.

Frankfort, Henri. Art and Architecture of the Ancient Orient. Baltimore: Pelican-Penguin, 1977.

Gafni, Schlomo, S. and A. Van der Heyden. The Glory of the Holy Land. Cambridge, London: Cambridge University Press, 1978.

Grey, Michael. Pre-Columbian Art. New York: Gallery Books, 1983,

Lommel, Andrea. Shamanism: The Beginnings of Art. New York: McGraw-Hill, 1967.

Ruskin, Ariane. Prehistoric Art and the Art of the Ancient Near East. New York: McGraw Hill Book Co., 1971.

Ruspoli, Mario. The Cave of Lascaux: The Final Photographs. New York: Harry N. Abrams, Inc., 1988.

Schapiro, Meyer and Michael Avi-Yonak. Israel: Ancient Mosaics. New York: New York Graphic Society, 1960.

Schele, Linda and Mary Ellen Miller. The Blood of Kings. Fort Worth: Kimbell Art Museum, 1986.

Scully, Vincent, J., Jr. Earth, the Temple, and the Gods: Greek Sacred Architecture. New Haven: Yale University Press, 1962.

PRINTMAKING

Castleman, Riva. American Impressions: Prints Since Pollock. New York: Alfred A. Knopf, 1985.

Heller, Jule. Printmaking Today. 2nd ed. New York: Holt, Rinehart and Winston, Inc.. 1972.

Lane, Richard. Images From the Floating World: The Japanese Print. New York: G. P. Putnam's Sons, 1978.

Mayor, Hyatt, A. Prints and People. Princeton, New Jersey: Princeton University Press, 1980.

Peterdi, Gabor. Printmaking. New York: Macmillan, 1971.

Robertson, R. G. Contemporary Printmaking In Japan. New York: Crown, 1965.

Ross, John, and Clare Romano. The Complete Printmaker. New York: Free Press (Macmillan), 1972.

SCULPTURE

Burnham, Jack. Beyond Modern Sculpture: The Effects of Science and Technology on the Art of This Century. New York: George Braziller, 1968.

Elsen, Albert E. Origins of Modern Sculpture. New York: George Braziller, 1974.

Hofman, Malvina. Sculpture: Inside and Out. New York: Bonanza Books,1939.

Kramisch, Stella. Indian Sculpture. Philadelphia: University of Pennsylvania Press, 1960.

Krauss, Rosalind E. Passages in Modern Sculpture. New York: Viking Press, 1977.

Lippe, Aschwin. The Freer Indian Sculptures. Washington, D. C.: Smithsonian Institution Press, Oriental Studies, no. 8, 1970.

Martin, F. David. Sculpture and Enlivened Space: Aesthetics and History. Lexington, Kentucky: The University Press of Kentucky, 1981.

Pope-Hennessy, John. The Study and Criticism of Italian Renaissance Sculpture. New York: Metropolitan Museum of Art, 1984.

Seitz, William C. The Art of Assemblage. New York: The Museum of Modern Art, 1961.

TRIBAL ART

Attenborough, David. The Tribal Eye. New York: W. W. Norton & Company Inc., 1976.

Bascom, William. African Art in Cultural Perspective. New York: W. W. Norton & Co., 1973.

Berlant, Anthony and Mary Hunt Kahlenberg. Walk in Beauty: The Navajo and Their Blankets. Boston: New York Graphic Society,1977.

Boas, Franz. Primitive Art. New York: Peter Smith, 1962,

Cole, Herbert M. and Chike C. Achebe. Igbo Arts: Community and Cosmos, Los Angeles: Museum of Cultural History and University of California, 1984.

d' Azevedo, Warren L. "Sources of Gola Artistry". in The Traditional Artist in African Societies. edited by Warren d' Azevedo, Indiana University.

Robert Farris Thompson. Flash of the Spirit. New York: Vintage Books, 1983.

Fagg, William. Tribes and Forms in African Art. New York: Tudor,1965.

Gerbrands, Adrian. ed. The Asmat of New Guinea: The Journal of Michael Clark Rockefeller, New York: The Museum of Primitive Art, 1967.

Holm, Bill. Northwest Coast Indian Art: An Analysis of Form. Seattle: University of Washington Press, 1965.

Thompson, Robert Farris. *African Art in Motion*. Berkeley and Los Angeles: University of California Press, 1974, pg. 51.

Vogel, Susan and Francine N' Diaye. *African Masterpieces*. New York: Harry N. Abrams, Inc., 1985.

Vogel, Susan, et. al. *Perspectives: Angles on African Art*. New York: Harry N. Abrams, Inc., 1987.

Wade, Edwin L. *The Arts of the North American Indian: Native Traditions in Evolution*. New York: Hudson Hills Press, 1986.

Wherry, Joseph H. *The Totem Pole Indians*. New York: Funk & Wagnalls, 1964.

Wyman, Leland C., ed. *Beautyway: A Navaho Ceremonial*. New York: Pantheon Books, 1957.

Wyman, Leland C. *Sandpaintings of the Navajo: Shootingway and the Walcott Collection*. Washington, D.C.: Smithsonian Institution Press, 1970.

index

photo credits

644